Lorenz Eitner

GÉRICAULT'S RAFT OF THE MEDUSA

Lorenz Eitner

GÉRICAULT'S RAFT OF THE MEDUSA

PHAIDON

Phaidon Press Limited · 5 Cromwell Place · London SW7 2JL
First Published 1972 · All Rights Reserved
ISBN 0 7148 1517 9

Phaidon Publishers Inc. · New York
Distributors in the United States · Praeger Publishers Inc.
111 Fourth Avenue · New York · N.Y. 10003
Library of Congress Catalog Card Number 70-158097

Printed in Great Britain
by The Cavendish Press Limited · Leicester

CONTENTS

List of Text Illustrations

vi

Preface

vii

THE MEDUSA AT THE SALON

1

THE STORY OF THE RAFT

7

GÉRICAULT IN 1817-1818

12

THE WORK IN PROGRESS

22

THE WORK ACCOMPLISHED

40

AFTERMATH

57

PLATES

69

CATALOGUE

137

List of Collections

174

Index

175

LIST OF TEXT ILLUSTRATIONS

A. Niquet: *Saturday at the Salon*. Lithograph, 1819

B. Charles Meynier: *France, Protectress of the Arts*. Salon of 1819. After an engraving

C. Abel de Pujol: *The Rebirth of the Arts*. Salon of 1819. After an engraving

D. Guillemot: *Christ Raising the Widow's Son*. Salon of 1819. After an engraving

E. Hersent: *Gustaf Wasa*. Salon of 1819. After an engraving

F. François-Edouard Picot: *Amor and Psyche*. Paris, Louvre. Salon of 1819

G. Antoine-Jean Gros: *The Embarkation of the Duchess of Angoulême*. Salon of 1819. Bordeaux, Musée des Beaux-Arts

H. Catalogue of the Salon of 1819

I. *The Evacuation of the Medusa*. Anonymous lithograph, about 1818. Paris, Bibliothèque Nationale

J. Corréard: Plan of the Raft. Engraving, 1817

K. "A Discharged Naval Officer": *The Lifeboats and the Raft leaving the Medusa*. Lithograph, about 1818. Paris, Bibliothèque Nationale

L. Hipolyte Lecomte: *The Mutiny on the Raft*. Lithograph, 1818. Paris, Bibliothèque Nationale

M. "A Retired Naval Officer": *The Survivors on the Raft Sighting the Argus*. Lithograph, about 1818. Paris, Bibliothèque Nationale

N. Géricault: *Self-Portrait*. Pen drawing, about 1818. Toronto, F. S. Jowell collection

O. Horace Vernet: *The Artist's Studio*. About 1818–20. After an engraving

P. Géricault: *Bull-Tamer*. Pen drawing, about 1817–18. Paris, Louvre

Q. Géricault: *The Start of the Race of the Barberi Horses*. 1817. Paris, Louvre

R. Géricault: *The Retreat from Russia*. Lithograph, 1818

S. Sébastien Coeuré: *The Body of Fualdès Taken to the Aveyron*. Lithograph, 1818

T. Géricault: *The Body of Fualdès about to be Cast into the Aveyron*. Chalk and wash drawing, 1818. Lille, Musée des Beaux-Arts

U. Jonas Suyderhoef after Rubens: *The Little Last Judgement*. Detail. Engraving, 1642

V. Girodet-Trioson: *The Deluge*. 1806. Paris, Louvre

W. Gabriel-François Doyen: *St. Genevieve Interceding for the Plague-Stricken*. 1767. Paris, Church of St. Roch

X. Antoine-Jean Gros: *Bonaparte Visiting the Plague-Stricken in the Hospital at Jaffa*. 1804. Paris, Louvre

Y. Géricault: Detail from *The Raft of the Medusa*. "The Father Holding the Body of his Dead Son"

Z. Géricault: Detail from *The Raft of the Medusa*. Head of the "Father"

AA. Henry Fuseli: *Ugolino in the Tower*. Etching by Moses Houghton. 1811

BB. Pierre-Narcisse Guérin: *Marcus Sextus*. 1799. Paris, Louvre

CC. Pierre-Narcisse Guérin: *Aurora and Cephalus*. 1810. Paris, Louvre

DD. Géricault: Detail from *The Raft of the Medusa*. Head of the "Dead Son"

EE. Antoine-Jean Gros: *The Battle of the Pyramids*. 1810. Versailles, Château, Musée d'Histoire

FF. Géricault: Detail from *The Raft of the Medusa*. Rising Figures

GG. Géricault: Detail from *The Raft of the Medusa*. Rising Figures

HH. Géricault: Detail from *The Raft of the Medusa*. The Dead Negro

II. Géricault: Detail from *The Raft of the Medusa*. The Cadaver at the lower right

JJ. Géricault: Detail from *The Raft of the Medusa*. Head of the Cadaver at the left

KK. Géricault: Detail from *The Raft of the Medusa*. The Group at the Mast

LL. Géricault: Detail from *The Raft of the Medusa*. The Signalling Negro

MM. Advertisement for the London Exhibition of *The Raft of the Medusa*

NN. Géricault: A Letter of Invitation to the Private Showing of *The Raft of the Medusa*. 1820. Paris, G. Delestre collection

OO–PP. Bullock's Egyptian Hall and Roman Gallery in Piccadilly. Engravings

QQ. N. S. Maillot: *The Raft of the Medusa in the Salon Carré of the Louvre*. About 1831. Paris, Louvre

RR. Eugène Lami: *The Raft of the Medusa in the Grande Galerie of the Louvre*. 1843. After an engraving by Mottram and Allen

PREFACE

About 1949, when still a student, I came across the remark by Walter Friedlaender, in his *David to Delacroix,* that the many sketches and studies for the *Raft of the Medusa* had never been reassembled. Although I knew very little about Géricault or the *Medusa* at the time, the suggestion which seemed contained in this observation for some reason stuck in my mind. I believe that it had some influence in starting me on my long occupation with Géricault, of which this book is a result. Though I cannot claim to have succeeded in reconstituting every detail of the complex of preliminaries which led to the *Medusa,* I have tried to follow the ramified circumstances surrounding the picture's conception and execution, and have searched for its significance not in the work's final shape only, but in the entire process which gave it birth. It was my hope that in doing this I should be able to deal with its historical situation, with its gradually unfolding form and its content in one continuous narrative, and thus arrive at an insight into its meaning through an effort of reconstruction, rather than analytical dissection. From the start, I was determined to limit myself to the genesis of the picture and to its immediate effect on contemporaries, and to leave for later consideration its influence on subsequent generations of painters.

I owe thanks for help received to Prof. Lee Johnson, Dr. Hans Lüthy, Dr. Frances S. Jowell, Dr. Françoise Forster, and Miss Hilary Smith. Grants by the Kress Foundation and the Carnegie Corporation decisively furthered my work. My greatest debt is to my wife, Trudi, for her encouragement and patience throughout these many years: I dedicate this book to her.

Stanford University, August 1972 L.E.

THE MEDUSA AT THE SALON

THE Salon which opened its doors to the public on the 25th day of August, 1819 (fig. A), was the largest and most brilliant exhibition of art held in France since Napoleon's fall and the return of the Bourbons. Under the circumstances, it was as much a political as an artistic event. The two officials in charge of the arrangements, Comte de Forbin and Vicomte de Senonnes, had spared no pains to use the occasion for the advancement of the monarchy. They had set the opening date on the feast of Saint Louis, patron saint of the dynasty, thus renewing pre-Revolutionary usage and paying a compliment to the reigning king, Louis XVIII. Salons had been held in Paris every other year for more than a century, with scarcely an interruption in time of revolution or war. They had become an influential institution which every successive régime had patronized, and at the same time exploited for political ends. The old monarchy had done so discreetly, the Revolution and Empire quite blatantly. The restored monarchy was attempting to maintain a middle course. The Salon of 1819 was the third exhibition held under its auspices. The two previous Salons, 1814 and 1817, had been overshadowed by military defeat and foreign occupation. By 1819 the time seemed ripe for a grand display of the results of the Restoration's patronage of the arts, to impress Frenchmen and foreigners with the renewed stability and prosperity of the nation. To give additional weight to this message, it had been decided to couple the Salon of 1819 with an industrial fair: installed in the Louvre's refurbished East wing, vast displays of cashmeres, printed wallpapers, and precision watches competed for attention with the paintings and sculptures shown in the adjoining galleries. The special point of these parallel exhibitions was to demonstrate the effectiveness and range of a system of royal patronage which embraced the whole of the nation's cultural and economic life. They were also to invite comparison between the Napoleonic and Bourbon régimes, in a manner designed to reveal Louis XVIII as the more enlightened and generous benefactor of all the arts of peace.

The grand stairs leading to the Salon had been embellished for the occasion with new painted ceilings which, in a series of bombastic allegories, proclaimed the monarch's generosity. In the largest of the ceilings, Abel de Pujol celebrated the *Rebirth of the Arts* (fig. C): surrounded by personifications of Truth, Peace, Commerce, and Liberty, the Genius of Art could be seen lifting his torch to dispel the clouds of Fanaticism and Ignorance, which had shrouded Painting, Sculpture, Architecture, and Engraving. The sister arts gratefully rose into the light of dawn, offering their attributes to the Genius. It was noted that the figure of Engraving carried under her arm a plate of David's *Oath of the Horatii,* a feature which introduced a troubling ambiguity into what might otherwise have seemed a simple tribute to Bourbon patronage. How could monarchy be credited with the rebirth of French art in the face of this reminder that the modern French School was, in fact, a child of the Revolution? Whom did the figures of Fanaticism and Ignorance represent in this cloudy allegory? And who was the liberating Genius, if not David himself, the Jacobin regicide and courtier of Napoleon, whom the Restoration had banished from France? The following ceiling, by Charles Meynier, fortunately stated its message in less confusing terms (fig. B). It showed France, royally enthroned, wearing Minerva's helmet encircled by the crown, and holding the lily sceptre of the Bourbons. At her feet, the arts pleaded for protection, while in the sky above the Genius raised his torch and palm, and a Goddess held out the rewards of Peace and Abundance. The official lesson of

the Salon—that prosperity in the arts is the reward for submission to lawful authority—could not have been more discreetly or more elegantly expressed.

A spectacular sight met the visitors who, on opening day, struggled up the congested stairs and entered the galleries of the exhibition (fig. A). Above the heads of the sweltering crowd, more than a thousand paintings[1] lined the immense walls of the Salon Carré and of the long gallery beyond it. In one grand perspective, endless rows of pictures offered themselves to the view, giving the impression of twin streams of gilt and shining canvas flowing along the walls into the distant, converging depths of the galleries. Along the margins of these rivers clustered the smaller pictures, innumerable portraits, still-lifes, genres, and landscapes, fitted frame to frame into a continuous, intricate mosaic. Above them, dominating the walls by their sheer size, hung vast historical or religious compositions, the stellar performances of the Salon, on which depended its artistic success. It was noted that the Salon of 1819 comprised no fewer than one hundred works of this class, paintings large and difficult enough to occupy an artist fully for a year or more. No other nation of the world could have equalled this massive display. While in the lesser branches of painting, in portraiture, landscape, or genre, the French painters admitted the rivalry of foreigners, in history painting they competed only with one another. By bringing together so many paintings of the very grandest kind, nearly all of them produced in the two short years since the previous Salon, the organizers of the exhibition had given triumphant proof of the continuing leadership and inexhaustible fecundity of the French School. So, at least, it seemed to most visitors, Frenchmen and foreigners alike. But there must have been some thoughtful observers as well who suspected that this abundance might be, as in fact it was, the result of artificial stimulation, rather than of free initiative.

For it was evident that grand history painting had long been entirely dependent on state patronage. Canvases filled with figures larger than life satisfied the ambitions of painters and heightened their reputations, but they were ruinously expensive to produce. Very few artists could afford the risk of starting work of heroic size without the support of a commission. Though the public might notice and the critics praise an ambitious historical composition, only the state, with its command of big walls and big budgets, could use such a work and repay the artist for his time, effort and expense. The appearance of a hundred wall-filling history paintings at the Salon of 1819 therefore testified above all to a generous programme of official support, designed to make up for the lack of private patronage, and at the same time to raise the level of French painting by encouraging artists to attempt work of the noblest and most strenuous kind.[2] The catalogue of the Salon pointedly informed visitors that the chief sources of this bounty were the King's Household, the Minister of the Interior, the Prefect, and the Duc d'Orleans.[3]

[1] The Salon's official catalogue lists 1,305 lots of paintings, several of them comprising more than one work, 208 sculptures, 157 engravings, and 27 architectural designs (*Explication des ouvrages de peinture, sculpture, architecture et gravure, des artists vivans exposés au Musée Royal des Arts, le 25 Août 1819*, Paris, C. Ballard, Imprimeur du Roi, 1819).

[2] "*Il n'appartient qu'à un Gouvernement tel que le notre,*" wrote C. P. Landon, one of the critics of the Salon, "*riche et essentiellement libéral (nous voulons dire généreux et magnifique), de tenter ces nobles et longues experiences: il n'est peut-être pas un seul de nos artistes qui n'ait été aidé ou encouragé: et si les résultats ne sont pas tous satisfaisants, il faut du moins convenir que la majeure partie des ouvrages remplissent l'attente des* ministres et des magistrats qui les ont commandés". (C. P. Landon, *Salon de 1819*, I, Paris, Imprimerie Royale, 1819, p. 7.)

[3] The official catalogue designates sixty-five paintings as having been commissioned by the Maison du Roi (the Ministry of the Royal Household, or Privy Purse), thirty-seven by the Ministry of the Interior, twenty (virtually all of religious subjects) by the Prefect of the Seine, and twenty-three by the Duc d'Orléans, of whose purchase no fewer than ten paintings were from the hand of Horace Vernet. In addition to these, many of the exhibited portraits of the King and of members of his family must also have been commissioned works, though they are not identified as such.

In matters of art, the Bourbon monarchy had steadily followed a policy which was, on the whole, more liberal and tolerant than the policies of the Revolution and the Empire. The instruments of this policy were rewards and honours, rather than compulsion, but its aim, however gentle the means, was to control the ideological content of art. The effectiveness of this control was evident at the Salon in the marked proliferation of monarchical and religious subjects, and in the corresponding decline of classical themes[4]—a phenomenon which few serious critics were naïve enough to attribute to a genuine revival of religious or royalist sentiment. Most of the commissioned paintings were as a matter of course destined for public buildings, particularly for churches, which meant that they had to deal with appropriate subjects. Nearly all of the large paintings shown at the Salon were, in the strict sense of the term, official. Ideologically indifferent or mildly controversial subjects were confined, with one important exception, to works of smaller scale and genre character: the freedom allowed to the artists was in inverse proportion to the size of their canvases. But this was not a new condition. From old habits of obedience, formed during the Revolution and the Empire, most painters easily submitted to official direction. In years past, Napoleon had paid them for battle pieces and ceremonial pictures, when they would have preferred to paint Spartan heroes. As beneficiaries of the Restoration, they accepted their new assignments with practised servility. The martyrdoms of saints and the death-bed communions of medieval kings which occupied so prominent a place on the walls of the Salon of 1819 came from the very studios which, not many years before, had furnished glorifications of Marengo, Austerlitz, and Eylau.[5]

The government of Louis XVIII had reason to be satisfied. The Salon seemed to demonstrate the success of its policy of conciliation through patronage. It proved that the restored monarchy was willing to forget the painful past and to give its support impartially to the artists of the nation. It also seemed to show that the artists in their turn had rallied around throne and altar. The size and brilliance of the Salon made it appear as if this mutual accommodation were working to the benefit of art itself, and the large crowds which filled the galleries from the Salon's opening day to its closing in December gave it the stamp of popularity.

It remained for a handful of serious critics to attempt a more solidly reasoned appraisal of the Salon's worth and significance. To do this with any degree of objectivity was difficult, since the Salon's official character stirred political reactions which interfered with artistic judgement. The mass of casual visitors had responded mainly to the agreeable trifles, which the Salon offered in great plenty. The critics were obliged, by the conventions of their craft, to address themselves to the more ambitious works, to those large historical compositions which the ordinary public tended to pass by in respectful boredom, but which to men of insight constituted the Salon's true worth and measure. Since these were also the very paintings which, being state-commissioned, reflected the government's influence,

[4] Besides a large number of portraits of the King and the royal family, the Salon included fifty-six narrative paintings of clearly dynastic import. Of these, fifteen dealt with Henry IV, eight with St. Louis, seven with François I, and three each with Marie Antoinette, Jeanne d'Arc, Clovis and Clothilde. A total of eighty-two paintings, many of very large size, treated specifically religious subjects, eleven of them scenes from the Old Testament, twenty-three from the New Testament, twenty-eight from the lives of the saints, ten from the Life of the Virgin. The official *Moniteur Universel* commented, on 9 September 1819,

p. 1189: *"Parmi les grands tableaux, ceux qui représentent des sujets religieux dominent généralement et par leur nombre et par leur étendue, ce qui donne à l'ensemble de l'exposition une gravité inaccoutumée . . . les sujets puisés dans la mythologie sont . . . en petit nombre"*.

[5] C. P. Landon, *op. cit.*, p. 25: *"Cette année, les sujets de piété ont été aussi nombreux au salon, que l'étaient pendant la révolution les tableaux de batailles, et certains traits de l'histoire de nos jours, si peu favorables aux progrès du dessin et aux touchantes beautés de l'art. Les encouragements ont enfin changé d'objet"*.

many critics found themselves torn between their political and their artistic convictions. Writers for the Royalist papers energetically applauded the Salon, though some of them admitted to a feeling of unease about the proliferation of religious scenes which they found it difficult to reconcile with sound, classicist doctrine. Even to loyal partisans of the crown and the Church, more than eighty religious subjects and more than fifty episodes from dynastic history seemed a great plenty. The critics of the Liberal and Bonapartist press poured scorn on the Salon's pieties and vehemently protested against its neglect of classical and national subjects. "Those Descents from the Cross, Ascensions, Maries at the Tomb, and assorted Martyrdoms are all very fine," mocked Étienne de Jouy in *La Minerve,* the chief organ of the opposition, "but they have been done hundreds of times by the great masters . . . Saints and monks, power and wealth, all have found their painters at this exhibition, all, that is, except our country. We look in vain for a monument raised to the glory of the nation."[6]

In retrospect, both the praise and the denunciation of the exhibition's content seem beside the point. Distracted by politics or blinded by habit, the critics of the time evidently did not see what now, a hundred and fifty years later, appears as the Salon's most serious defect—its flat mediocrity, spiritless-ness, and tedium. The Salon of 1819 was one of the last uncontested manifestations by the pupils of David and his many imitators and vulgarizers, who constituted what was called the French School. So formidable was the prestige of this numerous body of artists, after thirty years of dominance, that their rearguard action could still be represented as a triumph. Yet the Salon ought to have convinced careful observers that very little remained of the School's authentic core. With David in exile and his closest disciples declining, or already sunk into impotence, the succession had passed on to such colourless nonentities as Abel de Pujol, Ducis, Couder, Meynier and Ansiaux. By their uniformity of style and sheer quantity of production, they set the tone of the Salon and preserved the appearance of a flourishing movement. The illusion was quite convincing; scarcely anyone doubted in 1819 that France still possessed the most vigorous and progressive group of artists in Europe. But, in fact, the French School had been stagnant for at least a decade. Its younger members practised the routines of classicism without strong conviction. The public, deeply conditioned by habit, accepted the classicist stereotypes as inevitable. Yet the alliance between the restored monarchy and the heirs of David was nothing more than a bargain made by a political with an artistic anachronism. It did not revitalize the French School, but rather hastened its decay. Some critics of the Salon sensed this, and recognized in the ease with which the artists had suited their work to the demands of the day, in the facility with which they had turned out insipid altarpieces on commission, the signs of artistic bankruptcy. The French School had, in fact, become too pliable in essentials and too rigid in matters of form; it was held together not by principles, but by platitudes. Had the Restoration been a period of neglect or repression, the artists might have rallied to the heroic ideals which had animated the early phase of classicism. But coddled by a permissive government, spoiled with dull commissions, lulled with rewards and honours, the French School had grown torpid. The Salon was the showcase of its decline.

Very few of the works shown at the Salon have left a mark in the history of art. The state-commissioned pictures hang forgotten in provincial prefectures and in the side chapels of churches. The winner of the First Grand Prize, Nicolas Guillemot's *Christ Raising the Widow's Son* (fig. D), has joined them in their obscurity. The painting most admired by the critics, Louis Hersent's *Gustave Wasa,* perished in the Revolution of 1848 and can be judged only by old reproductions, which make it

[6] *La Minerve Française,* VII, Août 1819, pp. 237 ff.

appear as a very dull picture (fig. E). François-Edouard Picot's *Amor and Psyche,* which was much praised by the orthodox, neo-classical faction for its correct style, has recently been placed on view at the Louvre (fig. F). It is an attractive stillbirth, remarkable for its glacial eroticism. David's followers of the first rank were sparsely represented at the Salon. Gros sent his *Embarkation of the Duchess of Angoulême,* an attempt to treat a dynastic setback, the flight of a royal princess during the Hundred Days, as a national epic (fig. G). Girodet tardily submitted his feeble *Pygmalion* toward the end of the exhibition; Gérard and Guérin abstained. Of the independent artists, Prud'hon had little success with his *Assumption of the Virgin,* while Ingres was savaged by the critics for his *Odalisque,* the most despised picture at the Salon. The public showed a marked preference for paintings of moderate size and novel subject matter. Granet's melancholy *Interior of the Church of the Capuchins in Rome* and Horace Vernet's sensational *Massacre of the Mamelukes* attracted general notice and were treated with indulgence by most of the critics.

Opposite Horace Vernet's picture, placed high on the wall of the *Salon Carré* over the entrance to the long gallery (fig. A) hung an enormous, dark, many-figured painting, identified in the catalogue simply as "Scene of Shipwreck"[7] (fig. H). Despite the intentional vagueness of the title, visitors to the Salon had no difficulty in recognizing the picture's actual subject as the terrible *Raft of the Medusa,* still fresh in their memory as the climax of one of the most deadly maritime disasters of recent times. The loss of the government frigate, *La Méduse,* in 1816, and the abandonment of many of its crew on a makeshift raft, on which nearly all perished, had deeply shocked public opinion and provoked a political scandal. In the three years since, the Government had done its best to draw a veil of silence over the event, but the Opposition had kept the memory of it alive. To mention the *Medusa* was to embarrass the monarchy; to make so conspicuous a display of the subject as Théodore Géricault had done in sending this painting to the Salon was to commit an act of provocation. So at least it must have seemed to ultra-Royalists, but the true situation was more complicated. It was possible, in the confused political constellation of 1819, to please one minister by offending another, and in this instance the discomfiture of the Minister of the Navy seems to have caused secret satisfaction at the Palace.[8] It remains true, nevertheless, that the Revolutionary and Napoleonic governments would never have allowed the exhibition of so controversial a picture, and that the government of Louis XVIII, while serving a variety of purposes by its policy of toleration, was capable of using its powers of censorship very flexibly. On this occasion, it admitted the painting, but suppressed the title, thus lessening the scandal without altogether preventing it. The very size of Géricault's canvas must have strained the government's determination to exercise tolerance: the picture measured sixteen by twenty-four feet and was the largest easel painting at the Salon. It would have been impossible to overlook it, even if it had conformed more closely to the general character of the exhibition. But the *Raft of the Medusa* was in every way exceptional. In an exhibition filled with obsequious expressions of loyalty, it affronted the government, spurned official piety, and offered nothing to national pride. It blotted out the pallid fictions which covered the walls around it by the energy with which it concentrated on a horrible fact taken from modern reality. The work of an artist whose private fortune enabled him to dispense with patronage, it was the only large painting in the Salon

[7] The official catalogue (cf. note 1 above) gives an exceptionally terse entry to the *Medusa*: "Géricault. 510— Scène de naufrage".

[8] The circumstances are given in greater detail on p. 10 below.

which expressed a strongly personal view. It resisted classification by the accepted stereotypes of the time. As a shipwreck picture, it should have confined itself to the modest format of genre, yet it had the dimensions normally reserved for history painting. Only some extraordinary moral or national significance would have justified that, but the picture presented a tragedy without hero, a scene of physical suffering without redemption. The general public, disturbed and fascinated by the strange work, paid it the compliment of constant notice. The critics praised or blamed it according to their political opinions, or to the opinions promoted by their papers.

On 28 August 1819, the King paid his visit to the Salon. Despite the gout which made walking painful for him, Louis XVIII remained in the galleries for two hours, moving slowly from picture to picture, and addressing his compliments or witticisms to the artists who waited on him. He was visibly pleased with what he saw. In reporting the royal visit, the official *Moniteur Universel* noted that the painting of a "Shipwreck" by Géricault absorbed the king's attention for a long time, and drew from him "one of those felicitous sayings which at once judge the work and encourage the artist". The royal word, unreported by the *Moniteur,* is said to have been: *"Monsieur Géricault, vous venez de faire un naufrage qui n'en est pas un pour vous!"*⁹

⁹ Louis XVIII's visit to the Salon is described in the official *Moniteur Universel* of 30 August 1819, p. 1149. In the context of this article, the king's attention to Géricault's painting seems conspicuously and deliberately emphatic. The royal compliment, not quoted in this article, has been reported by various other sources, among others by the painter Jean Gigoux (*Causeries sur les artistes de mon temps,* Paris, 1885, p. 140), who claimed to have heard the story from Gros.

THE STORY OF THE RAFT

THE event which had given Géricault the subject for his painting lay three years in the past. On 2 July 1816, the government frigate *La Méduse,* flagship of a convoy carrying French soldiers and settlers to the colony of Senegal, struck bottom in shallow water close to the West African coast, south of Cap Blanc.[1] The main cause of the mishap was the incompetence of the captain, Hugues Duroys de Chaumareys, a nobleman and returned émigré, who owed his appointment to ministerial protection rather than to his seamanship. Outrunning the smaller ships in his convoy, de Chaumareys had steered an erratic course through the shoals along the Mauretanian coast, with the result that, when he ran aground on the sands of Arguin, there were no ships near him to help re-float the *Medusa.* After two days of confused and ineffectual efforts, it became apparent that the ship must be abandoned. Only six lifeboats, of various sizes and different degrees of dilapidation, were on hand (fig. I). They could take no more than about two hundred and fifty of the *Medusa's* four hundred passengers and crew. To accommodate the rest, a raft measuring about sixty-five feet in length and twenty-eight feet in width was built with the help of masts and beams crudely lashed together with ropes (fig. J). On the morning of 5 July, the frigate, which had begun to break up, was abandoned with undisciplined haste. The captain and many of the senior officers, concerned only with their own safety, had the brutality of commandeering the more seaworthy boats, leaving it to the lower ranks and the soldiers to try their luck on the Raft. One hundred and fifty persons, including a woman, were herded onto the slippery beams, which immediately submerged under this weight. The surgeon Savigny, one of the survivors of the Raft, later recalled that "it had sunk at least three feet, and so closely were we huddled together that it was impossible to move a single step. Fore and aft, we had the water up to our middle (fig. I)."[2]

An agreement had been made beforehand that all the boats should stay with the Raft and together tow it to the nearby shore (fig. K). But in their haste to reach land, the men in the boats soon cut the cables which held them to the heavy Raft, leaving its crew to the mercy of currents and winds, without means of navigation, without sufficient food or drink for even a short voyage, and so desperately crowded on their flooded timbers as to make every movement an affliction. *"We were not convinced",*

[1] The basic report of the shipwreck is the original submission by the ship's surgeon, Henri Savigny, to the Ministry of the Navy, of which a first, unauthorized publication was made by the *Journal des Débats* on 13 September 1816. *The Times* of London carried a full translation of this report in its edition of 17 September 1816; from this, the direct quotations in the present chapter are taken. Savigny and another survivor, Alexandre Corréard, later produced a fuller version of the original report. This was published as a book under the title *Naufrage de la Frégate la Méduse faisant partie de l'expédition du Sénégal en 1816,* the first edition of which appeared in November of 1817. A second, enlarged edition was published very early in 1818. On this was based the English edition, *Narrative of a voyage to Senegal in 1816,* published in London in April 1818. A fourth French edition, further amplified and illustrated with lithographic plates after Géricault and other artists,

appeared in 1821. The first-hand descriptions by Savigny and Corréard are the basis of all later accounts of the Raft's voyage, including Géricault's painting. It is therefore not useless to note that these two men were far from being impartial chroniclers. Their book was designed to incriminate the *Medusa's* captain, and at the same time to minimize or explain their own part in the atrocities which occurred on the Raft. (See also A. Praviel, *Le Radeau de la Méduse,* Paris, 1934; A. W. Lawrence [ed.], *The Wreck of the Medusa,* London, 1931, which contains the reminiscences of a female survivor of the shipwreck, Mme. Dard, née Picard, but contributes nothing new to the story of the Raft; Commandant J. Tonnele, "Le naufrage de la Méduse," *Revue Historique du Musée de l'Armée,* 1, February 1965, pp. 50 ff.).

[2] *The Times,* London, 17 September 1816, no. 9942, p. 2.

Savigny recalled, *"that we were entirely abandoned until the boats were almost out of sight. Our consternation was then extreme: all the horrors of famine and thirst were then depicted to our imaginations; and we had also to struggle with a treacherous element, which already covered one-half of our bodies. All the sailors and soldiers gave themselves up to despair, and it was with great difficulty that we succeeded in calming them."*[3] The first day passed quietly, with talk of rescue and revenge, but during the night the wind freshened and the waves rose higher. *"A great number of our passengers who had not a seaman's foot tumbled over one another; in fine, after ten hours of the most cruel sufferings, day arrived. What a spectacle presented itself to our view! ten or twelve unfortunate creatures having their lower extremities entangled in the interstices left between the planks of the raft, had been unable to disengage themselves, and had lost their lives. Several others had been carried off the raft by the violence of the sea; so that by morning we were already twenty fewer in number."*[4]

The next day, a mood of depression settled over the men on the raft. Mutiny was in the air. *"Night came on; the sky was covered with thick clouds; the sea was still more terrible than on the preceding night; and the men, being unable to hold fast to the raft, either fore or aft, crowded towards the centre, the most solid part. Almost all those perished who were unable to reach the centre; the crowding of the people was such, that some were stifled by the weight of their comrades, who were falling upon them every moment.*

"The soldiers and sailors, giving themselves up for lost, fell a-drinking until they lost their reason. In this state they carried their delirium so far as to display the intention of murdering their chiefs, and destroying the raft, by cutting the ropes which united its different parts [fig. L]. One of them advanced, armed with a hatchet, to execute this design; he had already begun to cut the ligaments, which was the signal of revolt. The officers came forward to restrain these madmen; that one who was armed with a hatchet, with which he dared to threaten them, was killed with the stroke of a sabre. Many of the officers and some passengers joined us for the preservation of the raft. The revolted drew their sabres, and those who had none armed themselves with knives. We put ourselves in a posture of defence, and the combat commenced. One of the rebels raised his weapon against an officer; he fell that moment pierced with wounds. This firmness appeared for a moment to intimidate the mutineers; but they closed in with one another and retired aft, to execute their plan. One of them, feigning to repose himself, had begun to cut the ropes with a knife, when, being advertised of it by a domestic, we darted upon him: a soldier, wishing to defend him, threatened an officer with his knife, and aiming a blow at him, struck only his coat. The officer, turning about, floored his adversary, and threw him into the sea, as well as his comrade.

"The battle soon became general: the mast broke, and, falling upon Captain Dupont, who remained senseless, nearly broke his thigh. He was seized by the soldiers, who threw him into the sea. We perceived this, and were in time to save him; we placed him on a barrel, whence he was torn by the mutineers, who wished to dig his eyes out with a knife. Roused by such ferocity, we charged them with fury, dashed through the lines which the soldiers had formed, sabre in hand, and many of them paid with their lives for their madness. The passengers seconded us. After a second charge, the fury of the rebels was subdued, and gave place to the most marked cowardice; the greater part threw themselves on their knees, and asked pardon, which was immediately granted."[5] Some sixty-five men died during this night.

On the following day, the third of the raft's voyage, raging hunger drove some of the survivors to cannibalism. *"Those whom death had spared in the disastrous night which I have just described,"* wrote Savigny, *"threw themselves ravenously on the dead bodies with which the raft was covered, cut them up in slices, which some even that instant devoured. A great number of us at first refused to touch the horrible food; but at last, yielding to a want still more pressing than that of humanity, we saw in this frightful repast only deplorable means of*

[3] *Ibidem.* [4] *Ibidem.* [5] *Ibidem.*

prolonging existence; and I proposed, I acknowledge it, to dry these bleeding limbs, in order to render them a little more supportable to the taste. Some, however, had still courage enough to abstain from it, and to them a larger quantity of wine was granted."[6]

As the days passed, hunger and thirst, exposure, murder, and insanity took their toll of the remaining men. From the fourth day on, all practised cannibalism and supplemented their small ration of wine with sea water or urine. On the sixth day of the Raft's voyage, only twenty-eight survivors remained. *"Out of this number,"* in the opinion of Savigny, the ship's surgeon, *"fifteen alone appeared able to exist for some days longer; all the others, covered with large wounds, had wholly lost their reason. However, they had a share in our rations, and might, before their death, consume forty bottles of wine; those forty bottles of wine were to us of inestimable value. We held a council; to put the sick on half-rations was to delay their death by a few moments; to leave them without provisions was to put them to a slow death. After a long deliberation, we resolved to throw them into the sea. This mode, however repugnant to our feelings, would procure to the survivors provisions for six days, at the rate of three quarts of wine a day . . . Three seamen and a soldier took upon themselves this cruel execution. We averted our eyes, and shed tears of blood over the fate of these unhappy creatures . . . After this catastrophe we threw all the arms into the sea; they inspired us with a horror that we could not conquer."*[7] The fifteen hardy and ruthless men who were now in sole command of the Raft managed to suffer through another seven days without further loss of life.

On the morning of 17 July, *"Captain Dupont, casting his eye towards the horizon, perceived a ship, and announced it to us by a cry of joy* (fig. M); *we perceived it to be a brig, but it was at a very great distance; we could only distinguish the top of its masts. The sight of this vessel spread amongst us a joy which it would be difficult to describe. Fears, however, soon mixed with our hopes; we began to perceive that our raft, having very little elevation above the water, it was impossible to distinguish it at such a distance. We did all we could to make ourselves observed; we piled up our casks, at the top of which we fixed handkerchiefs of different colours. Unfortunately, in spite of all of these signals, the brig disappeared. From the delirium of joy we passed to that of dejection and grief."*[8]

The brig which the men on the Raft had sighted was the *Argus*, part of the *Medusa*'s original convoy, which had been sent to search for them. When the *Argus* disappeared again, the shipwrecked men lost all hope; they lay down together in the tent which they had rigged beneath the mast and awaited death. Two hours later, they were surprised by the *Argus*'s sudden return. Of the fifteen survivors who were taken from the Raft, half-starved, bearded, sun-burnt, and covered with wounds, five died shortly after reaching land. The Raft's voyage had lasted thirteen days and cost one hundred and forty lives.

Reports of the disaster were slow to reach France. While the government did not entirely suppress the news, it sought to hide or soften its most atrocious aspects, and the Ministry of the Navy took particular pains to keep the public from learning of the incompetence and treachery of the *Medusa*'s captain. The first despatches arrived in Brest on 2 September 1816. Eight days later, their substance was published in Paris by means of an extremely terse note, inconspicuously inserted in the official *Moniteur Universel:*[9]

"On 2 July, at three o'clock in the afternoon, the frigate Medusa *was lost, in good weather, on the shoals of Arguin twenty leagues distant from Cap Blanc (in Africa, between the Canaries and Cap Verde). The* Medusa's *six launches and lifeboats were able to save a large part of the crew and passengers, but of 150 men who attempted to save themselves on a raft, 135 have perished."*

[6] *Ibidem.* [7] *Ibidem.* [8] *Ibidem.* [9] *Moniteur Universel,* 10 September 1816, p. 1024.

Here matters might have rested, if the government could have had its way. But some of the survivors of the Raft were about to make their way back to France. One of them, the surgeon Henri Savigny, had spent the days of his return voyage in composing a detailed account of the shipwreck and of the horrors of the Raft. On his arrival in France, he submitted his report to an official of the Ministry of the Navy. The Ministry would have been glad to bury it in the files; by mischance, however, a second copy of it fell into the hands of agents of the powerful Prefect of the Police, Élie Decazes, a man of vast ambition, who, as the King's intimate favourite, had designs on the government of France. Since it suited Decazes' strategy of the moment to discredit the Minister of the Navy, Debouchage, he allowed Savigny's account to be leaked to the editor of the widely-read *Journal des Débats,* who published it, without official authorization, on 13 September 1816.[10] This first, full disclosure of the circumstances of the shipwreck of the *Medusa* burst like a bombshell upon the public. It was immediately taken up by the French and the foreign press,[11] and brought on a resounding scandal, which was only aggravated by the Ministry's clumsy attempts to silence or discredit Savigny. The political opponents of the monarchy were quick to seize the opportunity for a broad attack on the government. They represented the loss of the *Medusa* as a political crime, rather than a natural disaster, and put the blame for it on the minister who had appointed the incompetent captain. It was not difficult for them to turn the shipwreck into an illustration of the danger to which France was exposed by a régime which put dynastic over national interest, gave the command of ships to political favourites and allowed aristocratic officers to abandon their men in times of crisis.[12] To the veterans of the Napoleonic reign, many of them idle, reduced to half-pay and furious at having been displaced by courtiers such as the lamentable de Chaumareys, the catastrophe of the *Medusa* summed up the plight of France under the Bourbons.

In February and March of 1817, a naval court was quietly convened aboard a warship in the harbour of Rochefort, to try the *Medusa*'s captain. It sentenced de Chaumareys to be degraded and to serve three years in prison—a lenient penalty for a crime which, according to the letter of the military code, could have been punished by death. Neither the trial nor the sentence was reported in the press.[13]

Savigny in the meantime had been joined by another survivor of the raft, the naval engineer and

[10] See A. Corréard and H. Savigny, *Naufrage de la Frégate la Méduse,* fourth edition, Paris, 1821, pp. 305 ff. Savigny wrote a second account of his experiences on the Raft, in the form of a doctoral dissertation, *Observations sur les Effets de la faim et de la soif éprouvés après le naufrage de la frégate du Roi la Méduse en 1816,* which he submitted to the faculty of Medicine on 26 May 1818, and which was published the same year by Didot. Savigny was suspected of having abused his position as ship's surgeon in organizing the "mercy" killings which decimated the men on the Raft.

[11] Cf the translation of Savigny's report in *The Times* of 17 September 1816, no. 9942, p. 2.

[12] Aside from the charge of negligence and political favouritism to which the disaster of the *Medusa* exposed the government, and particularly the ultra-royalist Minister of the Navy, it also had a direct bearing on one of the crucial political issues of the day, namely the struggle for the domination of the Army and Navy. The aristocratic and ultra-royalist factions were attempting to reserve officers' commissions for members of the nobility, and particularly for returned émigrés. Liberal opinion, on the other hand, demanded that military careers be opened to all qualified men, including veterans of the Napoleonic wars. The king, fully aware of the danger to the security of the state which would have resulted from the exclusion of veteran officers, sided with Liberal opinion and was seconded by his ministers Decazes and Gouvion de St. Cyr. The wreck of the *Medusa* furnished spectacular proof of the incapacity for command of at least some noble émigrés, and thus strengthened the position of the moderates. This was the one aspect of the case which gave secret satisfaction to the king and his confederates. The *lex* Gouvion de St. Cyr, democratizing admissions to the officers' corps, was passed in 1818, and brought to a conclusion this political controversy, while the memory of the *Medusa* was still fresh.

[13] Corréard and Savigny, *op. cit.,* third edition, 1821, pp. 373 ff., see also J. Tonnele, "Le naufrage de la Méduse", *Revue Historique du Musée de l'Armée,* 1, February 1965, pp. 64 ff.

geographer, Alexandre Corréard.[14] Together the two men continued to petition the government to compensate the victims of the shipwreck and to punish the guilty officers. The government responded with harassment, fines, and imprisonment. More serious still, both Savigny and Corréard were dismissed from government service. Destitute and despairing of ministerial justice, they decided to put their case before the nation, this time deliberately and with the intention of achieving the fullest publicity. Together they wrote an expanded version of Savigny's original report, adding many further details, and had it printed in the form of a substantial book, first offered for sale in November of 1817. The venture was a success from the start. After only a few months, a second, enlarged edition was required. Early in 1818, a full English translation of this second edition appeared in London. Encouraged, Corréard decided to turn his misfortune into profit. He established himself as a publisher at the Palais Royal and began to issue political pamphlets. His shop, under the irresistible sign *Au naufragé de la Méduse*, remained for years a rallying point for political malcontents and a thorn in the side of the government. Géricault made the acquaintance of Corréard and Savigny in 1817 or early 1818, most likely through his friend Auguste Brunet[15] or through the painter Horace Vernet. It was the book of Corréard and Savigny that gave him the idea for his painting of the *Raft of the Medusa*.

[14] Alexandre Corréard (1788–1857) was aboard the *Medusa* as engineer and geographer attached to the French colonial expedition to Senegal. He had lost the sum of 10,000 francs in the wreck (cf. A. Jal, *Souvenirs d'un homme de lettres*, Paris, 1877, pp. 409 ff.). For an account of the persecution he suffered after the shipwreck, see Corréard and Savigny, *op. cit.*, fourth edition, 1821, pp. 309 ff.

[15] Géricault's close friend, the economist Auguste Brunet, was among the first authors to publish a book with Corréard's firm (*De l'aristocratie et de la démocratie, de l'importance du travail et de la richesse mobilière*, Paris, Corréard, 1819). He may have drawn on Savigny's medical knowledge for another of his publications which appeared the same year, *Influence de la médecine légale sur la morale et sur le jury*, Paris, 1819.

GÉRICAULT IN 1817-1818

Personal Crisis

IN the autumn of 1817, when the thought of painting the *Raft of the Medusa* may first have come to his mind, Géricault was barely 26 years old. For all his youth, he had already passed the midway point of his career: about seven years had gone by since he had made his decision to become a painter, no more than six years of life were still left to him. He was not well known as an artist, only three of his paintings had been exhibited. At the Salon of 1812, his *Charging Chasseur* had surprised the critics by its precocious mastery; two years later, at the Salon of 1814, his sombre *Wounded Cuirassier* disappointed the expectations which the earlier painting had raised. While these works brought Géricault to the notice of fellow artists, they hardly left an impression on the general public. Even his friends continued to regard him as a gifted beginner who, after a promising start, still had a long way to go to complete his education. Several years went by during which he did not show any new works. In 1816, he left for Italy, where he intended to spend two years; he was back in France a year later, with many drawings and studies for an abandoned project, but no finished work. He knew that he was about to be forgotten, and was determined to make his mark at the coming Salon.

As the son of wealthy parents, Géricault had been able to follow an irregular and highly personal course of studies. A legacy which his mother had left him assured his independence; fond relatives and an indulgent father furthered his vocation, without fully approving of it. From the age of seventeen, he had received casual guidance from Carle Vernet, the painter of elegant society and thoroughbred horses. Two years later, he submitted briefly to the more systematic teaching of the academic classicist, Pierre Guérin. But his real school had been the Louvre, filled at that time with the spoils of Napoleon's Flemish and Italian campaigns. Confronted by the splendour of Titian and Rubens, he quickly forgot the routines of conventional training and began to form his own style. He was an ardent but fitful worker. The distractions of city life, his passion for horses and sportsmanship, and a brief enlistment in the King's guard cavalry, in 1815, caused interruptions in his studies. Alternating between concentrated effort and idleness, expending his energy on sketches and inconclusive projects, rarely finishing anything, Géricault gave the appearance of a gentleman-artist, an outsider, by habit and temperament, to the professional world of art. He may have been attempting to enter this world when he competed for the academic Rome Prize in the spring of 1816,[1] but he failed, and shortly after went to Italy as a private traveller, paying his own way.

There is reason to suppose that even on this occasion his motives were not entirely professional. He had for some time been embroiled in an adulterous love affair, a "shared, irregular, stormy love which he could not acknowledge and to which he brought all the vehemence of his character".[2] Documents have recently come to light which explain why his friends and family were later to conspire to keep this episode a secret. The woman he loved was a close relative, Alexandrine-Modeste, the

[1] For Géricault's participation in the Rome Prize competition of 1816, see L. Eitner, "Géricault's 'Dying Paris' and the Meaning of his Romantic Classicism", *Master Drawings*, I, no. 1, Spring 1963, pp. 21 ff.

[2] Charles Clément, *Géricault, étude biographique et critique*, Paris, 1867 (third, enlarged edition 1879), p. 77.

young wife of his maternal uncle Jean-Baptiste Caruel de Saint-Martin.[3] Born in 1785, she was only six years older than he. The dangers and difficulties of their meetings, and the scruples of conscience which their intimacy caused him, appear to have put him under a constant, painful strain. He repented the "terrible perplexity into which I have recklessly thrown myself",[4] and when he left for Italy, in September of 1816, at about the time the first news of the shipwreck of the *Medusa* reached France, he did so "hoping to find in separation and study an appeasement of his sorrows".[5]

But his journey was more than an escape. He had long wanted to see the monumental paintings of the Italian masters, the great frescoes of Michelangelo, above all, which he only knew through engravings. As he set out, he was determined to stay in Italy for two years, but driven by loneliness and depression he reappeared in Paris toward the end of September or in early October of 1817. His mistress awaited him and their relationship was resumed.[6] Sometime during November, she conceived a child by him. Their intrigue could no longer be kept a secret. The middle-aged uncle knew himself not to be the father of the child, a boy, who was born on 21 August 1818, and registered at the town hall of the Eleventh Arrondissement as being of unknown parents. Géricault's father discreetly arranged for the boy's care. The mother was sent to the country. A vehement quarrel rent the families of Caruel and Géricault, but the scandal was carefully hidden from the world.

What effect this domestic tragedy had on Géricault's state of mind and on his work can only be guessed. The documents are silent, and the reminiscences of his friends reveal very little. The secret preoccupation which for years had filled his life with tension, had used his energy and absorbed his feelings, had come to a sudden stop. His mode of existence changed, a part of his self was unemployed. He must have felt a strong urge to find some compensation, to immerse himself in work. Too many years had passed since he had finished his last important painting. Ambition and time, and perhaps a sense of guilt, pressed him to give some proof of his worth.

Influences

The year which followed his return to Paris was an interlude of strong, mainly painful, personal involvement coming between two periods of withdrawal, the solitude of his preceding Roman stay and the isolation to which he retired, in the autumn of 1818, to paint the *Raft of the Medusa*. It was also a time of sociability and of exposure to the events of the day. He was more ready than usual to be influenced by the men in whose company he lived. The circumstances of his personal life and the direction of his artistic development fatefully combined to determine the character of the work on which he was about to embark (fig. N).

He spent this year in the house of his father, at 23 rue des Martyrs, in what was then a suburb, only partially developed, at the foot of Montmartre on the northernmost fringe of the city. The privacy and inexpensiveness of its houses, which lay scattered among gardens, had attracted young families of the professional middle class to this new quarter, among them a fair number of writers,

[3] The researches of M. LePesant of the Archives Nationales in Paris have uncovered documents, in family possession at Evreux and in the Minutier Central des Notaires Parisiens, which establish at last the identity of Géricault's mistress and give information about the fate of his son. For M. LePesant's very great kindness in making the results of his search available to me, I should like to express my warmest thanks, together with the hope that he may soon publish this important material in full.

[4] This expression occurs in one of Géricault's letters from Italy and is quoted by Clément, *op. cit.*, p. 89.

[5] Clément, *op. cit.*, p. 78.

[6] Cf. A. Etex, *Les trois tombeaux de Géricault*, Paris, 1885, p. 23.

actors, painters, and Napoleonic officers on half-pay. With their wives and children, they formed a society of youthful taste and liberal outlook, fond of art and music. Too domestic to be considered Bohemian, the community acquired the slightly ironic nickname of *La Nouvelle Athènes*. One of its most visible members was the painter Horace Vernet, long a friend of Géricault and the son of his first teacher, Carle. A large garden connected Géricault's house with the studio of Horace Vernet (fig. O), at 11 rue des Martyrs, the liveliest and noisiest spot in the quarter, gathering place of a turbulent crowd of painters, soldiers, and politicians, brought together by their common detestation of the monarchy and by their admiration for Vernet's incredibly versatile talent.[7]

Vernet belonged to no school; neither a classicist nor a romantic, his head was filled with matters more practical and entertaining than theories of art. The national strain in the work of Gros and the other chroniclers of the Napoleonic epic was his main inspiration, but he did not limit himself to military subjects. Costume designs, caricatures, vignettes, landscapes, and portraits; scenes from Molière and from Byron; anecdotes of the Arabs of the desert and the bandits of the Abbruzzi poured pell mell from his studio. He had lived by his facile brush since the age of thirteen. Only two years older than Géricault, he was already one of the best-known and best-paid artists of France. His recipe was a blend of chauvinistic pathos, sentimentality and humour, of hard surface realism and virtuoso handling. His dash, his flair for publicity, and his smart vulgarity made him seem the embodiment of modernity. *"His talent is his entire person,"* wrote an admiring contemporary,[8] *"mobile, fiery, witty— that's the man and the painter: a lively eye, an expressive face, rapid speech and terse gestures, a sparkling imagination, and energetic mobility. His stature is neither tall nor short, he has the musculature of an antique gladiator. An ardent hunter, indefatigable horseman, instinctive musician, a soldier by inclination and painter by passion, we see him handling his palette and his gun in turn, smoking like a Spaniard, singing like an Italian, fencing with his foils, blowing his hunting horn, telling a story full of sentiment and melancholy, cracking a joke, shooting his pistol, or starting a boxing bout. His studio is a meeting place of the best society. Here we meet officers of great distinction, princes who treat Horace with the consideration his genius merits, artists of every kind, financiers, and charming women . . . It is not rare to find a sportive monkey at his easel, or a hind to which he is attached as others are to their dog, or a horse which he not only studies in its outward form but also in what might be called its private life. His studio often resounds to military commands, drum rolls, horn calls, the clatter of foils and the discordant sound of an ancient piano . . . But, impassive in the midst of this noise, he remains isolated and concentrated in his thought, once he has decided to paint and is possessed by his idea. He produces with the dash and facility of a brilliant, practised improviser, but everything he does bears the stamp of consummate talent, mature reflection, and a quick but rational mind."*

That Géricault should have felt the fascination of this paragon is not surprising. Though not uncritical of the artist, he seems to have admired the man.[9] It was natural that, on coming home from

[7] The milieu of the *Nouvelle Athènes* is vividly described by Géricault's friend and neighbour, Colonel Bro de Comères, in his *Mémoires* (edited by Henry Bro de Comères, Paris, 1914, cf. particularly chapter VII); see also D. Aimé-Azam, *Mazeppa, Géricault et son temps*, Paris, 1956, pp. 147 ff.

[8] A. Jal, *L'artiste et le philosophe, entretiens critiques sur le Salon de 1824*, Paris, 1824, p. 174.

[9] Cf. Th. Silvestre, writing about 1855 and drawing on the reminiscences of Delacroix: *"Il [Géricault] avait aussi un atelier dans le quartier des Martyrs, sur le même palier qu'Horace Vernet, sa bête noire. Toutes les fois qu'un visiteur se trompait en demandant Vernet chez Géricault, Géricault répondait: 'C'est la boutique à côté.' Cela n'empêchait pas Horace d'aller fumer des cigarettes chez son voisin et d'emprunter de lui des études de chevaux et de paysages pour les accommoder en son propre compte au goût du public"*. (Théophile Silvestre, *Les artistes français, I, Romantiques*, Paris, Bibliothèque Dionysienne, Editions G. Crés & Cie, n.d. [1926], p. 52.) Concerning the mutual influences between Géricault and Vernet, see L. Eitner, "Géricault's 'La Tempête'", *Museum Studies*, II, Art Institute, Chicago, 1967, pp. 7 ff.

his lonely stay in Italy, he should turn to this friend and neighbour. The painter Montfort, then a pupil of Vernet, but soon to become Géricault's disciple, has left an account which gives a hint of their relationship at the time of the friends' first reunion: *"One day, in the autumn of 1817, a young man came into the studio of my master, Horace Vernet, and rushed into his arms. At his first words, I understood that he was a painter just back from Italy. Since M. Vernet repeatedly addressed him by his name, another pupil standing near me asked me whether this was not the Géricault who, a few years earlier, had exhibited a* Mounted Chasseur *and a* Cuirassier *at the Salon? I vaguely remembered having seen these two paintings, but that was all . . . Géricault, then about twenty-six, was fairly tall and of elegant appearance. His face expressed vivacity and energy, but it also showed great gentleness. I noticed then, as I often did since, that he blushed at the slightest emotion."*[10] Some time later, Montfort saw Géricault's two paintings at his studio and spoke of them with admiration to Vernet, who agreed, with barely perceptible condescension: *"there are some quite beautiful passages in these paintings,"* and, pointing to the horse of the *Chasseur,* *"this head is full of life, and who has ever painted a better tiger skin?"*[11]

Géricault's closeness to Vernet at this time was providential. He had come to a point in his development at which the example of his friend, to whose defects he was by no means blind, could be of important use to him. Behind him lay the Italian year, which he had spent shut off from his familiar world, struggling with difficult problems of style, and attempting, with dwindling conviction, to master heroic, timeless subjects. Paris brought him back to the present. He welcomed the stimulus of the mundane company which he found in Vernet's studio, where the talk and much of the painting revolved round the news of the day.

Grand Style and Modern Subjects

Almost from the start of his career, Géricault's interests had run in two opposite directions. His temperament drew him toward vital, contemporary subjects, especially to those which belonged to the world of soldiers, sportsmen, and horses. His boyhood studies with Carle Vernet, his early impressions of Gros and his admiration for the hunts and battles of Rubens confirmed him in this bent. His earliest, most spontaneous self-expression took the form of studies from the life, fresh in colour and vigorous in handling, glowing with a sensuous relish for animate nature. Most of these works were rapid sketches and of intimate scale. But in the *Charging Chasseur,* his Salon entry of 1812, he boldly transformed what ought to have been a simple genre motif into a colossal image. The impulse which on this occasion carried him beyond realism stemmed from the other, opposite side of his nature, from his fascination with energy and grandeur. His ambition was to be a monumental painter. There was in him an urge *"to shine, to illuminate, to astonish the world",*[12] a declamatory strain, an explosive impulse to exaggeration which absolutely conflicted with his gift for intimate realism. Born with as much natural facility as Vernet, he wanted to be more than a good painter of horses and tiger skins. He hoped to compete with Gros, or even with Rubens, in painting dramatic historical subjects, modern subjects by preference, on the grandest possible scale. He recognized the limitations of his talent, and was resolved to go beyond them, even at the risk of destroying something in himself. The scale and intensity for which he aimed could be won only through discipline. His second exhibited

[10] Clément, *op. cit.,* p. 112.
[11] Clément, *op. cit.,* p. 116.

[12] From a manuscript by Géricault, quoted by Clément, *op. cit.,* p. 249.

painting, the *Wounded Cuirassier* of 1814, lacked the colour and dashing modernity of his earlier work. It was ponderous, excessively sombre, and showed the strain of laborious construction. Géricault himself was dissatisfied. The *Cuirassier*, nevertheless, was an important beginning and started him on his way toward a more forceful and controlled monumental style.

In the course of the following two years, 1815-16, while his friends thought him idle, he submitted to a tough, if intermittent, course of self-training,[13] He practised figure construction and composition, taking his motifs from art or from his imagination rather than from life, and rehearsing doggedly the classicist stock types, which he had avoided in his student days. A harder taskmaster to himself than the lenient Guérin, he harnessed his obstinate temperament and concentrated his energies. He was determined to acquire a grand style through the deliberate sacrifice of his natural spontaneity. The first results were strikingly clumsy, compared to the casual felicity of his earlier work, but his persistence gradually bore fruit. By 1816, before he had set foot on Italian soil, he had forged a vigorous new style which amounted to a reversal of his original manner: based on a limited set of highly artificial stereotypes, exaggeratedly heavy and angular, harsh to the point of crudity, it was utterly indifferent to the subtleties of visual appearance. This strange transformation was not a turning toward classicism. The intent which guided him was personal and expressive; more important even than his gain in control was his gain in strength. Unlike his earlier naturalism, this new, artificial style lent itself to resonant, declamatory statements. Romantic in its intensity, taking its clichés from Michelangelo rather than the school of David, the new manner encompassed the extraordinary, the terrifying, and the tragic. Yet while he was busy forming a grand style, Géricault did not entirely abandon his little manner. He used both as it suited him. In the one he sketched soldiers, horses, and portraits, in the other he projected antique scenes, heroic landscapes, the loves of the gods, and the battles of giants.

Géricault's turning from realism to a more abstractly formal style was not entirely a matter of his personal development alone, it reflected a fundamental change in the condition of French art. That the shift occurred at the time of the Empire's collapse was not a mere coincidence, for this event had affected the status, and even the very possibility, of monumental, realist painting in France. Under the Empire, modern historical subjects—significantly termed *"subjects honourable for their national character"*—had enjoyed a privileged status, equal to that of classical themes.[14] The promotion of modern history painting was a concern of the state; all such work, without exception, was national

[13] Concerning Géricault's stylistic re-orientation in 1814-16, see L. Eitner, "Two rediscovered Landscapes by Géricault and the Chronology of his Early Work", *Art Bulletin*, xxxvi, June 1954, pp. 131 ff. and "Géricault's 'Dying Paris' and the Meaning of his Romantic Classicism", *Master Drawings*, I, no. 1, Spring 1963, pp. 21 ff. which revises the chronology originally proposed.

[14] The official ideology and policy of the Imperial art administration is most clearly stated in the various jury reports issued on the occasion of the award of the *Prix Décennaux* in 1810. These reports also contain a quasi-official general definition of the difficult term "history painting": *"Il n'est pas aisé de définir avec précision ce qui constitue un tableau d'histoire, et ce qui le distingue essentiellement de ce qu'on appelle tableau de genre ... Ce qui caractérise éminemment la peinture d'histoire, c'est le choix d'un sujet, soit historique* *ou d'invention, soit fabuleux ou allégorique, qui offre au peintre une action noble ou intéressante, des caractères et des passions à exprimer: c'est encore ce* grandiose *dans l'exécution, ce grand goût de dessin qui constitue le style héroïque, et sur-tout ce beau idéal, dont le modèle, n'existant point dans la nature, est une création de l'artiste, mais qui n'est que la nature même conçue dans sa plus grande perfection."* (*Rapports du Jury chargé de proposer les ouvrages susceptibles d'obtenir les prix décennaux, avec les rapports faits par la Classe des Beaux Arts de l'Institut de France*, Paris, 1810, pp. 9 ff. Though couched in orthodox classicist language, the definition is careful not to exclude modern, i.e. national, subjects, provided they are capable of being executed in a grand style, thus rationalizing the equality of classical and national history painting on which the Emperor insisted and which was recognized by the award of separate, equal prizes.

and official. Napoleon's patronage provided the material base, his victories the subject matter which sustained a large number of artists. David and Gros by their modern works set high artistic standards for national history painting; its topical interest attracted a large public and shaped a popular taste. After Napoleon's fall, both the patronage and the subject matter disappeared. The Restoration did not include *"subjects honourable for their national character"* among its official commissions, there was a dearth of heroic episodes: princely death-beds and royal escapes into exile proved less suitable for monumental painting than victorious battles. Modern national history painting now fell to the initiative of individual artists, such as Horace Vernet, working to the taste of private patrons. Its format shrank to drawing-room scale, if not to the miniature size of lithograph or vignette, its subjects nostalgically recalled the recent, Napoleonic past, and avoided the inglorious present. From having been an eminently public art, the vigorous expression of Imperial power and popular enthusiasm, it became an object of private taste, sometimes—because of its Bonapartist implications—a clandestine occupation, and nearly always a speculation on the markets of art and fashion. Despite Napoleon's heavy-handed sponsorship, great artists had found it possible in his reign to reach their highest level in work of modern inspiration. After Napoleon's fall, such work declined to a petty specialty, practised by clever men of shallow talent. Events from contemporary life ceased to be fit subjects for monumental art. This meant that artists like Géricault, whose interests inclined them to modern subjects and who had the ambition of working in a monumental style and scale, found themselves in a dilemma: they had either to make a choice between modernity and monumentality, giving up one or the other, or to try to discover an entirely new form of modern history painting.

In Italy, Géricault was struck by the power of Michelangelo's work, *"he trembled before the masters of Italy, doubted his own ability, and only gradually recovered from this shock"*.[15] But he did not immediately change his working habits. He recorded impressions of Roman street life, casually, and at the same time composed mythological scenes of his own invention (fig. P). His newly-acquired style had by now lost much of its initial harshness, and his irrepressible virtuosity asserted itself with redoubled verve, despite the obstacles he had put in its way. With superb assurance, he drew a succession of erotic fantasies on Classical themes—Centaurs abducting Nymphs, the procession of Silenus, Leda in the swan's embrace. The fear that he might lapse into elegant routine prompted him to seek new problems. Mythological subjects did not deeply interest him. He could not work without the frequent stimulus of actual or at least imagined experience. Equally impressed by the drama of Italian life and the greatness of Italian art, he conceived the idea of treating an observation gathered in the streets of modern Rome in a monumental style reminiscent of Michelangelo or Raphael. The plan was novel in its disregard of the rule of propriety, according to which the grand style called for noble themes; its special appeal lay in the chance it gave him to combine the two main strains which had run separately through his work. The challenge he faced was to make ordinary reality grand, by cleansing it of trivial detail, and to do this without falling into lifelessness and boredom, despite the lack of an "interesting" subject.

An event of the Roman carnival of 1817, the traditional race of the riderless Barberi horses in the Corso, gave him the motif he needed (fig. Q). He began by recording the start of the race as he had actually seen it in the Piazza del Popolo, a turbulent and diffuse crowd scene. In a series of studies he then gradually reduced the panoramic spectacle to a few, clearly articulated groups, arranged these

[15] Clément, *op. cit.*, p. 82.

in a balanced frieze, stripped the figures of all merely picturesque bywork, and transformed the piazza into a colonnaded forum suggestive of ancient rather than modern Rome. The final design of the *Race of the Barberi Horses*, ready to be transferred to a large canvas, projected a severely stylized composition of athletes struggling with horses, in a setting of undefined location and a time neither ancient nor modern.[16] Had Géricault executed it in the vast dimensions which he envisaged, he would have produced a work entirely exceptional for its time: a painting of heroic format and grand style, without definable subject; a self-sufficient image, impressive in its formal dignity, suggestive of a high significance, but withholding all clues to the nature of the event or situation represented, and giving no hint of any connection with history, literature, or simple reality. Having conceived this feat of thematic abstraction, he stopped short of carrying it out, perhaps tired of the effort or uncertain of its feasibility. He left Rome abruptly, and returned to France.

Back in Paris, he briefly resumed his experiment with timeless compositions, with studies for a *Cattle Market*,[17] another contest between men and beasts, and a *Battle Scene* which he alternately cast in an Antique and a modern version.[18] The scattered remnants of these projects are among the most impressive examples of his *maniera magnifica*. But in the rush of Paris, the solemn visions soon faded, too remote to compete with the vivid reality which surrounded Géricault on all sides. Shaken by personal troubles, exposed through Vernet and his friends to the excitements and conflicts of the day, he found that he could not take his inspiration from Arcadia. The ideas which had occupied him in his Italian solitude now seemed to him to lack interest. It was questionable whether they could sustain the pictorial scale and intensity for which he aimed. He had come to a dead end, and the thought of the approaching Salon must have added an edge of anxiety to his awareness that he must find material more stirring than his Italian themes if he was to make an impression on the Parisian public.

It was at this point that Vernet's example showed him a way out of his difficulty. Géricault cannot have been unaware of the stylistic shallowness of his friend's work, but he was attracted by its modernity. He saw that what saved Vernet from insignificance was his skill in arousing interest by his choice of modern subject matter. This interest was ephemeral and extra-artistic in Vernet's case, as Géricault may or may not have sensed, but it was undeniably a source of vitality which gave Vernet an advantage over the solemn and lifeless Davidians. The lesson was not wasted on Géricault. It seems to have persuaded him that, in his too exclusive concern with formal expression, he had neglected an important resource. The alternative to the boredom of the subjects from Antiquity, Holy Writ, or dynastic history, which current patronage and convention prescribed, was not the elimination or neutralization of subject matter, but the use of more vital subjects, namely subjects from life, capable of touching a nerve in the contemporary viewer. Vernet's repertory consisted of the debris of the tradition of national, modern history painting which had ended with the Empire. It trivialized the material which Gros had used grandly. Why should it not be possible to treat modern subjects in a great style once again? In the absence of a central national cause such as had supported the

[16] The two main "modern" versions of the *Race of the Barberi Horses* are at the Palais des Beaux-Arts of Lille and the Walters Art Gallery in Baltimore. Of the "antique" versions, one (in the Rouen Museum) places the race in the setting of an Arcadian landscape, while the other (Louvre; Buehler coll., Winterthur; and priv. coll., Paris) gives it a background of classical buildings.

[17] Of this major project, only one painted version (Fogg Museum, Cambridge, Mass.) and scattered drawings (Louvre; Fogg; R. Hirsch coll.) survive.

[18] The "antique" versions at the Musée Bonnat, Bayonne (inv. 704 and 705) and Besançon (inv. D 2137), "modern" versions at the École des Beaux Arts, Paris, and Louvre.

painters of the Empire, modern history painting could no longer be national and official. It must, rather, concern events or circumstances of a more general interest and make its point by a direct appeal to the individual viewer's emotions.

Preparations

The difficult problem was to find ways of managing the shapelessness of actuality within the order of a monumental composition, without destroying its sense of life. It was important to avoid both the superficial liveliness of Vernet and the dead grandeur of the Davidians. To monumentalize fragments of timeless and eventless reality, as he had done in the *Race of the Barberi Horses*, was not enough. The real challenge was to translate an actual, contemporary event, fresh as the morning's news, into an image of superhuman scale and energy, worthy of standing beside the work of Michelangelo and the masters.

Only luck could give him the right subject for this attempt. While other history painters studied Plutarch and the lives of saints in preparation for the coming Salon, Géricault read the newspapers and waited, and while waiting tried his hand at work of small format and wholly modern character. Probably at Vernet's suggestion and with Vernet's help, he taught himself the new technique of lithography, and quickly achieved great mastery in it.

The craze for lithography, though still in its beginnings, had already brought into being a new industry of visual entertainment, pictorial journalism, and graphic satire. Some serious artists had adopted lithography as a convenient method for multiplying their own drawings, but the bulk of the production was of a popular, even vulgar character. Sentimental or chauvinistic trifles poured from the new presses week after week to supply the mounting demand. The cheapness and speed of the process made it a weapon in the political skirmishing of the Restoration which the enemies of the monarchy used with special skill. Tainted by its popular and political associations, considered unsuitable for work in an elevated style, lithography seemed to promote the subversion of the academic as much as that of the royal authority. Its special aesthetic quality, a rich tonal range from velvety black to silver grey, held little advantage for strict classicists, who preferred line engraving, but it opened new possibilities to modern-minded artists who, like the majority of the public, were attracted to descriptive realism and romantic effect.

To Géricault, tired of timeless generality, lithography offered a chance to try out contemporary subjects, unconfined by stylistic restrictions (fig. R). In the military scenes which he drew on stone in 1818,[19] the *Mameluke Defending a Wounded Trumpeter, Cart Loaded with Wounded Soldiers, Horses Battling in a Stable, Return from Russia, Artillery Caisson,* and in his single sporting subject, the *Boxers,* he went beyond Vernet in the closeness of his characterization of physiognomies and situations of the time. He gave his attention not only to the detail of military haberdashery but to the small accidents of appearance—the special sag of a greatcoat, the fall of an empty sleeve, the gesture of a blinded soldier's hand—which make for an intimate sense of reality. At the same time, he constantly showed his habit of monumental stylization in the amplitude of the figures and the noble simplicity of their groupings. He stated his subjects with reticence; few of the lithographs refer to a precise event or contain a definite narrative, their meanings are expressed, rather, in a quasi-symbolic form: two

[19] L. Delteil, *Géricault* (*Le peintre-graveur illustré*, xviii), Paris, 1924, nos. 9–14.

wounded stragglers sum up the retreat from Russia, an artillerist threatening to blow up his munitions cart signifies France's defiance of the invaders. Although the lithographs fall into the category of Napoleonic imagery which Vernet had pioneered, and which Charlet was at that time bringing to a kind of perfection, they are free of patriotic ranting. While the other military lithographers, Vernet and Charlet in particular, excelled in anecdotal humour or sentiment, and in tricks of well-timed surprise, Géricault made his points in simple visual terms by the physical drama of confrontation, conflict, and motion enacted by few figures. The lithographs were by no means a relapse into his earlier "little" manner, they achieved an impressive fusion of the natural and the grand, a discipline of style comparable to that of his Italian compositions. The very considerable effort which went into this achievement had a purpose that extended beyond Géricault's interest in lithography, it was part of the preparation for the great project on which he had begun to concentrate his thoughts.

The lithographic experiment did not, however, lead him to the modern subject which he needed for his project, nor did it address itself to the problem of how to treat a particular modern event in a grand style. Yet this problem remained very much on his mind. At some time near the end of 1817 or in the early part of 1818, he became interested in a recent, sensational crime, the murder of Fualdès, a former magistrate of Rodez (fig. S).[20] Popular indignation had been vehemently aroused, partly by the atrocity of the killing, partly by the unfounded suspicion that it had been committed by an ultra-royalist gang. Newspapers, pamphlets and lithographic prints broadcast luridly detailed accounts of Fualdès' death. Géricault was sufficiently impressed to draw a series of compositions in which he dissected the event into its successive phases (fig. T): the plotters conspiring, Fualdès dragged into the murder house, Fualdès murdered, his body carried to the river, the murderers exulting over their crime, and their escape after the disposal of the body. Several of these drawings bear a close resemblance to published lithographs of the event, and their technique of pictorial narrative reflects the style of contemporary journalistic imagery.[21] It is difficult to determine whether Géricault actually copied some of the prints then in wide circulation, or perhaps had some influence on their makers. According to Clément, usually well-informed, it was Géricault's plan to develop the subject into a major painting. He had begun to make preliminary drawings for it—significantly in the "antique style"—when he was shown penny prints of the murder, which he liked better than his own efforts and which discouraged him from going on.[22] If Clément's account is correct, the Fualdès drawings assume a very special importance, as Géricault's first attempt to base a grand composition on a newspaper story. The series constitutes, at any rate, a remarkable parallel to the *Medusa* project. It shows Géricault inspired by journalistic accounts of a recent occurrence, a crime noteworthy for its extreme

[20] There were two separate trials in the case of Fualdès' murder. The first, held from 19 August to 12 September 1817, at Rodez, was declared a mistrial. The second, begun on 25 March 1818, at Albi, concluded with a verdict on 4 May 1818. It is probable that Géricault drew his compositions in the spring of 1818. Four drawings for the project, formerly in the collection of the Duc de Trévise, are at present unlocated. Further drawings are in the Palais des Beaux-Arts, Lille (inv. 1395), the Rouen Museum (inv. 1389), and the Claude Aubry collection, Paris.

[21] The Cabinet des Estampes of the Bibliothèque Nationale, Paris, preserves three contemporary lithographs of various moments in the murder of Fualdès. The work of a little-known artist, Sebastien Coeuré (1778–c.1831), they bear a striking resemblance to Géricault's compositions, both in the choice of episodes and in the arrangement of the figures. The three prints, which may not constitute a complete set, are entitled: *"Mr. Fualdès entraîné chez Bancal"*, *"Made. Manzon menacée"* (with body of Fualdès in the background), and *"Le Corps de Mr. Fualdès transporté dans l'Aveyron"* (Fig. S). For a summary of the Fualdès case, see *La Grande Encyclopédie*, XVIII, Paris, n.d. [1887], pp. 227 ff.; for the drawings formerly in the Duc de Trévise collection, Duc de Trévise, "Géricault, peintre d'actualités", *Revue de l'art ancien et moderne*, XLIX, 1924, pp. 102 ff.

[22] Clément, *op. cit.*, p. 364, number 165.

horror and for its political implications. It also shows him struggling with a problem of dramatic narration which he had not faced before, attempting to select from among a sequence of episodes that particular moment which summed up the central meaning of the event and did so with the strongest pictorial effect. What he might have made of the Fualdès story is difficult to imagine. The idea of treating such a subject in a monumental work was of unprecedented boldness. It is conceivable that he could have abstracted from the narrative the kind of monumental and dramatic image for which he sought, but he would have found it difficult, if not impossible, to generalize the meaning of what, in effect, had been nothing more than an exceptionally vicious act of homicide, committed by unremarkable individuals for monetary gain. Perhaps it was the recognition of the actual poverty of this subject which caused him to abandon it and to go on with his search. *"Thus he came and went, varying and completing his studies, in that state of uncertainty which precedes great resolutions. He searched, meditated, gathered his strength, before beginning the work which was to provoke the School's anathema."*[23]

[23] Clément, *op. cit.,* p. 118.

THE WORK IN PROGRESS

Invention

IT was at this juncture that Géricault found in the book by Corréard and Savigny, *Naufrage de la Frégate la Méduse,* a subject which answered his needs. The book's first edition burst on the public in November of 1817, a short time after his return from Italy. During that winter, it went from hand to hand and stirred angry debate wherever it was read. Money was subscribed for the Raft's survivors in every corner of France; in the very prison of Rodez, where the accused murderers of Fualdès awaited their sentence, the plight of the shipwrecked aroused pity.[1] Nowhere, however, was the discussion more intense and more informed than in the circle of veteran officers and aspiring politicians round Vernet.

It is likely that Géricault first read the book and met its authors[2] soon after his arrival in France, and that it was then that he received his first strong impressions of the disaster. Exactly when the idea struck him that the story of the Raft might be used for a painting of large dimensions is difficult to guess. His plan may have ripened gradually, in the course of the winter and spring of 1818, while he was busy with his lithographs and the Fualdès drawings. Some of his earliest sketches for the project of the *Medusa* at any rate include details of the shipwreck that were only published in the book's second edition, put into circulation during the early months of 1818.[3] This indication of a fairly late start accords well with Clément's statement that Géricault *"used the spring and summer of 1818 to complete his information and his studies",* worked out the composition in the course of the summer and autumn, and was ready to transfer the completed design to canvas in November of 1818.[4]

The start of the work was slow and difficult. Its very gradual progress can be traced in a chain of preliminary studies, from which it appears that Géricault, at the outset, did not clearly visualize his subject. He was slow to make his choice among the various dramatic episodes which the story of the shipwreck offered. For some time, he hesitated between several incidents of quite different aspect and meaning. The difficulty was to lift from the flow of the narrative a single, significant, and pictorially effective moment; it was the very problem which had occupied him, a short time before, when he developed the subject of the *Murder of Fualdès.*

Géricault did not invent with ease. He needed the spur of experienced reality to start his imagination working. In trying to reduce the drama of the Raft to a single scene, he had to use verbal descriptions as a guide, to which his mind responded slowly. He struggled to translate the words of Corréard and Savigny into images, grasping at anything that might help him give substance to their tale—popular lithographs of the shipwreck (figs. K–M),[5] the talk of survivors, a scale model of the Raft, built for him by the *Medusa*'s carpenter (fig. J).[6] Gradually, he collected *"a veritable dossier crammed with authentic*

[1] A. Jal, *op. cit.,* p. 412.

[2] Clément, *op. cit.,* p. 130: *"Il s'était beaucoup lié avec MM. Corréard et Savigny, les principaux survivants parmi les acteurs de ce drame dont il se faisait raconter toutes les navrantes et horribles péripéties".*

[3] Among the episodes first published in the book's second edition were those involving the sutler's family and

the death of the young sailor in the arms of an older man. The publication date of this edition can be deduced roughly from the fact that the English translation of it, *Narrative of a voyage to Senegal in 1816,* London, 1818, includes a frontispiece dated April 1.

[4] Clément, *op. cit.,* pp. 129 and 136.

proofs and documents",[7] evidently not only to give accuracy to his work but to set his fantasy in motion. Many months later, close to the end of his long battle with the picture, he would occasionally expose himself to the sting of a fresh experience, to sharpen his flagging sense of the reality of his subject. This need for stimulation, which was to send him to the beaches of Le Havre to observe marine skies[8] and to Parisian hospitals to look into the faces of the dying,[9] already seems to have been acting on him when he compiled his dossier at the project's beginning.

While he laboured to re-create the actuality of his subject with the help of documents, he also looked for support from a very different kind of authority. Some aspects of the story of the Raft recalled to his mind parallels in art: scenes of battle, torment, and death in the works of the masters. Though these had nothing to do with the historical truth for which he aimed, they struck him as being appropriate to his subject in feeling and expression, and he freely used them as aids in its visualization. In this way, quotations from Michelangelo, Rubens, and Gros entered into his conception of the *Raft of the Medusa* at an early stage, and as the composition developed, became fused with elements taken from his imagination or from observed life.

Preferring to work from definite images in making his choice of the proper episode for full development, Géricault began by sketching several alternative moments of the disaster, a procedure which he had used in earlier projects. Of the first fugitive sketches which recorded his actual invention of these scenes (Plate 13, cat. 15), most are lost. The preserved drawings, with few exceptions, are remarkably precise and developed, giving the impression of being based on ideas already tested and settled in all essentials. To judge from the early drawings which survive, he was initially drawn to five episodes of Corréard's and Savigny's account. In several very elaborate drawings, he treated the ferocious *Mutiny* of the sailors against their officers (Plates 4–7, cat. 5–9). In another study, equally detailed, he represented the outbreak of *Cannibalism,* which followed the massacre (Plate 8, cat. 10). He explored in detail the incident of the inconclusive *Sighting of the Argus* (Plates 12 ff., cat. 14 ff.), on the morning of the thirteenth day of the Raft's voyage, and the desperate, futile efforts of the men to attract the notice of the searchers. It was this episode which he ultimately chose for his painting. In several drawings and a painted sketch (now lost), he dealt with the moment before the actual rescue, showing the survivors *Hailing the Approaching Rowing-boat* which will take them to safety (Plates 9–10, cat. 11–13). In other drawings, he sketched the *Rescue* itself, and, finally, the empty Raft after the departure of the survivors (Plates 1–3, cat. 1–4). It is not likely that he considered all these episodes as possible subjects for his projected picture. Some of them he may merely have sketched as exercises in visualization. This may be true, for example, of the drawings of the *Rescue* (Plates 1–3, cat. 1–4), and almost certainly applies to the drawing of the empty Raft. It is strange, on the other hand, that among the preserved studies there is not one which deals with the treachery of the *Medusa's*

[5] The Cabinet des Estampes of the Bibliothèque Nationale, Paris, possesses four contemporary lithographs of the shipwreck, based on the account of Corréard and Savigny, and evidently earlier than Géricault's picture: (1) *Naufrage de la Frégate la Méduse et Embarquement de l'Equipage sur le Radeau et dans les Ambarcations. D'après les renseignements exacts donnés par M. Savigny, l'un des naufragés du Radeau. An 1817.* (2) *Naufrage de la frégate la Méduse . . . départ des Embarcations et du Radeau . . . d'après les renseignemens les plus exacts donnés par Mrs. Savigny et Corréard.* (3) *La Révolte d'une partie de l'équipage,* signed by Hipolyte LeComte, 1818. (4) *Rencontre du Radeau par le brick l'Argus.* Two of the prints, nos. (2) and (4) bear the legend *Par un officier de marine en retraite.* It is probable that Géricault was familiar with these and other popular picture chronicles of the shipwreck and that they formed part of his *dossier.*

[6] Clément, *op. cit.,* p. 130.
[7] *Ibidem,* p. 129.
[8] *Ibidem,* p. 137.
[9] *Ibidem,* p. 130.

captain and the casting adrift of the Raft, though these were the most scandalous incidents of the shipwreck.[10]

At the very outset, Géricault may have toyed with several episodes at once, but as he began to develop their compositions in more concrete detail, he concentrated on one after the other, testing each thoroughly before going on to the next. The actual order in which he took them up in turn can be deduced with fair certainty from the surviving drawings, since they form a progressive sequence. Géricault's characteristic habit of building his compositions by successive additions and transformations, and his tendency to cling to figure motifs once he had invented them, carrying them from one compositional version to the next, give strong clues to the dates of the individual projects. The closer in total effect and in detail a particular study approaches the final solution, the later it is likely to fall within the chain of the preparatory designs. If the known compositional studies are arranged according to this principle of progressive development, it becomes evident that they divide into two main groups. The episodes of *Rescue, Mutiny,* and *Cannibalism* belong together and constitute an early, experimental stage in the development, while the studies of the *Hailing of the Approaching Rowing-boat* and of the *Sighting of the Argus* together form a later stage which leads directly to the final composition.

The scene of the *Rescue* did not, it seems, occupy Géricault for very long. The drawings which treat this subject (Plates 1–2, cat. 1–2) do not so much develop it, as cast it in two totally different versions. In the one, the action is shown from the side of the rescue boat. The survivors of the Raft, forming a confused mass, are seen pressing forward into the rowing-boat. In its general disposition, this sketch oddly resembles a painting which Gros was at that time preparing to send to the Salon of 1819, the *Embarkation of the Duchess d'Angoulême* (fig. G). It is not impossible that Géricault was influenced by Gros's work, which he may have seen in the master's studio. The other version, by contrast, treats the moment of rescue as seen from the Raft (Plate 2, cat. 2). The survivors, conceived as nudes in the "antique" manner, are separately articulated and strike Michelangelesque poses. The experiment of essaying one subject in two quite different modes, the one modern, the other classical, had repeatedly been tried by Géricault during 1817–18; it links the *Rescue* drawings with works from his Italian stay and the period which immediately followed it.

The episode of the *Mutiny,* unlike that of the *Rescue,* held Géricault's full attention for some time (Plates 4–7, cat. 5–9). There can be little doubt that he seriously considered using it for his picture. The several drawings of the *Mutiny* composition which survive give every indication of having been worked out carefully and slowly, in close dependence on the narrative of Corréard and Savigny. They show the Raft at a fair distance, moving to the left, driven by a strong wind, which billows its torn sail. Around it extends a wide margin of sky and agitated sea. The ocean's swell lifts the Raft's prow and causes its stern to sink among the towering waves. Along the downward slant of its timbers descends an avalanche of bodies, tightly crowded and yet in motion, as if spilling from the mouth of a gigantic cornucopia. At first sight, the figures on the Raft seem too numerous and too closely interwoven to be distinguished separately, but on closer look, the mass resolves itself into precisely

[10] E. Chesneau, in *Les chefs d'école,* Paris, 1862, p. 146, mentions a sketch in the Marcille collection showing *"le moment où, d'un coup de hache, le radeau est violemment détaché des canots remorqueurs: il avait exprimé la déception, le désespoir et la rage des victimes de cette trahison".* No such sketch is known, nor do the catalogues of the various sales in which the Marcille collection was dispersed prove that one ever existed. It seems probable that Chesneau in fact had in mind one of the *Mutiny* compositions.

TEXT ILLUSTRATIONS

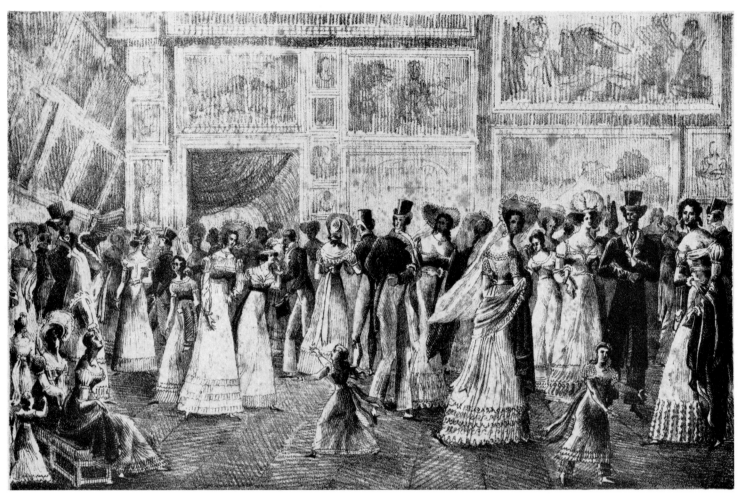

Fig. A. Niquet: *Saturday at the Salon*. Lithograph, 1819

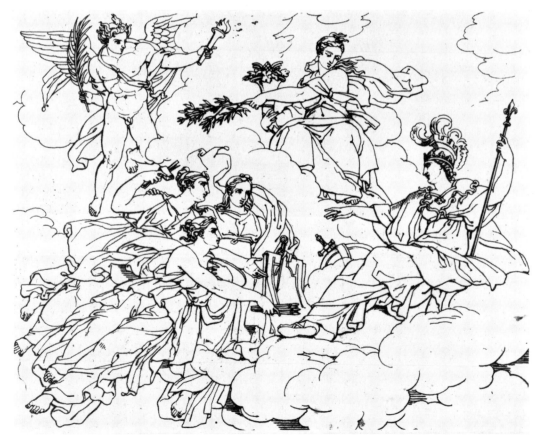

Fig. B. Charles Meynier: *France, Protectress of the Arts*. Salon of 1819. After an engraving

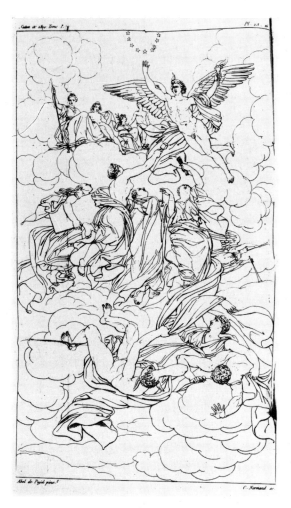

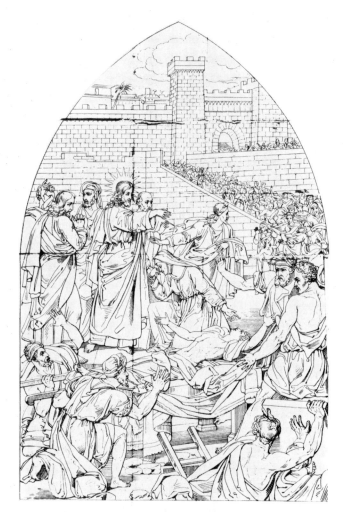

Fig. C. Abel de Pujol: *The Rebirth of the Arts*.
Salon of 1819. After an engraving

Fig. D. Guillemot: *Christ Raising the Widow's Son*.
Salon of 1819. After an engraving

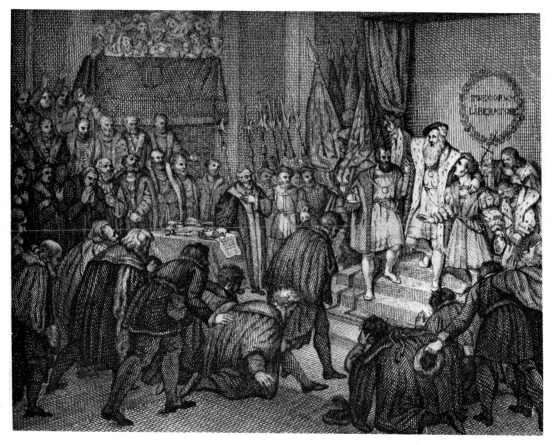

Fig. E. Hersent: *Gustaf Wasa*. Salon of 1819. After an engraving

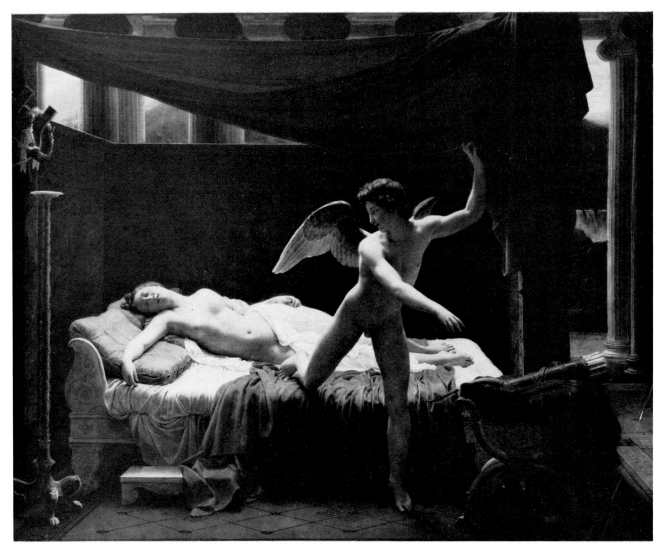

Fig. F. François-Edouard Picot: *Amor and Psyche*. Salon of 1819. Paris, Louvre

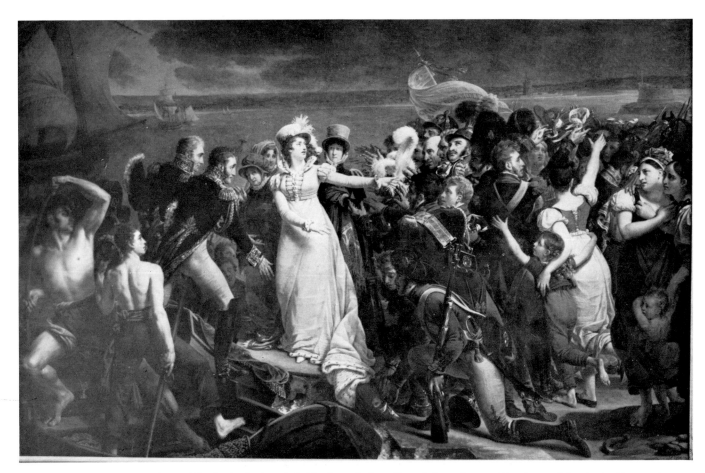

Fig. G. Antoine-Jean Gros: *The Embarkation of the Duchess of Angoulême*. Salon of 1819. Bordeaux, Musée des Beaux-Arts

EXPLICATION

DES OUVRAGES

DE PEINTURE,

SCULPTURE,

ARCHITECTURE ET GRAVURE,

DES ARTISTES VIVANS,

EXPOSÉS AU MUSÉE ROYAL DES ARTS,
LE 25 AOÛT 1819.

~~~~~~~~~~~~~~~~~~~~~~~~~
PRIX, 1 FRANC.
~~~~~~~~~~~~~~~~~~~~~~~~~

PARIS,

C. BALLARD, IMPRIMEUR DU ROI,

RUE J.-J. ROUSSEAU, No. 8.

1819

PEINTURE.

5o1 — Portrait de M. le Maire de la commune d'Argenteuil.

5o2 — Plusieurs portraits, *même numéro.*

GÉNILLION, *au Palais des Beaux-Arts.*

5o3 — Vue de l'église des Invalides prise de l'avenue de Breteuil.

GENOD, *de Lyon.*

5o4 — La bonne mère, intérieur de cuisine.

5o5 — Le petit malade.

Tandis que sa mère pleure, sa jeune sœur est à genoux, priant le ciel pour la convalescence de son frère.

5o6 — Un vestibule où sont des antiquités.

GÉRARD (F.)

5o7 — Portraits en pied de S. A. R. Mᵐᵉ. la duchesse d'Orléans et de Mgr. le duc de Chartres.

GÉRARD (L. A.), *rue de la Michaudière, n°. 2.*

5o8* — Vue de l'entrée du village d'Avray.

5o9 — Vue de la porte d'Auteuil, prise du bois de Boulogne.

GÉRICAULT.

51o — Scène de naufrage.

GERMAIN, *rue du milieu des Ursins, n°. 5, en la Cité.*

511 — Portrait en pied de S. A. R. Monsieur.
Tableau commandé par la ville de Reims.

512 — Portrait de M. J. C.

Fig. H. Catalogue of the Salon of 1819

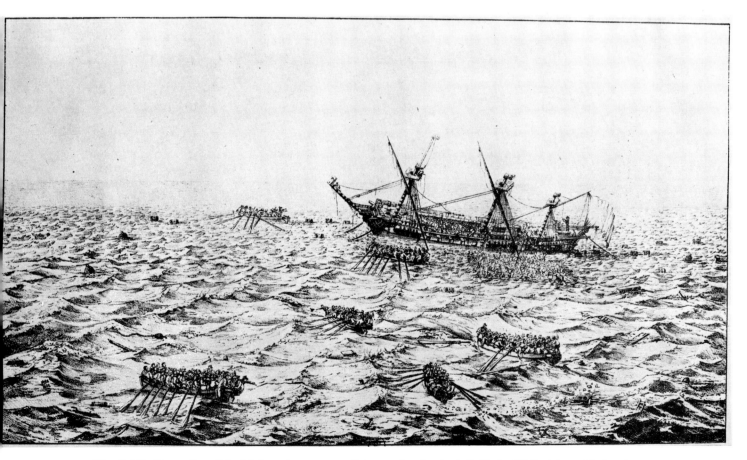

Fig. I. *The Evacuation of the Medusa.* Anonymous lithograph, about 1818. Paris, Bibliothèque Nationale

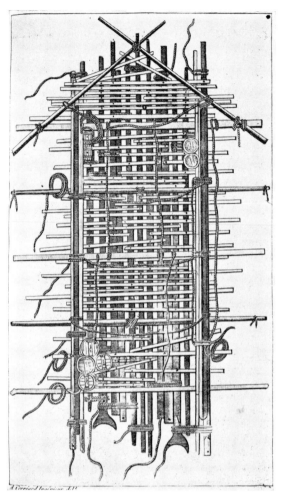

Fig. J. Corréard: Plan of the Raft. Engraving, 1817

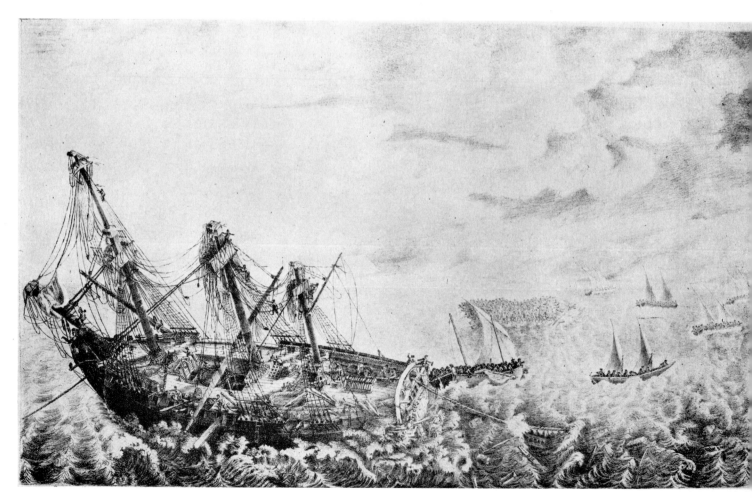

Fig. K. "A Discharged Naval Officer": *The Lifeboats and the Raft leaving the Medusa*. Lithograph, about 1818. Paris, Bibliothèque Nationale

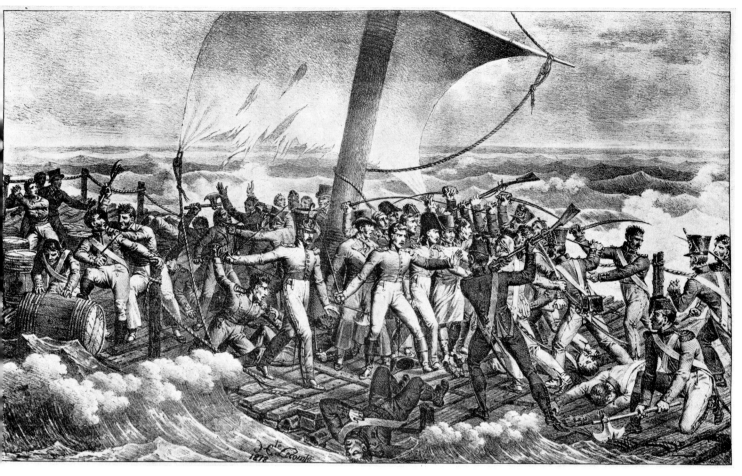

Fig. L. Hipolyte Lecomte: *The Mutiny on the Raft*. Lithograph, 1818. Paris, Bibliothèque Nationale

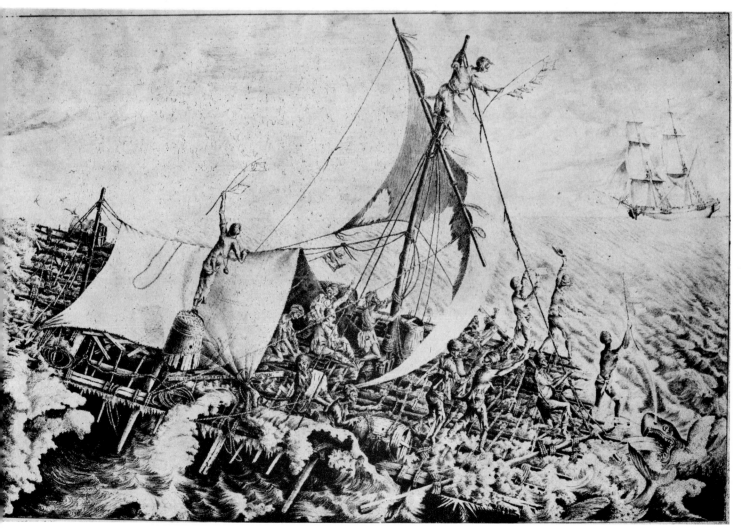

Fig. M. "A Retired Naval Officer": *The Survivors on the Raft Sighting the Argus*. Lithograph, about 1818. Paris, Bibliothèque Nationale

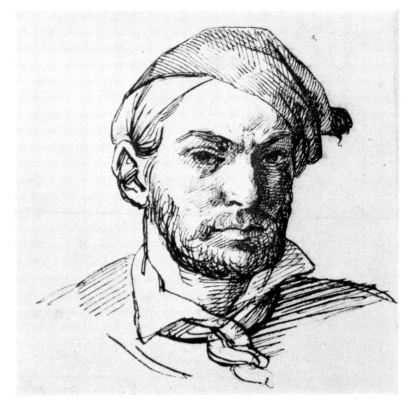

Fig. N. Géricault: *Self-Portrait*. Pen drawing, about 1818.
Toronto, F. S. Jowell coll.

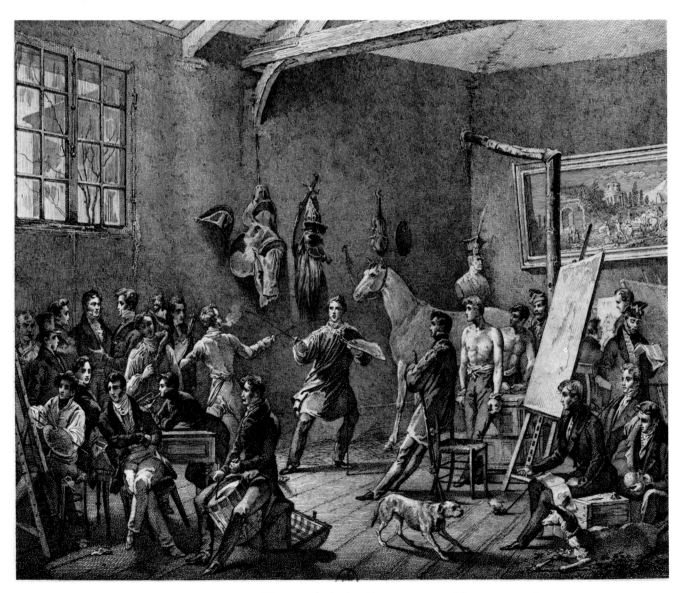

Fig. O. Horace Vernet: *The Artist's Studio*. About 1818–20. After an engraving

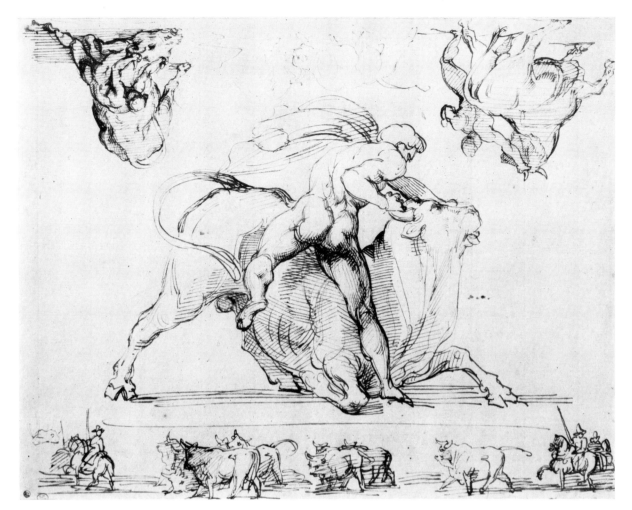

Fig. P. Géricault: *Bull-Tamer*. Pen drawing, about 1817–18. Paris, Louvre

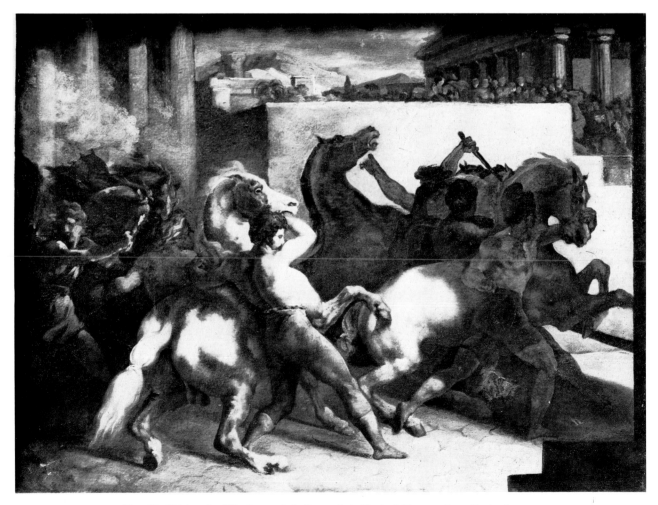

Fig. Q. Géricault: *The Start of the Race of the Barberi Horses*. 1817. Paris, Louvre

Fig. R. Géricault: *The Retreat from Russia*. Lithograph, 1818

Fig. S. Sebastien Coeuré: *The Body of Fualdès Taken to the Aveyron*. Lithograph, 1818

Fig. T. Géricault: *The Body of Fualdès about to be Cast into the Aveyron*.
Chalk and wash drawing, 1818. Lille, Musée des Beaux-Arts

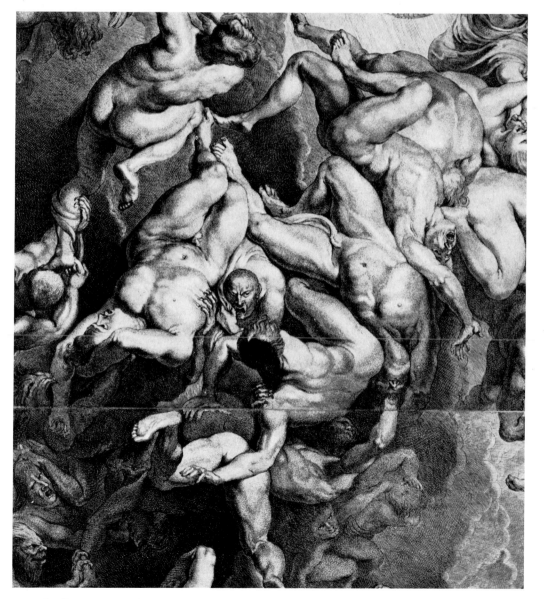

Fig. U. Jonas Suyderhoef (*c.*1613–86), after Rubens: *"The Little Last Judgement"*, detail.
Engraving, 1642

Fig. W. Gabriel-François Doyen: *St. Genevieve Interceding for the Plague-Stricken*. 1767. Paris, Church of St. Roch

Fig. V. Girodet-Trioson: *The Deluge*. 1806. Paris, Louvre

Fig. X. Antoine-Jean Gros: *Bonaparte Visiting the Plague-Stricken in the Hospital at Jaffa*. 1804. Paris, Louvre

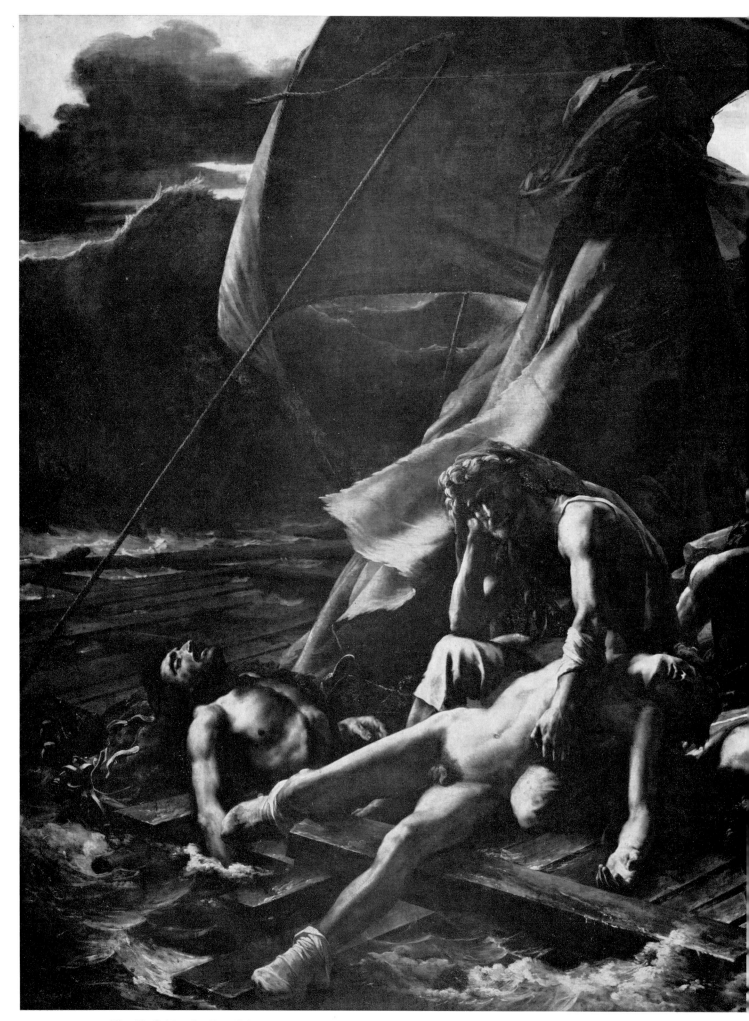

Fig. Y. Géricault: Detail from *The Raft of the Medusa:* "The Father Holding the Body of his Dead Son"

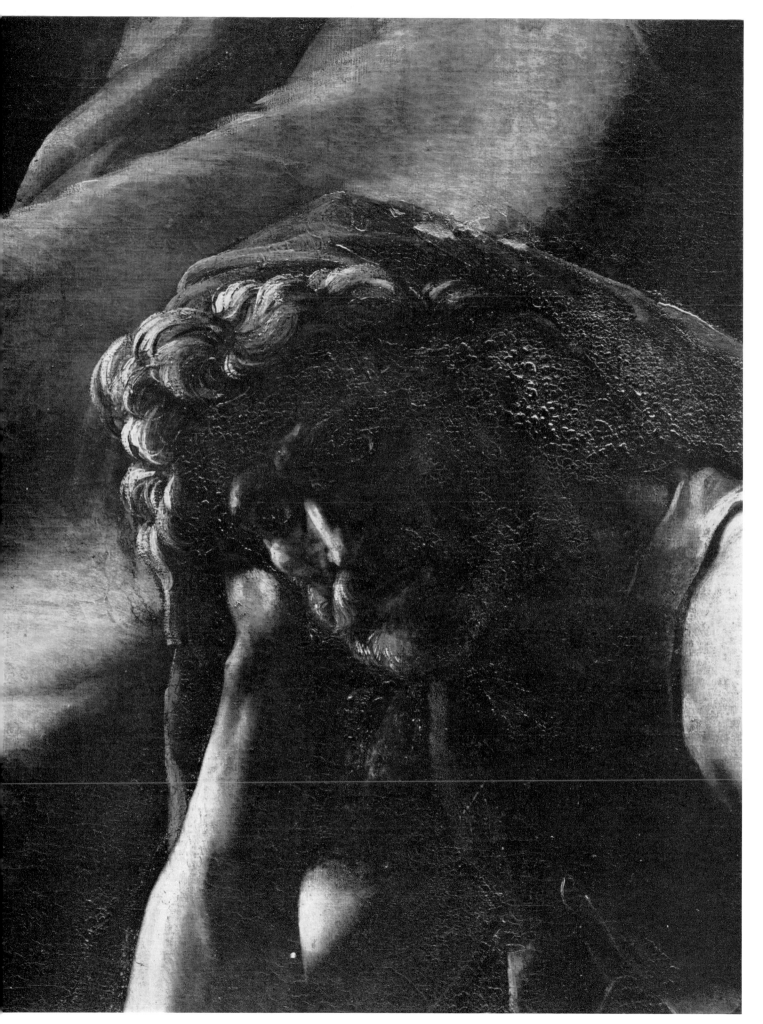

Fig. Z. Géricault: Detail from *The Raft of the Medusa:* Head of the "Father"

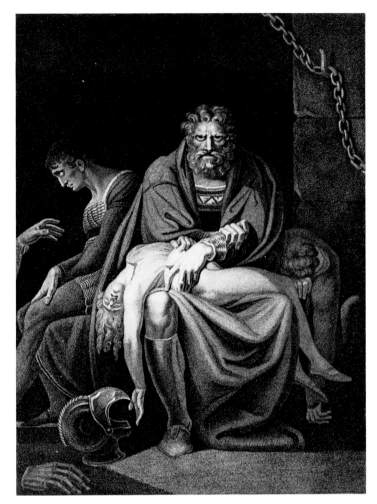

Fig. AA. Henry Fuseli: *Ugolino in the Tower*.
Etching by Moses Houghton. 1811

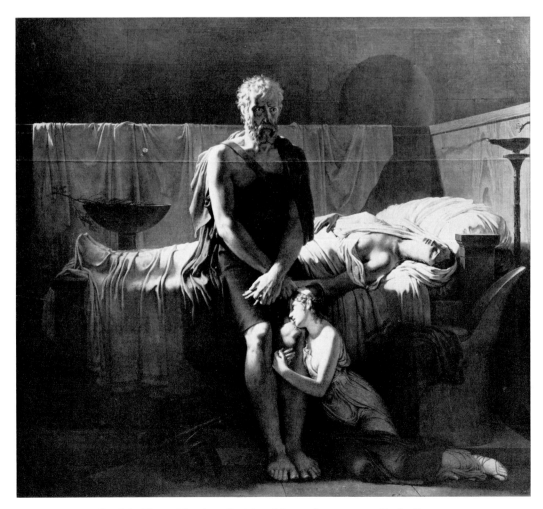

Fig. BB. Pierre-Narcisse Guérin: *Marcus Sextus*. 1799. Paris, Louvre

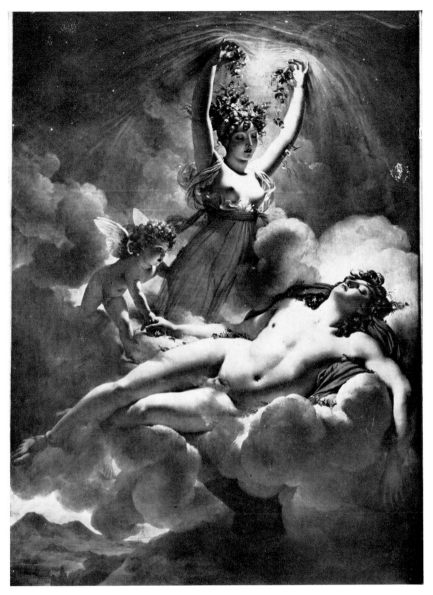

Fig. CC. Pierre-Narcisse Guérin: *Aurora and Cephalus*. 1810. Paris, Louvre

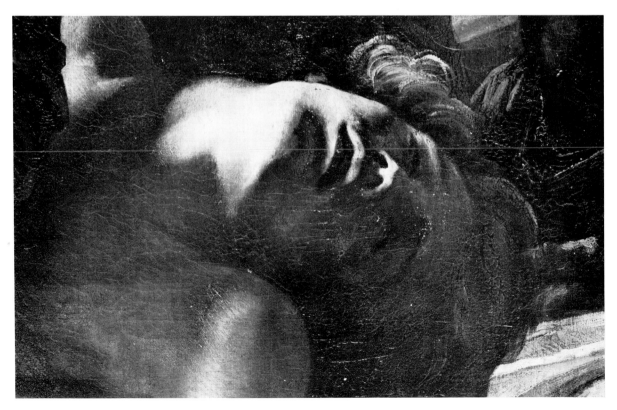

Fig. DD. Géricault: Detail from *The Raft of the Medusa:* Head of the "Dead Son"

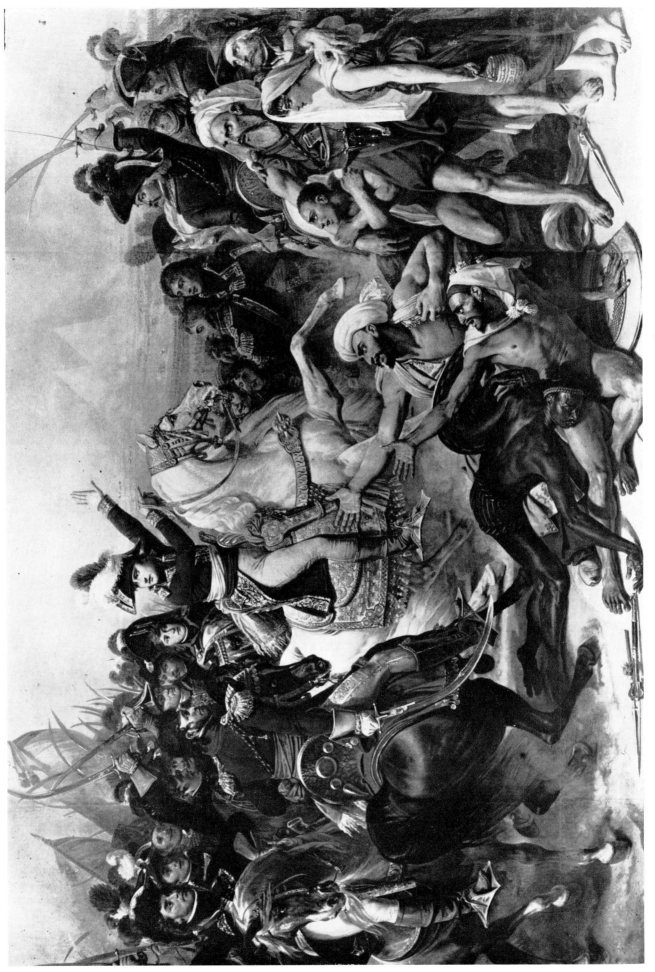

Fig. EE. Antoine-Jean Gros: *The Battle of the Pyramids*. 1810. Versailles, Château, Musée d'Histoire

Fig. FF. Géricault: Detail from *The Raft of the Medusa*: Rising Figures

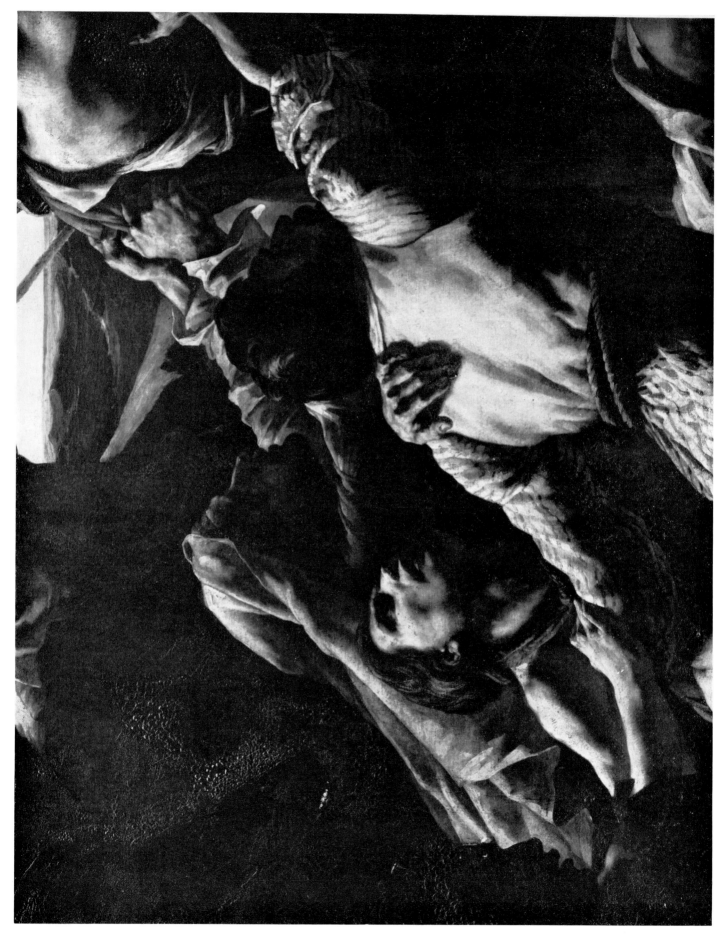

Fig. GG. Géricault: Detail from *The Raft of the Medusa*: Rising Figures

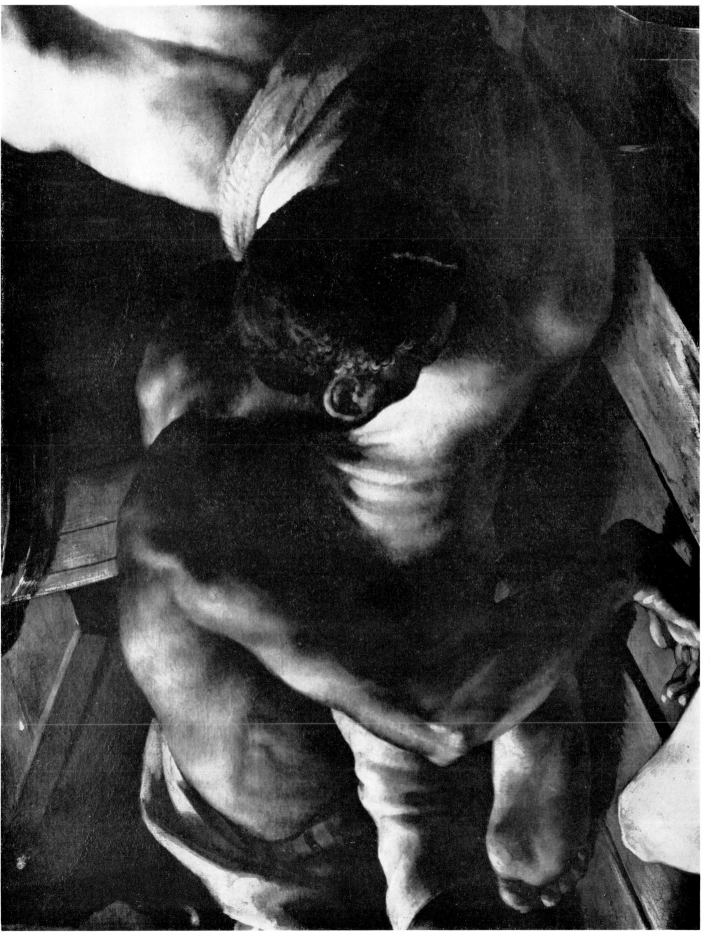

Fig. HH. Géricault: Detail from *The Raft of the Medusa*: The Dead Negro

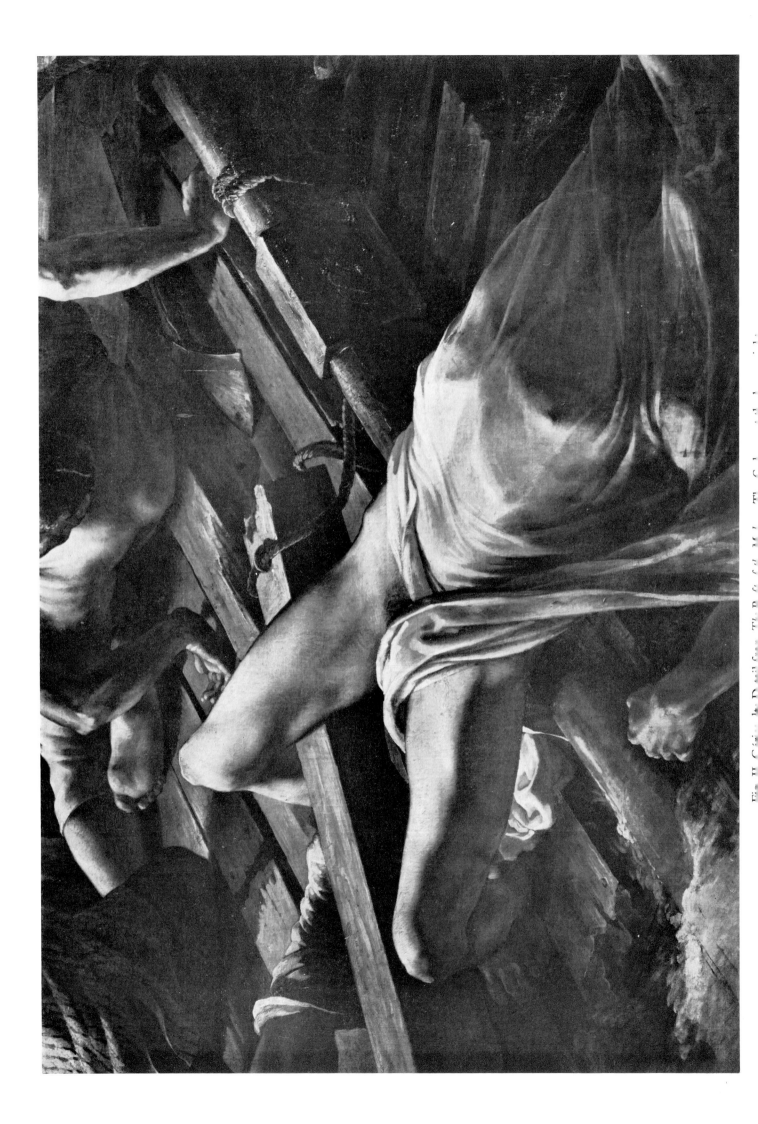

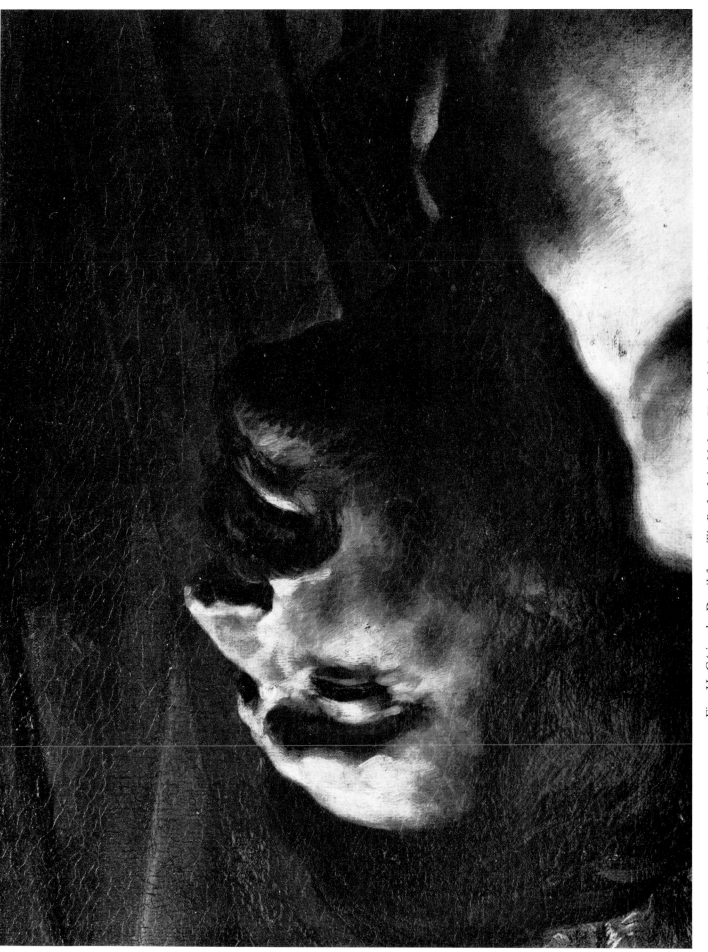

Fig. JJ. Géricault: Detail from *The Raft of the Medusa:* Head of the Cadaver at the left

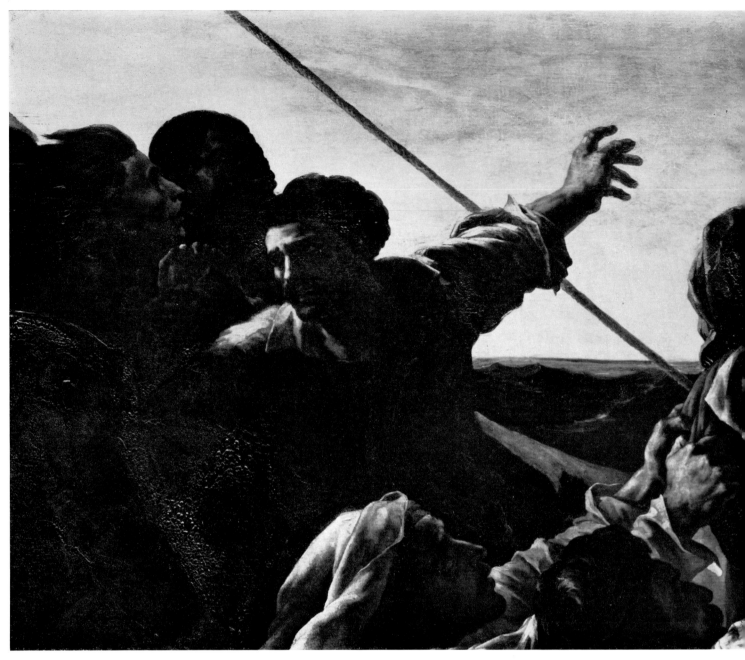

Fig. KK. Géricault: Detail from *The Raft of the Medusa:* The Group at the Mast

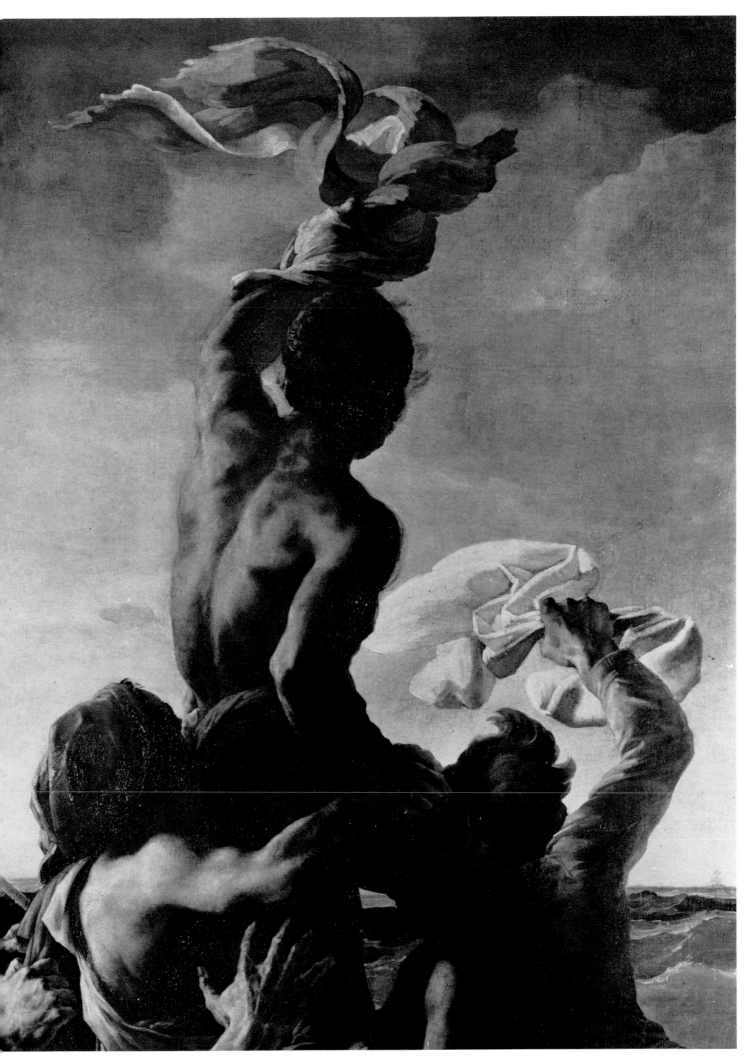

Fig. LL. Géricault: Detail from *The Raft of the Medusa:* The Signalling Negro

Fig. MM. Advertisement for the London
Exhibition of *The Raft of the Medusa*

Fig. NN. Géricault: A letter of Invitation to the Private Showing of
The Raft of the Medusa, 1820. Paris, G. Delestre collection

THE LONDON MUSEUM, IN PICCADILLY, ERECTED A.D. 1812.

Fig. OO–PP. Bullock's Egyptian Hall and Roman Gallery in Piccadilly. Engravings

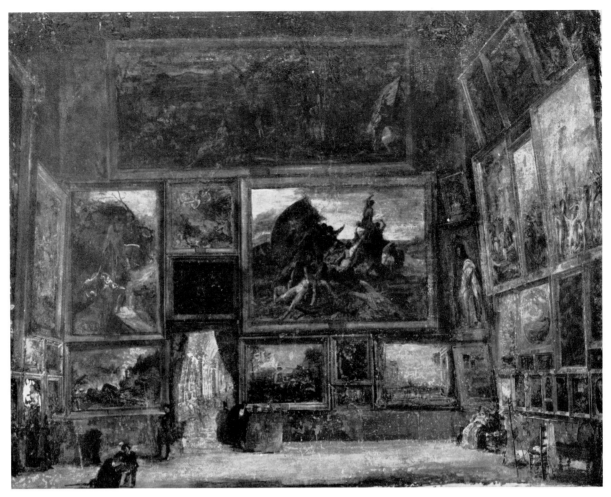

Fig. QQ. N. S. Maillot: *The Raft of the Medusa in the Salon Carré of the Louvre.* About 1831. Paris, Louvre

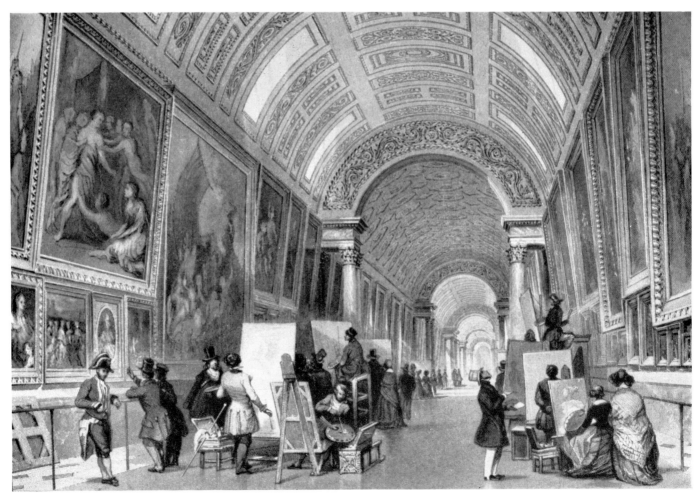

Fig. RR. Eugène Lami: *The Raft of the Medusa in the Grande Galerie of the Louvre.* 1843. After an engraving by Mottram and Allen

defined groups. On the Raft's raised prow, at the left, the shipwrecked men are in despair, some have sunk into apathy, others raise their arms in helpless supplication. Near them lie the wounded and the suffering. A father embraces his wife and child; one of the drawings shows, instead, a man who lifts the body of another from the water. Beneath the mast stands an exhausted officer holding a broken sword. Nearby, the battle still rages; hatchets and sabres flail the air, the sailors and officers, some uniformed, many nude, are locked in desperate combat. Brandishing a hatchet, a crazed mutineer throws himself into the sea. Clusters of wounded and dying men tumble from the Raft's stern and disappear among the waves. On the left side of the composition are grouped the defenders of the Raft and the innocent victims, while the right side is given over to the rebellious in their furious assault and final destruction. Nearly all the episodic details derive from the text of Corréard and Savigny, but Géricault has condensed into a single crowded scene various incidents which in actuality had occurred over a period of days. For all its modern detail, the scene of the *Mutiny* curiously resembles traditional representations of the Last Judgement in its separation of the innocent from the guilty, its symmetry of aspiration and damnation, and its spectacular fall of the mutinous. It is clear that Géricault's vision of the Raft trailing a stream of struggling nudes owed something to the famous bark in Michelangelo's Sistine fresco. But an even closer relationship links his *Mutiny* with Rubens' so-called *Little Last Judgement* (Munich), known to him through an engraving, after which he had drawn several careful pencil studies (Plate 27, cat. 33). The tumbling nudes in the *Mutiny* reflect his familiarity with the falling rebel angels in Rubens' composition, which evidently interested him mainly because he found it relevant, in theme as well as form, to his own project.

Géricault at length abandoned the *Mutiny* episode, after having spent much effort on it, perhaps realizing that its intricacy made it unsuitable for execution in a monumental format. In all his subsequent versions, he was to aim for greater simplicity.

Only one of the preserved drawings deals with the outbreak of *Cannibalism* among the survivors of the battles (Plate 8, cat. 10). Like the *Mutiny* drawings, it is a fully developed composition, not a groping sketch, and it further resembles them in the position and setting in which it presents the Raft. The figures are fewer, as historical accuracy required; the violence has ebbed, and the teeming cascade of bodies has dwindled to a single cadaver hanging from the stern. In the place of the family group, Géricault has put two naked men who feed on a corpse. This bold motif—cannibalism is one of the rarest subjects in Western art—gives the scene its particular fascination, but it is not enough to overcome the incoherence and meagreness of a design which lacks all the sweep of the *Mutiny* composition. The few principal figures, every one of them nude, are awkwardly aligned along the Raft's edge, somewhat like actors on a stage. The scene amounts to a reduction and stiffening of the turbulent *Mutiny*; what it has gained in legibility it has lost in interest, despite its sensational subject. Géricault, wisely, put it aside—one wonders how his man-eaters would have been received at the Salon—but his passing occupation with it was not entirely a waste. The *Cannibalism* episode contributed several new motifs to the further development of the *Raft of the Medusa,* notably the group of the old man, the "Father" of the final version, who holds a dead youth in his arms (Plate 22; cf. Plates 31 ff.).

The *Mutiny* and *Cannibalism* compositions shared one important trait: their action was conceived as a dramatic spectacle seen from a distance. They put the viewer in the position of one who watches the Raft as it passes him by, surrounded by water, looking like a floating stage covered with gesturing or battling figures. Géricault's next move in his development of the scene brought a change into it

which deeply altered its form and meaning. He re-oriented the figures on the Raft, turning them away from the spectator toward a point in the depth of the picture. At the same time, he moved the Raft so close to the foreground as to make the viewer feel transported onto its planks and to involve him in its drama as a participant rather than a detached observer.

This decisive change first appears in two drawings and a painted sketch which show the men on the Raft *Hailing an Approaching Rowing-boat* (Plates 9–10, cat. 11–13). This is the moment before the final deliverance, the handful of survivors stand at the Raft's edge or drag themselves forward to greet the boat, which bears down on them from the middle distance, across the crest of a small wave. The Raft, no longer surrounded by water, juts into view from the foreground at the right and points toward the rowing-boat, which approaches from the left. The effect of the scene now hinges on the juxtaposition of near and far elements. The immediate proximity of the Raft encourages the beholder to adopt the view of the shipwrecked men and to identify himself with their action. His eye is led by their excited gestures toward the rowing-boat in the middle distance which, despite its relatively small size, is the emotional centre of this drama of rescue. The entire composition is caught up in a strong, aimed thrust which runs diagonally from Raft to rowing-boat. In the place of the intricate agitation of the *Mutiny*, the composition of the *Hailing* expresses a focused tension. The Raft with its straining figures and the distant boat are the opposite poles of a directed force which spans the space between them. The figures on the Raft, no longer separable into individual groups, are welded into one action, the meaning of which is made clear by the overall design, not by narrative detail: composition and narration have become one.

Composition

In developing the scene of the *Hailing* (Plate 9), Géricault had found the dramatic motif and compositional structure which satisfied him. It now occurred to him that another episode in the story of the Raft offered him an even better chance to exploit the tensions and contrasts which gave power to his new-found image. From the episode of the *Hailing* he turned to that of the *Sighting of the Argus* (Plates 12 ff., cat. 14 ff.). His search was at an end: he had found his subject.

There is an important difference between the two episodes. The *Sighting* is not a part of the rescue, it is, rather, the ultimate ordeal of the shipwrecked men. The event occurs on the morning of the thirteenth day of the Raft's voyage. The *Argus* has come into view on the far horizon. The men on the Raft, in an agony of expectancy, respond to this uncertain promise in different ways. Some are stirred to frantic activity, others calculate their chance, some pray for deliverance, still others, past hope, turn their backs. Soon the *Argus* will disappear again.

Much more complex than the *Hailing* in its drama, the *Sighting* is a scene of anxiety, disappointment, and resignation, rather than relief. Yet the formal means by which Géricault expressed this content are similar to those which he had first devised for the *Hailing of the Approaching Rowing-boat*. The new composition grew directly from the previous one and retained its main features: the closeness of the Raft to the foreground, the diagonal recession of the whole, the coherence of the figure groups, and their orientation toward a point in the distance. The main change is in the relationship between Raft and rescue vessel. In contrast to the comforting proximity in which the rowing-boat appeared in the scene of the *Hailing*, the rescue ship is now so far removed as to be scarcely visible. It is too small to

form an appreciable shape within the general design, but it functions powerfully as the magnetic focus on which all movements converge. Throughout Géricault's further development of the scene, he steadily intensified the effect of extreme distance between Raft and rescue. In his final version (Plate 22), the disproportion between the overpowering nearness of the figures on the Raft and the infinitesimal spot on the far horizon toward which they gesticulate produces an almost unbearable sense of strain. What had begun, in the scene of the *Hailing,* as a subtle turning of the composition toward the middle distance, became in the end a plunging recession from nearest foreground into farthest distance, a dramatic device of a vehemence unparalleled in the art of Géricault's time.

It was entirely in keeping with Géricault's temperament that he arrived at this bold solution not in one energetic impulse, guided by an intuitive vision of the whole, but by patient, piecemeal effort. The decision to shift to the episode of the *Sighting of the Argus* did not win him any sudden break-through. While it enabled him to concentrate on one particular scene, it also made him face a fresh start; a situation which he always found difficult. The idea of his new subject had to be cast into a definite image, and of this he possessed at first only the merest rump, the general compositional scheme first suggested to him by the scene of the *Hailing of the Approaching Rowing-boat.* Accepting this as his base, he proceeded to form a core of figures appropriate to the new subject, then went on to increase this nucleus by fitting more and more figures around it (Plates 14 ff., cat. 16 ff.). In this manner, he cautiously expanded his composition, making it grow unit by unit, not unlike a building under construction.[11] As was his custom, he recorded every step of this process in a separate drawing or painted study. Whenever possible, he borrowed figures from the discarded projects of *Mutiny* and *Cannibalism.* In this, too, his method was rational and economical. He disliked wasting hard-won inventions, and since his imagination was not abundant he deliberately limited himself to a small repertory of motifs which he revised and transformed continuously, driven by restless perfectionism. The composition as a whole, and every part of it, underwent constant change as he worked along, uncertain about the outcome until near the end. The preserved studies show how little he foresaw at the start what form his image would ultimately take. The great ascent of straining figures, cul-minating in the signalling Negro, which totally dominates the final canvas, was not in his mind when he began, but assumed shape gradually, hesitantly, as the work went forward.

A pen drawing in Rouen (Plate 13, cat. 15) may be the earliest of the preserved designs for the *Sighting.* It is exceptional among the early drawings of the scene in giving a fairly comprehensive statement of the whole, while remaining notably vague and irresolute in every detail. These conflicting indications of early and relatively late date make it difficult to place it in the otherwise closely con-tinuous and progressive sequence of designs. It is possible that it reflects that earliest stage in the planning, when Géricault still experimented simultaneously with several different episodes. If so, the sketch in Rouen would indicate that he had dimly envisaged some of the crucial features of his final composition at the outset, then had abandoned them, only to be brought back to them, step by step, in the subsequent evolution of the composition (Plates 15 ff.).

Two tiny, rapid sketches of an old man holding the body of a youth on his knees, in the upper margin of the drawing in Rouen, link this early version of the *Sighting* to the main sequence of designs

[11] Géricault used a small scale-model of the Raft, on which he placed figures modelled in wax, in planning the composition (Clément, *op. cit.,* p. 130). His use of this device may help to explain his peculiarly gradual and piecemeal method of construction, his facility in turning the figures in different views, and the apparent ease with which he managed the distribution of lights and shadows.

leading to the definitive compositions. This seems to be the earliest appearance, as yet not integrated with the composition, of a motif—usually called the "Father Mourning his Dead Son"— which was to become the cornerstone on which Géricault based the intricate figure structure of the *Raft* (Plates 31 ff., cat. 38 ff.). After its initial appearance in the Rouen drawing, we meet with it in several separate sketches. One of these, at the Düsseldorf Museum (Plate 31, cat. 39), illustrates the start of his attempt to base further figures on this anchor group.

A very precise pen drawing in Lille shows the group of "Father and Son" for the first time firmly embedded in a complete composition (Plate 14, cat. 16). In the arrangement and leftward orientation of its figures, this drawing still echoes the discarded episode of the *Hailing of the Approaching Rowing-boat* (Plate 9). To adapt the earlier compositional scheme to the new subject, Géricault has begun to improvise a new set of figures, attaching them to the group of "Father and Son": a cadaver lying forward on its face; a crouching man looking sharply in the direction of the distant *Argus*; a man, seen in back view, dragging himself forward on his knees. They will remain constant elements in the further growth of the composition. The drawing in Lille marks the point from which the final development of the *Raft of the Medusa* can be followed without break.

Géricault's next step was to give the composition greater unity and to increase its dramatic force. To this end, he reversed its orientation,[12] making it face to the right. He also pulled the separate figures together into four main groups, each expressive of a particular emotion. A pen and wash drawing in Rouen (Plate 15, cat. 17) and an oil study at the Louvre (Plate 16, cat. 18) mark this stage of the work. In them, what was to become the definitive composition makes its first appearance, though still in rudimentary form.

Both depart from the slightly earlier pen drawing in Lille (Plate 14) by sharply pointing the action toward the right. This reversal has a double effect: it accommodates the motion of the viewer's eye and thereby accelerates the directional sweep of the scene; it also draws the viewer into a closer involvement with the action. In the Lille version of the *Sighting* (Plate 14), as already in the episode of the *Hailing* (Plate 9) which that drawing echoes, the rescue vessel came into view first. Moving on, the eye next met the outstretched arms of the men on the Raft. Striving against the motion of the scanning eye, the direction of the gestures gave the viewer the experience of an abrupt encounter, rather than a sense of participation in the figures' motion (Plates 15–16). Once reversed, the scene can be read in one ascending line, starting at the lower left with the men who mourn at the stern, rising toward the right with the straining, motioning figures, and coming to rest at last on the distant rescue ship.

Géricault realized, as he built his many-figured composition, that there was danger in its complexity. To give force and clarity to its action, he decided not to allow a separate role to each of the figures. Instead he gathered the figures into four distinct groups and made them act in concert (Plate 14). By fusing several bodies in one motion, by repeating one gesture many times over, and by drawing all the figures into a single, strong pattern, he not only avoided confusion but actually turned the number of his figures to compositional advantage. Conceived early in the development of the *Sighting* episode, the division into four dramatic groups determined the entire subsequent evolution of the

[12] A similar change from leftward to rightward orientation can be observed in the final stages of the compositional development of nearly all of Géricault's major works. For a discussion of this peculiarity, see L. Eitner, "Reversals of Direction in Géricault's Compositional Projects", in *Stil und Überlieferung in der Kunst des Abendlandes,* III, Berlin, 1967, pp. 126 ff.

composition and set its stamp on the final canvas. The cornerstone of the intricate structure is the group of dead, dying, or despondent men at the stern. It was the core from which the whole composition originally grew and the first group to be fully developed. The six figures which compose it (Géricault by way of afterthought added a seventh, the cadaver at the extreme left, when the painting was nearly finished) occupy all the space of the Raft's lower half, to the left of the mast. Turned away from the distant vision of rescue, lying or crouching in the shadow, they express lassitude, resignation and death. The four men who stand, alert and watchful, on the other side of the mast form a second group, in which Géricault included the portraits of Corréard and Savigny, the chroniclers of the disaster. The attitudes of these men and their subordinate place in the general design characterize them as observers who remain detached from the main drama. This group, too, took shape very early and changed little in the further development of the composition.

After these two quiet and compact groups follows the very different one of the men who struggle to rise to their feet and drag themselves toward the far edge of the Raft, raising their arms in frantic pleading. It is the most vividly pantomimic of the groups, and it gave Géricault great trouble. He showed the men, awakened from death-like torpor by a sudden flash of excitement, expressing the torment of their resurrection in a complicated play of convulsive gestures. Dissatisfied, he kept modifying these figures until the end, gradually increasing their number from three to five.

The fourth group consists of three men who mount some barrels at the Raft's forward end and signal to the *Argus*. Turned to the distance, their faces invisible, their bodies in vigorous motion, they form an extreme contrast to the moribund sufferers of the lower foreground. In these signalling men, and most of all in the dominating figure of the Negro, Géricault brought the aspirations of the victims to a focus and gave them release. It is the most important of the four groups; without it, the dramatic narrative and the compositional structure of the *Medusa* would lack a culmination. Yet it is the last which he invented. The space which it came to occupy remained a blank in the early studies. Géricault went about developing this group with characteristic caution. He began by moving the barrels, which at first had stood useless at the Raft's stern (Plate 14), to its forward end, where they still served no apparent function, save that of adding weight to this side of the composition (Plate 15). Near these barrels, he placed men waving shreds of cloth: a single man in the Rouen drawing, two men in the early oil study in the Louvre (Plate 16). But these two figures gave only a weak termination to the upward thrust of the figures behind them, being neither interesting enough to add anything to the drama of the scene, nor prominent enough to become its visual climax. The long horizon still weighed heavily on the Raft, its line unbroken except for a few hands that reached above it into the vacant sky.

Having come to this point, Géricault solved the problem with one sudden stroke and gave his composition the dramatic centre which it had lacked. In a rough sketch in the Aubry collection and a large, carefully finished drawing in the Louvre (Plates 18–19, cat. 20 and 22), the figure of an athletic Negro appears atop the formerly useless barrels. The two men at the prow now are joined to support and raise this crowning figure. The Negro's powerful torso stands out against the sky high above the horizon, the cloth unfurling in the wind from his uplifted arm gives the scene a splendid climax.

Géricault now felt that he was approaching the end of his preparatory work. He seems to have started the large compositional drawing at the Louvre (Plate 19) in the belief that he possessed the whole design, but he discovered while working on it that the group of rising figures in the centre

of the composition was too sparse and formed a weak connection between the much stronger terminal groups at the left and right. He may also have been troubled by the thought that in showing sixteen men on the Raft, only fourteen of them alive, he was being untrue to the fact that at the rescue there were fifteen survivors. He decided, at any rate, to insert two further figures into the middle group, one of a living, the other of a dead man. These additions first appear in a careful pen tracing of the revised figure groups which is in the Buehler collection in Winterthur (Plate 20, cat. 23). From this last drawing he seems to have gone on directly to the large second oil study in the Louvre (formerly in the Moreau-Nelaton collection), which does, finally, present the whole composition in the form in which he decided to execute it (Plate 21, cat. 24). He intended to make a finished painting of this rehearsal for the large canvas, but changed his mind and completed only a few of the figures in oil, letting the others stand as simple contour drawings on canvas lightly shaded with bitumen. Now that the composition was settled, his interest shifted to the Raft's wider setting of water and sky. Released from the mental strain of his compositional work, he took up the brush with pleasure to improvise a luminous cloudscape and a wide expanse of wind-ploughed sea around the Raft. He had spent half a year in preparatory work. The realization that time was growing short made him uneasy. Nervously impatient to go on to the execution of the final canvas, he abandoned this careful oil study, and also left unfinished a third, even larger painted study of the Raft, now lost (cat. 25).

The development of the composition to this point had been remarkably consistent and logical. Starting with the groups around the "Father" as a base (Plates 31 ff.), Géricault had built a pyramid of bodies, which, as he increased their number from twelve to eighteen, he gradually raised higher, giving it a strong slant toward the right. Since he added all the new figures to the right side of the composition, he caused it to become increasingly asymmetrical and top-heavy (Plate 16). From a state of balance at the beginning, with six figures to the left and six figures to the right of the mast, its centre of gravity steadily shifted rightward and upward, until in the end its right half contained twice as many figures as its left (Plate 21). At the same time, he made the horizon sink lower in each of the successive designs, giving further emphasis to the towering rise of the figures. He also steadily increased the tension between foreground and distance, bringing the near figures very close, while removing the distant rescue vessel ever farther. Finally, he sought to increase the momentum of the composition by concentrating all its movement in one flow (Plate 22). Like trees bending to a common wind, the figures seem swept by an invisible force which expresses itself in the repeated slant of their bodies and upward reach of their arms.

Before beginning to paint the picture, Géricault made one final change in its composition. The sight of the enormous canvas to which he was about to transfer his design may have given him second thoughts about the effect which enlargement would have on the composition. In tracing it on the canvas, he resolutely narrowed the margins of sky and water which had surrounded the Raft in all the preparatory studies. This cropping had the effect of bringing the Raft and its nearer figures into the immediate foreground, literally within the beholder's grasp. As drawn on the canvas, the Raft appeared larger and closer than in any of the earlier studies. Its figures, enlarged to nearly twice life-size, densely crowd the view. Only small patches of water appear beyond it, and even the sky has become congested with the silhouettes of sail and looming figures. It is evident that Géricault wanted to open his composition to the viewer, while also making it weigh on him with its oppressive nearness. His reduction of the margin of water round the Raft and his heavy crowding of the fore-

ground were later much criticized, as inappropriate to a shipwreck picture, but they were necessary to his purpose. His final enlargement of the figures was intended not only to give them the impressiveness—or "sublimity", to use Delacroix's word—which superhuman scale can confer, it was also to serve an expressive function essential to the meaning of the picture. Without representing the vastness of the ocean directly, Géricault sought to dramatize the isolation of the men on the Raft and the strain of their effort, by withdrawing beyond hope the rescue, toward which they frantically strive. He activated the distance, making it appear as a plunging recession, rather than a horizontal expanse, and intensified the illusion of space by means of radical foreshortenings. The enormous foreground figures push the horizon back; the few inches of canvas which separate the signalling men from the speck which signifies the *Argus* demand to be read as miles. It was clearly Géricault's purpose to draw the beholder into a close, empathetic participation with the action of his picture, and to make him feel the drama of the scene with his muscles as much as with his eyes. But this had to be accomplished by visual means. The accessibility of the Raft and the nearness of the figures were to compel the viewer to place himself in the picture's perspective. His eyes filled with the Raft's wide spread, his vision channelled by the gestures of the men before him, his attention irresistibly drawn to the point on which all motions converge, he was to be made to share the experience of the shipwrecked men.

Execution

The last preparatory studies were finished in the fall of 1818; Géricault now felt ready for the transfer of the composition to the canvas. Sometime during November, he exchanged his studio in the rue des Martyrs, too small and too exposed to the distractions of the *Nouvelle Athènes*, for larger quarters in the comparative solitude of the faubourg du Roule.[13] Here he had the enormous canvas set up, and then shut his door to his accustomed life. He knew that if he was to finish his painting in time for the Salon he must spend the months which remained in total concentration on his work. To make sure that he would not break out of his self-imprisonment, he called in a barber and had him shave his head.[14] It was a Spartan sacrifice for Géricault, who had always taken pride in his well-curled hair.

He worked alone,[15] rarely left the house, ate his meals in the studio, attended by an elderly concierge, and slept in an adjoining bedroom, which he shared with Jamar, his assistant and pupil. Only a few friends and some young painters of his acquaintance were welcome to visit him, to work with him in silence or, occasionally, to serve him as models. Among those who had entry to the studio were Dedreux-Dorcy, his closest friend, the painters Robert-Fleury and Steuben, and two very young pupils of Horace Vernet, Montfort and Lehoux, who had attached themselves to him.[16] Corréard, Savigny, and the carpenter of the *Medusa* came to pose for their likenesses in the painting.[17] Personal friends lent their services: a former schoolmate, the teacher Théodore Lebrun,[18] posed for the head

[13] Clément, *op. cit.,* pp. 130, 136.

[14] A. Etex, *Les trois tombeaux de Géricault,* Paris, 1885, p. 26.

[15] Clément, *op. cit.,* pp. 136 ff.

[16] *Ibidem,* p. 137.

[17] *Ibidem,* p. 130.

[18] Concerning Lebrun, cf. M. Tourneux, "Particularités

intimes sur la vie et l'œuvre de Géricault", *Bulletin de la Société de l'histoire de l'art français,* 1912, pp. 126 ff., which contains a letter by Géricault's friend, Théodore Lebrun (1788–1861), written in 1836 and giving details about Géricault's work on the *Medusa,* some of which Clément later used for his book. On Géricault's models for the *Medusa,* see Clément, *op. cit.,* pp. 143, 300.

of the "Father"; Dastier, an officer, for the man who attempts to raise himself at the far right; another friend, Martigny, served for the shrouded cadaver at the lower right of the picture, one of the two figures which Géricault added by way of afterthought after the completion of the rest. Eugène Delacroix, then still a pupil in Guérin's studio, modelled the figure of the young man who lies on his face, his left arm thrown forward, next to the group of the "Father". Géricault also used several professionals, the inevitable Cadamour, who lent his athletic body to the "Father", the famous black model Joseph, who seems to have posed for all three Negroes of the *Raft,* and a model named Gerfand, who served him for the cadaver lying on its back at the extreme left, the other of the two final insertions into the composition.

Painting almost without interruption from daybreak to dusk, he finished the enormous canvas in the relatively short time of eight months. By July 1819, in good time for the exhibition, the *Raft of the Medusa* was ready to be transported to the Salon.[19]

Several of the friends who came to his studio during these months later described what they remembered of his manner of work.[20] Their recollections show that he followed a method which David had introduced among French artists, and which Géricault may have learned from his former teacher, Pierre Guérin. He began by transferring the composition to the canvas, producing a huge contour drawing, some sixteen feet tall and twenty-four feet wide. Its appearance can be inferred from the unfinished portions of the oil study in the Louvre (Plate 21) in which the underdrawing is preserved; but on the much larger final canvas the lines bordering the figures, now enlarged to more than life size, must have looked rather sparse and thin. Into the nakedness of this schematic design, he then proceeded to paint the appearance of flesh and cloth, the illusion of body, light, and air. The break between compositional invention and pictorial realization was extremely abrupt. With the concept of the composition in his mind and a contour drawing of it on his canvas, he went on directly to execute the figures from the life. He posed his models singly, placing each in the proper light and the exact position prescribed by the design. Then he painted their bodies, one after the other, into the contours of the huge drawing on his canvas. As the work went forward, the figures sprang into relief on the blank surface one by one (cf. Plate 69), giving to the partly finished canvas the appearance of a white wall hung with fragments of sculpture.[21]

The difficulties of this procedure were formidable. It called for the synthesis of stylized design and nature study in the very act of final execution, and it required that a mosaic of separate life studies be fused into a coherent image. The physical reality of the gesticulating model had to be reconciled with the general form of the imagined composition, a patchwork of figures, painted in the course of many months, posed by a succession of models, in the changing light of winter, spring, and summer, on good days and bad, had to be welded together in such a way as to express the unity of a dramatic action in its encompassing space, light, and atmosphere. The disadvantage of Géricault's method was

[19] Clément, *op. cit.,* pp. 143-144.

[20] Cf. the observations of Lebrun, Tourneux, *op. cit.,* pp. 60 ff. and Clément, *op. cit.,* p. 135; Montfort's account, *ibid,* pp. 138 ff., and Jamar's description of Géricault's palette, *ibid,* p. 141, note 2.

[21] Géricault's earliest biographer, Louis Batissier, writing in 1842, took pains to point to the "eccentricity" of the execution of the *Medusa*: "*Nous dirons encore qu'il ne commençait pas par couvrir toute sa toile, comme la plupart des*

peintres, pour faire une grande esquisse dont il aurait repris chaque partie en sous-œuvre. Il choisissait, au contraire, une tête, une figure entière, et la peignait sans s'inquiéter du reste du tableau, jusqu'à ce qu'elle fût achevée. Cette manière excentrique de procéder n'empêche pas cependant qu'il ne règne une heureuse harmonie dans l'ensemble de sa composition". (Quoted by P. Courthion, *Géricault raconté par lui-même et par ses amis,* Vésenaz-Geneva, 1947, p. 44).

its extreme artificiality, its disaccord with the psychology of artistic work. By placing tedious obstacles between the idea and its realization, between the original, vivifying emotion and the piecemeal execution, it was bound to cool the ardour of the most inspired artist. In Géricault's case, the difficulty was compounded by the fact that he was attempting to treat a modern subject with a degree of realism. To evoke past history or to illustrate myth in a work of obvious artificiality was one thing, to treat a contemporary event in this way was quite another. The programme which he had set himself, and his own temperament, prevented him from making a virtue of stylistic artifice. The only way open to him was to try to embrace reality with such passion, to give it such powerful appeal and drama, as to conceal the contrivance which underlay his picture.

All who saw Géricault at work during these months were struck by his concentration. *"His manner of working was quite new to me,"* reported Montfort, *"it astonished me as much as his intense industry. He painted directly on the white canvas, without rough sketch or preparation of any sort, except for the firmly traced contours, and yet the solidity of the work was none the worse for it. I was struck by the keen attention with which he examined the model before touching brush to canvas. He seemed to proceed slowly, when in reality he executed very rapidly, placing one touch after the other in its place, rarely having to go over his work more than once. There was very little perceptible motion of the body or the arms. His expression was perfectly calm; only a slight flushing of the face betrayed his mental concentration. Witnessing this external calm, one was all the more surprised by the verve and energy of his execution. What salience! Especially in their half-finished state, the various parts of the picture had the look of roughly blocked-out sculpture* [Plate 69]. *Seeing the breadth of his manner, one might suppose that Géricault used very thick brushes, but this was not at all the case. His brushes were small, compared to those which I had seen used by other artists of my acquaintance. This can easily be verified by an examination of several of the figures in the picture which are executed entirely in hatchings."*[22] The speed and assurance of Géricault's work impressed all his visitors. His friend Lebrun, who had come to sit for him, once found him in the process of painting a head from memory: *"I saw him improvise, with the vivacity that was peculiar to him, that beautiful head of hair which belongs to a recumbent figure in the middle of the picture* [Plate 22]. *Dissatisfied with the one he had painted first, he scratched it out and repainted it in less than half an hour. I looked at his face while he worked. He said not a word and seemed totally absorbed. It seemed as if he were copying an actual head of hair. When he was done with it, he never touched it again."*[23]

Young Montfort, accustomed to the tumultuous vivacity of his master, Horace Vernet, was particularly struck, and perhaps made a little uncomfortable, by the fanatical seriousness with which Géricault pursued his work: *"Fortunate enough to have been admitted to Géricault's studio, to copy a few sketches, at the time when he was executing his picture, I was impressed, first of all, by the intensity with which he worked, and also by the quiet and reflection which he needed. He generally started work as soon as there was enough light and continued without interruption until nightfall. What forced him to work in this way was usually the size of the piece which, started in the morning, had to be finished the same day. This necessity arose from his use of heavy, extremely fast-drying oils which made it impossible for him to continue on the morrow what he had begun the previous day ... I was vividly impressed by the care with which Géricault worked. Being still quite young (I was only seventeen), I had trouble keeping still for several hours on end, without getting up and, accidentally, making a little noise with my chair. In the midst of the absolute silence which reigned in the studio, I would sense that this slight noise had disturbed Géricault. Turning my eyes toward the table on which he had mounted to reach the full*

[22] Clément, *op. cit.*, p. 140. [23] *Ibid*, p. 135, and Tourneux, *op. cit.*, p. 63.

height of his figures and on which he worked without uttering a word, I would see him smile at me with a slight expression of reproach. He assured me that the noise of a mouse was enough to stop him from working."[24]

In the confinement of the studio, the unfinished picture made a powerful impression on all who saw it. The enormity and sculptural bulk of the fragmentary figures springing from the naked canvas gave it a terrifying impact. Delacroix retained a life-long memory of his emotion on first seeing the uncompleted *Medusa*: "*The impression it gave me was so strong*", he wrote in 1855, "*that as I left the studio I broke into a run, and kept running like a fool all the way back to the rue de la Planche where I lived then, at the far end of the faubourg Saint-Germain.*"[25]

The speed and intensity of his work put Géricault under a heavy strain. The price he paid for it was lassitude, occasional discouragement and, in the end, exhaustion.

"*When evening came*", Montfort recalled, "*Géricault abandoned his palette and took advantage of the last rays of light to contemplate his work. It was then that, seated by the stove, his eyes turned to the picture, he spoke to us of his hopes and his disappointments. Usually, he was very little satisfied, but on some days he thought that he had found the proper way of modelling, that is, of giving relief to his figures, and seemed pleased. The following day, after a day of work equally well spent, he would confess to us that he was not on the right track and would have to make a fresh effort. One day, he had gone to see the* Sabines *and the* Leonidas. *He came back discouraged. What he was doing now seemed clumsy to him, and, referring to the young warriors, on the right side of the* Leonidas, *who rush forward to get their shields, he said to me: 'Ah, well! Those are tremendous figures!'—and he averted his eyes from his picture.*"[26]

Studies

Géricault's piecemeal execution of the *Raft* had been foreshadowed in the work's earlier stages by his practice of building the composition, figure by figure, as a composite of separate parts. From the beginning, he had given nearly as much attention to the development of each of his main figures as to the development of the composition in its totality. Groups of figure sketches cluster about each of the successive compositional designs. Several of the main figures went through a long process of changes and adjustments (Plates 31 ff., cat. 38 ff.). The preserved figure drawings not only form the largest body of studies associated with the project, they are also among the most revealing documents of Géricault's gradually unfolding purpose. They offer insights into aspects of his practice, his stylistic conceptions and thematic intentions which remain hidden in the final work.

The purpose of the sketches which accompanied the early compositional designs was to define postures and placements, to settle main contours and determine broad areas of light and shadow. He drew them from the imagination, rather than from life, nearly always in ink, improvising them in a very characteristic, rugged shorthand which, for all its spontaneity, is remarkably precise. Taut strokes of the pen shape the musculature of the bodies, dense hatchings or dashes of ink-wash give them relief.

The more highly finished figure studies from life, on the other hand, belong for the most part to a later stage of the work (Plates 44, 46, 50, 63, 70, 77). They reflect a composition already determined in its essentials; some of them were probably drawn during the final execution of the *Raft*. For these

[24] Clément, *op. cit.*, pp. 138 ff. [25] Quoted in L. Véron, *Mémoires d'un bourgeois de Paris*, I, Paris, 1856, p. 271.
[26] Clément, *op. cit.*, p. 142.

careful studies, Géricault preferred the softer tonal media of pencil, crayon, and black chalk. Their rather cautious technique lacks the energetic conciseness of the earlier, constructive sketches. It expresses, instead, Géricault's concern with effects of light, colour, and texture during his work on the large canvas. When, as occasionally happens, a single sheet contains drawings of the same figure in each of the two different manners (Plate 49), the contrast between them is very striking. The expressive vigour and linear abstraction in the conceptual sketches and the refined tonality and realism of surface in the studies from life represent the divergent qualities of style which Géricault tried to unite in the final execution of the painting.

While many figure drawings for the *Raft* have survived, painted figure studies for it are conspicuously rare (Plates 71, 79, 83). This probably indicates that Géricault painted few such studies and trusted his ability to achieve the synthesis of compositional design and model study during the actual execution of the large canvas, unaided by preparatory paintings from life. He did, however, paint several portraits in oil of the men who, for the sake of historical accuracy, were to figure in his picture. All of these portraits are simple heads or busts, not studies of attitudes or expressions, and were evidently meant to serve him merely as documents of the features of personages whom he planned to include in his composition in quite different poses (Plates 102–104).

As he became more and more deeply absorbed by the management of pictorial problems, Géricault tried not to lose sight of the basic significance of his picture. He had begun his work with an attempt to come as close as possible to having a concrete experience of the event which was his subject, in order to be able to give it convincing visual expression. As the work went on, he put his "dossier of authentic proofs" aside and, pressed by artistic necessity, took large liberties with historical facts. He had probably never intended to show the Raft and the men on it as they actually appeared at the time of the rescue: the Raft littered with strips of dried human flesh, the men emaciated, with matted hair and tangled beards, their bodies covered with wounds. Contemporary prints, which he probably knew well, represented the Raft in this way (fig. M), but at no point in the progress of his work did he imitate their literalism. From first to last, he gave his figures, the living and the dead, the appearance of athletes in vigorous health. His concern with the reality of the event centred throughout on what he regarded as its essential drama, not on its precise aspect. To treat the scene in its detail of rags, wounds, and haggard flesh would have meant giving it a picturesqueness which was not at all part of his plan—he wanted to paint history, not inflated genre. His own experience and Vernet's bad example had taught him, if ever he needed the lesson, that a canvas measuring sixteen feet by twenty-four feet must not be conceived as the enlargement of a lithograph. In avoiding crass and detailed realism, he acted not from a timid sense of propriety, but from a painter's knowledge of what could be done in a picture of monumental size. The special difficulty which he faced in the *Medusa* was to express the human reality of his subject, its content of terror, anguish, and tension, despite the formal restraint which the dimensions of his picture demanded.

To achieve this more fundamental realism, he had to make an effort to keep alive his original, vivid sense of the event and to maintain in himself the emotional tension under which he had begun his work. He must have found it difficult not to become dulled by the months of imprisonment in the solitude and artificiality of the studio, deflected from his main interest by a multitude of formal problems. The sheer weight of his enterprise threatened to extinguish the emotions needed to drive it forward. To refresh his imagination, perhaps also to find an outlet for observations which he could

not incorporate in his picture, he drew and painted many studies from life (Plates 99 ff., cat. 98 ff.). Not meant to be of immediate practical use, they accompanied his work as a stimulation and relief.

The most astonishing among them are the portraits of dying patients, painted at the Hôpital Beaujon (Plates 80–2, cat. 81–3), and the still-lifes of dissected limbs and severed heads, painted in his own studio (Plates 85–98, cat. 86–97), where for a time he kept these human fragments to observe and record their gradual decay.[27] He did not introduce any of these studies into his picture. All the figures of the *Raft*, even the cadavers, were painted from living models.[28] The interest in the intimate aspect of death which these works express went considerably beyond ordinary nature study. Pictorial realism alone did not require him to turn his studio into a morgue, as he did for some weeks, much to the discomfort of his friends and models. But from this exposure to death he may have hoped to gain insight that would help him to give a special authenticity to his work. If his picture was to carry conviction, it had to express genuine experience. Without making himself a cannibal, he familiarized himself with the sights and smells of death, and tried to live with it day by day, as had the men on the Raft. His preoccupation with the cadaverous expressed an effort to seize the reality of his subject, but it also contained an element of the aesthetic. His friend Lebrun, who had retired to the village of Sèvres to recover from an attack of jaundice which had so disfigured him that he terrified passers-by in the street, was met one day by Géricault, who greeted him with the cry: *"How beautiful you are!"* and pressed him to pose for a portrait. It was the year of the *Medusa*, and Lebrun understood that he *"did seem beautiful to this painter who was searching everywhere for the colour of the dying"*.[29]

Some of the studies which resulted from this preoccupation, the two "guillotined" heads in Stockholm (Plate 87, cat. 88), the head in the Dubaut collection (Plate 88, cat. 89), and the still-life consisting of severed arms and legs, in Montpellier (Plate 92, cat. 92), have a pictorial beauty which raises them above most of the other studies and portraits for the *Medusa*. It is impossible not to be chilled by the frankness with which they show an aspect of death usually hidden, but the most lasting effect which they leave with the beholder is an admiration of Géricault's steadiness of heart and eye in the face of an almost unbearable reality. To Delacroix, who saw several of these studies and remembered them all his life, they seemed *"truly sublime"* and *"the best argument for Beauty as it ought to be understood"*, because they demonstrated the power of art to transfigure what was odious and monstrous in nature.[30] Though his emotions were stirred by these macabre objects, Géricault painted them in an objective spirit, without a touch of graveyard horror, adding nothing from fantasy, and betraying his feelings only in the nervous intensity and heightened sensuousness of his handling.

Something of this quality also entered into the execution of the large painting, but only the studies, in a fresher state than the badly damaged *Medusa*, now give a full idea of the richness of Géricault's palette at that time (Plates 88, 92). The heads and limbs in them, about the size of life, are modelled by small, closely blended strokes, while the draperies and backgrounds are very broadly brushed. The marks of the brush follow the surfaces of skin with searching intensity, probing the hollows of cheeks, rounding the bony ridges of noses and foreheads, and giving the flesh a sense of matter beside

[27] Batissier, *op. cit.,* p. 42, Clément, *op. cit.,* p. 131.

[28] The single exception may be the cadaver at the extreme left, for which Géricault may have used one or the other of his studies of severed heads, cf. Clément, *op. cit.,* p. 131, note 1.

[29] Tourneux, *op. cit.,* p. 61, Clément, *op. cit.,* p. 132.

[30] Cf. the Journal entries for 13 January and 5 March 1857 (A. Joubin, *Journal d'Eugène Delacroix,* III, Paris, 1932, pp. 24, 70, 71).

which the stock figures of the Davidian school seem like tinted ghosts. A sharp illumination accentuates the relief. Several of the studies were painted by candle-light. The colours are toned to a dark harmony in which the brownish olive of dead skin is the dominant hue, but which also contains passages of deep brown, of blue-black in the shadows, streaks of glaring white in the draperies, and gashes of red in the bloodied cuts. The surfaces are rendered with the closest attention to the effects of sagging, unresilient skin and of humid gloss where skin is stretched over bone.

Looking at these studies, in which Géricault's realism reaches its extreme, and comparing them with the drawings in which he projected his composition, one realizes how wide was the gap between the compositional planning and the pictorial realization of the *Medusa*. The closing of this gap had to be accomplished in the final execution of his canvas, for it was only in this last phase of the work that Géricault addressed himself to the synthesis of stylized design and realistic life study. The outcome was necessarily a compromise. When it came to the final act of painting, he had to modify both the calculated abstraction of his compositional designs and the direct realism of his life studies. The figures of the *Medusa* in its final state are of a broader, more generalized execution than the studies; the colours are laid on in larger areas, the modelling is simpler, the illumination more artificial. Géricault's occupation with life study, nevertheless, has left its mark on the work. The hard specificity of its figures sets them apart from the elegant stereotypes which fill most of the monumental paintings of the time, even those of Gros which otherwise most closely anticipate the *Medusa*.

Completion

The *Medusa,* in mid-course of execution, was a gathering of superbly painted *morceaux,* vivid fragments set side by side on the white canvas. There came a moment, probably fairly late, after the completion of most of the figures, when Géricault had to direct his main effort to the integration of these separate parts into a coherent whole. He sought to achieve this by binding the figures to a common dark ground, making their saliences appear to be emerging from the depth of an enveloping darkness, or causing their contours to be silhouetted against patches of bright illumination. This meant that he had to introduce pockets of deep shadow among them. The modelled bodies, themselves painted in fairly sombre tones, required an even darker ground to set them off. Géricault was forced to use shadows of extraordinary blackness to suggest the recessions between the figures, and this, in turn, led him to darken the entire picture more than he had originally intended, as is suggested by the lighter tonality of the late oil study for the composition. In his effort to obtain the most intense black possible, he lavishly used bitumen, which gave him a very satisfactory, glossy, raven black, but which also (being chemically unstable) set in motion the slow, irreparable decay of portions of the paint surface.

While welding his figures together, Géricault painted the *Medusa*'s setting of sea and sky. The wide panorama of early-morning sky, with clouds dispersing in the premonitory light (figs. FF, II), is a very considerable feat of landscape painting, not by virtue of its size alone, for which he prepared himself by taking a trip to the seaside at Le Havre.[31] No less than the individual figures, this sky is a "life study" which had to be integrated with the main composition. And its integration was especially difficult, since the diffuse luminosity of morning light could not well be reconciled with the hard

[31] Clément, *op. cit.,* p. 137.

studio light unmistakably reflected in the figures. The reduction of the margins of sky and water lessened, but could not entirely overcome this trouble. There remained a disharmony between the luminosity above the horizon and the cellar light on the figures below; the Raft and its sky represent two different realities (figs. FF, KK).

Géricault must have foreseen and intended the patchy scattering of lights and shadows which his manner of execution brought into the composition. Some of his early wash drawings already had anticipated its effect (Plate 15). One purpose of this unquiet tenebrism was to blur the distinctness of the individual figures, to draw them together and set them in motion. As the light grazes the mass of the Raft, it lifts from the shadows the contours of raised arms, the relief of straining backs and shoulders. Leaping from figure to figure, it underlines the direction of their gestures and gives them a common momentum. But, in the heat of execution, Géricault may have overshot his aim. The chiaroscuro, even making allowance for the subsequent darkening of the colours, is excessively heavy, and yet not quite sufficient to overcome the immobility and separateness of the individual figures. When he was shown a copy of the *Medusa* on his death-bed, in 1824, Géricault anxiously asked one of his friends: *"Is my picture really spotted with black and white like that?"* and was much distressed to have his question answered in the affirmative.[32]

The picture was finished sometime during July of 1819. Before moving it from the studio, Géricault asked his former teacher, Pierre Guérin, to inspect the *Raft*. Guérin came, stayed for more than an hour, praised parts of the composition, criticized others, and spoke at length about "the line". He did not seem dissatisfied. Géricault, *"a respectful rather than submissive pupil"*, listened with attention, and at the end of the visit took ceremonious leave of Guérin. When the master had gone, he danced about the studio, still holding palette and staff. To his assistant, Jamar, who tried to raise objections to Guérin's remarks, he said: *"Jamar, I am to him what you are to me: he is my master and I am his apprentice"*. Guérin had spoken wisely, he insisted, and he would try to profit from his observations.[33]

On seeing his picture outside the studio for the first time, in the foyer of the Théatre Italien where the paintings for the Salon were being assembled, Géricault suddenly became aware of two enormous gaps in his composition. Carried away by the momentum of his design, he had concentrated his attention on the upward sweep of his figures, raised his figure pyramid ever higher, but neglected to adjust its base to this rise. Looking at his picture with fresh detachment, in a new light and different setting, he became aware that he must widen and strengthen the groups of the foreground. With extraordinary speed, if Clément's account is to be credited,[34] he improvised two further bodies, the one at the far left, the other at the lower right of the immediate foreground, bringing the number of figures on the Raft from eighteen to twenty (Plate 22). In performing this feat, he was able to fall back on figure motifs which he had developed earlier and which he now inserted into the composition with only minor modifications. For the cadaver at the left (figs. Y, JJ), he used studies originally made for the figure of the "Son", simply reversing them to suit his new purpose. In composing the half-shrouded cadaver trailing at the right (fig. II), he remembered the figure which he had used in the same place in the scene of *Cannibalism* (Plate 8). As he added these figures, he may also have made several rapid alterations of which traces are visible in the lower part of the canvas. He extended the left leg of the "Son" into the foreground and shifted the position of the Raft's two large beams

[32] Clément, *op. cit.*, pp. 172–173. [33] *Ibidem*, p. 144. [34] *Ibidem*, pp. 126, 144.

which converge in the form of a "V" toward the picture's lower edge. All these final additions and changes tended to increase the weight and proximity of the foreground, and to counteract the oblique rise of the figures above.

After more than eighteen months of constant work, the *Raft of the Medusa* was ready for the exhibition.

THE WORK ACCOMPLISHED

Perspective

AT the installation of the Salon, Géricault was given the privilege of selecting a place for his picture. He asked to have it hung in the Salon Carré, the most prestigious of the galleries, in a position of prominence, above the tall door leading to the Grande Galerie (fig. A). It is hard to understand how he could have made this mistake. By raising the picture high above eye-level, he defeated its composition, calculated as it was to make the viewer feel as one of the men on the Raft. Géricault anxiously watched as the huge picture was being hoisted into position. His *"chagrin and regret"* were keen, he later said, when he found that the higher his picture rose on the wall, the more its figures seemed to lose scale and impact until, in the end, they seemed nothing more than *"petits bons-hommes"*. He realized his error only when it was too late to make a change, an odd reflection on the slowness of his perceptions.[1] The painting, wrongly hung, disappointed all who had seen it properly, at close range and near eye-level, in Géricault's cramped studio. The impression on the public and the critics was bad, according to Clément, and *"the enemies of the young reformer triumphed"*. During a general re-hanging, midway in the course of the exhibition, his good friend Dorcy managed to have the picture correctly placed, *"à hauteur d'appui"*, i.e. as low as possible.[2] Delacroix, reporting the change to his friend Guillemardet, wrote of it jokingly, but with insight: *"On a descendu le tableau des Naufragés et on les voit de plein pied, pour ainsi dire. De sorte qu'on se croit déjà un pied dans l'eau. Il faut l'avoir vu d'assez près, pour en sentir tout le mérite".*[3] The incident underlined the fact that, despite its large size, the *Raft of the Medusa* is an easel painting which yields its full effect only to the intimate viewer.

Colour

From its height above the entrance to the Grande Galerie, the *Medusa* struck most visitors to the Salon as excessively sombre and monochrome. Nearly all critics, the friendly and the hostile, noted its lack of colour, its earthen drabness, its monotony of bistre and bitumen, defects the more conspicuous in a Salon of unprecedented brightness. *"Never before"*, wrote a reviewer, *"has this public exhibition been so brilliantly illuminated, never before has the French School so impressively revealed the quality of its colour."*[4]

Reproached by his friends for the darkness of his picture, Géricault declared: *"If I had to start it*

[1] Clément, *op. cit.,* pp. 147 ff. Géricault's earliest biographer, Louis Batissier, writing in 1842, probably on the basis of information furnished by Géricault's friend, Dedreux-Dorcy, gives a vivid account of the hanging of the *Medusa*: *"[Géricault] entre dans le salon carré, il cherche, pour ainsi dire, sa toile, et il l'aperçoit accrochée, tout en haut, au-dessus de la porte de la longue galerie. Ainsi placée, la* Scène du Naufrage *était presque un tableau insignifiant. La perspective de la composition ne pouvait être saisie: tout semblait confus: Géricault ne reconnaît pas son œuvre. Un éclair de désespoir brille dans ses yeux: il se frappe le front, comme un homme atteint par un cruel désenchantement. Il quitte le Louvre et va cacher ses*

chagrins à Versailles, protestant de l'intention où il était de renoncer à la peinture." (Pierre Courthion, *Géricault raconté par lui-même et par ses amis,* Vésenaz-Geneva, 1947, pp. 45 ff.).

[2] Clément, *op. cit.,* pp. 147–148.

[3] Letter to Felix Guillemardet, 2 November 1819, in A. Dupont (ed.), *Eugène Delacroix, Lettres intimes,* Paris, 1954, p. 105.

[4] *Journal de Paris,* 26 August 1819. An excellent digest of press reviews of the *Medusa* is to be found in D. Aimé-Azam, *Mazeppa, Géricault et son temps,* Paris, 1956, pp. 195 ff.

all over again, I would change absolutely nothing about that!"[5] and *"The more black there is in a picture, the better it is".*[6]

In its present state, the *Medusa* is a partial ruin.[7] Bituminous paints, which Géricault used to deepen the shadows, have dulled its surface and darkened its colours. The first impression it gives is one of brownish darkness, shot through with lighter patches of yellowish or greenish hue. Yet the picture does not lack colour.[8] The actual richness which makes up its sombre harmony becomes apparent only when the eye has adjusted to the abrupt play of light and shadow, and has learned to make allowance for the damage which the decaying bitumen has produced in its surface. Géricault, in composing the colours of his picture, almost as carefully as he had composed its figures, tuned them to an accord of three main hues—a muted green changing to blue, a brown with accents of red and orange, and a complex grey, which fluctuates between shades of liver, slate and yellow. He massed these colours in three concentric zones: a margin of blues and greens defines the sky and sea; it encloses the darker brown of sail and timbers which, in turn, serves as a foil to the greyish relief of the figures. Between these zones there are many exchanges and reflections of colour.

The brightest light falls from a patch of sky at the upper left of the picture. Its luminous blue is shot through with faint yellow. A touch of rose along the edges of the cloud near the top of the sail announces the imminent rise of the sun from behind a mass of clouds, through which it has begun to send a dark orange glow. Behind the Raft, at the left, rises an enormous wave, glassily transparent at the crest, its base a chasm of deepest green. Set against wave and sky, the Raft's sail has the colour of tanned leather, yellowish on the side of the light, a warm brown in the faintly translucent shadows. Farther to the right, the sky casts its strongest light, yellow mixed with silvery blue, over the dark figures at the mast; farther still, the sky turns to a bluish grey. The bronze torso of the signalling Negro jutting into the sky divides its areas of light and dark, his solid bulk causes the air spaces around him to recede into a vapoury distance. No less solid than this figure, the flank of a wave, bottle-green and veined with white, swells against the right edge of the picture.

The wooden platform of the Raft emerges, on the left, from the darker green of the waves and juts, at the right, as a dark silhouette into the fresh green of the light-struck water. The planks brighten to a flat beige where the light touches them and are streaked with black and green in the shadows. White foam washes about the beams in the foreground, emphasizing the dark solidity of these timbers. The figures which crowd the Raft seem oddly drained of body colour. Where the light strikes their flesh or their clothing it turns them a lustreless grey, rising to greenish yellow in the brighter parts and declining into pearly blue-greys or dark tans toward the shadows. The shadows themselves

[5] Clément, *op. cit.*, p. 172.
[6] According to an account by the painter Henner, reported by R. Regamey (*Géricault*, Paris, 1926, p. 24).
[7] The canvas of the *Medusa* underwent cleaning and restoration during 1949. Despite this, the heavy darkening of large areas of the picture, and the disappearance of some colours in the bituminous underpainting which Géricault used to deepen his shadows, is still, and will always remain, very apparent. The first signs of deterioration seem to have become noticeable at an early date (cf. Clément, *op. cit.*, p. 139). In 1860, a full-scale copy of the picture was made, by order of the authorities of the Louvre, because the original at that time appeared to be so "sick", as the

official report has it, that it was feared that it could not be preserved (cf. G. Oprescu, *Géricault*, Paris, 1927, p. 127).
[8] Clément obtained from Géricault's assistant, Jamar, a list of the colours used by Géricault, in the order in which they were arranged on his palette (*op. cit.*, p. 141, note 2): vermilion, white, Naples yellow, yellow ochre, *terre d'Italie* (presumably a red ochre), *ocre de Brie* (presumably a yellow or red ochre), raw Sienna, light red, burnt Sienna, crimson lake, Prussian blue, peach black, ivory black, Cassel earth, bitumen (asphaltum). He adds the quite characteristic touch: *"Il travaillait avec une très-grande propreté, gardant les tons séparés sur la palette, qui le soir paraissait à peine avoir servi".*

deepen into a very dark brown, and in some areas, as in the group of men standing at the mast, into pure black. To this ashen monochromy, the bodies of the Negroes contribute more positive colours. Géricault, curiously, differentiated their complexions, giving the Negro who lies at the foot of the barrel a charcoal-grey skin, in marked contrast to the warm bronze of the signalling Negro, who stands above him. Géricault also scattered touches of red among the figures—red in the head cloth of the "Father", red in the drapery of the crouching man next to him, in the sash which the man raising himself at the right wears round his waist, and in the cloth which the Negro waves—but these touches accentuate, rather than relieve, the pervading greyness. There is something perverse in the ingenuity with which Géricault has used colour to defeat colour in achieving the sombre austerity for which he aimed.

The muted colours in all the bodies which receive direct light give a strange pallor to the light itself. There is an effect of double lighting, literally of twilight, in the picture. The warmer and more diffuse light of the morning sun, which irradiates the sky and strikes the sail, is not the same as the sharper, colder light which falls at a slant across the figures of the Raft. This second light gives substance to the composition; without it, the Raft and its figures would appear as a dark silhouette against the brightening sky. Limited to the Raft, it is not a natural light but a pictorial artifice, needed to give relief to the figures and to make them cohere in an animated group. But the artifice of his illumination also helped Géricault to set the expressive momentum of his figures against a resistant mass. The patches of light hold the life of the composition, the shadows around them the weight of matter.

Expression

The *Medusa*'s composition puzzled visitors to the Salon as much as its colour. But while condemnation of the picture's blackness and monochromy was fairly unanimous, opinion was divided, and rather confused, about its composition. Some critics dismissed it as a mere jumble of figures, others blamed it for being too obviously pyramidal,[9] others again admired its boldness and power. Its lack of a "centre", of a "main action" or "general expression", filled many reviewers with unease.[10] They recognized that Géricault had departed from usage, and reacted to this in various ways, blaming or praising, but his intention escaped them. There is no indication that anyone at the time understood the reasons for the picture's strangeness, though its impact was strongly felt even by those determined to hate it. *"Tableau, que me veux-tu?"* exclaimed one critic in irritated fascination, having searched the picture in vain for episodes to his liking—the expected stereotypes of fear, pain, regret, ingratitude, hope, despair—and found nothing but the troubling sight of *"men jostled between life and death"*.[11]

The difficulty of the work lay in the unprecedented directness of its attack on the viewer's feelings, in its by-passing of familiar guides to comprehension. Géricault, in developing his subject, had gradually turned from the spectacle to the inward experience of the shipwrecked men's suffering, and had attempted to give direct expression to this experience by the very structure of his composition. Purged of episodic detail, all figures fused in a single action, all forms converging in one large design, the picture in its final form could no longer be read as a reconstruction of the event or as a dramatic

[9] Cf. *Revue Encyclopédique*, IV, 1819, p. 527.
[10] Cf. *L'Indépendant*, 29 August 1819; *La gazette de France*, 31 August 1819; C. Landon, *Annales du Musée, Salon de 1819*, Paris, 1819, pp. 65 ff.
[11] Gault de Saint-Germain, *Choix des productions de l'art les plus remarquables exposés au Salon de 1819*, quoted by D. Aimé-Azam, *op. cit.*, p. 209.

narrative. It demanded an act of empathy, not with the individual gestures of its figures, but with its general configuration, with the contrasts and stresses of its whole structure.

A frieze of colossal bodies fills the foreground, four cadavers sprawling like fallen giants on the planks, watched over by the "Father" and the shadow-covered man who crouches beside him. These six figures form the base from which the composition rises. They are also the only ones which confront the viewer, oppressing him by their nearness and superhuman size, blocking his way, yet compelling him, by the turn of their bodies and the direction of their limbs, to enter the Raft. From the dense shadow of the tent, which hides two figures in attitudes of despair, emerges the rising chain of straining and reaching men, their bodies lifted from the shadows by a raking beam of light (fig. GG). This central surge combines and directs all the vital motion in the composition along one strong diagonal, which traverses the picture from the mourning "Father" in the depths to the Negro atop the barrel who waves his cloth at the distant *Argus*. From the group of men near the mast, an arm is thrust toward the rescue ship, as if in support of the Negro's signal (figs. KK, LL). The gesture is echoed by the raised arm of the man, at the extreme right, who struggles to free himself from the weight of a cadaver which has fallen across his legs; his gesture seems to sum up what the scene as a whole suggests—life trying to rise from the heaviness of death (figs. FF, HH).

The radical dynamism and asymmetry of the composition is without close parallel in the history-painting of the period. Contrary to the usage of the School of David, it thrusts all the figures which have motion into a single direction. Even Gros, in his most violent battle pieces, had always treated dramatic action as a balanced confrontation, in which the movement of one mass was countered by that of another, and in which, in the final effect, all stresses were resolved within an encompassing harmony. In the *Medusa*, by contrast, a powerful surge of figures meets with no visible riposte, a formidable discharge of energy is seemingly spent in a void. The *Medusa* offers the unaccustomed spectacle of a dramatic action without an obvious antagonist and without resolution, an effect which contemporaries found difficult to reconcile with their notions of history painting, but which was not without precedent in earlier monumental art. The dramatic character of the scene, in fact, is that of a resurrection, with its pantomime of awakening, gradual animation, and compulsive ascent. It has an unmistakable resemblance to pictures of the Last Judgement, to those portions of them, at any rate, which show the rise of the dead from their graves (Plate 22).

The drama of the *Medusa* arises from conflicts and contrasts which are implied rather than directly represented. Three strong currents of tension run through the composition. The viewer experiences them as forces opposing the effort of the men on the Raft. The weight of the cadavers and passive mourners in the foreground, whose bodies Géricault has enlarged out of proportion to the men struggling behind them, holds back the surge of signalling figures. Their rise against this pull of gravity seems like a doomed attempt to fly: nature, in its most elemental manifestation, inert matter, defeats the human effort. The overwhelming nearness of the crowded Raft makes the rescue ship on the horizon seem distant beyond reach. To the eye which follows the movement of the figures, the sail of the *Argus* appears to be dwindling: nature, in its vastness, intervenes between the men and their salvation. The ascent of the reaching and signalling men is crossed, in its middle, by the descending lines of sail, mast, and rope which end in the corpse at the lower right. The intersection of these diagonals describes an enormous "X" which spreads its arms into the four corners of the picture. It is as powerful a sign of conflict as can be imagined, and not likely to have been used unconsciously

by Géricault. The fatal line which crosses the attempt of the shipwrecked to rise from death expresses a natural force. The hostile wind which swells its sail drives the Raft into the darkness of the wave behind it: nature sends the men to their destruction.

"The picture . . . falls far short of the well-known account of the shipwreck", declared the critic of the ultra-royalist *Drapeau blanc*.[12] When he chose the Sighting of the *Argus* as his subject, Géricault had in fact passed over episodes much more gory or pathetic, and therefore more likely to interest the public of the Salon. The passage in the book by Corréard and Savigny which he took as his text is comparatively meagre in its visual suggestion: *". . . in the morning, the sun appeared entirely free from clouds . . . a captain of infantry, looking toward the horizon, descried a ship, and announced it to us by an exclamation of joy: we perceived it was a brig; but it was at a very great distance; we could distinguish only the tops of the masts. The sight of this vessel excited us to transports of joy . . . we gave a thousand thanks to God; yet fears mingled with our hopes: we straightened some hoops of casks, to the ends of which we tied handkerchiefs of different colours. A man, assisted by us all together, mounted to the top of the mast and waved these little flags. For about half an hour we were suspended between hope and fear; some thought they saw the ship become larger, and others affirmed that its course carried it from us . . . the brig disappeared. From the delirium of joy, we fell into profound despondency."*[13] (cf. fig. M).

Géricault took from this passage the suggestion of morning, the horizon, the very distant brig, the straightened hoops and coloured handkerchiefs, the common effort of the men to assist the signaller; he omitted the initial discovery of the brig, the transports of joy, the thanks to God, the sailor at the top of the mast. He chose to interpret the scene as one of physical effort, something which the text by no means required him to do. On the contrary: as described by Corréard and Savigny, the Sighting of the *Argus* is a moment of psychological suspense. Other painters would have been tempted to dwell on the "mingled hope and fear" in faces and gestures. Géricault turned all his most active figures into back view, hid their faces, showed their straining muscles, and merged their individualities in one movement. His composition does not invite contemplation, but participation. It yields its meaning to the viewer who, identifying himself with the shipwrecked, experiences with his muscles as much as through his eyes what the picture does not simply represent—the force against which the men on the Raft spend their energy. Géricault has succeeded in representing a struggle of men against the elements by rendering one side of the conflict. He has expressed the might and vastness of nature in a painting filled with human bodies. He has generalized his subject, removed from it much of its topicality and interest for contemporary viewers, and given it a larger significance.

Borrowings and Echoes

The only figures which are not wholly caught up in the general drama, but seem to be absorbed in a particular sorrow, are the ones usually described as the "Father" and his dead, or dying, "Son" (fig. Y). There is no clear authority for this motif in the historical account of the shipwreck.[14] To Géricault it was evidently of great importance. He first used it in the scene of *Cannibalism* (Plate 8) and later adapted it to the scene of the *Sighting,* of which it became the first, fully developed part. It is the lone vestige, in the *Medusa's* final version, of his earlier, more narrative conception of the

[12] *Le drapeau blanc,* 28 August 1819. [13] J. B. Henri Savigny and Alexandre Corréard, *Naufrage de la frégate la Méduse,* Paris, 1817, p. 91. [14] See p. 155 below.

disaster. To contemporary viewers, the sorrowing "Father" bent over the body of his "Son" recalled Dante's description of Count Ugolino, starving in the Pisan tower surrounded by his dying children.

The death of Ugolino was one of the favourite horror stories in romantic poetry and art, chiefly because of its suggestion of cannibalism: an ambiguity in one of Dante's lines permitted the suspicion that Ugolino, whom the poet found in Hell gnawing the head of Archbishop Ruggieri, had previously practised cannibalism on his sons and grandsons in the Pisan prison.[15] Salon reviewers imagined that they saw a resemblance between the "Father" (fig. Z) and Sir Joshua Reynolds' *Ugolino*,[16] but this resemblance is slight. Géricault's group corresponds much more closely to Henry Fuseli's version, which he may well have known through a print after it by Moses Houghton (fig. AA). Some years earlier, Géricault himself had drawn an *Ugolino in Prison*, of rather similar appearance,[17] and there can be little doubt that to his mind the image of the brooding Count did not simply represent starvation, but symbolized the unpaintable horror of cannibalism. This association certainly existed in the mind of Byron, who at this time introduced Ugolino into the "Shipwreck Canto" of *Don Juan* for much the same purpose:[18]

[15] "*There he died; and even as thou seest me, saw I the three fall one by one, between the fifth day and the sixth: Whence I betook me, already blind, to groping over each, and for three days called them, after they were dead; then fasting had more power than grief.*"
(*The Divine Comedy*, transl. C. Wicksteed, Modern Library, New York, 1950, Inferno XXXIII, 70–75). The Salon of 1819 included a painting of Ugolino in the Tower, by Soulary, which the official catalogue describes in some detail: "*. . . c'est dans cette situation qu'il vit successivement périr ses trois fils. L'un d'eux . . . s'offrit à lui servir d'aliment. Ugolin eut en horreur cette proposition . . .*" (*Explication des ouvrages de peinture etc. exposés au Musée Royal des Arts, le 25 août 1819*, Paris, 1819, p. 116, no. 1045).
[16] Cf. the critic Kératry in *Le courrier royal* of 30 August 1819, republished in *Annuaire de l'École française de peinture*, Paris, 1820, p. 25. The motif of Ugolino was also in the minds of other reviewers, though they did not specifically connect it with the figure of the "Father"; thus the reviewer of the *Revue encyclopédique* (IV, 1819, p. 527) in his curiously confused discussion of the *Medusa*: "*Le but de la peinture est de parler à l'âme et aux yeux, et non pas de repousser. Si donc la poésie ne doit jamais essayer, selon les règles qu'Aristote a prescrites, d'aller plus loin que la pitié et la terreur, il en résulte que M. Géricault, quelque part qu'il eut adopté, eut toujours été au delà du but. Seulement on trouve des forces pour voir ce qui est horrible: car il y a quelquefois une sorte de sublimité dans ce qui est horrible, ainsi que Dante l'a prouvé dans son épisode du comte Ugolin.*" The association between the *Medusa* and the Ugolino episode was still in the mind of Gustave Planche, writing of the picture in 1851: "*Si je cherchais dans un art qui parle une autre langue, dans la poésie, un terme de comparaison: si j'essayais de montrer comment la parole, maniée par une puissante intelligence, lutte d'énergie et d'épouvante avec la peinture, je ne trouverais dans mes souvenirs que la tour d'Ugolin. Il y a en effet une évidente analogie entre la scène racontée par le poète florentin et la scène retracée par le peintre français. Dans la tour d'Ugolin comme sur le Radeau de la Méduse, nous voyons le désespoir poussé à ses dernières limites.*" (G. Planche, "Géricault", *Revue des deux-mondes*, XXI, 1851, p. 524). For a general discussion of themes from the *Inferno* in neo-classical and romantic art, cf. Irène de Vasconcellos,

L'inspiration dantesque dans l'art romantique français, Paris, 1925.
[17] Musée Bonnat, Bayonne, inv. 735; the drawing, in washes and gouache, dates from about 1815–16.
[18] Byron wrote Canto II of *Don Juan* between September 1818 and January 1819, at about the time when Géricault was finishing the compositional studies for his picture and starting work on the large canvas. The fact that the poem and the picture are exactly contemporary and contain many parallels is remarkable. It raises the question of the possibility of a link between them. Byron's main source is known to have been Sir J. G. Dalzell's *Shipwrecks and Disasters at Sea*, Edinburgh, 1812. But it is very probable that he had read of the *Medusa*, the most notorious shipwreck of his time. He may even have known the account of it by Corréard and Savigny, either in one of the French editions, or in the English translation published in April of 1818. While shipwrecks have a way of resembling one another, there are details in the poem which may have come from Corréard and Savigny, rather than Dalzell. The earliest comparison between Byron's "Shipwreck Canto" and the *Medusa* known to me occurs in a British review of the Paris Salon of 1819, "State of the Fine Arts in France, written in Paris, after Viewing the late Exhibition at the Louvre", by David Carey, Esq., and published in *The Monthly Magazine*, 1 June 1820, vol. 49, no. 5, p. 417: "*The dreadful account of the 'Shipwreck of the Medusa' affords a distressing picture of calamity and hideous circumstances to the imagination; but a painter hazards much in attempting to convey the particulars of that event to the canvas. Lord Byron has tried his able and eccentric pen on the subject,—he has succeeded in exciting disgust, more than commiseration . . . M. Géricault has had the ambition to portray a shipwreck of this kind on an extended scale . . . 'horror accumulated on horror's head', but still the scene is not such as the public recital has acquainted us with. Lord Byron has striven to add to the anti-picturesque by the wantonness of his fancy; Mr. Géricault, in endeavouring to avoid this effect, has weakened the interest of the piece.*" The somewhat unclear intent of this passage is to censure Byron for having dealt openly with cannibalism, and Géricault for not having done this. For further parallels between Byron's poem and Géricault's picture, see pp. 55, 155.

" . . . Remember Ugolino condescends
To eat the head of his arch-enemy
The moment after he politely ends
His tale: if foes be food in hell, at sea
'Tis surely fair to dine upon our friends,
When Shipwreck's short allowance grows too scanty,
Without being much more horrible than Dante."

(*Stanza* LXXXIII)

From Géricault's final version of the scene, every direct reference to cannibalism was purged: only the figure of the sorrowing "Father" and his dead "Son" remained, to recall the story of Ugolino and to remind the knowing spectator of the horrors through which the men on the Raft had passed. Understood in this sense, the group takes on a double meaning. Its veiled hint at an occurrence too hideous to be plainly stated adds the dimension of allusive symbolism to what is otherwise a composition of notably direct impact.

But the meaning and derivation of this group are in fact even more complex than that. The "Father" also recalls, perhaps by design, two of the best-known paintings of the period, Pierre Guérin's *Marcus Sextus* (1799) (fig. BB) and J. A. Gros's *Plague Hospital at Jaffa* (1804) (fig. X).[19] Salon visitors could not fail to notice the similarity in type and expression between him and the noble Roman in Guérin's painting who, returned from exile, finds his wife dead; the figure of *Marcus Sextus* had impressed itself on the contemporary imagination as the very model of paternal grief. Nor was it possible to overlook the resemblance of the "Father" (fig. Y) to the dark figure of the desperate man who crouches among the bodies of the *Plague Hospital,* occupying in the shadowed foreground of that picture a place which corresponds to the place of the "Father" on the Raft. Various as these associations are, they do not seem accidental, or purely formal; they converge on the ideas of death and intense suffering. The figure of the "Son", no less than that of the "Father", is a complicated medley of adaptations. It combines reminiscences of figures from paintings by Guérin (figs. BB, CC), Girodet, and Prud'hon.[20] In a work which contains so many echoes of past art, these manifold references to well-known paintings are not surprising in themselves. What does seem strange is that Géricault, far from hiding these resemblances, gave them prominence. There is reason to suppose that he purposely used these evocative associations, which cluster most densely around the foreground figures of "Father and Son", as aids to the viewer. The group is the only one which directly turns to him; it is his introduction to the Raft. Like an emblematical frontispiece, it offers him a comment on the drama in which he is about to become involved. In a picture mainly designed for immediate emotional participation, it is an element which speaks to the viewer's memory of art and literature.

Géricault needed the stimulus of art as much as he needed the experience of reality. Throughout his labour over the *Medusa*, he drew on past art for two distinct purposes. He looked to earlier history painting for analogies of theme or pictorial form which might help him in developing the content

[19] Cf. Kératry, *loc. cit.;* and Clément, *op. cit.,* p. 157: "*La figure du vieillard . . . ne lui appartient pas. Elle se trouve presque littéralement dans les* Pestiférés de Jaffa *de Gros, et elle n'est pas sans quelque rapport avec le* Marcus Sextus *de Guérin.*"

[20] The origin of the type seems to be Girodet's *Endymion* (1793, Louvre). Guérin re-used it, with slight variations, for his Cephalus in *Aurora and Cephalus* (1810, Louvre), and Prud'hon adapted it for the figure of the murdered man in *Justice and Divine Vengeance Pursuing Crime* (1808, Louvre), a picture of which Géricault had painted a copy (Louvre, RF 221).

and composition of his picture. He also gathered particular figure types, poses and gestures, usually from modern works. It was difficult for him to visualize figures or dramatic groups except in terms of some near parallel in art. His borrowings, however, were never simple: the *Raft of the Medusa* contains many echoes,[21] but no outright copies. During his years of self-training, Géricault had filled his mind with the works of the masters and developed a sharp visual memory. He could quote figures or complicated groups at will, and in the process transform, combine, hybridize them with great facility, arriving in the end at figures and groupings which bore little resemblance to their sources. Imagination and memory interacted so closely throughout this transformation that it is difficult to define the share of each. Géricault himself was probably not always conscious of his quotations. What traces of influence survived the process were further obscured in the final execution after living models. In the finished work, only the poses and types of some figures, not their style, still betrayed their origins.

His sources were not the most obvious. He took little, if anything, from the long tradition of shipwreck painting.[22] He must have been familiar with the wreck-strewn seacoasts of de Loutherbourg and Joseph Vernet, and he may have known English prints after pictures of modern naval disasters by painters such as Copley, Morland and Westall, but he made no direct use of them, perhaps because they disagreed with his monumental, man-centred conception of his subject. On the other hand, reflections of Last Judgement imagery occur at different stages of the *Medusa*'s evolution.[23] The association with Michelangelo, which the picture has always called up despite the fact that none of its figures is conspicuously Michelangelesque in type or pose, comes from distant echoes of the Sistine fresco in the gigantism of the rising or fallen bodies. Géricault had "trembled" before Michelangelo's *Last Judgement* on his visit to Rome;[24] the powerful impression which he then received was at the root of his ambition to paint a grandiose figure composition. The memory of it accompanied the work as a guiding vision, and something of it survives in the picture's final form. More direct was the influence of a painting of smaller scale, Rubens' so-called *Little Last Judgement,* actually a Fall of the Damned, which was known to Géricault through a print (fig. U),[25] after which he drew a number of copies at the time (Plate 27) and from which he took ideas for the tumbling figures of the *Mutiny* scene. The realistic detail, the vehement melodrama and dynamism of this painting gave him much that was relevant to the episodes of rebellion, battle, and fall in the *Medusa*'s story. Besides, Rubens' cascade of bodies demonstrated that a many-figured composition could be set into strong motion, without sacrificing the integrity of the individual figures. But his interest in images of the

[21] Among them, for example, the cadaver of the Negro who lies slumped over the legs of a man who attempts to raise himself: the Negro has a close parallel in the Negro who sprawls in the foreground of Gros's *Battle of the Pyramids* (1810, Versailles; fig. EE), while the rising figure resembles the wounded Arab in the centre of Gros's *Battle of Aboukir* (1806, Versailles). Some of these resemblances are deceptive: Robert Lebel has pointed to the quite startling similarity of the figures of the dead man who lies forward on his face and the cadaver lying on his back, farther to the right, in the foreground of the *Raft,* to two figures in Rosso's *Moses and the Daughters of Jethro* (Uffizi). But what is known about the gradual development of Géricault's two figures establishes beyond doubt that this similarity is accidental. (R. Lebel, "Géricault, ses ambitions

monumentales et l'inspiration Italienne", *L'arte,* October-December 1960, n.s. xxv, pp. 327 ff.).

[22] Cf. B. Nicolson, "The *Raft* from the Point of View of Subject Matter," *Burlington Magazine,* August 1954, xcvi, pp. 241 ff., and T. S. R. Boase, "Shipwrecks in English Romantic Painting," *Journal of the Warburg and Courtauld Institutes,* July-December 1959, pp. 332 ff.

[23] Cf. L. Eitner, "Dessins de Géricault d'après Rubens et la génèse du Radeau de la Méduse," *Revue de l'art,* no. 14, 1971, pp. 51–56.

[24] Clément, *op. cit.,* p. 82.

[25] Géricault used the engraving by Jonas Suyderhoef of 1642 (illustrated in M. Rooses, *L'Œuvre de P. P. Rubens,* Antwerp, 1886, pl. 24).

Last Judgement very likely went beyond their purely pictorial form. Traditional art offered no grander or more terrifying picture of aspiration and despair than the Last Judgement. The victims of the Raft had endured a long agony between death and rescue; to invoke the Last Judgement in representing their situation was to express something about the nature and intensity of their suffering that could not easily have been put into other terms, and certainly not into the terms of simple representation. In hinting at the Fall of the Damned in the *Mutiny* and at the Resurrection of the Dead in the *Sighting*, Géricault expanded the meanings of these episodes by a device of associational suggestion, not unlike that by which he had turned the Ugolino-figure of the "Father" into a reminder of cannibalism.

Baroque painters had embroidered on the iconography of the Last Judgement to produce mythological or allegorical variants, such as the Fall of the Titans or the Expulsion of the Vices, cloud-borne spectacles which lent a touch of physical violence to the apotheoses of royalty which they often accompanied. Their earthly counterparts were scenes of actual catastrophe, particularly pictures of the plague. Numberless altar-pieces and ex-votos commemorated the miracles by which divine intervention and the prayer of saints had put a stop to pestilence. These subjects offered artists unusual scope for the realistic representation of death and agony, of heaped cadavers and of tormented sufferers straining toward the salvation appearing to them from the skies. Artists of the post-Revolutionary period still took some interest in these images of obsolete devotion; they found in them ideas for pictures of modern military carnage. A spectacular, late example of the type, G.–F. Doyen's *Miracle des Ardents* (1767) in the church of Saint-Roch (fig. W), gave Géricault the head of a figure in the *Mutiny* (Plate 25) and very likely suggested to him ideas for the postures and the general disposition of the cadavers in the foreground of the *Raft*. An even later plague picture, Louis David's *Peste de Saint-Roch* (1779) may have played a role in determining the pose and expression of the "Father". But it was A. J. Gros's triumphant annexation of religious plague imagery to a modern, national cause, his *Napoleon Visiting the Plague-Stricken in the Hospital at Jaffa* (1804), which most deeply influenced Géricault. The dark figures of the stricken men which loom, terrifyingly near, in the *Plague Hospital* (fig. X) were strongly in his mind when he composed the frieze of cadavers and mourners which fills the foreground of the *Raft*.[26] Gros's painting is without doubt the immediate ancestor of the *Raft*, its main link with the secular history painting of the Napoleonic era and, beyond it, with the traditions of Baroque religious art.

Continuity and Innovation

Reflecting on the Salon of 1819, the critic and painter Étienne Delécluze, who had been one of its more perspicacious reviewers, thought that the *Medusa*'s "extraordinary success" had been the first signal of the younger generation's rebellion against David and his School.[27] Oddly enough, he found in Géricault's revolutionary picture a "retrograde" tendency. It reminded him of the *"manière un peu*

[26] Clément, *op. cit.*, pp. 256 ff., quotes Géricault's disciple Montfort at length concerning Géricault's admiration of artists of the past and of his own time. His favourite modern artist clearly was Gros. On being asked by Montfort *"dans quel tableau moderne il trouvait les plus grandes qualités de dessin: il me cita, dans les* Pestiférés de Jaffa, *les figures sur le devant de la composition"*. In this connection, the following passage from Louis Batissier's early biography (1842) of Géricault is of particular interest: *"Quant à Gros, Géricault avait pour lui une admiration qui tenait du fanatisme. Chaque ouvrage de ce maître était pour le jeune peintre le sujet des méditations les plus sérieuses. Il allait sans cesse les voir, les étudier. Puis, rentré chez lui, il traduisait ses impressions sur la toile; il faisait, de souvenir, des copies qui avaient bien, certes, leur originalité."* (P. Courthion, *Géricault raconté par lui-même et par ses amis*, Vésenaz-Geneva, 1947, p. 54).

lâche de Jouvenet",[28] in other words, of the exaggerated pantomime, eccentric composition, and showy illumination which he disliked in French Baroque church painting. In direct contradiction to Delécluze, Charles Clément described the *Medusa* as an entirely original work, and Géricault as the only truly innovating artist to come after David.[29] He acknowledged Géricault's grasp of tradition, but asserted that this had merely given him the confidence needed to challenge the aridity and abstraction of David's system with a modern work, conceived in an entirely personal, realistic style. In one respect, Delécluze and Clément agreed with one another: they both believed that the *Medusa* signified a break with the School of David; however what seemed to Clément a bold advance was to Delécluze a relapse into an obsolescent style.

It is possible to take yet another view, and to see in the *Medusa* not a rejection but a further continuation of David—to regard its style as an intensification of the strain of Baroque realism already evident in the work of David and of some of his followers. This accords better, at any rate, with Géricault's quite unrebellious attitude toward David and Guérin, and with his great admiration for Gros.[30] Delécluze rightly sensed an element of baroque style in the *Medusa*, but he was mistaken in

[27] E. J. Delécluze, *Louis David, son école et son temps,* Paris, 1855, p. 381. *"Pour s'expliquer aujourd'hui le succès extraordinaire qu'il* [Géricault] *eut au Salon de 1819, il faut remarquer qu'il servit à peu près également le parti d'opposition politique . . . et la réaction violente des jeunes artistes qui voulaient détrôner David et renverser son école. On reprochait au peintre des* Sabines *le choix des sujets pris dans les temps du paganisme, la recherche exagérée du beau visible, l'étude pédantesque du dessin, et surtout l'emploi du nu pris abstraitement, poétiquement, et sans qu'il fut raisonnablement motivé . . . Géricault . . . réalisa dans un tableau fort grand, toutes les idées, toutes les espérances de réforme artistique rêvées jusque-là par ses jeunes confrères . . . la* Méduse *de Géricault, mise en avant par la jeune école comme l'expression la plus nette et la plus énergique de son système, occasionna une levée de boucliers contre le peintre exilé . . . Au fond, Géricault n'avait eu l'idée que d'imiter la nature, sans choix, il est vrai, mais sans s'appuyer systématiquement sur le laid; il avait peint du nu parce que son sujet l'y obligeait . . . mais, forcé d'envisager ici son* Radeau de la Méduse *comme représentant une doctrine mise en opposition à celle de David, on ne peut plus y voir qu'une renovation de l'école et de la manière de Jouvenet, en sorte que l'on est amené à conclure que l'effort de ce jeune peintre fut dirigé dans un sens rétrograde, et qui est loin d'avoir fait avancer l'art, comme on l'a cru pendant quelque temps."* Delécluze wrote this estimate several decades after the exhibition of the *Medusa,* as an historical judgement, rather than a description of the actual, immediate reaction of contemporaries to the *Medusa.* His own review of the Salon of 1819 and critique of the *Medusa* had appeared under the title "Beaux-Arts, Sixième lettre", in *Le Lycée français,* II, 20 October 1819, p. 412. It is a perceptive appreciation, not without strictures, and reflects a moderate, classicist point of view. Delécluze (1781–1863) had been a pupil of David.

[28] *Le Lycée français,* II, 20 October 1819, p. 412. Jean Jouvenet (1644–1717) was a pupil of Le Brun, a member of the Academy since 1675 and its director after 1705. Jouvenet represented the freer, "Rubeniste" current in French Baroque painting of the late seventeenth century, but he was also noted for his effective use of light-dark contrasts, and it is in this respect that he seems to have

reminded Delécluze of Géricault. The painting by Jouvenet which was in Delécluze's mind was the *Miraculous Draught of Fishes* (Louvre), which has only a very remote resemblance to the *Medusa* and can scarcely have influenced it directly. Delécluze's suggestion, however, was later taken up by Charles Blanc (*Histoire de la peinture moderne, École français,* III, Paris, 1865, p. 8), who applied it to Géricault's manner of execution, in which he saw *"la facile largeur des Jouvenet".* More recently, J. Knowlton ("The Stylistic Origins of Géricault's 'Raft of the *Medusa*'", *Marsyas,* II, 1942, p. 315) has reopened the matter by claiming that Géricault derived several figures in the *Mutiny* composition from Jouvenet's *Triumph of Justice* (Musée de Rennes; sketches in the Louvre, Grenoble, etc.). There are, in fact, some similarities between figures in the *Mutiny* and in Jouvenet's painting, but these are not, as Knowlton asserts, due to any influence by Jouvenet on Géricault. The reason for these similarities is, rather, that both Jouvenet and Géricault incorporated reminiscences of Rubens' *Little Last Judgement* (see pp. 25, 47 above) in their compositions.

[29] Clément, *op. cit.,* pp. 9 ff. and pp. 152 ff. Clément specifically rejected the notion that Géricault had returned to a baroque style: *"On a voulu en faire un disciple, un continuateur, presque un imitateur de Michel-Ange de Caravage, des Bolonais et même de Jouvenet. Les rapports qu'il a sans doute avec ces peintres sont tout extérieurs et méritent à peine d'être remarqués. Comme eux, il emploie des ombres puissantes . . . Mais . . . son dessin est autrement personnel, savant, précis que le leur, son modelé bien plus souple et plus puissant. Ils s'en tenaient à l'apparence, lui possède la réalité."*

[30] In November of 1820, Géricault made a pilgrimage from England to Belgium to visit David in his exile (cf. G. Lebreton, "Schnetz et son époque", *Réunion des Sociétés des Beaux-Arts,* IX, 1885, pp. 320–321; and R. Régamey, *Géricault,* Paris, 1926, p. 38). While painting the *Medusa,* he went to see the *Sabines* and *Leonidas* and found them superior to his own work (Clément, *op. cit.,* p. 142). His expressions of admiration and respect for David and his School are abundantly reported by Batissier (*op. cit.,* pp. 53 ff.) and Clément (*op. cit.,* pp. 144, 243, 256 ff.).

regarding it as signifying a reaction against David. In this point, on the contrary, Géricault was closer to David and his early followers than was the intervening generation of neo-classical purists, to which Ingres and Delécluze himself belonged. Baroque traditions had continued, as a strong undercurrent, throughout the decades of David's hegemony. They had by no means come to an end in 1819. In some broad areas, their old authority had never been challenged. When painting contemporary subjects in an elevated style, French artists, even at the height of Davidian classicism, had consistently followed the models of traditional church and court art. David himself treated his commemorations of the fallen heroes of the Revolution in the manner of baroque martyrdoms, and freely quoted from Rubens' monarchical pageants to give splendour and an air of legitimacy to Napoleonic ceremonial. Gros, meanwhile, looted the repertory of the grand tradition to enrich the political iconography of the Empire. The Baroque had furnished such compelling models for the dramatization of every conceivable secular subject as to leave no room or need for alternatives: scenes of catastrophe, of battle and of triumph in particular presented themselves to the mind in the form of already familiar image-types. In this respect, the *Medusa* was entirely normal, neither innovative nor retrograde. It represented not so much a break with the School of David as a striking intensification of the realist and baroque elements in it, at the expense of its classicism: perhaps it was this one-sidedness which Delécluze found objectionable. The style of the *Medusa,* moreover, lay entirely within the main current of Géricault's own development. Its baroque tendencies had been latent in his work at least since 1812. The powerful, oblique movement of the *Charging Chasseur,* the dynamic figure compositions of the *Death of Paris* (1816) and of some of the versions of the *Race of the Barberi Horses* (1817), the tenebrism of his military subjects of 1814–16, all portended the style that emerges with final clarity in the *Medusa.*

David and Gros were the modern masters whose precedent was in Géricault's mind when he painted the *Medusa.* It was against their achievement that he measured his own intentions and results, often with trepidation.[31] Their large history paintings are the only ones with which his picture can be compared in ambition and sheer size. But the example which they offered him was contradictory in important respects. Beside the clarity and firmness of David's compositions, the compositions of Gros seem incoherent and sometimes flaccid. Gros's paintings, on the other hand, have a turbulent vitality next to which David's symmetrical arrangements seem static. A similar contrast separates them in the matter of colour: light, sharp, definite hues in David, complex, animated harmonies in Gros. It is part of the originality of the *Medusa* that it bridges these contradictions. In it, Géricault attempted to combine the chief qualities of both his precursors and to avoid what he saw as their defects. He sought to express a powerful, directed motion, while preserving the utmost solidity of construction. By making all the figures converge in one thrust, he gave his picture unity without balance, physical motion without picturesque flutter. Seen, as now it can be, in the close company of David's *Coronation, Sabines* and *Leonidas,* and Gros's *Plague Hospital* and *Battle of Eylau,* its neighbours in the Grande Galerie of the Louvre, the *Medusa* surprises the viewer with its relentless, concentrated energy, to which even the harsh light-dark contrasts make a contribution. Its composition seems to consist entirely of nerve and muscle; surrounded by paintings sumptuously clothed in colour, it appears naked: a gigantic *écorché,* forever in tension, galvanized by an effort without possible release.

Géricault's individuality, his personal departure from the norms of painting of his time, is most apparent in the vivid concreteness of the *Medusa*'s execution. The large design is solidly fleshed out

[31] Clément, *op. cit.,* p. 142.

with figures painted directly from the life. In this respect, it conforms to the usage of David's School. But instead of discreetly idealizing the figures as he painted them into his composition, Géricault left them raw, refraining from making the aesthetic corrections, the smoothing, harmonizing adjustments which were a second nature to the Davidians. Every particular form in the picture gives a strong sense of material existence. There are few passages in the *Medusa* of merely suggestive brushwork and none of the bland generalities which were expected of work in the grand style. It was this refusal to rise to a higher aesthetic plane, this lack of "choice" or "purity", which distressed classicists, such as Delécluze, and made them overlook the affinities that bound the *Medusa* to the tradition of David. There are abundant indications throughout Géricault's work that he reacted to concrete impressions with more intense feeling than to pure imagination. His studies from life are, on the whole, more expressive than his fantasies. This accounts for the decisive importance of life study in the realization of the *Medusa* and for the role which the highly personal quality of its execution plays in the total effect. Compared to the nervous responsiveness of Géricault's brush, the handling of David seems mechanical and that of Gros facile. An emphatic seriousness pervades the *Medusa*'s very execution. Its striving for corporeality has the force of a rhetorical statement. There is pathos in its tough materialism, in its insistence on the actuality and mortality of flesh.

Géricault took from the tradition of David and his School two quite different elements, the science of expressive composition and the practice of painting from life. He pushed each of these to an extreme of intensity, far beyond what Davidian doctrine would tolerate, and formed of them a style too personal and too complex for simple classification.

Meaning

In adapting Baroque models to modern political requirements, the painters of the Napoleonic era, and particularly Gros, embraced a new ideology, no less official than the old. The programme of their modern histories was the glorification of the Emperor; the gore of the battlefields and the clutter of the charnel-house at Jaffa were settings for Imperial pomp. Gros made this subordination of human suffering to a higher, political interest naïvely clear in the horizontal subdivision of his canvases: above the victims of war agonizing in the lower foreground, the Emperor and his retinue pass like a celestial vision (figs. X, EE).

Géricault departed from the norms of national history painting in a way that must have struck his contemporaries as extremely odd. Despite its grandly public format, the *Raft of the Medusa* is a personal statement free from official ideology. Its drama has no heroes and no message. No God, saint, or monarch presides over the disaster; no common cause is in evidence; no faith, no victory justifies the suffering of the men on the Raft: their martyrdom is one without palm or flag. It is as if Géricault had taken the foreground of human misery from one of Gros's pictures and omitted the apotheosis above. Neither a miracle of faith, nor a *"subject made honourable by its national character"*, the *Raft of the Medusa* casts a human tragedy in the terms of the artist's own materialistic and pessimistic outlook.

This breach of the rules was properly noted and criticized at the time of the picture's first exhibition. The reviewer for the *Annales du Musée* complained that dimensions as vast as those which Géricault had chosen were "reserved for the representation of events of general interest, such as a national celebration, a great victory, or one of those instances of sublime self-sacrifice that are the glory of

religion and of patriotism", adding, not without point, "what public building, what royal palace or private collection will receive this painting?"[32]

That so large a work should express a personal view seemed inconceivable. Critics of the time, like some commentators since,[33] took it for granted that the *Medusa* reflected a general, partisan attitude, that it spoke for the Opposition. It was judged accordingly, condemned by the friends and praised by the enemies of the régime. But a note of unease crept even into the favourable reviews published by the Opposition press. If the *Medusa* was a work of political inspiration, what precisely was its message? In a period when political lines were sharply drawn and when partisanship declared itself by unmistakable signs and slogans, the polemical point of the picture seemed unusually obscure. The faction which had the strongest interest in the exploitation of the scandal of the shipwreck, and which called itself the Liberal, was not "liberal" in the modern sense so much as it was vehemently nationalistic. The outcry over the *Medusa* had given voice to injured chauvinism, as well as to political and humanitarian concern. Géricault's concentration on a scene of suffering, devoid of any clear partisan or nationalist reference, irritated the polemicists as a wasted opportunity.

Géricault may well have been drawn to the subject of the *Medusa* under the influence of the political passions which the shipwreck had stirred. The project originated in the same climate of opinion as his military lithographs and the *Fualdès* drawings. When he began to think of the Raft as the possible subject for a large painting, he lived among outspoken enemies of the monarchy who saw the shipwreck as an opportunity for harassing the conservative ministers. His earliest awareness of the event must inevitably have been coloured by the political militancy he encountered in the circle of Horace Vernet, which included the two most famous survivors of the Raft, Savigny and Corréard, then in the midst of their bitter dispute with the Ministry of the Navy. The frequency and vehemence of his friends' discussions, their indignation at the injustice of the government, which had seen fit to treat the guilty captain with mildness while sending his victims to jail, no doubt helped to impress the story of the Raft on his imagination and contributed to his decision to take up the subject.

But these influences were not his main motivation, nor did they determine the meaning of his work. If political controversy stimulated Géricault at the outset, it failed to leave clear traces in the final work, or, for that matter, in the preliminary stages which led to it.[34] All the evidence shows, on the contrary, that his interest was focused from the start on the event itself, on its horrible reality, rather than its political implications. As the work progressed, he kept his mind on the physical and psychological circumstances of the Raft's voyage. It seems not to have occurred to him to appeal to the popular emotions which the scandal had aroused, as Vernet would unfailingly have done. In his exploration of the various incidents of the shipwreck, he by-passed the very ones which would have attracted a polemicist, the aristocratic captain's desertion of the Raft, for instance. Instead, he chose scenes of pathos or horror, and made his appeal to sympathy rather than to partisan indignation. His

[32] C. Landon, *Annales du Musée, Salon de 1819*, Paris, 1819, pp. 65 ff.

[33] Cf. R. Régamey (*Géricault*, Paris, 1926, p. 27): "*La Méduse est un pamphlet*." For the opposite view, see G. Oprescu, *Géricault*, Paris, 1927, pp. 92 ff. The point that a painting of large dimensions ought to have social significance was clearly stated by a critic writing in 1833 who had the *Medusa* particularly in mind and felt no doubt about Géricault's basically political intentions: "*Depuis le succès de*

la Méduse, *il n'y a guère d'artistes qui n'aient essayé de rivaliser avec Géricault: pour cela ils ne s'attaquent qu'à la dimension de la toile, et non à la portée du sujet, ni à la manière dont il est entendu. Ils ne songent pas que Géricault voulait agir sur la société, qu'il faisait un acte d'opposition, et que c'est là ce qui a fait sa force. Ils ne songent pas qu'il avait choisi un sujet dramatique en même temps que révolutionnaire, et qu'il l'avait rendu avec une peinture destinée à faire une révolution.*" (G. Laviron and B. Galbacio, *Le Salon de 1833*, Paris, 1833, p. 220.)

surprise at the politically inspired hostility with which his picture met at the Salon, and his disappointment at the government's failure to buy the *Medusa* after the exhibition, seem to have been genuine.[35] While his reaction betrays naïveté—it should not have been difficult to foresee that a picture of this subject was bound to cause annoyance in high places—it makes it appear unlikely that he had meant to attack the government with his painting. Whatever political feelings he may have held at the start, they had long since become overshadowed by artistic considerations, and by ideas at once more general and more personal. He had not laboured for eighteen months in order to inflict a fleeting embarrassment on a short-lived ministry. There is no reason to doubt his own, emphatic declaration: *"This year, our journalists have reached the height of ridicule. They judge every painting according to the* spirit *in which it was composed. You will find a liberal article praising some work for its truly patriotic brush, its national stroke. The same work, judged by a rigorous conservative, turns out to be nothing less than a revolutionary composition, pervaded by a general tint of sedition; the heads of its figures are described as wearing expressions of hatred for the paternal government. I have been accused by a certain* Drapeau blanc *of having slandered the entire Ministry of the Navy by the expression of one of the heads in my picture. The wretches who write such nonsense have certainly never gone without food for two weeks on end, otherwise they would realize that neither poetry nor painting can ever do justice to the horror and anguish of the men on the Raft."*[36]

It is clear from the surviving early studies for the *Medusa* that the meaning of his subject was not firmly settled in Géricault's mind at the start, but underwent a gradual development. The experimental versions of the scenes of *Rescue, Mutiny* and *Cannibalism* show that he was initially undecided about which historical moment best summed up the essential meaning of the event. What seems to have held his interest most strongly in the beginning was the spectacular occurrence itself, the monstrous reality of the disaster. He was tempted to deal with it like a reporter: as something to be known in detail and to be described with truth. All the early versions of the *Raft* shared an emphasis on narration

[34] The *Mutiny,* probably the earliest of the highly developed experimental versions of the composition, is a scene of pitched battle, in the tradition of the Napoleonic painters. Géricault's treatment, even of this relatively controversial incident in the story of the Raft, lacks any political point. Following Corréard and Savigny, he dwelt on the cruelty of the battle, the fierceness of the fighting, the variety of action and of suffering. Like Corréard and Savigny, he seems to have been partial to the defenders of the Raft, and at any rate showed no leaning to the side of the desperate, anarchical mutineers. He moralized rather than politicized the subject. His comment seems addressed to the irony of the situation: while the men are fighting one another, the elements threaten to engulf them all in a common destruction. The storm which rages round the battling figures, without distracting them from the business of mutual killing, is Géricault's imaginative contribution to the scene. The stream of nude bodies which fairly abruptly emerges from the otherwise quite "modern" scene of battle comes from art, specifically from Rubens' *Fall of the Damned.* This association with the idea of Last Judgement introduces an element of allegory into the scene of the *Mutiny;* it implies that Géricault saw the destruction of the mutineers as a form of punishment, a damnation. The episode of the *Rescue,* as he developed it, seems entirely devoid of any ulterior meaning. The scene

of *Cannibalism* is one of pathos, rather than drama. Passive despair dominates it entirely; it is the only one among the different versions of the subject which contains no element of conflict or struggle, and this is clearly expressed in its static and incoherent composition. While this scene details the most notorious horror of the Raft's story, it is also the most purely descriptive and most lacking in suspense. It is scarcely possible to read any political significance into it. The episode of *Cannibalism* was, at any rate, less damaging to the government than the others, and highly embarrassing to the survivors of the Raft, including Corréard and Savigny, all of whom found themselves implicated in this crime—a fact which weakened their moral and legal case.

[35] Cf. pp. 60–61.

[36] Clément, *op. cit.,* p. 177. Géricault's letter jokingly distorts the actual comment of the review published in the *Drapeau blanc,* a journal of the ultra-royalist party: *"Ce tableau d'un ton blanc et noir, d'un effet bizarre, est beaucoup en dessous de la relation que tout le monde connaît. Nous n'avons pu nous défendre à ce souvenir de regretter que la manifestation de sentiments coupables ait reserré dans le cercle obscur d'un parti méprisé cet appel à la bienfaisance qu'auraient voulu pouvoir entendre les amis du trône et de la légitimité."* (28 August 1819; cf. D. Aimé-Azam, *Mazeppa, Géricault et son temps,* Paris, 1956, p. 197).

and description. In them, Géricault strove for the visual recreation of the historical event; he sought for an image which would be true to fact and effective as a picture.

But gradually his attention shifted from the visual to the psychological reality of his subject. He began to conceive of the drama of the Raft not as a spectacle, but as an interior experience. He seems to have understood that the central reality of the event was the suffering of the shipwrecked men, and that to give a merely "accurate" view of the Raft, as it might have appeared to an imaginary, detached observer, was to miss this reality. It was necessary, rather, to enter into the experience of the Raft's victims. The spectator had to be made a participant in the drama. This realization seems to have struck Géricault toward the end of his search for the proper episode. Having chosen the least controversial aspect of the event—the survivors' final, common striving toward rescue—he progressively stripped his composition of all merely descriptive and narrative features, in order to concentrate on a powerfully simple, physical action and to present this action in a way that would involve the viewer in its momentum.

Inevitably, this change in attitude toward his subject affected its meaning. In putting his stress on the most broadly human aspect of the drama and making his appeal to an immediate muscular or emotional response, Géricault divested it of some of its historical character, and sacrificed much of the theme's interesting modernity, the very quality which had first attracted him to it. Salon critics were quick to point this out. *"The artist has failed to specify the nationality or condition of his personages"*, observed Fabien Pillet in the *Courrier de Paris*, *"are they Greeks or Romans? Turks or Frenchmen? Under what skies do they navigate? To what era of ancient or modern history does this horrible catastrophe belong?"*[37] The picture, in its final form, presents an elemental conflict, not an incident from recent French history. It overwhelms the viewer with the sense of an enormous human effort frustrated by an even greater force. Its immediate theme, the struggle of men against the forces of nature,[38] against the vastness of distance and the weight of death, is stated with such urgency as to blot out not only the *"nationality or condition"* of the men, and their individuality, but all external associations as well. The picture hardly stimulates reflection on the state of the French naval administration under the Bourbon monarchy. Géricault has generalized his subject beyond timeliness and controversiality, fulfilling, perhaps without realizing it, one of the requirements of traditional history painting. The Salon catalogue's description of his painting as "A Scene of Shipwreck", rather than as "The Shipwreck of the *Medusa*", was perhaps not merely an evasion of censorship. For the picture's significance does not lie in what it tells of the *Medusa*, but in its comment on *nature* as the destroyer of the shipwrecked. Géricault describes the contest in physical rather than moral terms. Naked instinct rouses the men to effort, an

[37] *Courrier de Paris*, 28 August 1819.
[38] The theme of conflict between human and natural energies had occupied Géricault in most of his earlier projects, as well as in the *Medusa*. The horses restrained by athletic grooms in the *Race of the Barberi*, the oxen struggling with their butchers in the *Cattle Market*, the horse defying the blacksmith in the *Signboard* (Zürich), the horse resisting the *Wounded Cuirassier*'s retreat from the field, and the raging mount carrying the *Charging Chasseur* into battle are so many variations on a theme to which Géricault returned with obsessive persistence throughout his life. The differences in subject matter seem less significant than the underlying similarity in dramatic action. The image of a

contest between animal and human strength, of human will imposed on animal wildness, deeply fascinated him. It is perhaps not unreasonable to regard the animals in these pictures as the physical embodiments of natural force, and the scenes of contest as an expression of a view of life. The spirit of these earlier works is heroic and confident; man dominates (even in the *Wounded Cuirassier*), his struggle is a conquest. In the *Raft of the Medusa*, the scope of the conflict has become immensely magnified. The shipwrecked men face an invisible antagonist of infinite power. Despair has replaced athletic optimism. The men are exposed and abandoned, victims of nature, rather than its rivals.

impartial might opposes them. Nature does not "frown" on its victims, as in Byron's poem[39]—which in other respects offers a remarkable parallel to Géricault's work—it assumes the form of a moderately heavy sea, a scattering of clouds, a day of average dismalness. If Géricault has given his picture something of the aspect of a Last Judgement, he has made it a Judgement without sin or mercy, and without ultimate transcendence. The normal functioning of the material world both animates the men and threatens their destruction. Only by their ability to feel and suffer are they set apart from the inanimate nature which surrounds them; this is their particular reality, and it provides the emotional lever of Géricault's dramatization of the scene. It is possible that here the picture obscurely touches on his private sorrows of those years, the central tragedy in his life, which can hardly have failed to leave some trace in a work that, perhaps not by coincidence, was begun just after the unhappy resolution of his troubles.[40] But exactly what role Géricault's mood of the time played in shaping the meaning of his picture can only be guessed. *"If there is any certainty on earth, it is our pain"*, he had written to a friend not long before, *"only suffering is real . . ."*

Considering the sensational topicality of his subject, Géricault's final generalization of it is especially significant. It is not likely that he had foreseen this transformation at the start. His final conception of the disaster of the Raft as an example of the fundamental conflict between men and nature, rather than an accident, seems to have imposed itself on him as the work went forward. The preserved studies give an insight into the gradualness of this change. What brought it about was evidently not philosophical reflection so much as his effort to recreate the essential reality of the event, and his determination to convey his sense of it with the utmost energy. His original choice of a strong, contemporary subject was therefore by no means irrelevant to his development of the picture. Working through imaginative self-projection, he needed the conviction and excitement that only an actual incident could give him. Contemporaneity was not his end, but his material and stimulant. The conventional repertory of scripture, literature, or myth could not rouse him to an enthusiastic and sustained effort. He needed the challenge of a fresh occurrence, still vivid in the memory, of still unexhausted significance, as yet not hardened into historical fact or accepted legend. And he had the boldness, once he had chosen such an occurrence for his subject, to bend it to his own purpose—not in a modestly experimental essay, but in a work of the grandest and most public format. It was a feat that went beyond anything the Napoleonic painters of modern national history had done. Their version

[39] *Don Juan*, Canto II, 49:
""Twas twilight and the sunless day went down
Over the waste of waters; like a veil
Which, if withdrawn, would but disclose the frown
Of one whose hate is masked but to assail.
Thus to their hopeless eyes the night was shown
And grimly darkled over the faces pale
And the dim desolate deep; twelve days had fear
Been their familiar, and now Death was here."
Concerning parallels between the "Shipwreck Canto" of *Don Juan* and the exactly contemporary *Raft of the Medusa,* see also pp. 45, 155.

[40] See pp. 12–13. It might be mentioned that among Géricault's later works which can perhaps be regarded as the overflow of the *Medusa* project is the composition known as *La Tempête* or *L'Épave* (paintings in Brussels and the Louvre, watercolour in the Chicago Art Institute) which shows the body of a woman holding a child thrown by the waves onto a rocky beach. The source of this motif is not known. Without putting much weight on such speculations, one might bear in mind the possibility that this image might conceivably refer to what Géricault, in moments of guilt, may have seen as his abandonment of his mistress and of their child. And this raises the further question of whether the theme of abandonment may not also have played a role in the genesis of the *Medusa*. One might ask, for example, whether Géricault shrank from representing the abandonment of the men on the Raft by the *Medusa*'s captain, this act of disloyalty, because it called up painful personal associations. There is no way of substantiating such an assumption, though it is tempting to suppose that Géricault's ultimate generalization of the subject into a broadly human tragedy was motivated by a desire to present the abandonment of the shipwrecked as a matter of universal fate rather than individual guilt.

of reality had been buttressed by the authority of army bulletins and Imperial decrees. Géricault, by contrast, assumed a position of unheard-of independence. He did not consciously seek official approval or court popularity. It may never have entered his mind that by transforming the *Raft of the Medusa* into a timeless, elemental drama he was bound to puzzle the public, disappoint his political friends, and leave the government unappeased.

But by this transformation he gave his work the power of survival and continuing suggestiveness. While pictures more narrowly focused on issues of their day have sunk into obsolescence and incomprehensibility with the passing of their time, the *Medusa* has kept its hold on the imagination. *"Il y a encore dans les cafés des gens qui s'interessent aux naufragés de la Méduse"*, noted the brothers de Goncourt in 1857.[41] The painting, then as now, loomed larger than the event it represented. The shipwreck would long since have been forgotten, had it not been for the abiding fascination of Géricault's *Raft*, which continued, for a hundred and fifty years, to give impartial hospitality to a variety of ideologies and world-views. The romantic historian and polemicist, Jules Michelet, in 1848, saw it as the image of France adrift in the current of reaction.[42] In the following year, when the revolution which Michelet had hailed was foundering, the caricaturist Bertall compared the *Raft* to the wreckage of Republican hopes.[43] The *Raft* was in Delacroix's mind when he painted the *Bark of Dante*; its echo can still be felt in his *Liberty on the Barricade*. To the critic Gustave Planche, writing in 1851, it was a Dantesque vision of death;[44] to Ernest Chesneau, in 1861, a protest on behalf of the spirit of life and the *"beau moderne"* against death and academicism,[45] and to Charles Clément, in 1867, an expression of compassion and solidarity with suffering mankind.[46] Down to the present, the picture's unspent power has occasionally been enlisted for urgent political causes,[47] all of which it has outlasted in their turn.

[41] *Journal des Goncourt,* I, 1851–1861, Paris, Charpentier, 1906, p. 183.

[42] Jules Michelet, "Cinquième leçon non professée", *Cours professés au Collège de France, 1847–1848,* Paris, 1848, cf. F. D. Klingender, "Géricault as Seen in 1848", *Burlington Magazine,* LXXXI, 1942, pp. 254 ff.

[43] *Journal pour rire,* II, no. 52, January 1849; drawing by Bertall (Albert d'Arnoux, 1820–1882), engraved on wood by Pothey.

[44] Gustave Planche, "Géricault", *Revue des Deux-Mondes,* 1851, pp. 524 ff.

[45] Ernest Chesneau, "Le mouvement moderne en peinture; Géricault", *Revue Européenne,* XVII, 1861, pp. 482 ff.

[46] Clément, *op. cit.,* p. 161.

[47] Most recently in the tumultuous demonstrations which accompanied and put a stop to the première of Hans Werner Henze's oratorio, *Das Floss der Medusa,* in Hamburg on December 9th, 1968.

AFTERMATH

Illness

SHORTLY after the king's visit to the Salon on 28 August 1819, Géricault left Paris for the country. He was exhausted and badly in need of a rest. Together with a friend, the economist Auguste Brunet, he took vacation quarters in the village of Féricy, near Fontainebleau, on 10 September. But the completion of his picture, instead of giving him relief, had thrown him into a state of depression and irritability. About two weeks after his arrival in the country, he fell seriously ill, took to his bed, and had to be cared for by his friend. The nature of his illness is not known. In late October, apparently back on his feet again, though still not fully recovered, he began to worry his friends by the irrationality of his behaviour. He imagined himself the target of obscure persecutions, and during an autumnal outing on the Seine was seized by a sudden suspicion of the boatmen who, he feared, were spying on him and plotting his ruin. His friends were alarmed enough by his physical and mental state to think it wise to take him back to Paris, where he could be given medical help.[1]

These circumstances, not mentioned by his early biographers, throw a new light on the probable cause and nature of Géricault's unhappiness in the months following the exhibition of his picture. The blame for his overwrought condition has usually been put on the *Medusa*'s supposed failure at the Salon, on his disappointment at finding his picture unappreciated by the general public, slighted by fellow artists, and savagely attacked by the reviewers.[2] In reality, he seems already to have been in poor physical and mental health before he could have formed a clear idea of the reception of his work. His subjective misery preceded and probably magnified the injustice of which he later came to believe himself the victim.

The Critics of the Medusa

It is difficult to know what the public thought of the *Medusa*. The picture seems, at the very least, to have attracted its attention. What artists thought of it can only be inferred from anecdotes of dubious authenticity, such as that which quotes Gros as saying that Géricault was a most promising young artist who needed to have *"several palettes full of blood taken from him"*.[3] Delécluze, who, as a painter of high intelligence and a thoughtful critic of the Salon, deserves to be taken seriously, spoke of the *"extraordinary success which the* Medusa *had at the Salon"* and of its profound effect on the younger artists of the time.[4]

But the Salon reviews are still there to be read,[5] and their evidence contradicts the traditional assumption that the critics were on the whole hostile to Géricault. Clément observed that in running through the press notices one is struck by the *"injustice, unintelligence and critical ineptitude"* of their comments on the *Medusa*, and voices his surprise that there should not have been a discerning minority,

[1] Concerning Géricault's state during the months following the completion of the *Raft,* see the account, based on previously unknown documents, by D. Aimé-Azam, *Mazeppa, Géricault et son temps,* Paris, 1956, pp. 216 ff.

[2] Clément, *op. cit.,* pp. 170 ff. Batissier, *op. cit.,* p. 49.

[3] Batissier, *op. cit.,* p. 55; Clément, *op. cit.,* p. 164, mentions that this remark has also been attributed to Guérin.

[4] Delécluze, *op. cit.,* p. 381.

[5] See Clément, *op. cit.,* p. 163; G. Oprescu, *Géricault,* Paris, 1927, pp. 119 ff.; D. Aimé-Azam, *op. cit.,* pp. 195 ff.; M. A. Tippetts, *Les marines des peintres, vues par les littérateurs,* Paris, 1966, pp. 65 ff.

at least, to recognize and appreciate its qualities.[6] He was doubtless right about the ineptitude of most of the criticism, but this merely reflected the general low level of art journalism at the time, a condition from which other artists suffered as much as Géricault. So far as the lack of an appreciative minority was concerned, Clément overstated the case: the critics were in fact evenly divided in their opinion of the *Medusa,* and for every unfavourable review it is possible to cite a notice of praise.[7] If the amount of critical attention given to the picture is taken as a measure of its recognition, the *Medusa* can hardly be said to have failed at the Salon. Only one paper, the *Journal des Débats,* omitted it from its Salon review, for reasons which seem to have had little to do with matters of art.[8] All the other papers and pamphlets paid it the tribute of very prominent notice, even when they ignored or dismissed with contempt the works of artists such as Prud'hon and Ingres. Géricault had hoped to make a mark at the Salon, and in this he had amply succeeded. It must not be forgotten that the *Medusa* was the work of a very young and nearly unknown painter, that it baffled the public and the critics with its novelty of conception and style, that it offended against a wide range of political and artistic prejudices. In view of all this, it is difficult not to agree with Delécuze that the picture's success at the Salon was extraordinary.

The chief complaints of the critics: the picture's sombre monochromy, its inappropriate monumentality, its lack of an "interesting" narrative, and its failure to dwell on the vastness of the ocean, have already been discussed.[9] A querulous didacticism and nagging insistence on details—"incorrections" of design, "exaggerations", mistakes in the choice of the dramatic moment—run through the unfavourable reviews, often coupled with suggestions for improvement. With irritating fairness, some critics granted Géricault such extenuating circumstances as his youth, the brevity of his training, and the speed[10] with which they supposed him to have dashed off his picture:

"Courage, M. Géricault! Try to moderate an enthusiasm which might carry you too far. Being a colourist by instinct, try to become one in practice; being still an imperfect draughtsman, study the art of David and Girodet."[11]

The admirers of the *Medusa,* by contrast, put their emphasis on the picture's emotional impact and general effect—*"My heart trembled on seeing the shipwreck of the* Medusa *. . . I shudder while I admire".*[12] *"What movement, what verve",* wrote another reviewer,[13] falling into the exclamatory tone which pervades many of the friendly notices. The truth, daring, and energy of Géricault's conception of his subject, and the power of his execution were the qualities of his painting most generally and most warmly praised. There is no sign in this medley of applause and fault-finding of any serious inquiry into the *Medusa*'s significance and originality, let alone of an awareness that this picture marked an epoch in the development of the French school. Even artists less precariously balanced than Géricault might

[6] Clément, *op. cit.,* pp. 163 ff.

[7] The distinctly unfavourable reviews are those of the *Gazette de France* (27 and 31 August), *Drapeau blanc* (28 August), *L'Indépendant* (29 August), *La Quotidienne* (30 August), *Courrier royal* (by Kératry, 30 August), *Choix des productions de l'art* (by Gault de Saint-Germain), *Annales du Musée* (by Landon), and *Revue Encyclopédique* (by P.A.); the review by David Carey in *Monthly Magazine* (1 June 1820) does not count, since its criticisms plagiarize the article of the *Revue Encyclopédique.* Favourable reviews appeared in *La Renommée* (26 August), *Le Constitutionnel* (26 August), *Lettres à David sur le Salon de 1819* (8 September), *Moniteur Universel* (by Emeric Duval, 12 October), *Le Conservateur* (by Count O'Mahony), *La Minerve française* (by Jouy), and

L'Ombre de Diderot (by Jal). Mixed praise and blame is contained in the reviews of the *Courrier de Paris* (by F. Pillet, 28 August), *Le Lycée* (by Delécluze, 20 October), and *Lettres Normandes.*

[8] D. Aimé-Azam, *op. cit.,* p. 214.

[9] See pp. 40, 42, 44 above.

[10] Cf. *Lettres à David,* 8 September; *Moniteur Universel,* 12 October, and *Lettres Normandes.*

[11] Jal in *L'Ombre de Diderot et le bossu du Marais,* Paris, 1819, p. 129.

[12] *Le Constitutionnel,* 26 August 1819, cf. D. Aimé-Azam, *op. cit.,* p. 195.

[13] *La Renommée,* 26 August 1819, cf. D. Aimé-Azam, *op. cit.,* p. 196.

well have shared his exasperation with the agile superficiality of the reviewers who, as he put it, *"so* judiciously *dispensed both praise and insult"*.[14]

One assumption about the *Raft of the Medusa,* made by friends and foes alike, was that because of its subject it must necessarily be a work of crass realism. In this conviction, abetted by the fact that the picture was hung too high to be closely examined, the critics let their imaginations roam. *"A work for the delight of vultures",* commented *La Gazette de France,* "M. *Géricault has pleased to offer us . . . some twenty cadavers which death had already begun to devour, but to whose breasts a barbarous divinity has restored the breath of life only to plunge them again into an anguish of destruction."*[15] A pious reviewer, Count O'Mahony of the strongly royalist *Conservateur,* experienced a mixture of shock and admiration which clouded his vision, but which moved him to pay Géricault an apparently sincere compliment: *"On a raft which is about to be engulfed by a wave, the painter has assembled the most revolting aspects of despair, rage, hunger, death and putrefaction, and he has expressed them with an abundance of verve, a truth of touch, a boldness of handling and of colour which multiply their effect a hundredfold. Nothing can mitigate these horrors. All must die, there is no chance of salvation, since none of them raises his arms toward Him whom the winds and seas obey. Shut unto themselves, they will sink from the abyss of the waters into that of Eternity. For as they have forgotten God, so they have also forgotten one another. They receive no consolation and they offer none. Each sees only his own death and laments only for his own life: egoism has reached its last extreme! Is it possible that suffering should not have joined two souls, two brothers, a father and his son? What a hideous spectacle, but what a beautiful picture!"*[16] Putting on his spectacles, the reviewer for *La Renommée* felt obliged to admit that though *"the sight of this large composition inspires terror, the artist has avoided with great skill everything that might have caused disgust or revolted the senses".*[17] But his colleague of the *Revue Encyclopédique* objected precisely to this reticence. His disappointment in Géricault's failure to go to the extreme of realism inspired what must rank as the most foolish notice of all: *"M. GÉRICAULT. The subject of the picture exhibited by this artist is a* Scene of Shipwreck *according to the catalogue. At first sight, it might seem as if he had intended to represent the raft of the* Medusa. *Careful examination does not quite bear out this supposition, however, though one remains convinced that the painter has at least been inspired by this event. It seems to me that the reasons why M. Géricault has not represented the scene as we know it through the published accounts are, first, his desire to avoid having to use modern dress, which would have been anti-picturesque, and, second, his wish to avoid details which would have made the scene hideous. But in softening the features of the picture which he presents to us, he has perhaps weakened its interest. He could have made it horrible, and he has made it merely disgusting; this picture is a heap of cadavers from which one turns away. If he had rendered the subject in all its energy, all its truth, if he had dared to show the unfortunates of the* Medusa, *driven by the pitiless motives of self-preservation, fighting over the corpse of one of their comrades in order to prolong their existence by a few hours, then, to be sure, he would have inspired horror, but he would have been sure to attract attention.*

"M. Géricault seems to have made a mistake. The aim of the art of painting is to speak to the soul and to the eyes, and not to repel. Horace has said: ut pictura poesis. *Thus if poetry, according to Aristotle's rule, must never go beyond compassion and terror, it follows that, whichever course M. Géricault might have chosen, he would always have overshot the mark. But while one may find the strength to face the horrible, because there is a kind of*

[14] Géricault in a letter to his friend de Musigny, quoted by Clément, *op. cit.,* p. 170.

[15] *La Gazette de France,* 31 August 1819, cf. D. Aimé-Azam, *op. cit.,* p. 197.

[16] Count O'Mahony, in *Le Conservateur,* v, Paris, 1819, p. 190; cf. D. Aimé-Azam, *op. cit.,* p. 206.

[17] *La Renommée,* 26 August 1819, cf. D. Aimé-Azam, *op. cit.,* p. 196.

sublimity in horror, as Dante has shown in his episode of Count Ugolino, one does not willingly look at what is merely revolting.''[18]

It is hard to avoid the impression that the controversiality of Géricault's subject provided welcome copy for reviewers who otherwise might have found little to say: political prejudice came to the rescue of the myopic critics. The discreet title which the picture officially bore at the Salon, *Scene of Shipwreck,* gave them a pretext for a great deal of unnecessary, space-filling jocularity and malice. On the whole, the tone and substance of the reviews expressed the party affiliations of the papers which published them, rather than the personal artistic convictions of the reviewers. Liberal journalists were ready to applaud the *Medusa* on principle, for the sake of the cause which they thought it served, while ultra-royalists gladly damned it to avenge their government. But there were some notable crossings of the party lines. Some Liberal critics, stiff classicists in matters of art, had difficulty with the style and even with the subject of the picture. They would have preferred a work with a clearer message and more modest format. Their efforts to praise it, unsupported by genuine enthusiasm, produced awkward results,[19] which probably grated as much on Géricault's nerves as the spite of the frankly hostile papers. There were, on the other hand, some Conservative writers of romantic inclination, men such as Count O'Mahony, who disliked the subject but could not resist the fascination of the painting. Political and artistic sympathies were in a strange tangle over the *Medusa.* Had Géricault chosen a less controversial theme, he would have confronted a quite different alignment of critics. As it was, he fared almost best of all with that moderate segment of the Conservative press which stood for the middle-of-the-road constitutionalism of Louis XVIII and his more enlightened ministers. A taste for romantic literature and art had grown strong among this faction, partly in reaction against revolution-tainted classicism. It disposed men in influential positions to regard the *Medusa*'s originality without fear, and prepared the way for a tolerant reception of the picture in the very heart of the official establishment. It is worth noting that the *Moniteur Universel,* the government's mouthpiece, gave the *Medusa* a review that was objective and on the whole friendly.[20] The word of encouragement which Louis XVIII had spoken to Géricault at the Salon may,[21] after all, have signified something more than routine affability. Even while the exhibition was still under way, one of its organizers, the Comte de Forbin, who was also the director of the Royal Museums, cautiously set in motion a campaign to have the *Medusa* bought for the king's collection,[22] a remarkable attempt which would have cost him his position in any other reign.

This effort had no immediate results. Rumours of it may have reached Géricault and raised his expectations. But the time was not yet ripe. On prize-giving day, his picture failed to win the purchase award in the class of history painting, for which it had been proposed, and he had to content himself with a gold medal.[23] A month after the Salon's close, de Forbin informed him, in a very courteous

[18] "P. A." in *Revue Encyclopédique,* IV, 1819, p. 527.

[19] Cf. the half-hearted praise of the classicist Jouy writing for the Liberal *Minerve Française* (VII, 1819, p. 266) and the comical ineptitudes of Jal in *L'Ombre de Diderot* (1819, pp. 126 ff.) published by Corréard.

[20] *Le Moniteur Universel,* 12 October 1819, p. 1323.

[21] Cf. p. 6 above.

[22] Clément, *op. cit.,* p. 176.

[23] Two first prizes were awarded, one of 10,000 francs for the best history painting, the other of 4,000 francs for the best genre painting. According to Batissier (*op. cit.,* p. 53), the *Medusa* was fourth on the list for the award in history painting; according to Clément (*op. cit.,* p. 174) it was listed in the eleventh place. The first prize was given to a large panel of ogival shape, Guillemot's *Christ Raising the Widow's Son,* commissioned by the Prefect of the Seine for one of the choir chapels of Notre-Dame in Paris, where it is still to be seen. The gold medal awarded to Géricault was his second, the first having been given to him for his *Charging Chasseur* in 1812.

note, that he had obtained for him a state commission worth 6,000 francs. The subject, characteristically, was to be a glorification of the Sacred Heart, not at all what Géricault wanted, as de Forbin probably knew, but he hinted in his letter that this commission was to be only a beginning.[24]

Deeply discouraged, Géricault took the *Medusa* back. There was no room for it in the rue des Martyrs; the enormous canvas had to be rolled up and stored in the studio of the painter Léon Cogniet. One day, visiting this friend, Géricault found him studying the picture which had been unrolled on the floor. His work no longer pleased him: "It's not worth looking at," he told Cogniet, "I'll do better."[25] He had moments of dejection in which he thought of giving up painting.

The crisis of self-doubt through which Géricault passed in the winter following the Salon must have had more serious causes than his recent disappointments. Neither the half praise and half blame of the critics (whom, at any rate, he pretended to despise as "merchants of hot air"),[26] nor the official recognition which he had received justified his gloom. Had he considered his situation objectively, he would have found reasons for confidence and hope. But the persistent malaise which eroded his will, and at times deepened into physical or mental illness, arose from sources beyond the reach of common sense.

He had begun the *Medusa* immediately after the disaster of his love affair, and for a year and a half this work had been the centre of his life, an outlet for his energies and emotions, and perhaps a refuge from guilt. A strong compulsion was needed to keep him to his labour, and such a compulsion was at work in him at the time. Never before had he devoted himself so completely to one long-sustained effort. His earlier large projects had either been left unfinished or carried off in short bursts of very rapid work.[27] To complete the *Medusa,* he changed not only his normal manner of working but, for a remarkably long period, his way of life. All who saw him then were struck by his nervous concentration. Totally absorbed in his painting, he lived withdrawn in a protective solitude, shut off from everything that ordinarily gave him pleasure, but sheltered, too, from the painful realities of his personal situation. When his work was done, he fell into a state of inactivity, alternating between depression and restlessness. Sheer fatigue may have had a part in this collapse, but more damaging was the end of his central, sustaining occupation, which left him for the moment disorganized and without direction.

England

As he had done before, Géricault sought a cure in travel. He made plans "to leave France, try a life of adventure, perhaps visit the Orient".[28] Baron Gérard, the portrait painter, did his paternal best to argue him out of his more exotic projects. "What is it you think you lack here? You have wealth and talent, your first efforts in a difficult art have been crowned by success. Why take on the risk of

[24] Batissier, *op. cit.,* p. 56, Clément, *op. cit.,* pp. 175 ff. Géricault accepted the commission, but passed it on to Delacroix, who executed a *Notre-Dame des Douleurs* which Géricault acknowledged, but the payment for which he left to Delacroix. Destined for the Cathedral of Nantes, the painting was actually placed in the Cathedral of Ajaccio on Corsica.

[25] Clément, *op. cit.,* p. 172.

[26] In a letter to his friend de Musigny, Clément, *op. cit.,*

p. 171; Géricault's expression is *"vendeurs de vaine fumée"*.

[27] The *Charging Chasseur* of 1812, Géricault's first exhibited work, was rumoured to have been finished in twelve days (Clément, *op. cit.,* p. 51). Though this seems improbable, it is certain that the very large picture was completed in no more than two months. The *Wounded Cuirassier,* his second large work, was said by Géricault himself to have been finished in two weeks (Clément, *op. cit.,* p. 67, note 1).

[28] Clément, *op. cit.,* p. 176.

travel in nearly unexplored countries? Don't you have an almost inexhaustible source of inspiration here at home? What more do you want?" To which Géricault gave the strange answer: "What I want is the trial of misfortune."[29]

By chance, a fairly prosaic opportunity for travel offered itself. Never a despiser of money, Géricault was made aware of the possibility of entering into a business arrangement with an English showman, Mr. William Bullock, who operated the Egyptian Hall in Piccadilly (fig. PP),[30] an establishment which combined the character of an exhibition gallery with that of a museum of art and of scientific oddities, and which functioned at the same time as an auction house. In 1816, Bullock had shown the large and sensational canvas of *Brutus Condemning his Sons* by the French painter, Guillaume Lethière, at an admission charge of a shilling a head.[31] The exhibition had been profitable. Géricault learned of this venture through Auguste Lethière, the painter's son, and was persuaded to try out the *Medusa* on an English public. On 10 April 1820, he sailed from Calais on the packet *Iris* to treat with Bullock in London. An agreement was quickly reached. Auguste Lethière forwarded the rolled canvas of the *Medusa* to London,[32] where Bullock meanwhile had launched a campaign to advertise the forthcoming exhibition. In the second week of June, London dailies carried the following announcement on their front pages:

> "MONSIEUR JERRICAULT'S GREAT PICTURE, 24 feet long by 18 feet high, representing the Surviving Crew of the Medusa French Frigate on the Raft, just descrying the Vessel that rescued them from their dreadful situation: this magnificent picture excited universal interest and admiration at the last exhibition of the Louvre, and is now open for public inspection in the Roman Gallery, at the Egyptian Hall, Piccadilly: the public attention is respectfully invited to this chef-d'oeuvre of foreign art. Admission 1s. Description 6d."[33]

With the help of Charlet, who had accompanied him to London, Géricault lithographed the fairly crude print of his picture (Plate 23, cat. 27) which was to be given to visitors with the "Description".[34] He personally wrote some of the invitations for the private viewing of the picture (fig. OO),[35] which was held on 10 June and appears to have been well attended. Among the guests, *The Globe* noticed

[29] Batissier, *op. cit.*, pp. 53–54.

[30] Concerning Géricault's English voyage, cf. Lee Johnson, "The 'Raft of the Medusa' in Great Britain", *Burlington Magazine*, XCVI, August 1954, pp. 249 ff., and S. Lodge, "Géricault in England", *Burlington Magazine*, CVII, December 1965, pp. 616 ff.

[31] Johnson, *op. cit.*, p. 249, note 3.

[32] Lodge, *op. cit.*, p. 617.

[33] The exhibition of works of art, in return for an admission charge, was an alternative to state or private patronage, much debated by artists in the late eighteenth and nineteenth centuries. To some, it seemed a democratic and independent way of earning a living, much to be preferred to aristocratic or bureaucratic sponsorship, but the practical arrangements always proved difficult, and the expenses involved often defeated the purpose of such exhibitions. They were not uncommon in England, however, where normal patronage was particularly scant. In France, David had given the example when, in 1800, he showed his *Battle of Romans and Sabines* for a fee. In assessing the *Medusa*'s considerable success with the London public, it is important to bear in mind the share which Bullock's

management and advertising must have had in drawing attention to Géricault's work. Bullock placed no fewer than twenty-two prominent, front-page notices in *The Times* during the weeks of the exhibition's run, and paid for comparable series of advertisements in *The Morning Chronicle, The Globe, The Morning Post,* and the *London Literary Gazette.* He also saw to it that the picture was reviewed in London's principal papers.

[34] The "Description" is a pamphlet of fifteen pages, containing a brief account of the Raft's voyage, based on the narrative of Corréard and Savigny, and a summary description of the picture. The whole is prefaced by an excerpt from Southey: " 'Tis pleasant by the cheerful hearth to hear / Of tempests and the dangers of the deep . . ." and followed by a fulsome puff for Bullock's own Egyptian Hall, lately converted into *"a Mart for either public or private Sale . . . of Pictures, Marbles, Drawings, Books, and Engravings, Cameos, Subjects of Natural History and Antiquity, rare Works in Ivory, Japan, &c. &c. China, Cabinet Work, and furniture of every description; in short, every article of either ornament or use, for which any demand can be created".*

"the Marquis of Stafford, the Bishop of Ely and Carlisle, Sir T. Baring Bart., and a number of the most eminent patrons of the Fine Arts, together with several Members of the Royal Academy. Several Ladies of distinction also graced the throng."[36]

The exhibition opened to the general public on 12 June, and from the start attracted large crowds of visitors. After its close, on 30 December 1820, Bullock claimed that "upwards of 50,000 persons" had visited the picture at the Egyptian Hall, and while this may have been an exaggeration it is apparent that the exhibition was a popular and financial success. Géricault's share of the receipts amounted to between 17,000 and 20,000 francs, a considerable sum.[37] Nearly all of the more important London papers published accounts of the *Medusa*. The "dreadful wreck was still fresh in everybody's recollection", as the reviewers pointed out, and this fact certainly counted for much in the popularity of the exhibition. While Géricault's picture was on view in Piccadilly, a "new Melo-Drama, called the 'Shipwreck of the Medusa or the Fatal Raft' " also catered for London's connoisseurs of naval disasters, nightly attracting "overflowing audiences to the Coburg Theatre".[38]

Devoid of political implications for the general British public, the *Raft of the Medusa* was appreciated by them for the sake of its subject, as much as for the "power of art and ability of the artist", whom all the papers insisted on styling "Mr. Jerricault", in accordance with the spelling favoured by Bullock. It may have given Géricault wry amusement to find himself described in the English press as a "French Artist of great eminence", or at least as "an artist of great promise in France", and his picture as "one of the finest specimens of French art". The reviews were on the whole warmly favourable. The tireless Bullock, a heavy advertiser, may have had some influence on this, but it is apparent that British critics saw the picture more objectively and judged it with more insight than the majority of their French colleagues. What faults they found—chiefly with the picture's colour and the artificial attitudes of some of its figures—they tended to blame on "that cold pedantic school of which David may be considered the founder", and they were agreed that, while Géricault possessed all the merits of the Davidian School, he had "broken through the trammels of its system"[39] to achieve energy, truth and pathos. *"There is more of nature, of the grand simplicity of art, and of true expression than is usual with the highest of modern French painters"*, wrote the critic of the *Morning Post*.[40] The *Literary Gazette* was even more emphatic in its praise: *"In this tremendous picture of human sufferings, the bold hand of the artist has laid bare the details of the horrid facts, with the severity of Michel Angelo and the gloom of Caravaggio . . . The light brought into the piece and thrown upon the upturned faces of a centre group powerfully assists in arresting the attention. This seems to break on them from the illumination of a highly illuminated cloud above their heads, and is contrasted by much surrounding gloom, and this again by the bright rays of the morning . . . The powerful element of the mighty waters is very happily depicted by the hand of the artist; and taken all together, his work is, as we before observed, one of the finest specimens of the French school ever brought to this country."*[41]

The writer of *The Globe* ventured beyond a general appreciation of the picture to an interpretation

[35] Two of these are extant. Beside the one illustrated here there exists another, addressed to "Mr. Philips", on the back of a drawing of a lion, in the Musée Bonnat, Bayonne, inv. 700.

[36] *The Globe*, 12 June 1820, p. 3.

[37] Cf. Johnson, *op. cit.*, pp. 252–253.

[38] *The Morning Herald*, 24 June 1820, p. 3.

[39] *The Times*, 22 June 1820, p. 3; cf. Johnson, *op. cit.*, p. 250.

[40] *The Morning Post*, 13 June 1820, p. 3; cf. Johnson, *op. cit.*, p. 250.

[41] *The London Literary Gazette and Journal of Belles Lettres, Arts, Sciences, etc.*, 1 July 1820, p. 427; cf. Johnson, *op. cit.*, p. 251.

of its significance: "*Monsieur Jerricault . . . has selected for his first great historical effort a subject of the utmost difficulty, and with singular absence of the national vanity ascribed to his countrymen, one which it would be well for the naval character of France to have blotted from her maritime annals. The story of the shipwreck of the Medusa . . . records a narrative of the most criminal ignorance, pusillanimity, and individual suffering, which has no parallel in modern history. The acts of the revolutionary artist David do not seem to have brought down a censorship upon his art, as that of some of his colleagues did upon the press, else this subject would never have been permitted to have recalled the attention of the Frenchman on the walls of the Louvre, to the little attention which was in the case of the Medusa devoted to the responsibility of naval appointment. The artist, however, has selected the subject on account of its difficulties, and he has triumphed over many in the completion of his design. In the first place, to embody and concentrate the interest of this appalling subject, he had selected the time when the ruin on the raft may be said to be complete, and when the wretched survivors were first roused from their state of despair, by the appearance of the vessel that rescued them from their perilous situation. The personification of horror which his grouping exhibits baffles description; there is one figure of an old man, who still retains at his feet the dead body of his son, that is full of appalling expression. It is the very countenance of Ugolino's despair, which Reynolds pourtrayed with an effect finely forcible indeed, though without the haughty distinction which Michael Angelo gave the Italian Nobleman.*"[42]

After the exhibition closed at the Egyptian Hall, Bullock sent the picture to Dublin, where it was put on view at the Rotunda from 5 February until 31 March 1821. This showing proved far less successful than that in London, and it was ignored by the Dublin press.[43] One reason for the *Medusa*'s comparative failure seems to have been the competition it had to face from an elaborate popular entertainment, the "Novel Marine Peristrephic Panorama of the Shipwreck of the Medusa". This enormous, moving picture consisted of nearly 10,000 square feet of canvas, covered with figures the size of life and of "a superior style of brilliancy and effect", and it had the further advantage over Géricault's painting of being "accompanied by a full and appropriate band of music". The drama of the shipwreck unwound, scene after scene, before a seated audience; in the sixth scene, the men on the Raft were shown "at the moment they descried the *Argus* Brig" to the accompaniment of the strains of "Vive Enrico!".[44]

Géricault in the meantime stayed in London, occupied with a variety of work of small scale, drawing much and painting little. Still not fully recovered from the ordeal of the *Medusa,* he had given up, for the time being, all thought of grandiose subjects or grand style. Instead, he devoted himself to the observation of English life and to lithographic work from which he hoped to derive a profit.

"*I don't amuse myself at all*", he wrote to his friend Dedreux-Dorcy from London, on 12 February 1821, "*my life is absolutely the same as in Paris. I work a lot in my room and then roam the streets for relaxation. They are so full of constant movement and variety that you would never leave them, I am sure. But the reasons which would keep you there are the very ones that chase me away. I feel that prudence is increasingly becoming my lot, though I am still the most foolish of all sensible men; my desires are still insatiable, and whatever I do, it is never what I should have wanted. Yet I am more reasonable than you, since at least I work and turn out lithographs with all my might. I have for some time been devoting myself to this art which is a novelty in London and is having an incredible vogue here. With a little more tenacity than I possess, I am sure one could make a considerable fortune.*

[42] *The Globe,* 12 June 1820, p. 3.
[43] Except for Bullock's advertisements in the *Freeman's Journal* and the *Dublin Evening Post:* cf. Johnson, *op. cit.,* p. 251.
[44] *Dublin Evening Post,* 20 February 1820, p. 1; cf. Johnson, *op. cit.,* p. 251.

I flatter myself that this will merely be my advertisement, and that as soon as the true connoisseurs have come to know me they will use me for work worthier of myself. You'll call it ambition, but, by God, it is just a matter of striking the iron while it is hot. Since I am receiving encouragement, I'll send to the devil all those Sacred Hearts of Jesus. That's work for starving beggars. I renounce the buskin and Scripture, to lock myself into the stables, from which I expect to return covered with gold."[45]

Beneath the banter and defiance, there was distress. The stay in London had not improved Géricault's mood or health. He had suffered serious sickness and undergone repeated spells of depression during which, it is said, he had attempted suicide.[46] The reception of the *Medusa* in London must have given him some satisfaction, but his lithographic enterprise ended in disappointment and financial loss.

Last Years

He returned to France with his picture in the last days of December 1821.[47] His life was now rapidly winding down to its end. Frequently ill, he suffered from what seemed to his friends a kind of physical and moral fatigue. "There was a trouble in him", according to Clément, "that was difficult to define, but impossible to mistake."[48] Géricault in fact behaved as one who seeks unhappiness and self-punishment. An urge to self-destruction, barely concealed, guided his conduct in these last years. The repeated riding accidents, which succeeded in breaking what remained of his health, the ruinous speculations and reckless expenditures which brought him to the edge of want, and the reported attempts at suicide[49] give the impression of a purpose followed, a wish for death rapidly carried out. A self-portrait painted about this time (now at the Rouen Museum) shows a bearded, drawn face with sunken cheeks and the signs of premature aging.

During 1822, he suffered a serious illness from which he recovered only very slowly. Early in 1823, he had a relapse. His fatal illness—a disintegration of the spine, perhaps caused by tubercular infection—now declared itself, and forced him on his sickbed, from which he was able to rise less and less often. The latter half of 1823 was a prolonged agony.[50] Delacroix noted in his diary on 30 December 1823: *"Some days ago, I was at Géricault's in the evening. What a sad time! He is dying—his emaciation is horrible. His thighs are as big as my arms. His head is that of an aged and dying man. I sincerely want him to live, but I no longer have hope. What a frightful change!"*[51]

On 16 January 1824, Charlet added a postscript to an otherwise remarkably cheerful letter: *"There is nothing new; everybody is in good health, but that poor Géricault is in bed, perhaps for the last time."*[52]

Ten days later, Géricault died, aged thirty-three years. Toward the end, as his condition grew more and more hopeless, his desire for life returned with full force and he was tormented by a thirst for work. In one of his last letters, he wrote to the young painter, Eugène Isabey: *"From within my bed, dear Eugène, I send you my greetings, with a thousand good wishes, and above all with a little more hope than I had*

[45] Clément, *op. cit.,* pp. 192 ff.

[46] The suicide attempt was reported by Géricault's travelling companion, Charlet (cf. La Combe, *Charlet,* Paris, 1856, p. 19); Clément doubted the truth of Charlet's account (*op. cit.,* p. 188).

[47] Cf. Johnson, *op. cit.,* p. 253.

[48] Clément, *op. cit.,* p. 228.

[49] The painter Paul Chenavard claimed, several decades after the reported fact, that during this last period of his life, Géricault attempted suicide (cf. Boyer d'Agen, *Ingres,*

d'après une correspondance inédite, Paris, 1909, p. 166). Though this may be merely another version of Charlet's account of the earlier suicide attempt in London, it is significant that these rumours were current among men who had known Géricault.

[50] Clément, *op. cit.,* pp. 251 ff.

[51] A. Joubin (ed.), *Journal d'Eugène Delacroix,* I, Paris, 1932, p. 40.

[52] La Combe, *Charlet,* Paris, 1856, p. 36.

*when you left . . . I so much envy you the ability to work that I advise you not to lose a single instant your good
health allows you to put to good use. Your youth, too, will pass, my young friend."*[53]

The old ambition to attempt work of tremendous scale plagued him once more. He lamented his
many unfinished projects, his frequent changes of direction and style, the frittering away of his
energies in small enterprises. He imagined that he had never really achieved anything: "If only I
had painted five pictures! But I've done nothing, absolutely nothing."[54] It is reported that when
someone mentioned the *Medusa* he dismissed it—"Bah! a vignette!".[55] Yet his thoughts anxiously
returned to his picture until the very end. He examined a copy of it on his sickbed, found defects,
and looked for reassurance from his friends.[56]

The *Medusa* was, as he well knew, the culminating achievement of his life. In hindsight, it is apparent
that what had seemed scattered and inconclusive in his earlier work in fact converged with a steady,
logical progression on this painting. The course of Géricault's development had described a pattern
of remarkable symmetry: ramified in its beginnings, it had come to a focus in the *Medusa,* to diverge
again into a variety of directions in his late years. For a moment, in the middle of his career, all the
circumstances of his personal existence and artistic preparation combined to arm him for this effort.
During a lull in the world of art around him, and at a time of highest personal readiness, he met
with an opportunity which challenged his artistic powers. By chance, the challenge found him in a
state of emotional tension which enabled him, perhaps compelled him, to concentrate his energies
on this enterprise and to carry it to completion. When it was done, there came a break, and a lapse
into work of smaller scale and ambition, of shorter duration and experimental variety. This did not
signify a decline, but it brought with it a lessening of that driving intensity which had made the
Medusa possible and given it its particular expressive character. After the *Medusa,* Géricault never
again attempted a project of remotely comparable scale or difficulty, though at the very end, too late,
he was troubled by the desire to cover vast surfaces with scenes from modern life. Had he lived a few
years longer, the compositions which he imagined on his sickbed,[57] the *Surrender of Parga,* the *Opening
of the Doors of the Inquisition,* or the *Negro Slave Trade,* might have competed at the Salon with Delacroix's
Massacre of Chios and *Greece Expiring on the Ruins of Missolunghi.*

The Purchase of the Medusa

The Director of the Louvre, de Forbin, in the meantime had continued in his effort to persuade
the government to buy the *Medusa* for the royal collections.[58] Shortly after the picture's return from
England, on 2 February 1822, he addressed a letter to M. de Lauriston, Minister of the Royal House-

[53] Clément, *op. cit.,* p. 265.

[54] *Ibidem,* p. 261.

[55] Cf. H. Lachèvre, *Details intimes sur Géricault,* Rouen,
1870, quoted in Courthion, *Géricault raconté par lui-même et
par ses amis,* Vésenaz-Geneva, 1947, p. 267.

[56] Clément, *op. cit.,* pp. 172–173.

[57] Cf. Clément, *op. cit.,* pp. 232 and 261; Batissier, *op. cit.,*
p. 61. Scattered studies and sketches for these projects are
preserved in the Dubaut collection (*Surrender of Parga* and
Liberation of the Prisoners of the Inquisition), the Besançon
Museum (*Inquisition*) and the Ecole des Beaux-Arts (*Negro
Slave Trade*).

[58] The documents relating to the purchase of the *Raft*
were published by Chennevières in *Archives de l'art français,*
I, 1851–52, pp. 71–80, and excerpted by Clément, *op. cit.,*
pp. 170 ff. Thoré (*Le Salon de 1846,* Paris, 1846, p. 30) claimed
that it was Horace Vernet's intercession which set de Forbin
in motion, but this seems unlikely. Himself a painter of the
picturesquely romantic, mediaevalizing kind, de Forbin had
exhibited a large, historical genre painting at the Salon of
1819, *Inez de Castro, Disinterred and Crowned, Several Days
after her Death, in the Abbey of Alcobaca.* De Forbin's strong
advocacy of the *Medusa* is all the more remarkable in view
of his own, quite different artistic direction.

hold, again proposing the purchase and suggesting that the picture might be placed in the Palace of Versailles. The *Medusa,* he pointed out, had been a costly work to produce. It had won the esteem of French artists and of the British public. Géricault had brought it back to Paris in the hope that it might remain in France. A payment of 6,000 francs would be acceptable to the artist. This plea remained unanswered, as did another sent on 27 May. Exactly one year later, on 27 May 1823, de Forbin returned to the charge with a vigorous remonstrance:

"The administration of the Fine Arts has often been accused of failing to give exclusive encouragement to history-painting, which wholly depends on the government for support. By way of substantiation of this ill-founded criticism, the government's neglect of an important work is often cited . . . The Raft of the Medusa *shows its painter, M. Géricault, to have taken from the works of Michelangelo that grandeur which does not please the masses but which constitutes true history-painting . . . M. Géricault is completely discouraged by the way we have ignored his picture, which he has been willing these past two years to sell for five to six thousand francs. This is the price currently being paid for small genre paintings."*

This request, too, was ignored.

Knowing that he was close to death, Géricault made his last will on 30 November 1823. His intention was to leave all his property to his natural son, still legally unacknowledged but much on his mind. He tried to achieve his end by appointing as his sole heir his father, aged eighty, who thereupon wrote a will of his own bequeathing all property to the child. Following Géricault's death, an inventory was drawn up which covered his paintings and other works stored in the house at the rue des Martyrs or in the studios of various friends. In the meantime, a family intrigue had induced the elder Géricault to change his will, thus frustrating the artist's intent—instead of going to the child, most of the property was now to be apportioned among maternal and paternal relatives. The gold medal which the *Medusa* had won at the Salon fittingly enough was to be given to one of the legitimate sons of Géricault's mistress.[59]

After Géricault's horses and other movable belongings had been turned into money, a public auction of the remaining paintings and drawings was arranged for 2-3 November 1824.[60] The first and most important item to be offered for sale was the *Medusa,* still listed in the auction catalogue as "Scène de naufrage". The alert de Forbin urgently advised the Vicomte de la Rochefoucault, who had succeeded to the Royal Household Ministry, of this opportunity which, he feared, might well be the last. The Ministry responded by authorizing an expenditure of between 4,000 and 5,000 francs, not enough to meet the estimate of 6,000 francs. At the sale, Géricault's friend, Dedreux-Dorcy, purchased the *Medusa* for 6,005 francs, while de Forbin made further efforts to obtain funds to cover the full purchase price.[61] These were granted by a ministerial decree on 12 November 1824. Thus the *Raft of the Medusa* was secured for the French nation by the Bourbon monarchy, to which it had given offence at the Salon five years earlier. It is said that an English collector had offered 23,000 francs for the picture[62] and that merchants had advised cutting it up into separate "studies".[63]

[59] This information has been very kindly communicated to me by M. Le Pesant of the Archives Nationales in Paris.

[60] Cf. L. Eitner, "The Sale of Géricault's Studio in 1824", *Gazette des Beaux-Arts,* 6e ser., LIII, 1959, pp. 115 ff.

[61] Clément, *op. cit.,* p. 180.

[62] "Tombeau de Géricault, par M. Etex", *Magasin Pittoresque,* 1841, p. 110. The story of the English offer, also reported by other early sources, seems the more

credible since it is contained in an article largely based on information furnished by Dedreux-Dorcy himself.

[63] Achille Devéria, writing to Ricourt, founder of the magazine *l'Artiste,* in 1831 mentioned that *"à sa vente les amateurs demandaient que l'on mit en morceaux son tableau des Naufragés de la Méduse, ce qui pour eux eut fait d'assez belles études".* (M. Gauthier, *Achille et Eugène Devéria,* Paris, 1925, p. 69). Cf. also T. Thoré, *Le Salon de 1846,* Paris, 1846, p. 30.

PLATES

COMPOSITION STUDIES
AND THE RAFT
Plates 1–24

FIGURE STUDIES
Plates 25–107

LATER REPRODUCTIONS
Plates 108–114

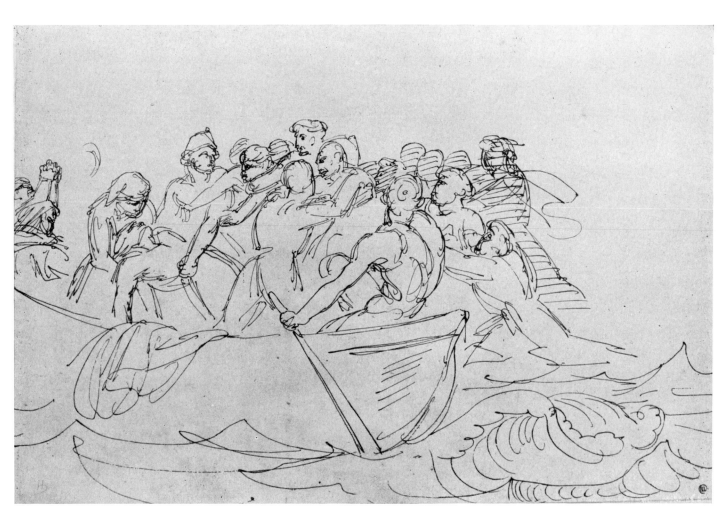

1. The Rescue of the Survivors (Cat. no. 1). Dijon, Musée des Beaux-Arts

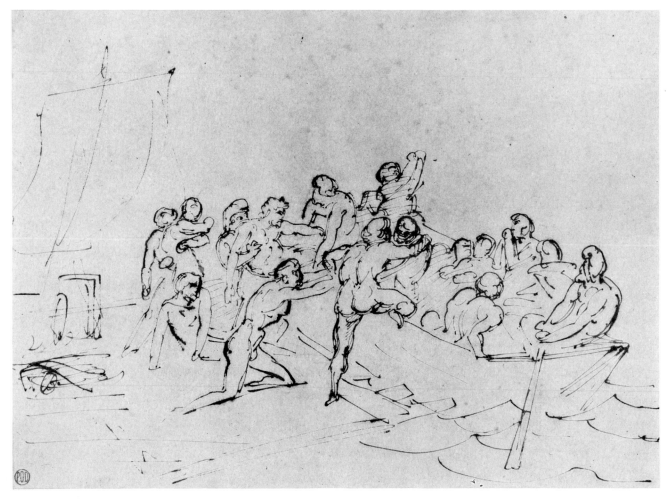

2. The Rescue of the Survivors (Cat. no. 2). Paris, Dubaut collection

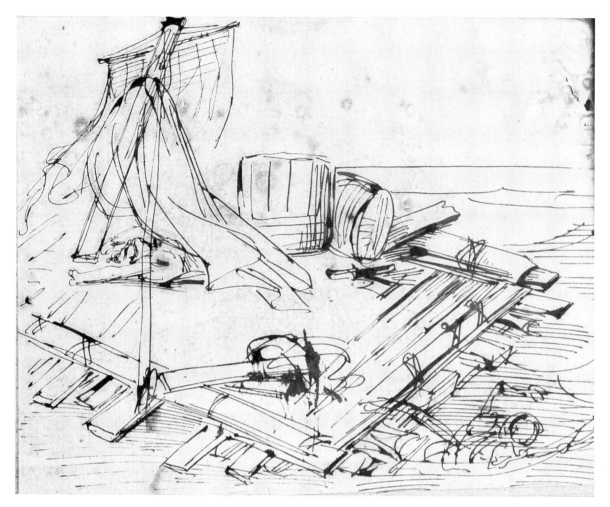

3. The Abandoned Raft (Cat. no. 3). Poitiers, Musée des Beaux-Arts

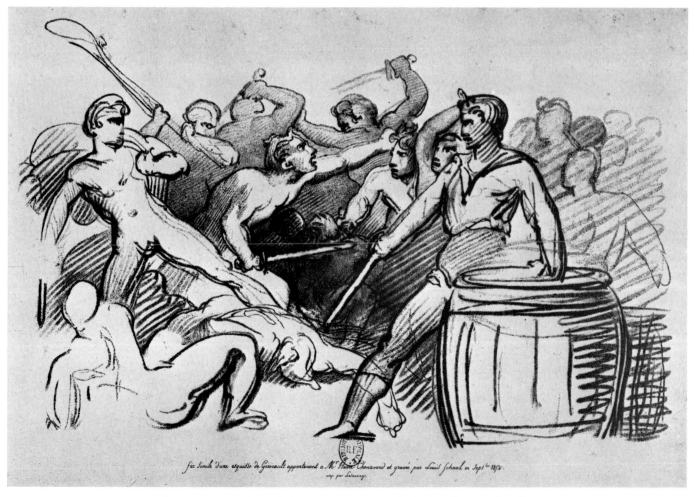

4. The Mutiny on the Raft (Cat. no. 5). Formerly Paris, Chenavard collection

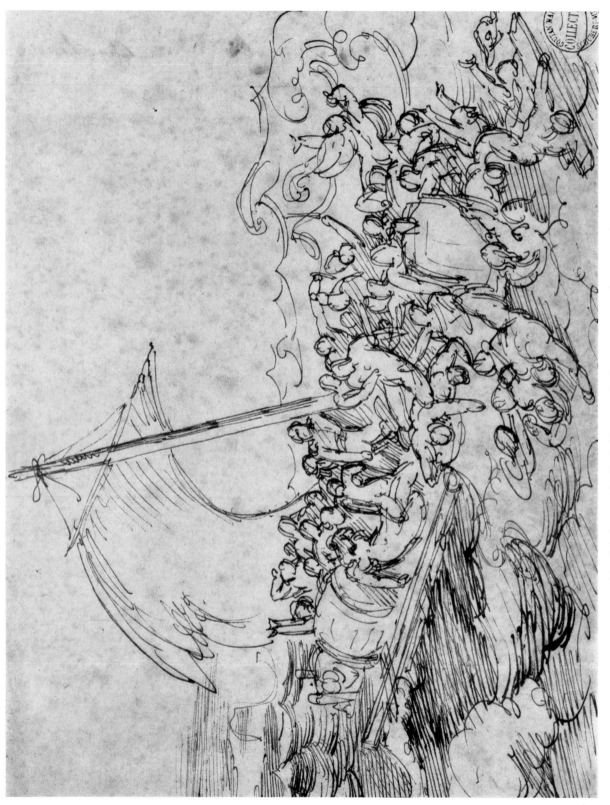

5. The Mutiny on the Raft (Cat. no. 6). Rouen, Musée des Beaux-Arts

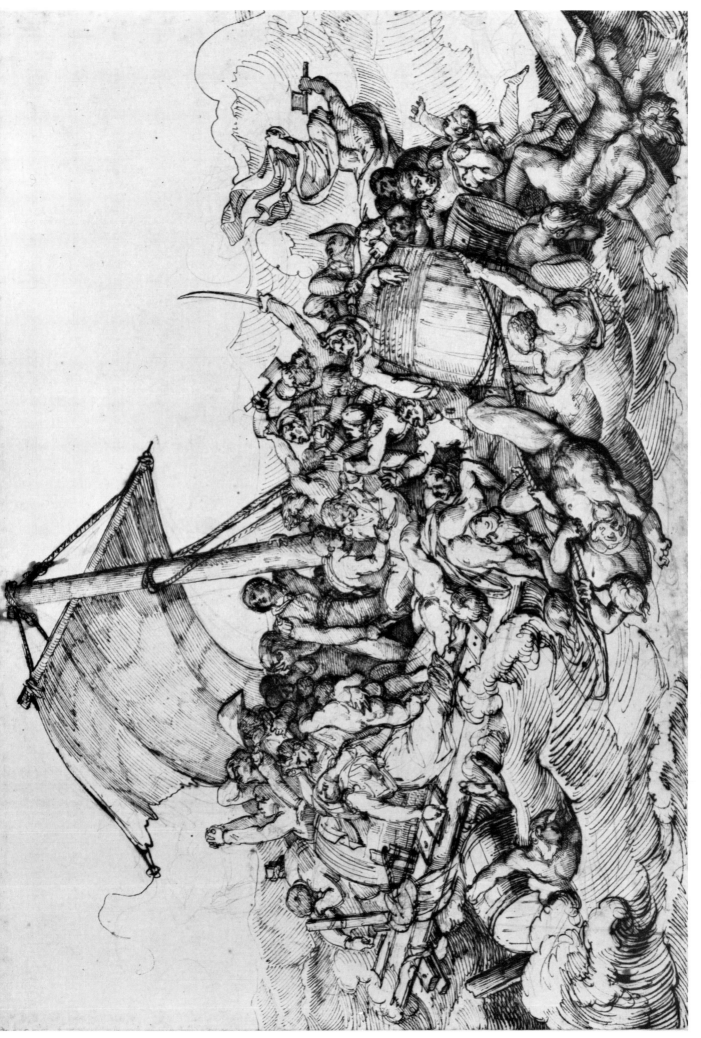

6. The Mutiny on the Raft (Cat. no. 7). Amsterdam, Stedelijk Museum

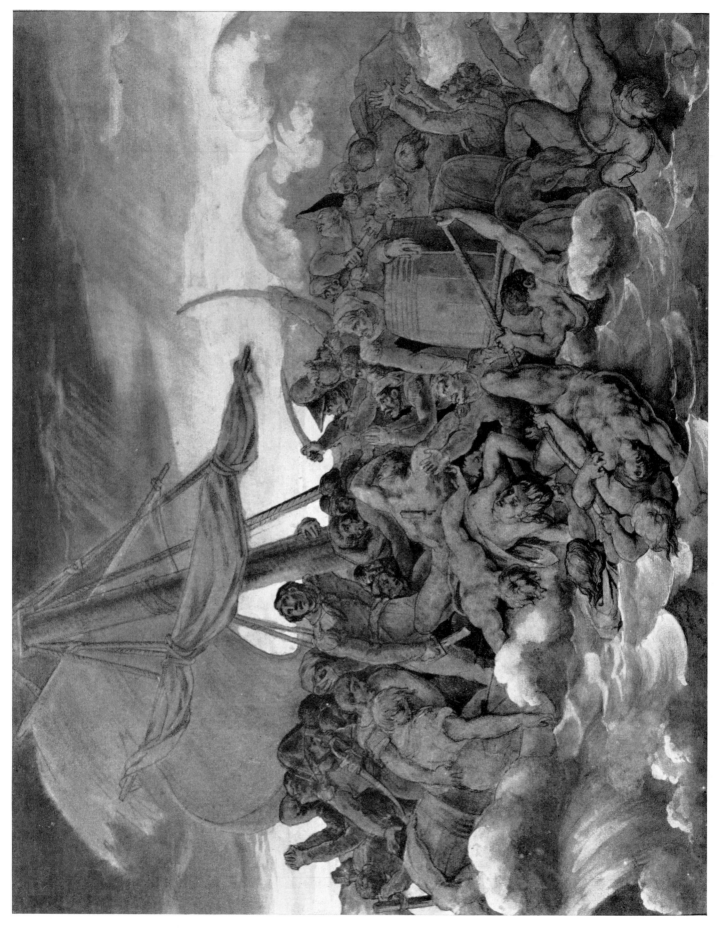

7. The Mutiny on the Raft (Cat. no. 8). Cambridge, Massachusetts, Fogg Art Museum

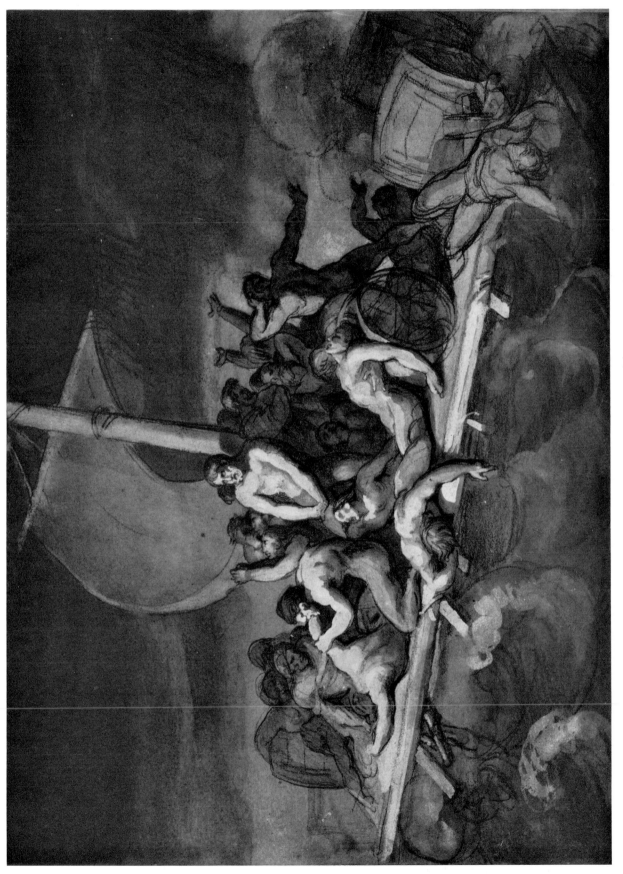

8. Despair and Cannibalism on the Raft (Cat. no. 10). Paris, Gobin collection

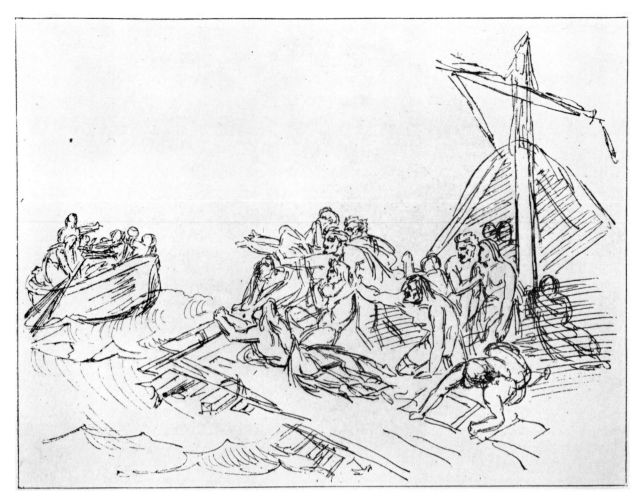

9. The Survivors hailing the Approaching Rowing-boat (Cat. no. 11). Formerly Paris, Marcille collection

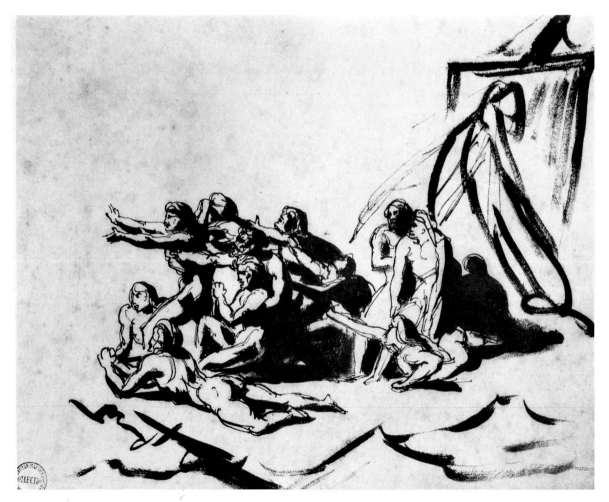

10. The Survivors hailing the Approaching Rowing-boat (Cat. no. 12). Rouen, Musée des Beaux-Arts

11. The Survivors hailing the Approaching Rowing-boat (Cat. no. 3v). Poitiers, Musée des Beaux-Arts

12. Three Sketches of the Raft amidst high Waves (Cat. no. 14). Besançon, Musée des Beaux-Arts

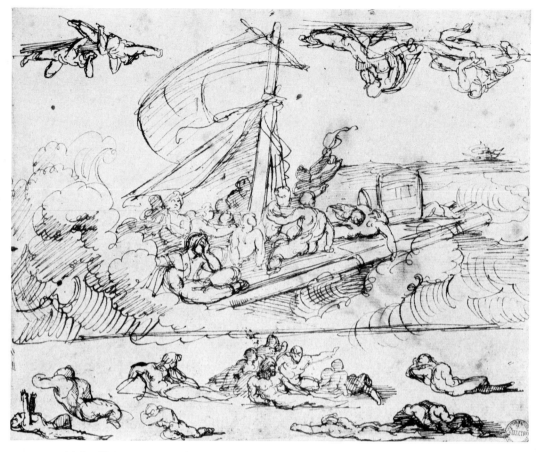

13. The Sighting of the distant *Argus* (Cat. no. 15). Rouen, Musée des Beaux-Arts

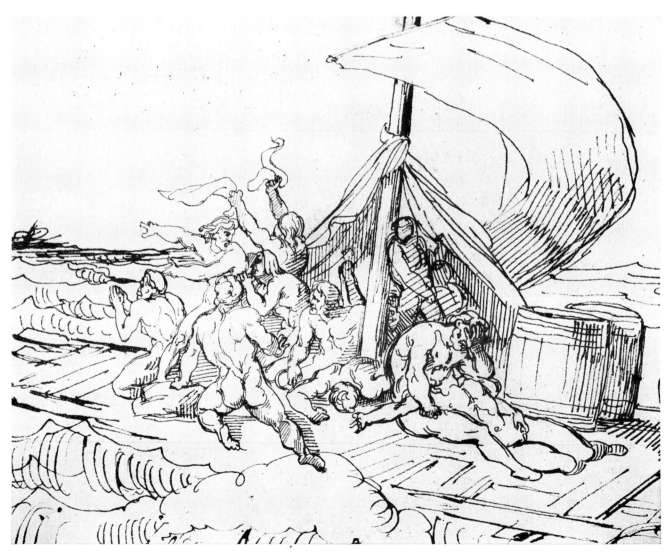

14. The Sighting of the distant *Argus* (Cat. no. 16). Lille, Palais des Beaux-Arts

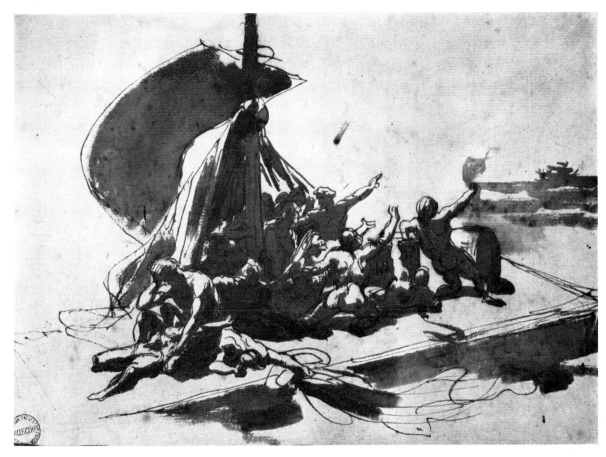

15. The Sighting of the distant *Argus* (Cat. no. 17). Rouen, Musée des Beaux-Arts

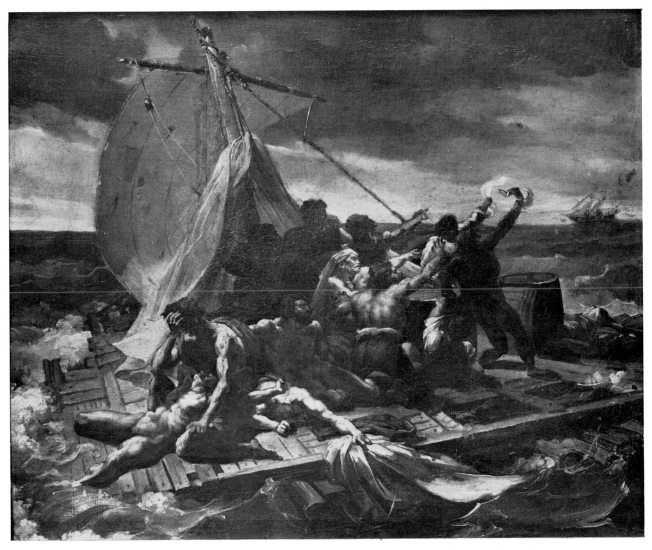

16. The Sighting of the distant *Argus* (Cat. no. 18). Paris, Louvre (ex-Schickler collection)

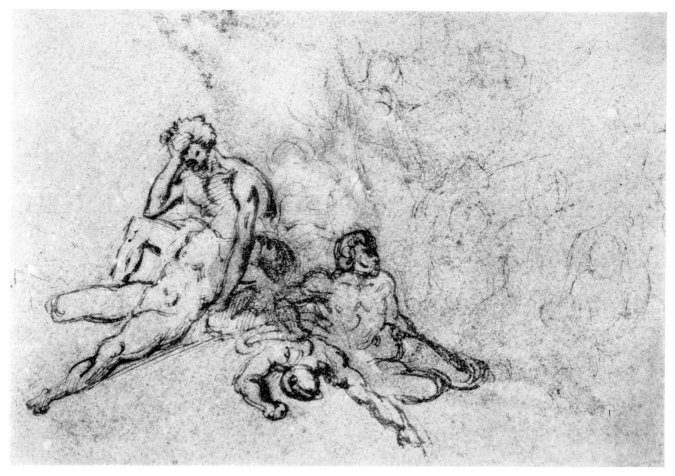

17. *The Raft of the Medusa:* early version of the definitive composition (Cat. no. 19). Paris, Aubry collection

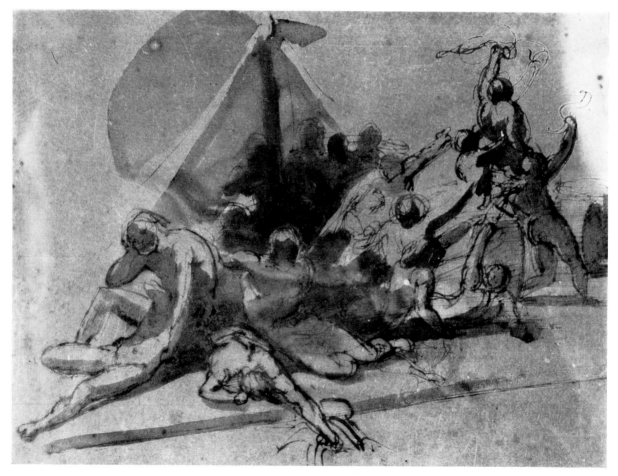

18. *The Raft of the Medusa* (Cat. no. 20). Paris, Aubry collection

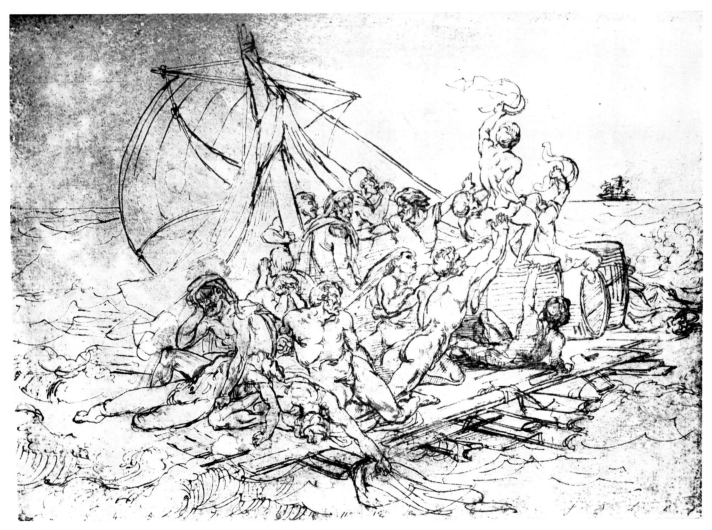

19. *The Raft of the Medusa* (Cat. no. 22). Paris, Louvre (ex-Trévise collection)

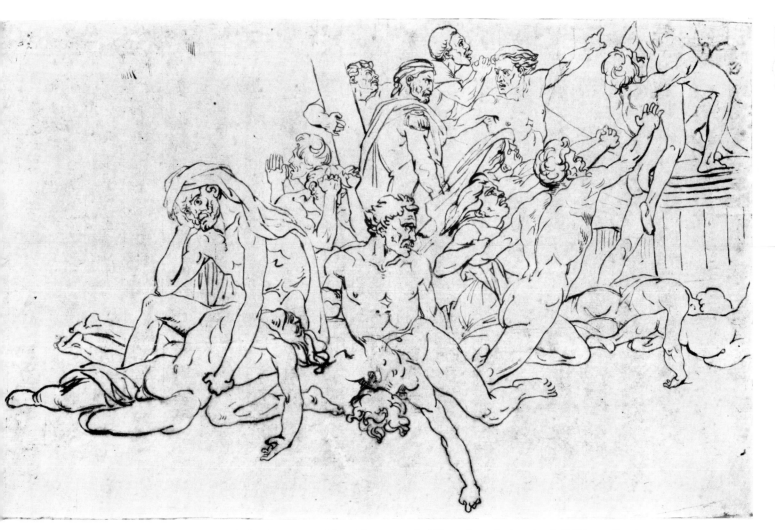

20. *The Raft of the Medusa:* definitive composition (Cat. no. 23). Winterthur, Switzerland, Bühler collection

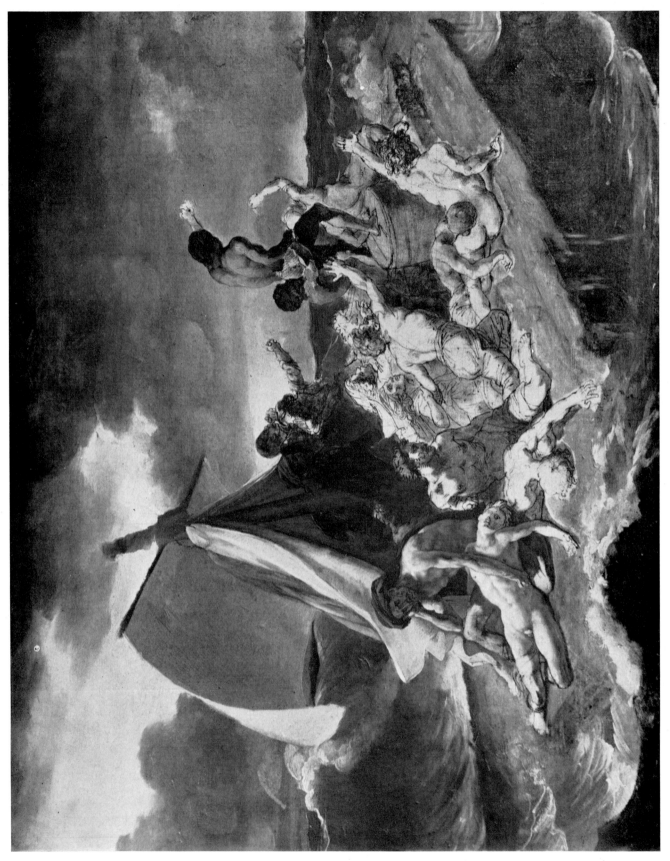

21. *The Raft of the Medusa*: definitive composition (Cat. no. 24). Paris, Louvre (ex-Moreau-Nelaton collection)

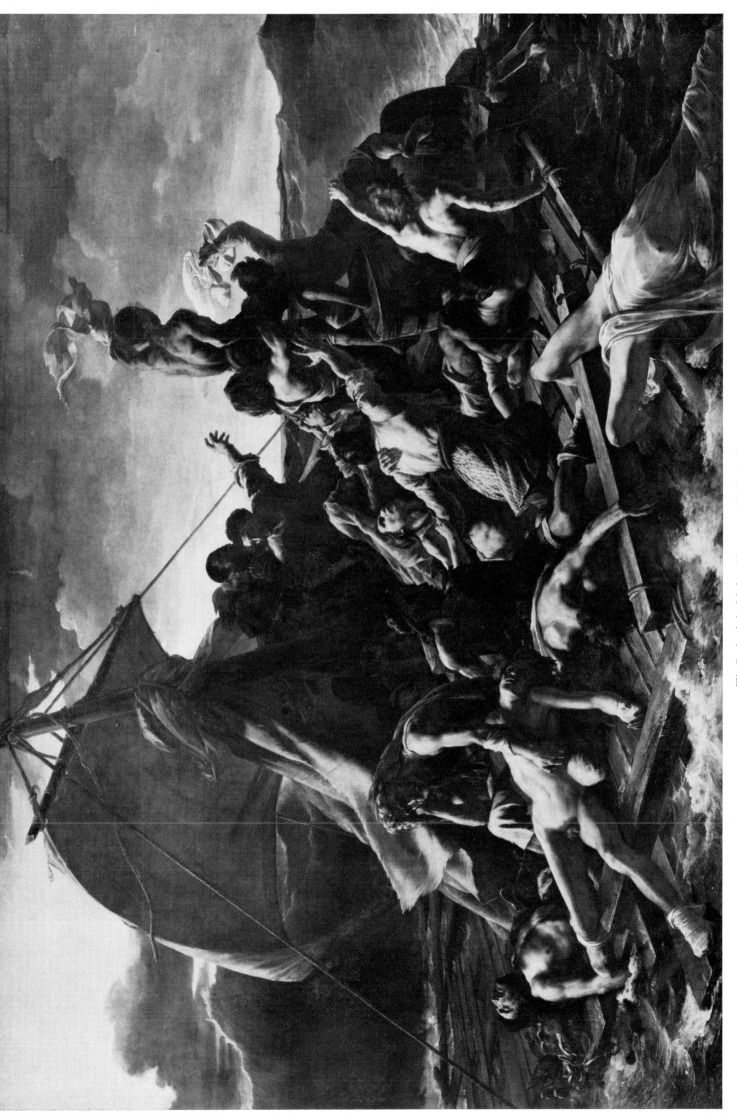

22. *The Raft of the Medusa* (Cat. no. 26). Paris, Louvre

SHIPWRECK OF THE MEDUSE.

C. Hullmandel's Lithography.

23. "Shipwreck of the Medusa" (Cat. no. 27). Lithograph

24. *The Raft of the Medusa* (Cat. no. 28). Reproduction of lost watercolour

FIGURE STUDIES

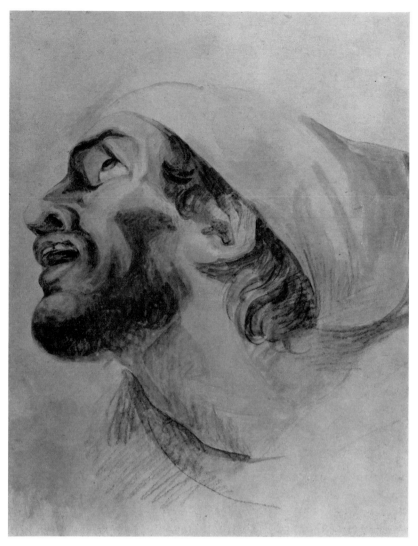

25. Head of a bearded Man, after a painting by Doyen (Cat. no. 32).
Paris, Bellier collection

26. Study for the Group of a Father holding his Wife and Child (Cat. no. 34). Paris, Marillier collection

27. Copy after a portion of an engraving of Rubens' "Little Last Judgement" (Cat. no. 33).
Stanford, California, Stanford University Museum

28. Study for the Group of a Father holding his Wife and Child (Cat. no. 35). Cambridge, Massachusetts, Fogg Art Museum

29. Study of a Man lifting the Body of Another from the Water (Cat. no. 36). Bayonne, Musée Bonnat

30. Study of a Man lifting the Body of Another from the Water (Cat. no. 37). Formerly London, Powney collection

31. Study for the "Father holding his dead Son" and three adjacent figures (Cat. no. 39). Düsseldorf, Kunstmuseum der Stadt

32. Study for the "Father" and partial study
of the seated Man (Cat. no. 40).
Toronto, Jowell collection

33. Sketch of the "Father" (Cat. no. 41).
Vienna, Albertina

34. "Father and Son" (Cat. no. 78v). Besançon, Musée des Beaux-Arts

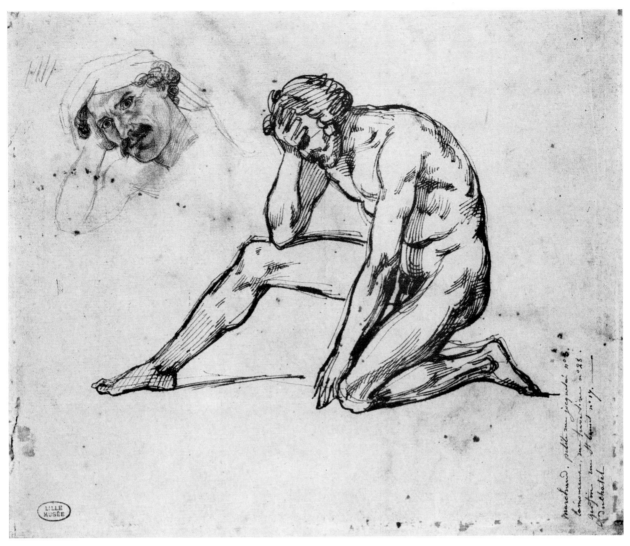

35. Study for the "Father" (Cat. no. 42). Lille, Palais des Beaux-Arts

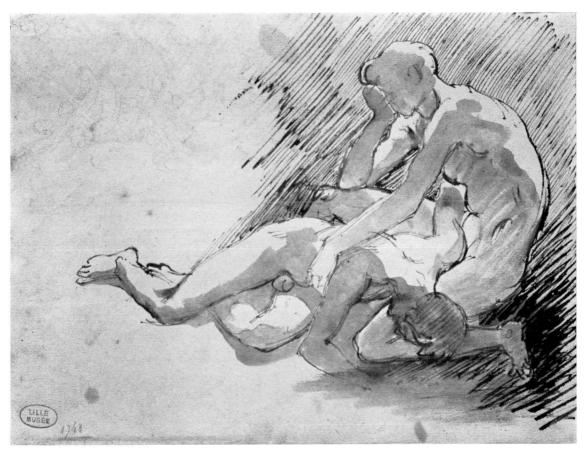

36. Study for the "Father holding his dead Son" (Cat. no. 43). Lille, Palais des Beaux-Arts

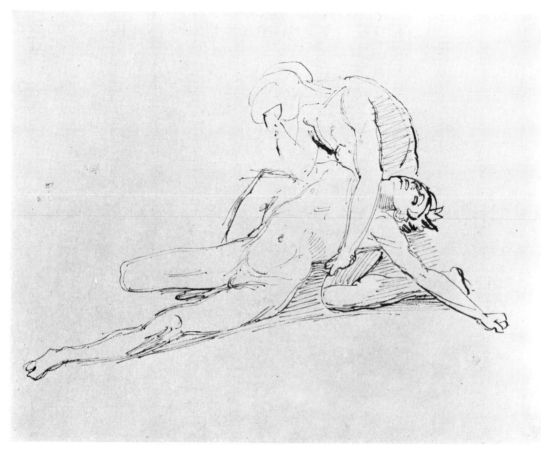

37. Study for the "Father holding his dead Son" (Cat. no. 44). Paris, Aubry collection

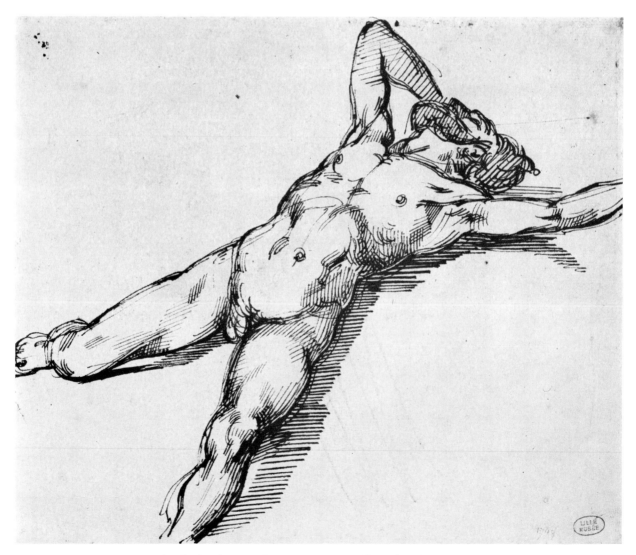

38. Study for the "Son" (Cat. no. 42v). Lille, Palais des Beaux-Arts

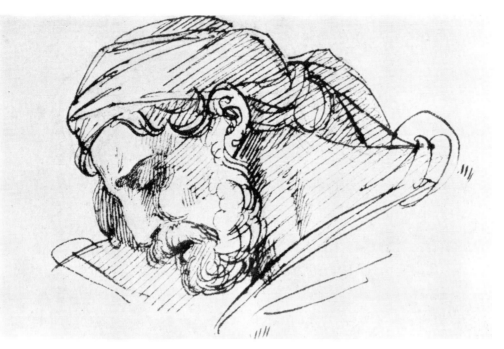

39. Sketch for the Head of the "Father" (?) (Cat. no. 46). Toronto, Jowell collection

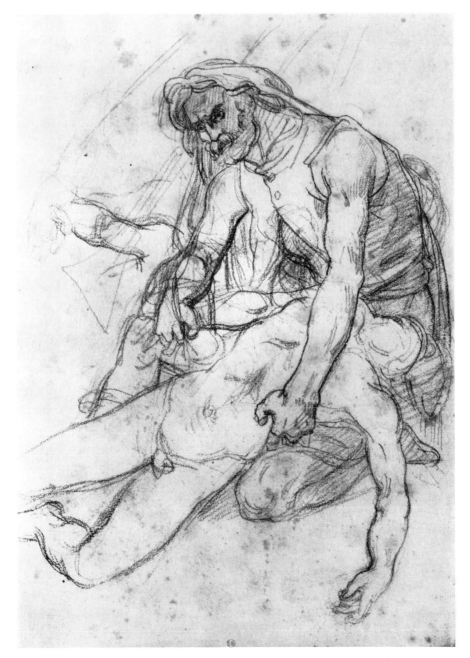

40. Study for the "Father holding his dead Son" (Cat. no. 45). Bayonne,
Musée Bonnat

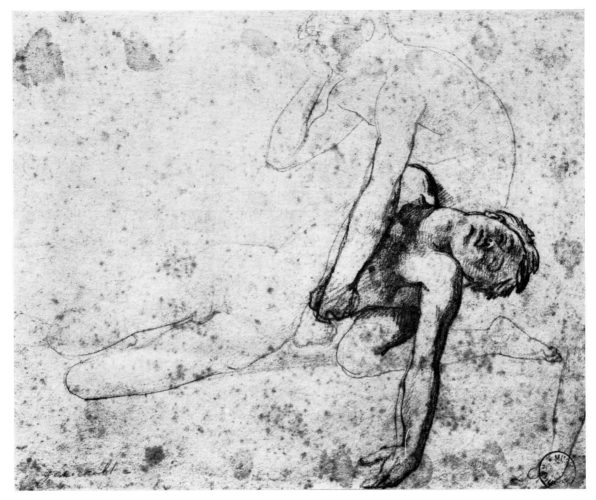

41. Study for the "Father holding his dead Son" (Cat. no. 47). Rouen, Musée des Beaux-Arts

42. Study for the Figure of the "Dead Son" (Cat. no. 48). Lille, Palais des Beaux-Arts

43. Study of an emaciated male Nude (Cat. no. 49). Bayonne, Musée Bonnat

44. Study for the Figure of the "Father" (Cat. no. 50). Paris, Dubaut collection

45. Youth lying on his Face (Cat. no. 15v). Rouen, Musée des Beaux-Arts

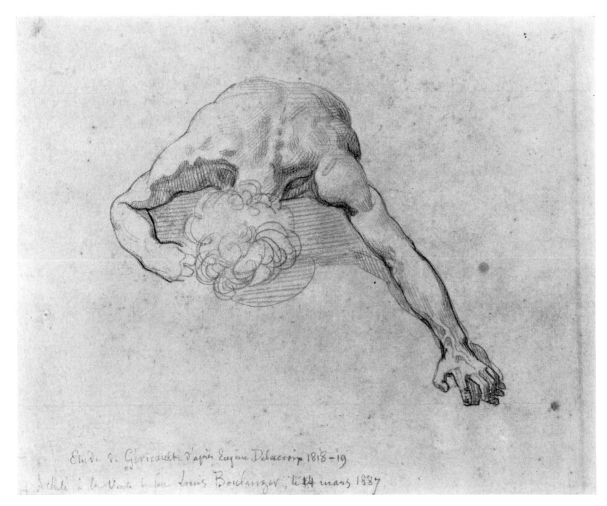

46. Study for the dead Youth lying on his Face (Cat. no. 51). Paris, Dubaut collection

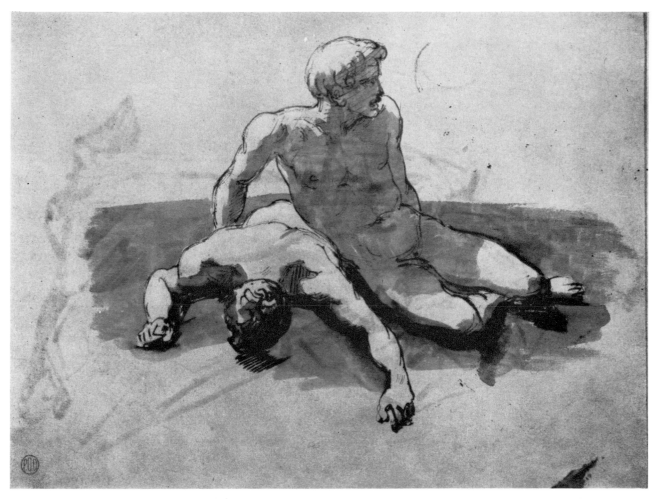

47. Study of a seated and a reclining Figure (Cat. no. 52). Paris, Renand collection

48. Youth lying on his Face (Cat. no. 79v). Besançon, Musée des Beaux-Arts

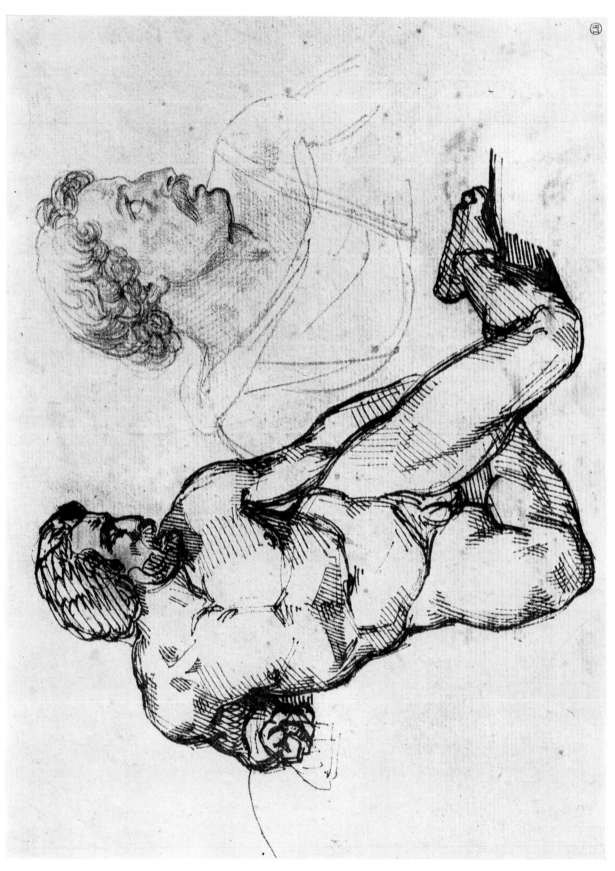

49. Study of a seated, nude Man and of the Head of a Man (Cat. no. 54). Bayonne, Musée Bonnat

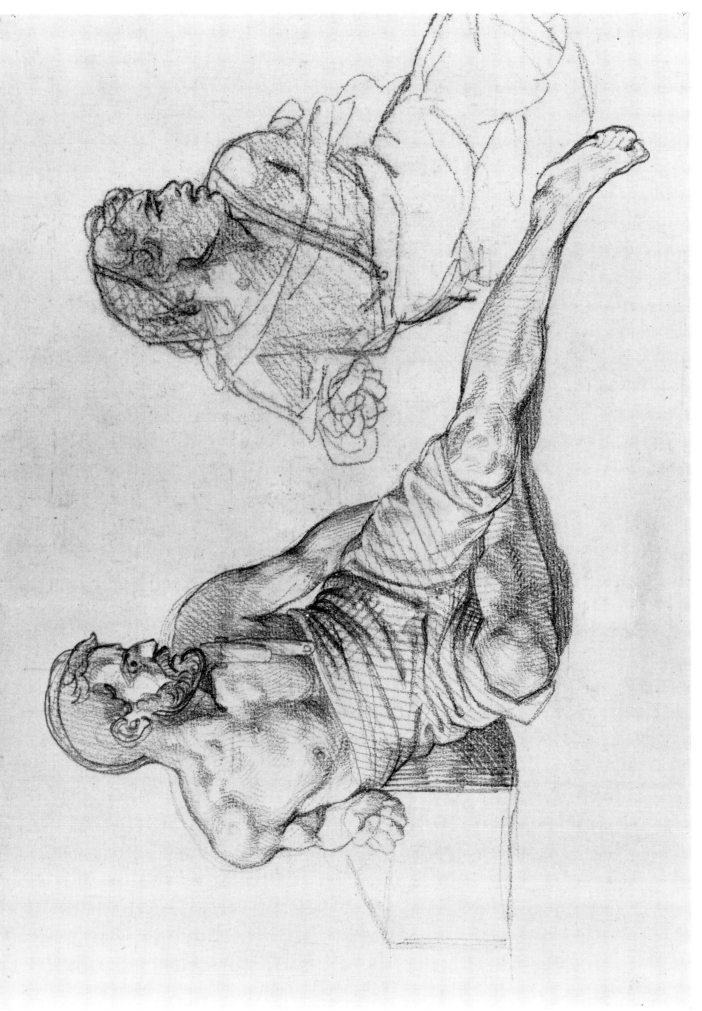

50. Study for the seated Man on the "Father's" right (Cat. no. 50v). Paris, Dubaut collection

51–52. Two sketches of a kneeling Man (Cat. nos. 55 and 56). Toronto, Jowell collection

53. Study of a kneeling Man reaching forward with both Arms (Cat. no. 57). Toronto, Jowell collection

54. Study of a kneeling Man raising his right Arm (Cat. no. 58). Bayonne, Musée Bonnat

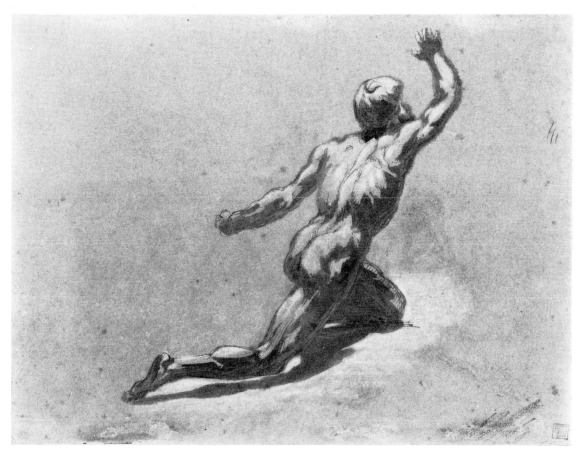

55. Study for the figure of the Man dragging himself forward on his Knees (Cat. no. 19v).
Paris, Aubry collection

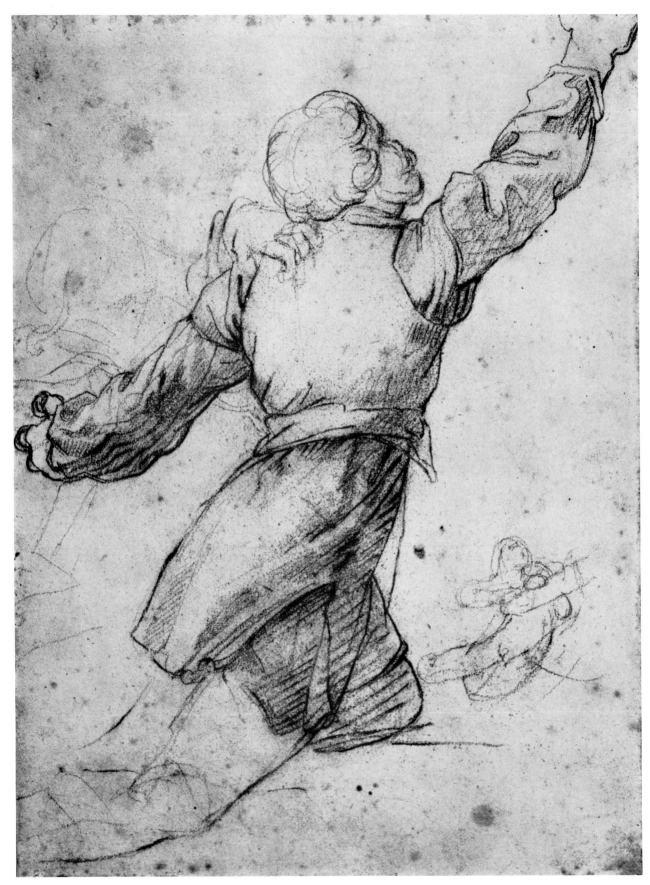

56. Study of a Man dragging himself forward on his Knees (Cat. no. 59). Paris, Louvre

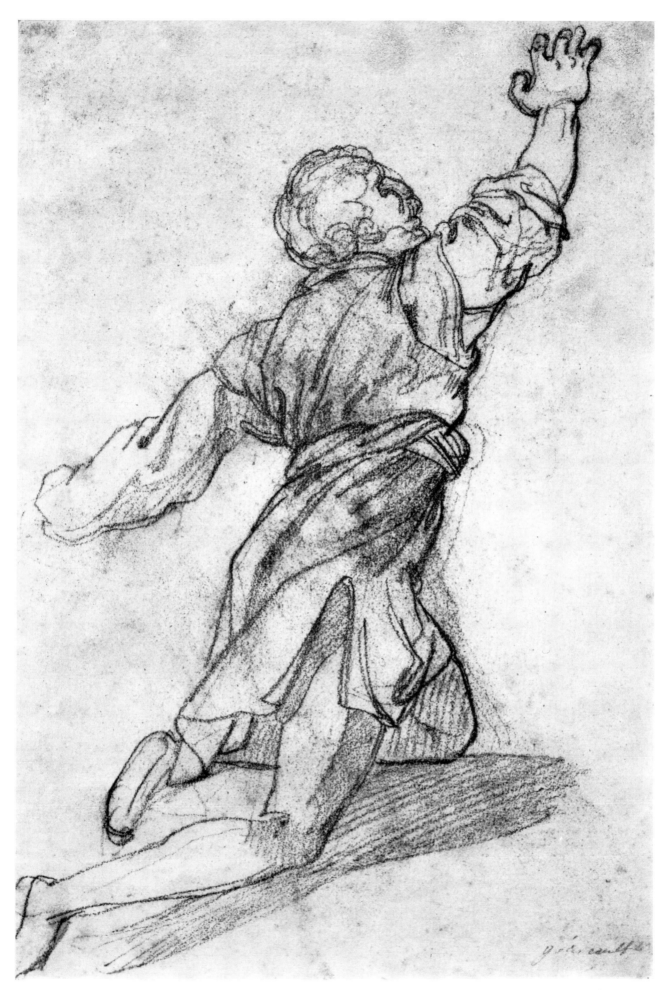

57. Study of a Man dragging himself forward on his Knees (Cat. no. 60). Rouen, Musée des Beaux-Arts

58. Two studies of the upper part of a shrouded Figure raising
the left Arm (Cat. no. 61). Paris, Aubry collection

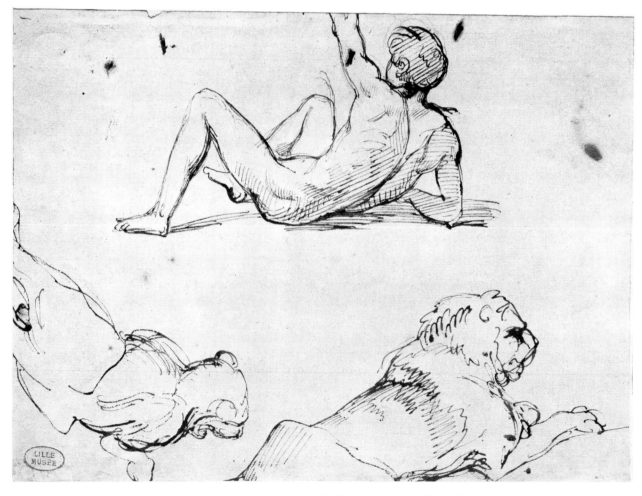

59. Study of a Man attempting to raise himself (Cat. no. 43v). Lille, Palais des Beaux-Arts

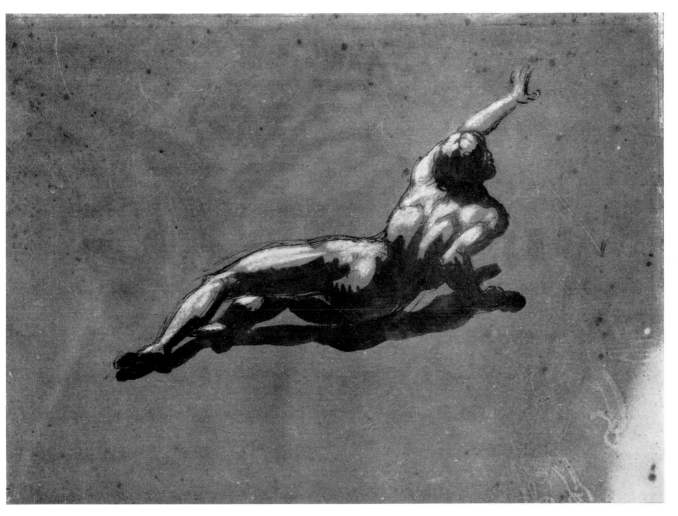

60. Study of a Man attempting to raise himself (Cat. no. 20v). Paris, Aubry collection

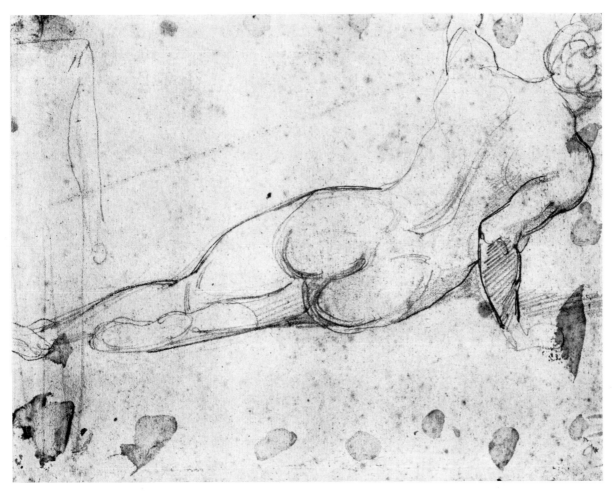

61. Study for the Man attempting to raise himself (Cat. no. 47v). Rouen, Musée des Beaux-Arts

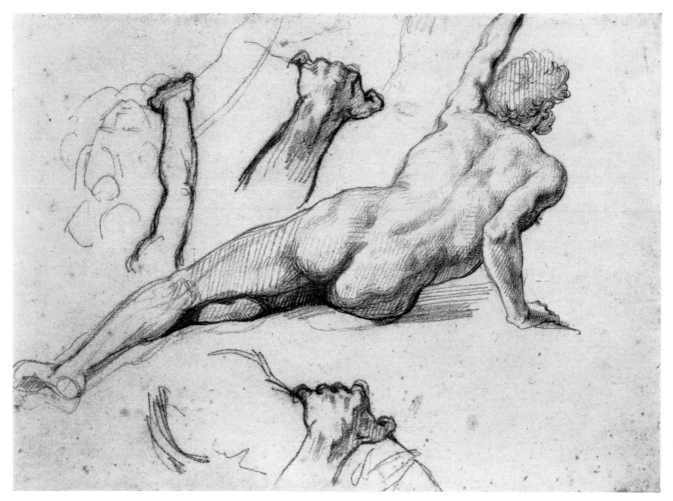

62. Study of a Man attempting to raise himself; Studies of Hands and of an Arm (Cat. no. 62).
Rouen, Musée des Beaux-Arts

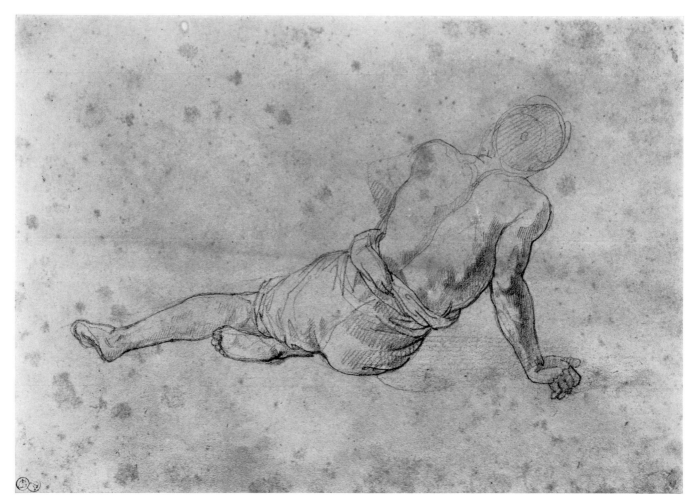

63. Study of a Man attempting to raise himself (Cat. no. 63). Dijon, Musée Magnin

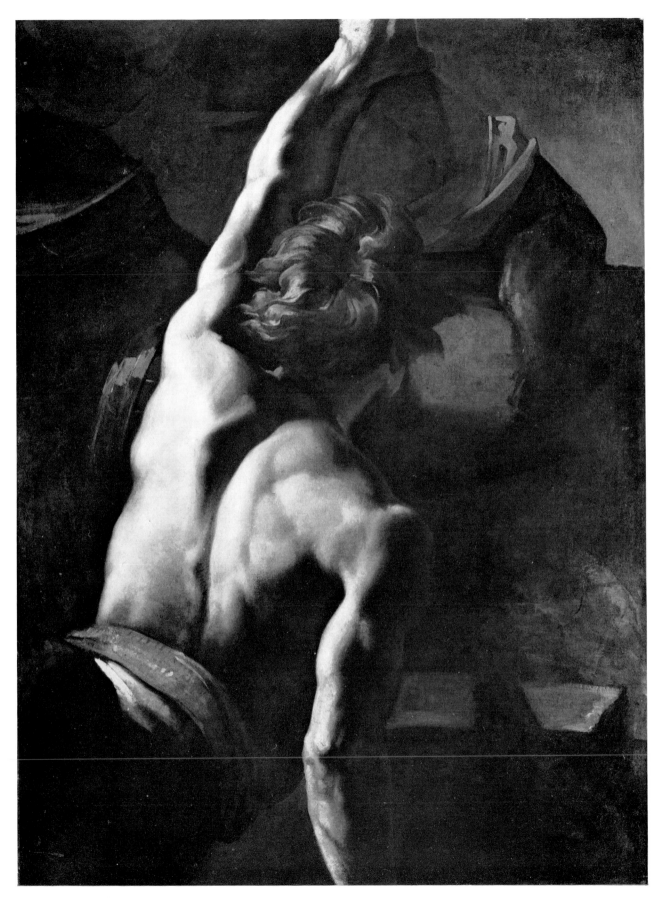

64. After Géricault (?): Study of a Man attempting to raise himself (see Cat. no. 64). Zürich, private collection (1971)

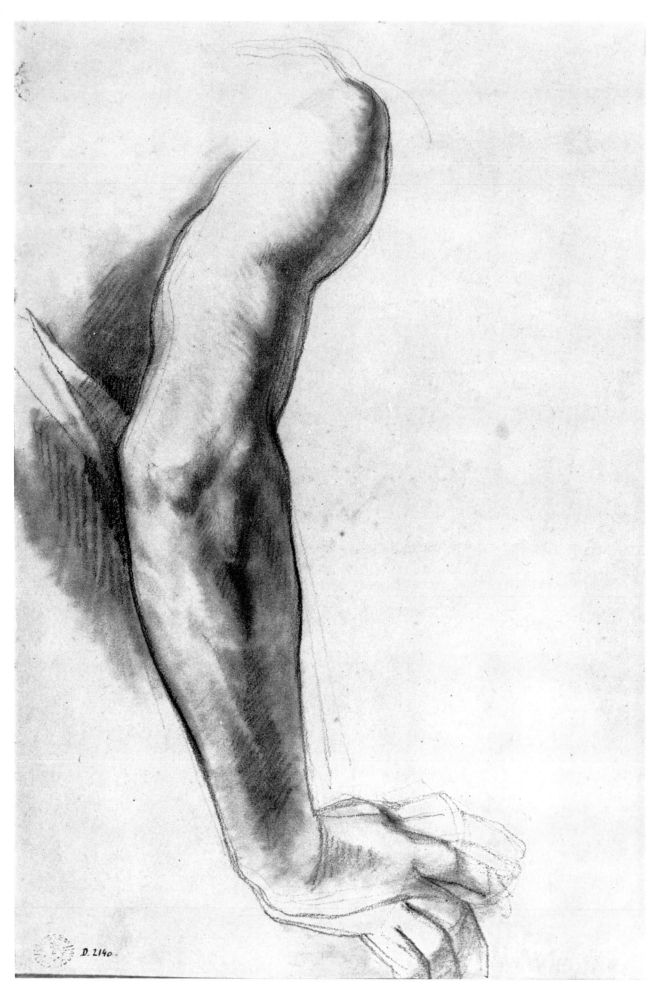

D. 2140.

65. Study of an Arm (Cat. no. 65). Besançon, Musée des Beaux-Arts

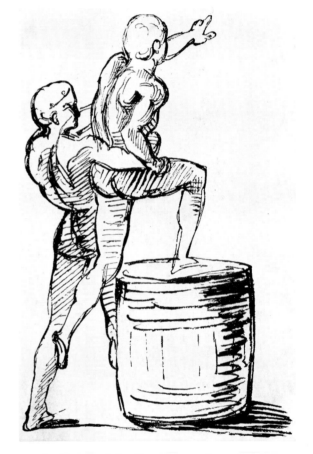

66. Sketch of the Negro mounting a Barrel, assisted by another Man (Cat. no. 67). Paris, Louvre

67. Sketch of the Negro mounting a Barrel, assisted by another Man (Cat. no. 68). Present location not known

68. Sketch for the Leg of the signalling Negro, a Hand, a Caricature (Cat. no. 69). Paris, Dubaut collection

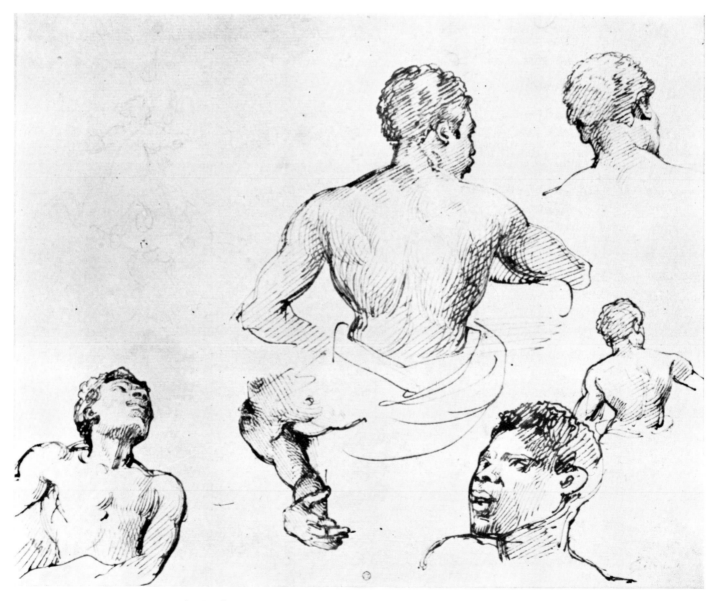

69. Studies of a Negro (Cat. no. 70). Lyon, Musée des Beaux-Arts

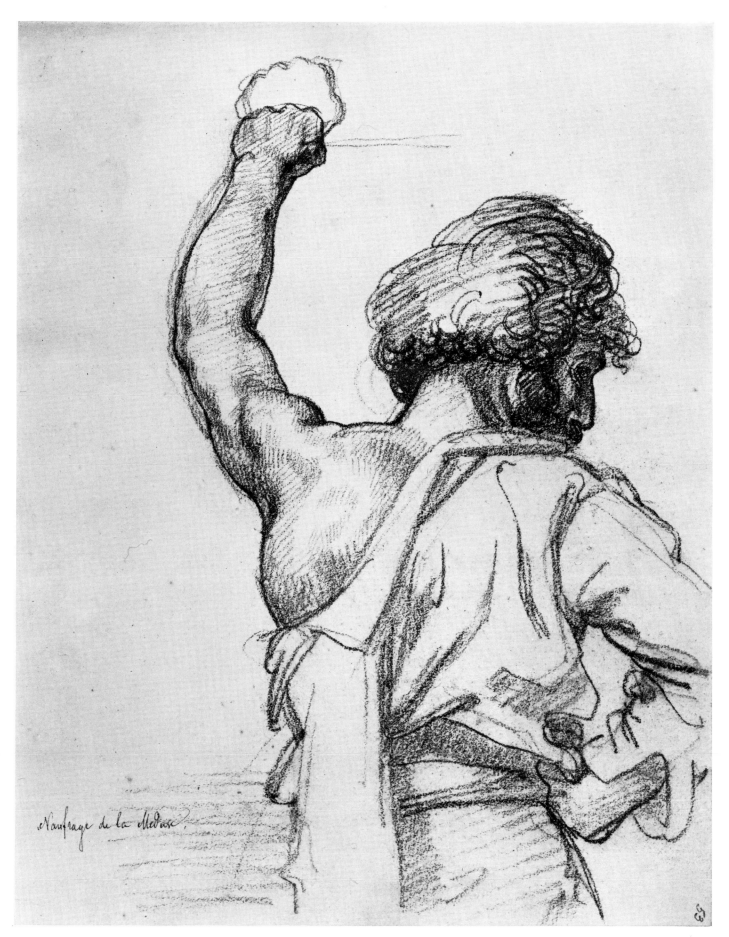

70. Study of a Man in back view raising his left Arm (Cat. no. 71). Zürich, Kunsthaus

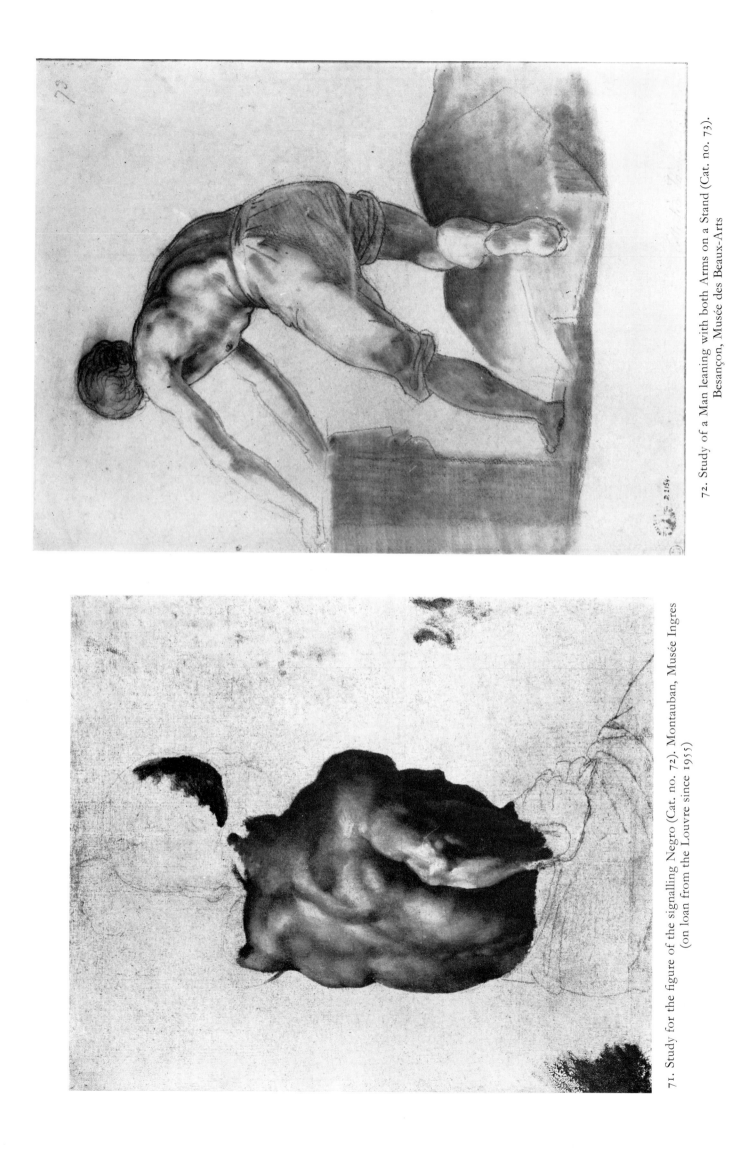

72. Study of a Man leaning with both Arms on a Stand (Cat. no. 73).
Besançon, Musée des Beaux-Arts

71. Study for the figure of the signalling Negro (Cat. no. 72). Montauban, Musée Ingres
(on loan from the Louvre since 1955)

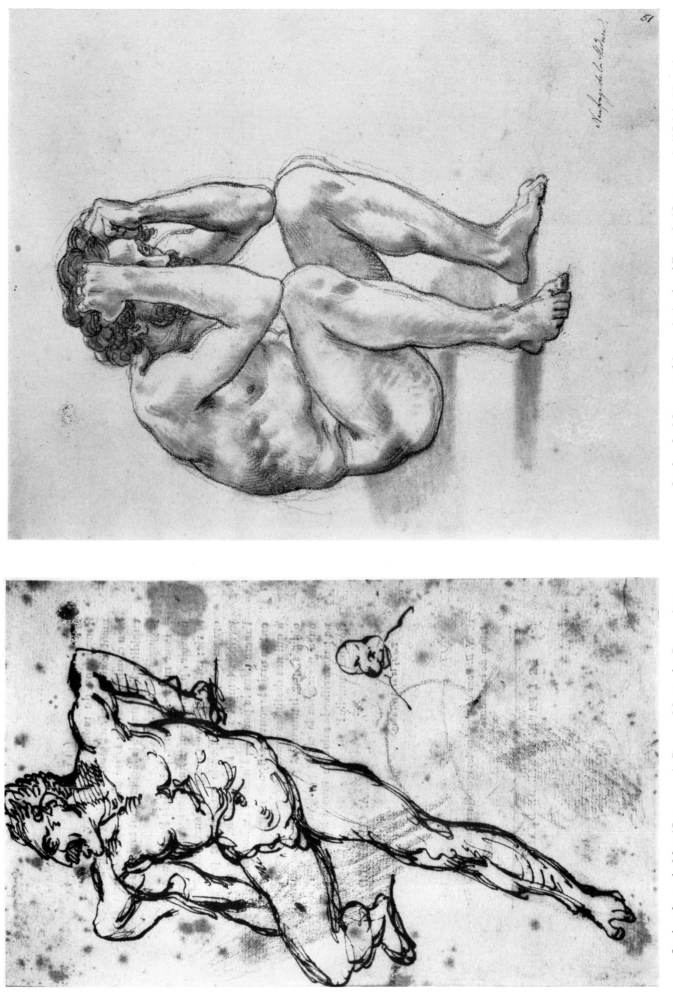

74. Study of a Man seated in an Attitude of Despair (Cat. no. 75). Zürich, Kunsthaus

73. Study of a nude Man (Cat. no. 74). Rouen, Musée des Beaux-Arts

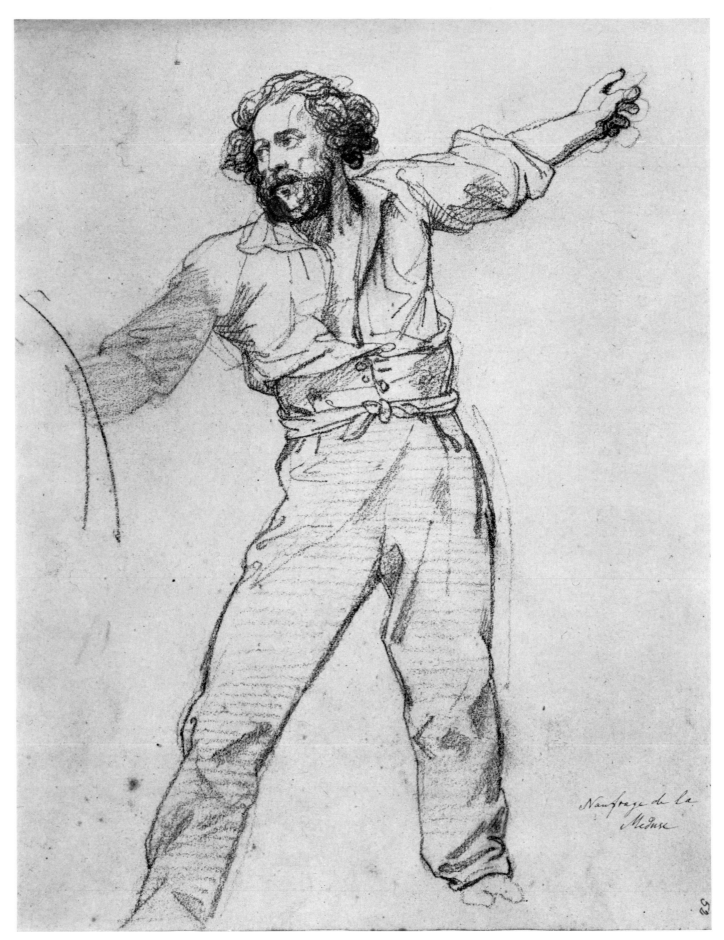

Naufrage de la
Méduse

75. Study of a Man pointing with his left Hand (Cat. no. 76). Zürich, Kunsthaus

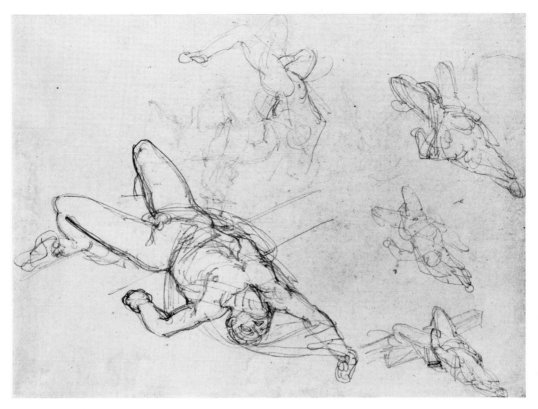

76. Five sketches of a nude Man lying on his Back (Cat. no. 77). Paris, Delestre collection

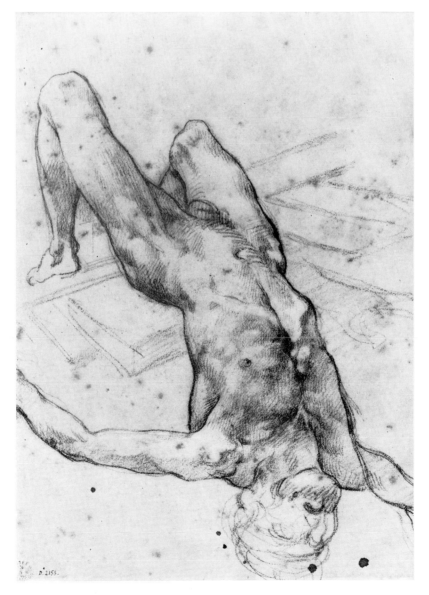

77. Study of a nude Man lying on his Back (Cat. no. 78).
Besançon, Musée des Beaux-Arts

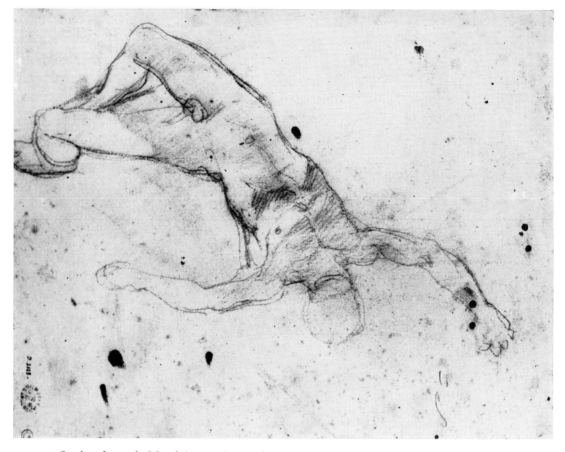

78. Study of a nude Man lying on his Back (Cat. no. 79). Besançon, Musée des Beaux-Arts

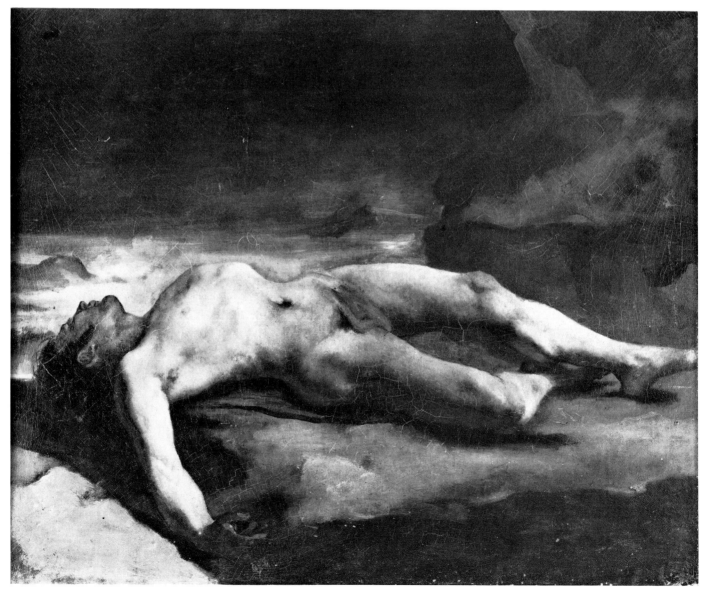

79. Study of the Body of a dead Youth (Cat. no. 80). Alençon, Musée de Peinture

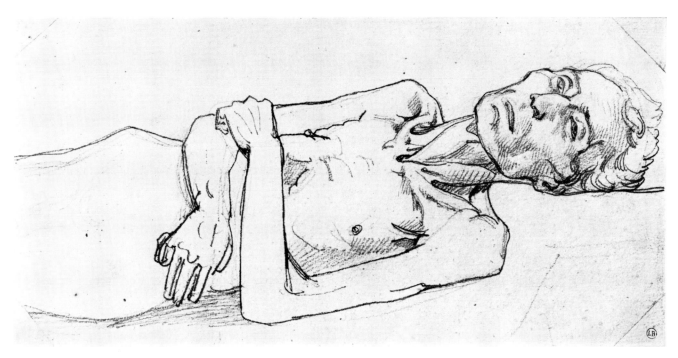

80. Study of an emaciated, elderly Man (Cat. no. 81). Bayonne, Musée Bonnat

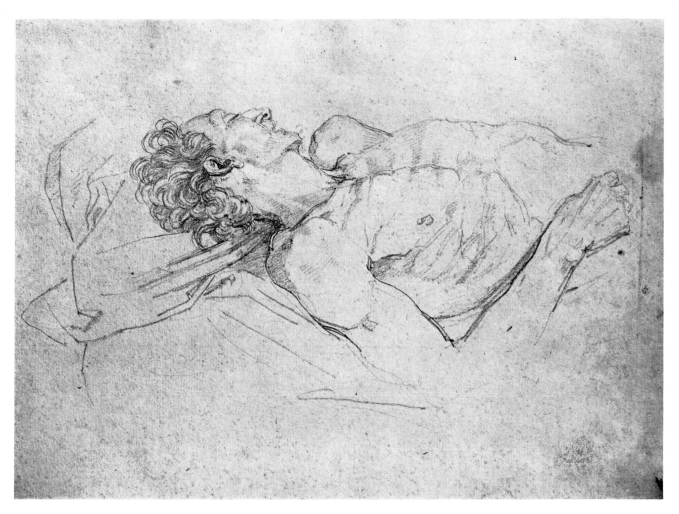

81. Study of a sick or dying Man (Cat. no. 82). Paris, Gobin collection

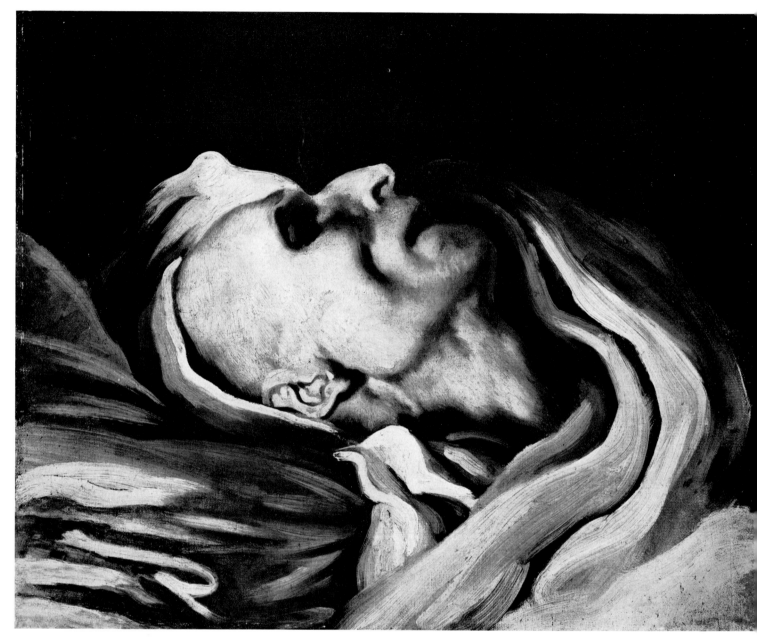

82. Study of the Head of a Corpse (Cat. no. 83). Chicago, The Art Institute

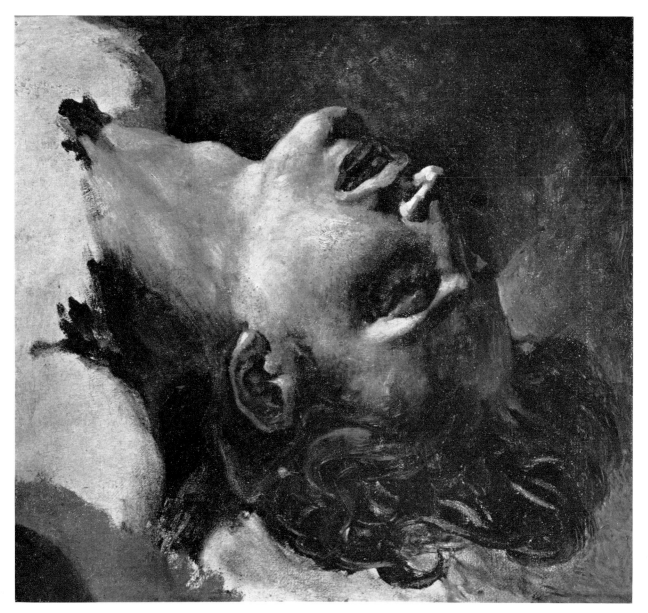

83. Study for the Head of the dead "Son" (Cat. no. 84). Rouen, Musée des Beaux-Arts

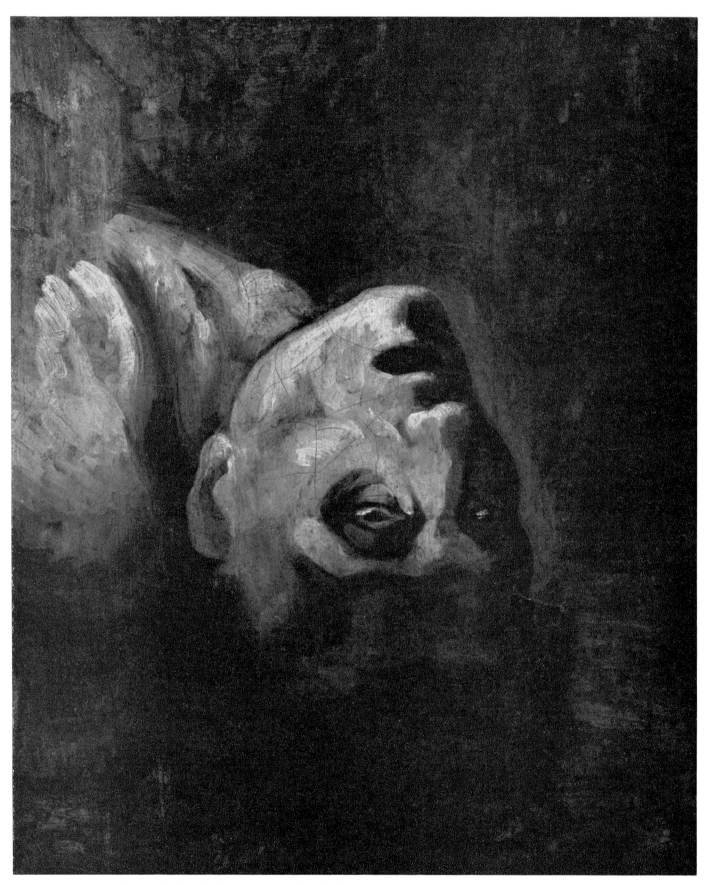

84. Sketch for the Head of the dead "Son" (Cat. no. 85). Malaga, Prince Hohenlohe collection

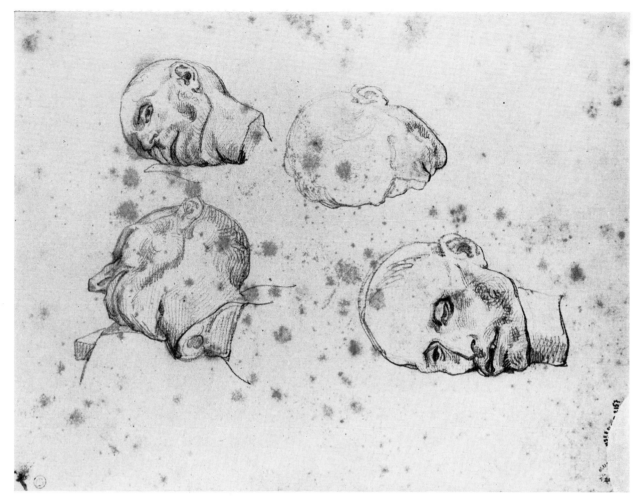

85. Four Studies of the severed Head of a Man (Cat. no. 86). Besançon, Musée des Beaux-Arts

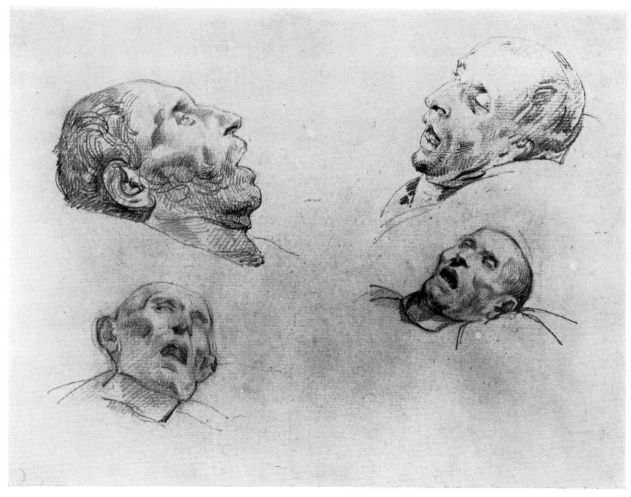

86. Four Studies of the severed Head of a Man (Cat. no. 87). Paris, Dubaut collection

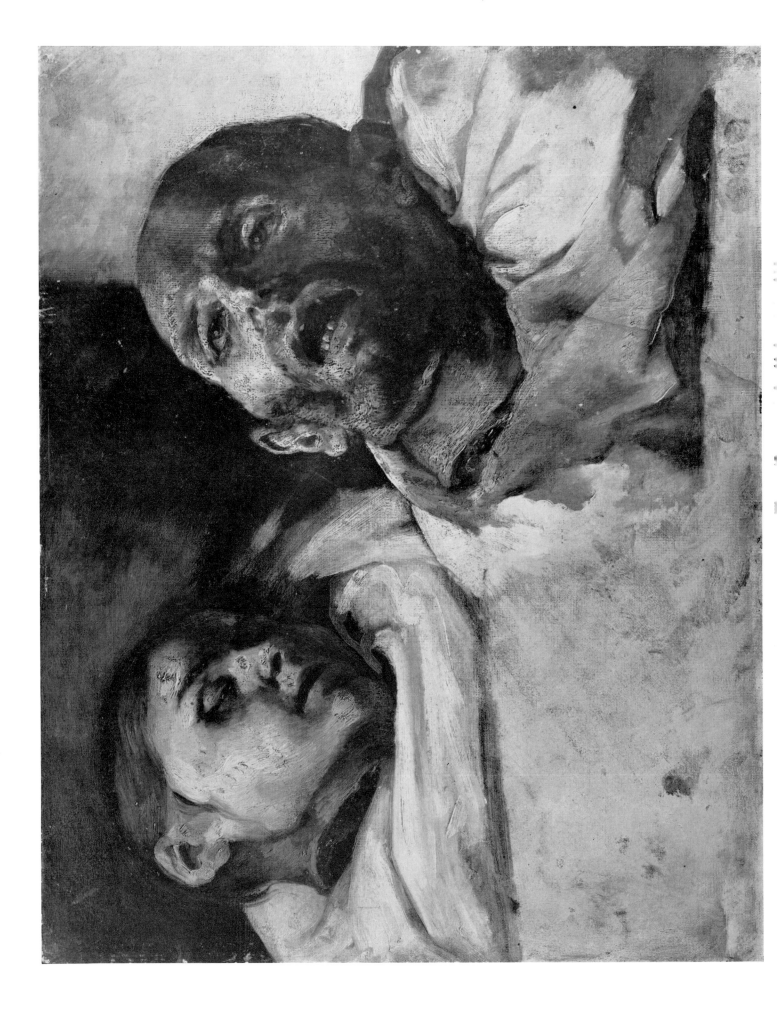

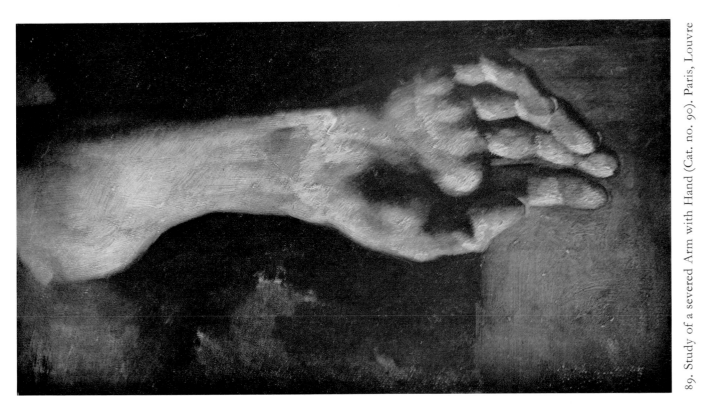

89. Study of a severed Arm with Hand (Cat. no. 90). Paris, Louvre

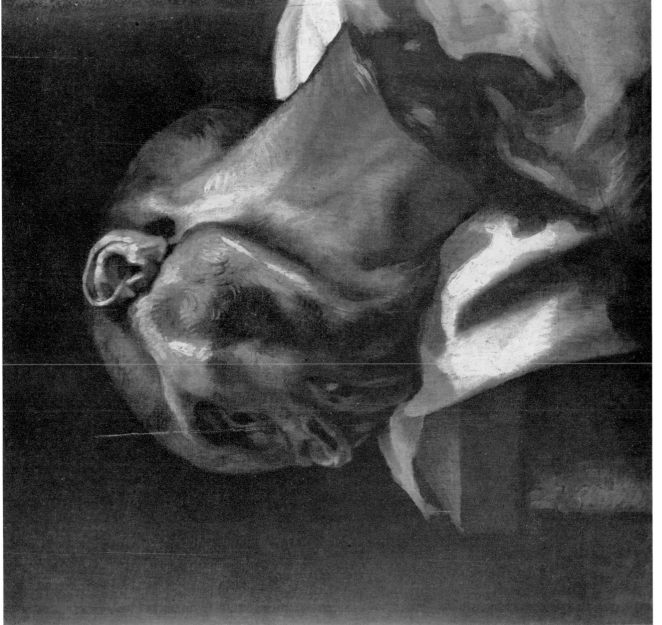

88. Study of the severed Head of a Man (Cat. no. 89). Paris, Dubaut collection

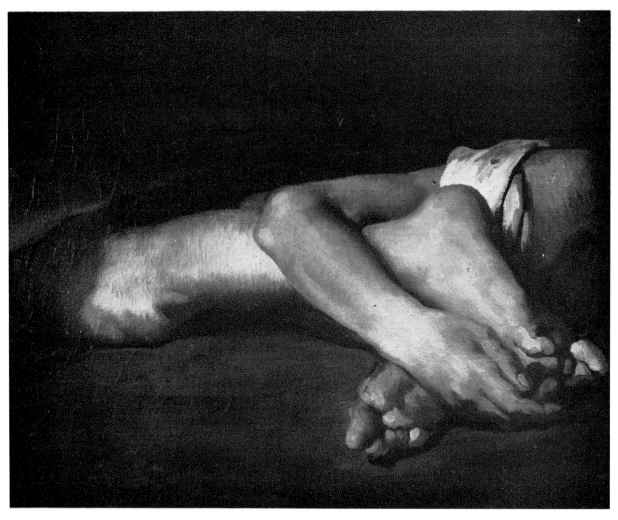

90. Study of two severed Legs and an Arm (Cat. no. 91). Paris, Lebel collection

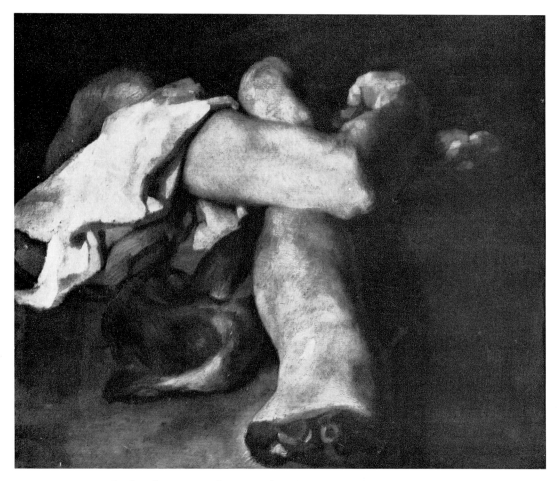

91. Study of two severed Legs and an Arm (Cat. no. 93). Paris, Louvre

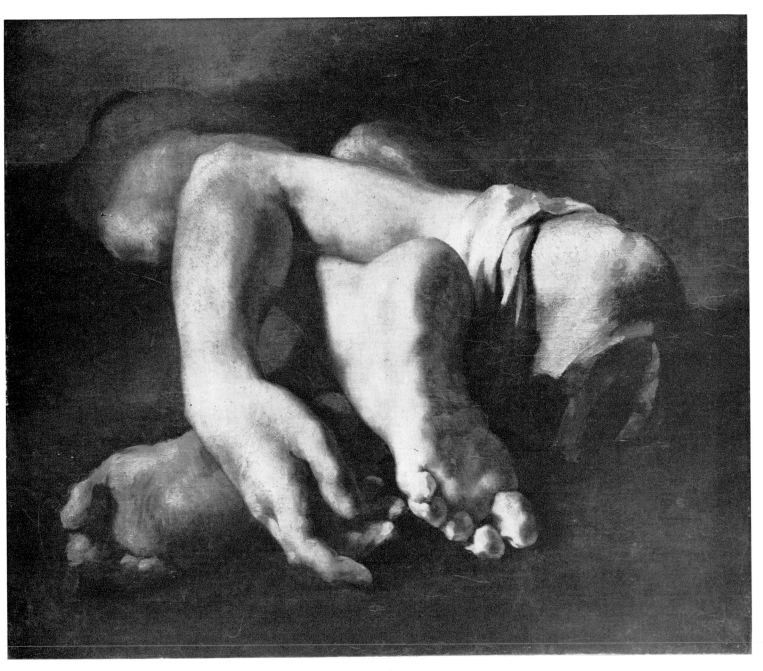

92. Study of two severed Legs and an Arm (Cat. no. 92). Montpellier, Musée Fabre

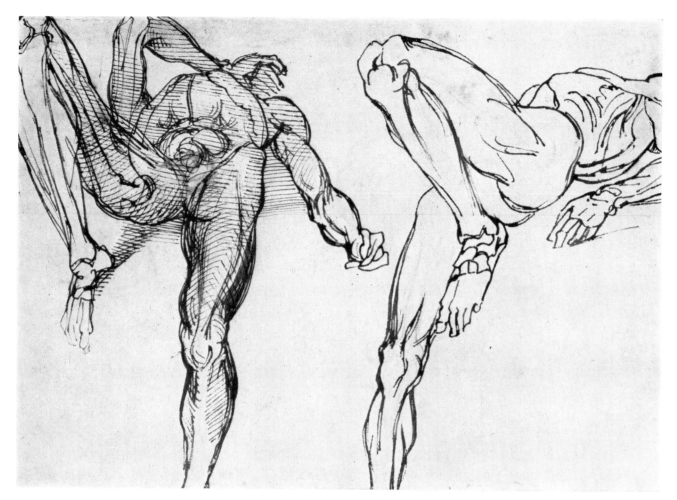

93. Study of two flayed Cadavers (Cat. no. 94v). Toronto, Jowell collection

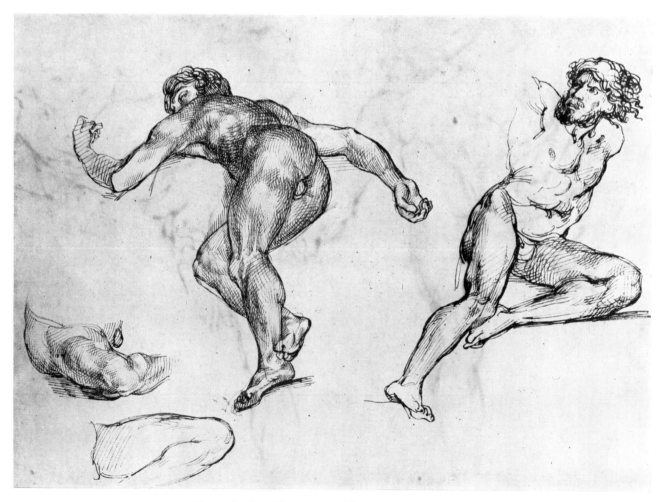

94. Figure Studies (Cat. no. 94). Toronto, Jowell collection

95. Study of a flayed Cadaver (Cat. no. 40v). Toronto, Jowell collection

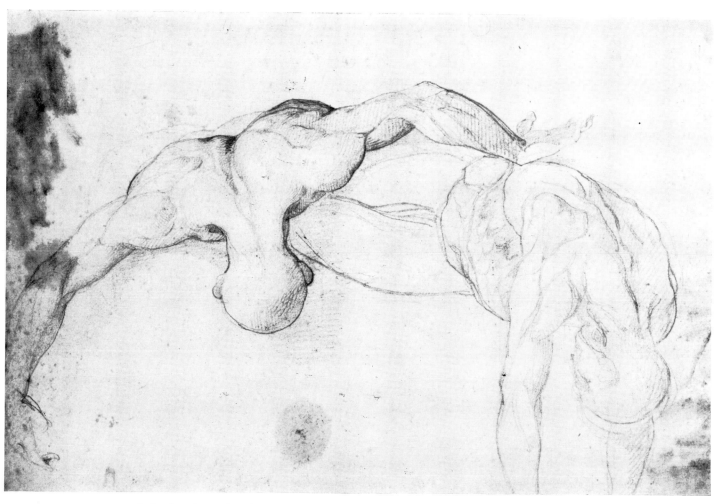

96. Study of two flayed Cadavers (Cat. no. 95). Formerly London, Powney collection

98. Study of a flayed Leg and Feet (Cat. no. 97). Besançon, Musée des Beaux-Arts

97. Study of a flayed Leg (Cat. no. 96). Besançon, Musée des Beaux-Arts

99. Six Studies of Heads (Cat. no. 98). New York, Baker collection

101. Portrait of the Painter Jamar (Cat. no. 101). Destroyed; formerly Budapest, de Hatvany collection

100. Portrait Study of the Head of a Youth with Eyes closed (Cat. no. 99). Paris, Dubaut collection

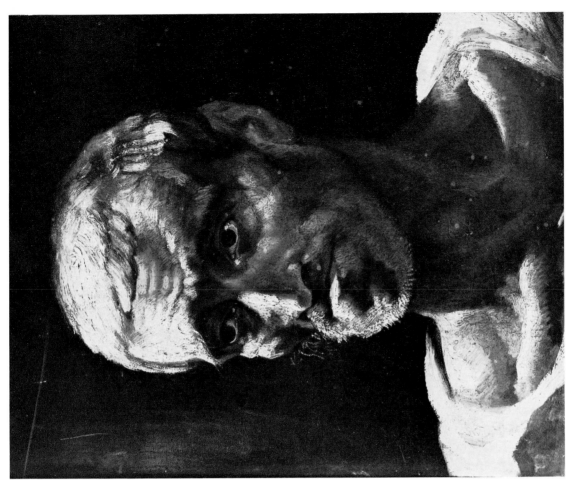

103. Portrait Study of the Head of an elderly, emaciated Man (Cat. no. 103).
Besançon, Musée des Beaux-Arts

102. Portrait of a Man, sometimes called "The Carpenter of the Medusa"
(Cat. no. 102). Rouen, Musée des Beaux-Arts

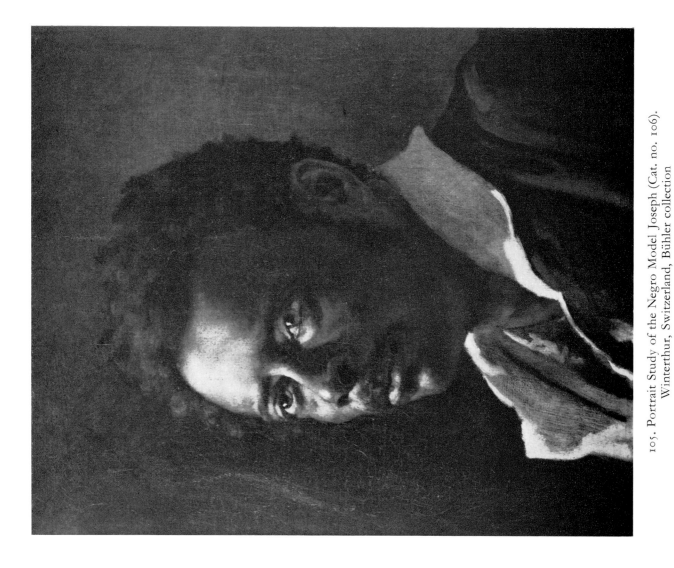

105. Portrait Study of the Negro Model Joseph (Cat. no. 106).
Winterthur, Switzerland, Bühler collection

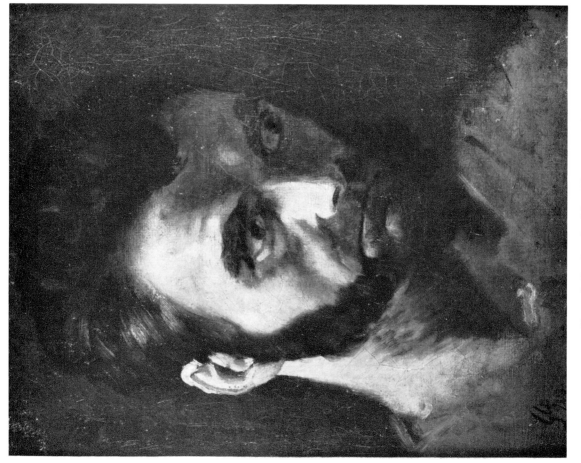

104. Portrait Study of a Man (Cat. no. 105).
Winterthur, Switzerland, Bühler collection

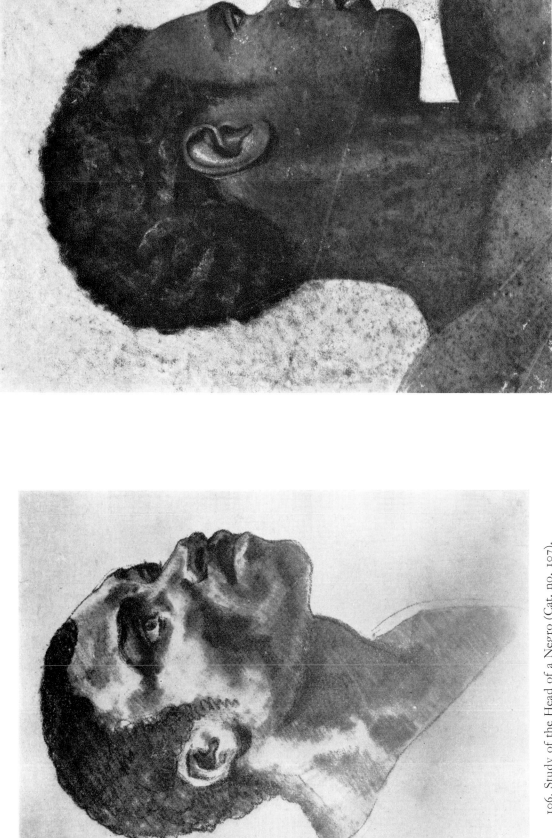

107. Head of a Negro in lost profile view (Cat. no. 108).
Rouen, Musée des Beaux-Arts

106. Study of the Head of a Negro (Cat. no. 107).
Paris, Dubaut collection

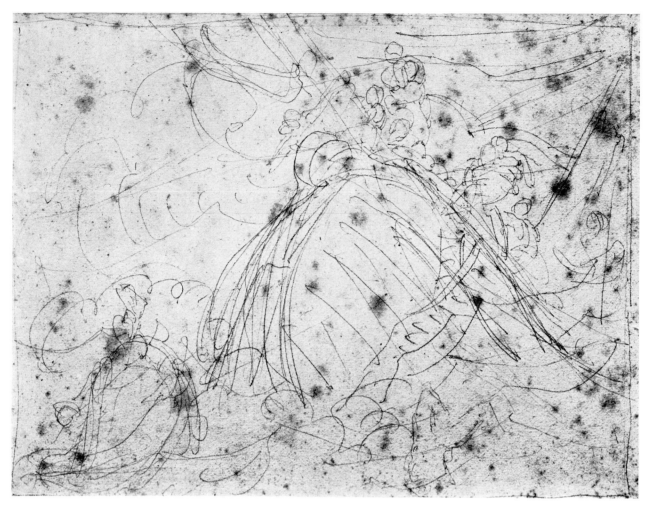

108. A Ship sinking in a stormy Sea (Cat. no. 109). Rouen, Musée des Beaux-Arts

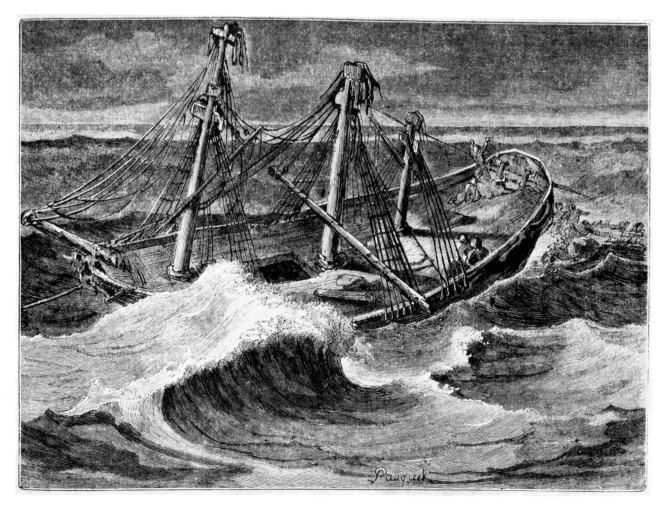

109. The abandoned Medusa, after the Departure of the Boats and the Raft (Cat. no. 110). Wood engraving by Pauquet
after a lost watercolour drawing

110. The Minister of the King Zaïde tracing the Map of Europe (Cat. no. 111). Wood engraving by Pauquet after a lost watercolour drawing

111. English Officers and the Survivors of the Medusa (Cat. no. 112). Wood engraving by Pauquet after a lost watercolour drawing

112–114. The abandoned Medusa, after the Departure of the Boats and the Raft—The Minister
of the King Zaïde tracing the Map of Europe—English Officers and the Survivors of the Medusa.
Lithographs by Champion after Géricault (cf. Plates 109–111), from Savigny and Corréard,
Naufrage de la Frégate la Méduse, Paris 1821

CATALOGUE

NOTE

THERE are few paintings of the nineteenth century that are more fully documented than Géricault's *Raft of the Medusa*. The following Catalogue gathers together all the sketches and studies related to this painting which are known to me at this time (1971), either directly or through documents. Extensive as it may seem, the Catalogue is necessarily incomplete. Many of the studies for the *Medusa* have perished, some fairly recently (see nos. 13 and 101); others still await rediscovery. The painter Eugène Lami, who knew Géricault, recalled in his *Mémoires "il y avait à sa vente après décès onze esquisses du* Radeau de la Méduse *et ces onze esquisses avaient été faites coup sur coup, sans qu'il se fut refroidi"*, which raises the possibility that there once existed more painted compositional studies for the *Medusa* than are recorded or preserved. The meagre text of the catalogue of Géricault's posthumous sale unfortunately offers few clues. It refers only to the two painted compositional studies which are still preserved (see nos. 18 and 24), and very summarily lumps together, without describing them, other painted studies and drawings for the *Medusa* (cf. L. Eitner, "The Sale of Géricault's Studio in 1824", *Gazette des Beaux-Arts,* 6e ser., LIII, February 1959, pp. 115 ff.).

The Catalogue groups the preserved or recorded studies under separate headings: the compositional studies are followed by studies and sketches relating to individual groups or figures in the composition, and these in turn by peripheral studies—portraits, anatomical drawings and studies of cadavers—which form part of Géricault's preparatory work for the *Medusa,* though not all were actually used. In this last category, it is difficult to distinguish sharply between studies directly relevant to the *Medusa* and others, contemporary with this central work, which reflect rather than contribute to it. The items of this kind included in the Catalogue are those which, in my opinion, are the most likely to have played some role in the picture's development.

Within each of the Catalogue's main divisions, the arrangement of the entries follows a chronological order, in so far as this can be determined.

Where dimensions are given, height precedes width.

In the accompanying bibliographical listings and exhibition records, abbreviations have been used, as sparingly as possible, to refer to the most frequently quoted publications and exhibitions.

ABBREVIATIONS USED IN THE CATALOGUE

AUBRY: *Géricault dans les collections privées françaises,* Galerie Claude Aubry, November-December 1964 (catalogue by Pierre Dubaut).

BERGER: K. Berger, *Géricault und sein Werk,* Vienna, 1952.

BERNHEIM-JEUNE: *Exposition Géricault,* Galerie Bernheim-Jeune, Paris, May 1937 (catalogue by P. Dubaut).

BIGNOU: *Géricault . . . cet inconnu,* Galerie Bignou, Paris, May–June 1950 (catalogue by P. Dubaut).

CENTENARY: *Exposition Géricault,* Hotel Jean Charpentier, Paris, April–May 1924 (catalogue by the Duc de Trévise and P. Dubaut).

CLÉMENT: C. Clément, *Géricault, étude biographique et critique,* 3rd edition, Paris, 1879.

EITNER: L. Eitner, "Reversals of Direction in Géricault's Compositional Projects", *Stil und Überlieferung in der Kunst des Abendlandes (Akten des 21. Internationalen Kongresses für Kunstgeschichte in Bonn),* III, Berlin, 1967, pp. 126 ff.

GOBIN: *Dessins, aquarelles et gouaches par Géricault,* Chez Maurice Gobin, Paris, December 1935 (catalogue by M. Gobin).

KNOWLTON: J. Knowlton, "The Stylistic Origins of Géricault's Raft of the Medusa", *Marsyas,* II, New York 1942, pp. 125 ff.

LOS ANGELES: *Géricault,* Los Angeles County Museum, Detroit Institute of Arts, Philadelphia Museum, October 1971–May 1972 (catalogue by L. Eitner).

MARLBOROUGH: *Théodore Géricault,* Marlborough Fine Arts Ltd., London, October–November 1952 (catalogue by P. Dubaut).

REGAMEY: R. Regamey, *Géricault,* Paris, 1926.

ROSENTHAL: L. Rosenthal, *Géricault,* Paris, n.d. (1905).

ROUEN: *Géricault, un réaliste romantique,* Musée des Beaux-Arts, Rouen, January–March 1963 (catalogue by P. Popovitch).

WINTERTHUR: *Théodore Géricault,* Kunstmuseum Winterthur, August–November, 1953 (catalogue by P. Dubaut).

1. COMPOSITIONAL STUDIES

(a) The Rescue

On the morning of 17 July 1816, the thirteenth day of the Raft's voyage, the brig *Argus,* which had been sent to search for the survivors of the *Medusa,* briefly came into sight on the horizon, but soon disappeared again. The men on the Raft gave up all hope and withdrew into a tent, which they had improvised beneath the mast, to prepare themselves for death. Two hours later, they were surprised to discover the *Argus* rapidly approaching under full sail. When the brig had come close enough, according to Corréard and Savigny, *"a boat was immediately hoisted out; an officer belonging to the brig, whose name was Mr. Lemaigre, had embarked in it, in order to have the pleasure of taking us himself from this fatal machine. This officer, full of humanity and zeal, acquitted himself of his mission in the kindest manner, and took himself, those that were the weakest, to convey them into the boat. After all the others were placed in it, Mr. Lemaigre came and took in his arms Mr. Corréard, whose health was the worst and who was the most excoriated: he placed him at his side in the boat, bestowed on him all imaginable cares, and spoke to him in the most consoling terms. In a short time, we were all removed on board the* Argus". (A. Corréard and H. Savigny, *Narrative of a Voyage to Senegal in 1816,* London, 1818, p. 138.) Géricault briefly investigated the episode of the Rescue, evidently at a very early stage of his work on the *Medusa.*

1. THE RESCUE OF THE SURVIVORS (Plate 1)
Pen on paper; 195 × 286 mm.
Collections: His de La Salle (stamp, Lugt 1333); H. Delacroix (stamp, Lugt 838; Sale, 1962, no. 56 brs); Granville, Paris; Musée des Beaux-Arts, Dijon (acquired in 1971).
The rowing-boat sent by the *Argus* is about to receive the survivors, who press forward eagerly and are helped into the boat by muscular, nude sailors. The general arrangement of the scene bears a conspicuous resemblance to Gros's *Embarkation of the Duchess of Angoulême,* which was shown at the Salon of 1819 together with Géricault's *Raft of the Medusa.* The resemblance may be accidental, but it is not impossible that Géricault saw Gros's painting before its exhibition and took hints from it for his own work. He does not seem to have pursued this compositional idea very far. The drawing in the Granville collection, a spirited improvisation, is the only one known of this particular scene. Clément omitted it from his catalogue, but reproduced it in the *Gazette des Beaux-Arts,* XXII, 1867, p. 325.
Bibliography:
G. Oprescu, *Géricault,* Paris, n.d. [1927], p. 98.

2. THE RESCUE OF THE SURVIVORS (Plate 2)
Pen on paper; 210 × 290 mm.
Collections: Courtin; P. Dubaut (stamp, Lugt Suppl. 2103-B); M. Dubaut, Paris.
The drawing shows the rescue as seen from the Raft.

In visualizing the scene, Géricault remembered Michelangelo's cartoon of the *Pisan Battle.* The nude sailor, seen in back view, who is about to climb into the rowing-boat is taken from this source. It is a figure motif which Géricault had often used before, for a variety of purposes, and which came under his pen with the force, and assurance, of old habit. This may be why it is the most clearly articulated element of the composition, which otherwise has the look of a fairly rapid improvisation. Though it is probably not the earliest preserved drawing for the *Raft of the Medusa,* it exemplifies the beginning stage in the development of a compositional idea. Drawings somewhat like it, now lost, must have preceded the more fully developed extant drawings of the *Mutiny, Cannibalism,* and the *Sighting of the Rescue.* Géricault evidently did not pursue the idea embodied in this drawing.
Bibliography:
Clément, *Dessins,* no. 112.
D. Aimé-Azam, *Mazeppa,* Paris, 1956, illustrated opposite p. 192.
A. del Guercino, *Géricault,* Milan, 1963, plate 56.
Exhibited:
Gobin, 1935, no. 43.
Bernheim-Jeune, 1937, no. 126.
Bignou, 1950, no. 45.
Marlborough, 1952, no. 49 (illustrated).
Winterthur, 1953, no. 173.

"Gros, Géricault, Delacroix", Bernheim-Jeune, Paris, 1954, no. 53.
Aubry, 1964, no. 68 (illustrated).
Los Angeles, Detroit, Philadelphia, 1971–72, no. 74 (illustrated).

3. THE ABANDONED RAFT (Plate 3)
Pen on paper; 220 × 280 mm.
Collections: Camille Marcille (sale, 1876, no. 80); Babinet (1882); Musée des Beaux-Arts, Poitiers.
The Raft, deserted by the survivors, is seen in approximately the same view as in the previous drawing. A cadaver lies in the tent at the foot of the mast, another floats in the water at the lower left. It is not likely that Géricault ever intended to paint this scene. The drawing merely served him as an aid in his effort to visualize the successive aspects of the disaster.
The verso of the drawing (Plate 11) contains four figure and two head sketches for the composition of

The Survivors Hailing the Approaching Rowing-boat (see catalogue nos. 11–13).
Bibliography:
Clément, *Dessins*, no. 138.
P. Dubaut, "Les dessins de Géricault", *Dibutade, Fascicule Spécial du Bulletin des Amis des Musées de Poitiers,* I, 1954, pp. 43 ff.

4. THE ABANDONED RAFT
Pen on paper; 146 × 224 mm.
Collection: Private collection, Paris.
This drawing, which I have never seen, was described by P. Dubaut as being similar to the one in Poitiers (Cat. 3), except for the fact that it shows a rowing-boat, in the middle distance, taking the survivors to safety.
Bibliography:
P. Dubaut, "Les dessins de Géricault", *Dibutade, Fascicule Spécial du Bulletin des Amis des Musées de Poitiers,* I, 1954, p. 45.

(b) The Mutiny

The dramatic account by Savigny and Corréard of the outbreaks of mutiny on the Raft, during the second and fourth nights of its voyage, prompted Géricault to make a very thorough investigation of the pictorial possibilities of this scene. In his drawings of the *Mutiny,* he followed the narrative fairly closely, combining in a single image incidents which in actuality occurred over a period of several days. What caught his imagination most strongly was the emphasis which the account laid on the terrible crowding of the men on the Raft, the vehemence of the nocturnal storms, the steep rise and fall of the timbers on which the frantic men fought one another: *"Before and behind, the waves dashed with fury, and carried off the men in spite of all their resistance. At the centre, the crowd was such that some poor men were stifled by the weight of their comrades, who fell upon them every moment; the officers kept themselves at the foot of the little mast, obliged, every instant, to avoid the waves, to call to those who surrounded them to go on the one or on the other side, for the waves which came upon us, nearly athwart, gave our raft a position almost perpendicular . . . The soldiers and sailors, terrified by the presence of an almost inevitable danger, gave themselves up for lost. Firmly believing that they were going to be swallowed up, they resolved to soothe their last moments by drinking till they lost the use of their reason . . . Thus inflamed, these men, become deaf to the voice of reason, desired to implicate, in one common destruction, their companions in misfortune; they openly expressed their intention to rid themselves of the officers . . . and to destroy the raft by cutting the ropes which united the different parts that composed it . . . One of them advanced to the edge of the raft with a boarding axe, and began to strike the cords: this was the signal for revolt: we advanced in order to stop these madmen: he who was armed with the axe, with which he even threatened an officer, was the first victim: a blow with a sabre put an end to his existence. This man was an Asiatic, a soldier in a colonial regiment . . . Some persons . . . joined those who wished to preserve the raft, and armed themselves: of this number were some subaltern officers and many passengers. The mutinous drew their sabres, and those who had none armed themselves with knives: they advanced resolutely against us; we put ourselves on our defence: the attack was going to begin. Animated by despair, one of the mutineers lifted*

his sabre against an officer; he immediately fell pierced with wounds . . . the combat became general. Some cried 'Lower the sail'; a crowd of madmen instantly threw themselves on the yards and the shrouds, and let the mast fall, and nearly broke the thigh of a captain of foot, who fell senseless. He was seized by the soldiers, who threw him into the sea: we perceived it, saved him, and placed him on a barrel, from which he was taken by the seditious, who were going to cut out his eyes with a pen knife. Exasperated by so many cruelties, we no longer kept any measures, and charged them furiously. With our sabres drawn, we traversed the lines which the soldiers formed, and many atoned with their lives for a moment of delusion . . . Armed with his sabre, [Corréard] assembled some of his workmen on the front of the raft . . . they had several times to defend themselves against the attacks of the mutineers; who, falling into the sea, returned by the front of the raft . . . During this combat, Mr. Corréard was informed by one of his workmen who remained faithful that one of their comrades, named Dominique, had taken part with the mutineers, and that he had just been thrown into the sea. Immediately . . . he threw himself in after him, at the place where the voice of the wretch had just been heard calling for assistance: he seized him by the hair, and had the good fortune to get him on board . . . Another voice was heard; it was that of the unfortunate woman who was on the raft with us, and whom the madmen had thrown into the sea, as well as her husband, who defended her with courage. Mr. Corréard . . . seized a large rope which was on the front of the raft, which he fastened round the middle of his body, and threw himself, a second time, into the sea, whence he was so happy as to rescue the woman . . . while her husband was likewise saved . . . We seated these two poor people upon dead bodies, with their backs against a barrel . . . The servant of an officer of the troops on board was in the plot . . . When he perceived that the plot was discovered, he armed himself with the last boarding-axe that there was on the raft, wrapped himself in a piece of drapery, which he wore folded over his breast, and, of his own accord, threw himself into the sea." (A. Corréard and H. Savigny, *Narrative of a Voyage to Senegal in 1816,* London, 1818, pp. 83 ff.).

5. THE MUTINY ON THE RAFT (Plate 4)
Red chalk (?) on paper; dimensions not known.
Collection: Henri Chenavard; present location not known.
The only surviving record of this drawing appears to be an engraving in imitation of sanguine technique, inscribed *"fac simile d'une esquisse de Géricault appartenant à Mr. Henri Chenavard et gravée par Louis Schaal en Septbre. 1852, imp. par Lesauvage".* Misled by the term *esquisse,* which normally designates a painted sketch, Clément catalogued this drawing, which he had never seen, among Géricault's paintings, though Schaal's facsimile leaves no doubt about its actual character. The composition of the Mutiny scene, distantly influenced by David's *Battle of Romans and Sabines,* has no close parallel among the preparatory sketches for the *Raft of the Medusa.* It probably dates from a very early stage in Géricault's search for a suitable dramatic moment from among the sequence of events which the *Medusa's* story offered.
Bibliography:
Clément, p. 122, note 1, and *Peintures,* no. 102.

6. THE MUTINY ON THE RAFT (Plate 5)
Pen on paper; 163 × 214 mm.
Collections: Coutan-Hauguet (stamp, Lugt 464); Musée des Beaux-Arts, Rouen, cat. 1386 (acquired in 1890). Mounted with no. 15 of this catalogue.
The earliest preserved sketch of the entire composition of the *Mutiny* episode. Despite its rapid execution, all the figures are so fully articulated that it is safe to assume that this drawing was preceded by earlier, exploratory sketches. The thoroughness of Géricault's planning, even at this stage of the work, is proved by the existence of a separate detail study (see no. 34 of this catalogue) for one of the groups in this *Mutiny* composition, the family consisting of father, mother and child which has found refuge near a barrel, beneath the sail, close to the Raft's bow.
Bibliography:
Catalogue, Musée des Beaux-Arts, Rouen, 1890, no. 774.
Catalogue, Musée des Beaux-Arts, Rouen, 1911, no. 1386.
P. Lafond, *Le musée de Rouen,* n.d., p. 78.
Rosenthal, ill. opp. p. 80.

Knowlton, p. 135, fig. 20.
Exhibited:
Exhibition Centennale, Paris, 1900.
Fransk Malerkunst, Copenhagen, 1914.
Centenary, 1924, no. 123-a.
Bernheim-Jeune, 1937, no. 124-a.
David à Millet, Kunsthaus, Zürich, 1937, no. 140-a.
Bignou, 1950, no. 43.
French Drawings, Washington, Cleveland, St. Louis, Fogg
Museum, Metropolitan Museum, 1952–53, no. 121.
Rouen, 1963, no. 34.

7. THE MUTINY ON THE RAFT (Plate 6)

Pen, crayon, and pencil on paper; 417×591 mm.
Collections: A. J. Lamme; J. C. Fodor; Fodor Museum
(stamp, Lugt 1036); Stedelijk Museum, Amsterdam
(Fodor Collection).

Drawn in firm and precise pen strokes over a light and
fairly loose under-drawing in pencil, this compositional
design is unequalled in its richness and concreteness of
detail among the preparatory studies for the *Raft of the
Medusa.* It resembles the more summary drawing of
the *Mutiny* in Rouen (no. 6 of this catalogue), but its
figures are more numerous and in many respects
different. A case in point is the family group at the left,
near the Raft's forward edge, which broadly resembles
its counterpart in the Rouen drawing, but differs from
it in every particular of turn and gesture. It is remark-
able that for this revision of the family group, Géri-
cault again drew a separate detail study (no. 35 of this
catalogue). Other studies for details of the *Mutiny*
composition attest to the seriousness with which he
explored this episode before turning to others (cata-
logue nos. 29–37).
Various prototypes for individual groups or figures of
the *Mutiny* composition have been proposed. The spill
of tumbling bodies at the stern of the Raft recalls, in
its general effect, rather than in specific motifs,
portions of Michelangelo's *Last Judgement,* particularly
the infernal bark at the lower right of the fresco.
Berger (p. 71) sought to link figures in the *Mutiny*
drawing with motifs from Roman sarcophagus reliefs
in the Capitoline Museum (Amazon Battle) and the
Louvre (Fall of Phaethon, Murder of Clytemnestra,
Death of Adonis). None of these comparisons is
entirely convincing. Knowlton (p. 135) relates the
cascade of tumbling nudes to portions of the *Triumph
of Justice,* a monumental composition by Jean Jouvenet
(1644–1717), of which several versions are known.
But the immediate source which Géricault used (and
which had also influenced Jouvenet) was Rubens'
Fall of the Rebellious Angels (Munich), known to him

through the engraving by Suyderhoef. Of this
engraving, he drew careful copies (see no. 33 of this
catalogue) from which he then adapted several figures
for his composition. Such Classical or Michelangel-
esque reminiscences as the *Mutiny* drawings contain
entered them through the intermediary of Rubens'
work.

Bibliography:
*Beschrijving der schilderijen, teekeningen, etc. in het Museum
Fodor te Amsterdam,* Amsterdam, 1863, no. 823.
Clément, p. 122 and *Dessins,* no. 109.[1]
R. Huyghe, *Le dessin français au XIX siècle,* Lausanne,
1948, plate 16.
Berger, p. 71, plate 46.
J. Q. van Regteren Altena, "Het vlot van de Medusa",
in *Openbaar Kunstbezit,* v, 1961, no. 10 (illustrated).
F. Lugt, *Le dessin français de Claude à Cézanne dans les
collections Hollandaises,* 1964, p. 114, no. 137 (illustrated).
Eitner, p. 132, plate III/23-3.
L. Eitner, "Dessins de Géricault d'après Rubens, et la
genèse du *Radeau de la Méduse*", *Revue de l'Art,* no. 14,
1971, p. 54, fig. 12.
Exhibited:
Teekeningen van Fransche Meesters, Gemeentemusea,
Amsterdam, 1946, no. 102.
Die Handschrift des Künstlers, Städtische Kunsthalle,
Recklinghausen, 1959, no. 109.
Polarität, das Apollinische und das Dionysische, Städtische
Kunsthalle, Recklinghausen, 1961, no. D-95 (illus-
trated).
Idee und Vollendung, Städtische Kunsthalle, Reckling-
hausen, 1962, no. 20-B (illustrated).
Rouen, 1963, no. 31.

[1] Clément confused the history of this drawing with that
of another drawing of the *Mutiny,* the one now at the Fogg
Museum in Cambridge, Massachusetts (catalogue no. 8).
He mistakenly describes the Amsterdam drawing as having
been sold at the sale of the Scheffer collection, in 1859.
Actually, it was the drawing now at the Fogg Museum
which passed through that sale, as item no. 12, and was
sold to the French collector, Hulot, for 1,050 frs. It again
figured in the sale of the Hulot collection, in 1892, as item
no. 202, and ultimately found its way to the United States.
The earliest known owner of the Amsterdam drawing, on
the other hand, was A. J. Lamme, from whom it passed to
J. C. Fodor, who gave it to the Amsterdam museum. Since
Lamme was a cousin of Ary Scheffer, it is likely that his
Mutiny drawing had also once been owned by Scheffer and
been given or sold to Lamme at some time before 1859, a
fact which may explain Clément's confusion of the two
drawings. His error leads him (p. 122) to describe the
drawing now at the Fogg Museum in terms which actually
apply to the drawing in Amsterdam when he speaks of it
as containing figures of women.

Fodor 100 Jaar, Fodor Museum, Amsterdam, 1963, no. 74 (illustrated).
Los Angeles, Detroit, Philadelphia, 1971–72, no. 75 (illustrated).

8. THE MUTINY ON THE RAFT (Plate 7)
Black chalk, ink wash, watercolour, and white gouache on light brown paper; 400 × 510 mm.
Collections: Ary Scheffer (sale, 1859, no. 12); A. Hulot (sale, 1892, no. 202); Baron Vitta; Grenville L. Winthrop (acquired 1935); Fogg Museum of Art, Cambridge, Massachusetts (1943.824).
This is the most fully developed of the extant studies for the *Mutiny.* Its painterly execution is strikingly different from the crisp, graphic manner of the two preceding drawings. The fairly rough chalk contours are brushed over with dark-toned washes and with patches of sharp white which, by their contrasts, emphasize the compact bulk of the forms, particularly of the heavy bodies. The figures are fewer, but they loom large, crowding the view of sea and sky. The Raft is seen at close range, its timbers almost disappear beneath the bodies and the waves. Some figures have been eliminated, notably the family group at the left which Géricault has replaced with the less conspicuous

figure of a man who lifts the body of another from the water (see nos. 36–37 of this catalogue for separate sketches of this group). The narrative focus of the scene has shifted to the figure of the officer who leans against the mast in an attitude of despair, holding his broken sword, while his victim, a nude sailor, falls back into the mêlée, his chest transfixed by the sword's point. Studies related to this drawing will be found in another section of this catalogue (cf. nos. 29–33).
Bibliography:
Gazette des Beaux-Arts, II, 1859, p. 47 (account of the sale of the Ary Scheffer collection).
Clément, p. 122 and *Dessins,* no. 110.[2]
Knowlton, p. 135, fig. 22.
Berger, p. 71, plate 47.

9. THE MUTINY ON THE RAFT
Pencil on paper; 30 × 50 mm.
Collection: Private collection, Paris.
This small, rough sketch was shown at the Centenary exhibition in Paris, in 1924. Its present whereabouts is not known.
Exhibited:
Centenary, 1924, no. 122.

[2] See note 1 above.

(c) Cannibalism

On the third day of the Raft's voyage, after a night of fighting during which more than sixty men had perished, hunger began to drive the survivors to despair. *"Those whom death had spared",* reported Corréard and Savigny, *"fell upon the dead bodies with which the raft was covered, and cut off pieces, which some instantly devoured. Many did not touch them; almost all the officers were of this number ... Those who had firmness enough to abstain ... took a larger quantity of wine. We tried to eat swordbelts and cartouche-boxes ..."* (A. Corréard and H. Savigny, *Narrative of a Voyage to Senegal in 1816,* London, 1818, p. 108).

10. DESPAIR AND CANNIBALISM ON THE RAFT (Plate 8)
Black chalk, ink wash, watercolour, and white gouache on light brown paper; 285 × 385 mm.
Collections: J. Nepveu, Amsterdam (sale, 1837); P. Grégoire, Paris (sale, 1842); Duquesne; the late M. Gobin, Paris.
The shipwrecked men, decimated by the fighting of the preceding night, are shown in a state of despair. Two of them are about to feed on one of the cadavers which litter the planks. The general disposition of the Raft and of the figures recalls the *Mutiny* compositions,

particularly that in the Fogg Museum (cat. no. 8) which this drawing also resembles in style and technique of execution. It is the only surviving drawing for the *Raft of the Medusa* actually to represent an incident of cannibalism, though this was the most notorious horror of the Raft's voyage. Géricault probably drew it in the early stages of his general exploration of the different episodes of the story, most likely just after the *Mutiny,* with which it shares several figure motifs. A single cadaver trailing from the Raft's stern replaces the cascade of falling figures of the *Mutiny* drawings; it is the direct precursor of the half-

shrouded cadaver which Géricault was later to introduce in this position into the final version of the scene (see catalogue nos. 26, 77–79). A noteworthy innovation of the *Cannibalism* drawing is the figure of a dead, nude youth, close to the foot of the mast, whom Géricault originally intended to show leaning against a barrel. This barrel he then transformed into the figure of an elderly kneeling man who holds the youth in his lap. This is the earliest appearance of the group of the "Father" holding the body of his dead son, a prominent feature of all the later versions of the *Raft of the Medusa* (see nos. 38–50 of this catalogue).

Bibliography:
Clément, *Dessins,* no. 111.
Commemorative Catalogue, French Art 1200–1900, Royal Academy, London, 1932, p. 176, no. 847, illustrated plate 184.
M. Gobin, *Géricault dans la collection d'un amateur,* Paris, n.d. [1958], no. 22 (illustrated).
M. Gobin, *L'art expressif,* Paris, 1960, p. 15 (illustrated).
Exhibited:
French Art 1200–1900, Royal Academy, London, 1932, no. 847.
Chefs-d'œuvre de l'art français, Paris, 1937, no. 655.

(d) The Approach of Rescue

Of the final moments before the rescue of the survivors from the Raft, Corréard and Savigny had given a particularly vivid description, which tempted Géricault to try a translation of it into the form of a dramatic composition. On the thirteenth day of their voyage, the men on the Raft had for a moment believed their rescue to be imminent when they sighted the *Argus* in the distance, but the ship vanished, and the men retired into the shade of their tent, having lost all hope. *"After we had passed two hours, absorbed in the most cruel reflections, the master gunner of the frigate wishing to go to the front of the raft, went out of our tent: scarcely had he put his head out, when he turned toward us, uttering a loud cry: joy was painted on his countenance, his hands were stretched toward the sea, he scarcely breathed: all that he could say was, 'Saved! see the brig close upon us'. And in fact it was, at the most, half a league distant, carrying a press of sail, and steering so as to come extremely close to us; we precipitately left the tent: even those whom enormous wounds, in the lower extremities, had confined for some days past always to lie down crawled to the back part of the raft, to enjoy the sight of this vessel, which was coming to deliver us from certain death. We all embraced each other with transports that looked like delirium, and tears of joy rolled down our cheeks, shrunk by the most cruel privations. Everyone seized handkerchiefs or pieces of linen to make signals to the brig, which was approaching rapidly. Others, prostrating themselves, fervently thanked Providence for our miraculous preservation. Our joy redoubled when we perceived a great white flag at the foremast head, and we exclaimed: 'It is then to Frenchmen that we shall owe our deliverance'. We almost immediately recognized the brig to be the* Argus . . . *a boat was immediately hoisted out to take the survivors from the Raft and convey them to the rescue ship."* (A. Corréard and H. Savigny, *Narrative of a Voyage to Senegal in 1816,* London, 1818, pp. 137 ff.).

11. THE SURVIVORS HAILING THE APPROACHING ROWING-BOAT (Plate 9)
Pen on paper; 240 × 330 mm.
Collections: Camille Marcille (sale, 1876, no. 82); Lesourd; present location not known.
As the rowing-boat approaches, in the middle distance at the left, the shipwrecked men crowd the Raft's forward edge, in the right foreground, gesturing toward their rescuers in desperate anticipation. The drawing is known only through an old, indifferent reproduction.

Clément considered it to have been the point of departure for the development which led to the final version of the *Raft of the Medusa,* and it is evident that, in its theme and form, the scene of the *Hailing* foreshadows that of the *Sighting of the Argus,* which Géricault ultimately chose for his painting. Though only very few sketches for it survive, it seems to have held Géricault's interest for some time. It is remarkable, at any rate, that he made this episode the subject of a large painted study (catalogue no. 13), something

he had not done with the episode of the *Mutiny*.
Bibliography:
Clément, *Dessins*, no. 113.
L'Art, IV, 1876, p. 294 (illustrated).
Eitner, p. 132, plate III/24–1.

12. THE SURVIVORS HAILING THE
APPROACHING ROWING-BOAT (Plate 10)
Pen and sepia wash on paper; 205 × 260 mm.
Collections: Coutan-Hauguet (stamp, Lugt 464); Musée
des Beaux-Arts, Rouen, cat. 1385 (acquired in 1890).
Mounted with no. 15 of this catalogue.
The drawing gives only the right half of the total view.
It is the earliest example, among the studies for the
Raft of the Medusa, of the powerfully simple pen-and-
wash technique which Géricault was to use often in
experimenting with the distribution of the main
shadows and lights of his composition.
Bibliography:
P. Gonse, *Chefs d'œuvre des musées de France,* II, Paris,
1904, p. 318.
P. Lafond, *Le musée de Rouen,* n.d., p. 78.
M. Delacre and P. Lavallée, *Dessins de maîtres anciens,*
Paris-Brussels, 1927, p. 94.
R. Regamey, *Géricault,* Paris, 1926, plate 17.
G. Oprescu, *Géricault,* Paris, 1927, p. 97.
J. Knowlton, p. 133, fig. 14.
W. Friedlaender, *David to Delacroix,* Cambridge, 1952,
fig. 60.
Exhibited:
Exposition Centennale, Paris, 1900
Fransk Malerkunst, Copenhagen, 1914, no. 286.
Centenary, 1924, no. 121.
Bernheim-Jeune, 1937, no. 125.
David à Millet, Kunsthaus, Zürich, 1937, no. 141–A.
Meisterzeichnungen aus Frankreichs Museen, Vienna, 1950,
no. 147.

Winterthur, 1953, no. 174.
Gros, Géricault, Delacroix, Bernheim-Jeune, Paris, 1954,
no. 53-bis.
French Drawings, Chicago, Minneapolis, Detroit, San
Francisco, 1955, no. 111 (1), plate 22.
Französische Zeichnungen, Hamburg, Cologne, Stuttgart,
1958, no. 133 (1).
Idee und Vollendung, Städtische Kunsthalle, Reckling-
hausen, 1962, no. 200.
Rouen, 1963, no. 32.
Los Angeles, Detroit, Philadelphia, 1971–72, no. 77
(illustrated).

13. THE SURVIVORS HAILING THE
APPROACHING ROWING-BOAT
Oil on canvas; 430 × 540 mm.
Collections: Clouard; M. Queslier; destroyed during a
bombardment of the town of Mortain in Normandy
in 1944.
Clément described this painted study, which for some
reason remained in the possession of Géricault's family
until its destruction in 1944, as highly finished. Its
composition corresponded to that of the two preceding
drawings. "*Le radeau n'occupe que la moitié du tableau. A
l'avant, six marins debout ou agenouillés, les bras tendus ou
les mains jointes, attendent avec anxiété un canot qui vient à
leur secours: derrière eux, cinq autres personnages exténués se
traînent avec effort: à l'arrière, un nègre prie à côté d'un
soldat impassible et d'un cadavre mutilé. Debout, adossé au
mât, Corréard parle avec un de ses compagnons, probablement
le chirurgien Savigny. On aperçoit à l'horizon le brick
l'Argus.*" (Clément, p. 123).
Bibliography:
Clément, p. 123 and *Peintures,* no. 101.
L. Rosenthal, *Géricault,* Paris, n.d. (1905), p. 166.
Drs. Jules and Gilles Buisson, in *Art de Basse Norman-
die,* 1960, no. 4.

(e) The Sighting of the *Argus*

The episode which Géricault finally chose as the subject for his painting was suggested to him by the
following passage from the narrative of Corréard and Savigny, which is, in fact, the "text" which
underlies the *Raft of the Medusa:* "*On the 17th* [of July] *in the morning, the sun appeared entirely free from
clouds; after having put up our prayers to the Almighty, we divided among us a part of our wine; every one was
taking with delight his small portion, when a captain of infantry, looking towards the horizon, descried a ship,
and announced it to us by an exclamation of joy: we perceived that it was a brig; but it was at a very great distance;
we could distinguish only the tops of the masts. The sight of this vessel excited in us a transport of joy which it
would be difficult to describe; each of us believed his deliverance certain, and we gave a thousand thanks to God;*

yet fears mingled with our hopes: we straightened some hoops of casks, to the end of which we tied handkerchiefs of different colours. A man, assisted by us all together, mounted to the top of the mast and waved these little flags.

For about half an hour we were suspended between hope and fear; some thought they saw the ship become larger, and others affirmed that its course carried it from us: these latter were the only ones whose eyes were not fascinated by hope, for the brig disappeared. From the delirium of joy, we fell into profound despondency and grief; we envied the fate of those whom we had seen perish at our side." (A. Corréard and H. Savigny, *Narrative of a Voyage to Senegal in 1816,* London, 1818, p. 135.) In the fourth edition of Corréard's and Savigny's account, one of the authors added a footnote to the passage quoted above, to indicate that this episode was the subject of Géricault's painting. Since it is one of the earliest detailed descriptions of the picture and, being by one of the survivors of the Raft, carries considerable authority in its identifications of the persons represented, it is worth noting: *"M. Géricault a fait sur cette épisode un tableau dont voici la description. Le groupe principal est composé de M. Savigny au pied du mât, et de M. Corréard, dont le bras étendu vers l'horizon et la tête tournée vers M. Savigny, indique à celui-ci le côté où se dirige un bâtiment aperçu au large par deux matelots, qui lui font des signaux avec des lambeaux d'étoffe de couleur. Les expressions de ces differentes figures sont énergiques et tout-à-fait conformes à la vérité historique. Découragé et croyant remarquer que la corvette signalée fait une route opposée à celle qu'on espère, le chirurgien Savigny indique à ses amis qu'ils se flattent en vain; son camarade, au contraire, par une inspiration qui eut la plus heureuse réalité, essaie de lui persuader que le bâtiment en vue étant à leur recherche, ne saurait manquer de virer de bord et de les rencontrer avant la fin du jour. Pendant cette petite scène, à laquelle trois personnages rapprochés des deux que j'ai nommés, prennent part, chacun dans un sens bien marqué, les hommes qui agitent leurs signaux poussent des cris de joie, auxquels répond M. Coudin, qui se traîne jusqu'à eux. L'une des victimes, presque mourante, entend cette clameur, qui pénètre jusqu'au fond de son coeur; elle lève sa tête décolorée et semble exprimer son bonheur par ces mots:* Au moins nous ne mourrons pas sur ce funeste radeau. *Derrière cet homme, abattu, exténué de maux et de besoin, un Africain n'entend rien de tout ce qui se passe autour de lui; il est morne, et sa figure immobile accuse la situation de son âme. Plus loin, dans un état d'anéantissement et de douleur, un vieillard, tenant couché sur ses genoux le cadavre de son fils expiré, se refuse à toutes les impressions de la joie que peut faire éprouver la nouvelle de sa délivrance. Que lui importe la vie qu'il va recouvrer? Ce jeune homme, qui faisait son espoir et sa consolation; cet ami qui avait partagé tant de maux, vient de succomber; il est condamné à lui survivre quelques jours, quelques heures seulement; car les souffrances inouïes qu'il éprouve sont de sinistres précurseurs du trépas; mais ce peu d'instans lui doit être à charge; l'Océan va engloutir l'objet de toutes ses affections et de tous ses regrets. Cet épisode est des plus touchans, il fait honneur à l'imagination de M. Géricault; enfin, çà et là sur le premier et le second plan, des corps morts ou des malheureux prêts à rendre le dernier soupir. Telle est assez fidèlement la marche de cette vaste composition, à laquelle la variété des poses et la vérité des mouvemens donne un grand caractère."* (A. Corréard and J. B. H. Savigny, *Naufrage de la frégate La Méduse,* fourth edition, Paris, 1821, p. 155, n. 1.)

14. THREE SKETCHES OF THE RAFT AMIDST HIGH WAVES (Plate 12).
Pencil on paper; 132 × 205 mm.
Collections: J. Gigoux; Musée des Beaux-Arts, Besançon inv. D.2137 (verso).
The three faint pencil sketches are position studies of the Raft, evidently related to the episode of the *Sighting* and corresponding, in so far as they can be clearly seen,

to the very early pen study in Rouen, catalogue no. 15. It is possible that these sketches are part of Géricault's first formulation of the scene which he was eventually to adopt for his picture. They show him preoccupied with the directional thrust of the Raft which, in all three sketches, is turned into the distance and toward the right, as in the final version. In one of the sketches, at the right of the sheet, Géricault has plotted diagonal,

perspectival lines converging on the point where the distant *Argus* is to appear. Slight as they are, these drawings give an interesting insight into an intimate phase of the compositional planning which the more finished drawings do not reveal. The other faint sketches on the sheet, representing an equestrian battle, are unrelated to the Medusa project. On the recto, a fine, fairly highly finished pen drawing of a nude horseman, related to the project of a *Battle Scene* which occupied Géricault in 1817–1818. It refers, in particular, to the two compositional drawings in Bayonne (Musée Bonnat, inv. 2.025 and 2.026).

15. THE SIGHTING OF THE DISTANT ARGUS
(Plate 13)
Pen on paper; 240 × 300 mm.
Collections: Coutan-Hauguet (stamp, Lugt 464); Musée des Beaux-Arts, Rouen, cat. 1386 (acquired in 1890). Mounted with no. 6 of this catalogue.
This fairly rough pen drawing has the look of an improvisation; the sketch in the middle, nevertheless, strikingly anticipates the general form of the *Raft of the Medusa's* definitive composition. Several of the basic features of that composition are already in evidence: the huge wave which rises ominously at the stern of the Raft, the steep diagonal of the figure groups, and the decided turn of the Raft and its figures toward the point at the far right where the *Argus* appears on the horizon. By contrast, the definition of the individual figures is still very vague. The drawing only hints at a few of the figure inventions and combinations with which Géricault was later to build his composition. The large seated figure at the stern is a precursor of the "Father", who will be a prominent feature of the painting; the athletic nude seen in back view in the middle of the Raft and the man slumped across the body of another will also play a role in the further development of the scene, of which this drawing is evidently the earliest surviving sketch. All the subsequent studies for it are in fact so much more fully developed that it is necessary to assume the intervention of additional sketches and studies between this very early drawing and the rest. It is also noteworthy that, while this early sketch owes nothing to the compositions of the *Mutiny, Cannibalism,* and the *Hailing of the Approaching Rowing-boat,* the later drawings of the episode of the *Sighting* invariably incorporate important borrowings from them. The evidence suggests that Géricault drew this sketch of the *Sighting* at a very early time, close to the beginning of his general exploration of the various dramatic incidents which the story offered. After he had rapidly noted his

conception of the episode of the *Sighting* in this drawing, he laid it aside to concentrate on other episodes. When, having exhausted these others, he at length returned to the episode of the *Sighting,* he was able to resume his earlier idea, armed with a stock of ready figure motifs and compositional schemes which he had acquired in the meantime.

Among the marginal figure drawings, at the top of the sheet, are an early version of the group of "Father and Son" and two drawings of the prone body of the "Son" in different, foreshortened views. These sprightly sketches recall the tradition that Géricault composed his figures with the aid of wax sculptures placed on a small-scale model of the Raft (Clément, p. 130).

The verso of the sheet contains, besides some slight sketches not related to the *Medusa* (trees, the head of a cow, a seated peasant boy), a large pen-and-wash drawing of the body of a man lying on his face (Plate 45). This is an early version of a figure which plays a role in the *Mutiny* and *Cannibalism* scenes, as well as in the more fully developed compositions of the *Sighting* (see also nos. 15v, 51–52 and 79v of this catalogue).

Bibliography:
Catalogue, Musée des Beaux-Arts, Rouen, 1890, no. 774.
Catalogue, Musée des Beaux-Arts, Rouen, 1911, no. 1386
P. Lafond, *Le musée de Rouen,* n.d., p. 78.
Rosenthal, ill. opp. p. 76.
Regamey, plate 18.
Knowlton, p. 133, fig. 15.
W. Friedlaender, *David to Delacroix,* New York, 1952, plate 58.
D. Aimé-Azam, "La Passion de Géricault", *Jardin des Arts,* 89, April 1962, p. 26 (illustrated).
V. N. Prokofief, *Théodore Géricault,* Moscow, 1963, p. 131.
Eitner, p. 132, plate III 24-3.
Exhibited:
Exhibition Centennale, Paris, 1900.
Fransk Malerkunst, Copenhagen, 1914.
Centenary, 1924, no. 123-b.
Bernheim-Jeune, 1937, no. 124-b.
David à Millet, Kunsthaus, Zürich, 1937, no. 140-b.
Bignou, 1950, no. 43.
French Drawings, Washington, Cleveland, St. Louis, Fogg Museum, Metropolitan Museum, 1952-53, no. 121.
Rouen, 1963, no. 35.

16. THE SIGHTING OF THE DISTANT ARGUS
(Plate 14)
Pen on paper; 350 × 410 mm.

Collections: Jules Boilly (sale, 1869, no. 118); Palais des Beaux-Arts, Lille, inv. 1391.

Unlike the preceding sketch, this careful pen drawing presents a clearly articulated composition, every part of which has undergone some preparatory study. In the grouping and strong leftward orientation of its figures, it recalls the scene of the *Survivors Hailing the Approaching Rowing-boat* (catalogue nos. 11–13). The general conception derives from the earlier sketch of the *Sighting* (catalogue no. 15), which is also the source of the group of "Father and Son", of the rising nude seen in back view, and of the man waving two pieces of cloth. The figure of a man lying forward on his face is a borrowing from the *Mutiny* or *Cannibalism* drawings (catalogue nos. 5–10). The figures of the man seated against the mast and the man pointing to the *Argus* are new. The drawing is the earliest coherent statement of the pictorial idea expressed in the *Raft of the Medusa*. Its twelve figures are the core from which grew, in many successive additions and adjustments, the final composition of the picture.

The sheet bears an erased and illegible inscription at its upper left. The handwriting does not appear to be that of Géricault.

Bibliography:
Catalogue, Jules Boilly sale, Paris, 19–20 March 1869, no. 118 (illustrated).
Catalogue: Dessins, Musée Wicar, Lille, 1887, p. 310, no. 1391.
Pluchart, *Catalogue du Musée Wicar,* Lille, 1899, no. 1391.
Knowlton, p. 133, fig. 16.
Eitner, p. 132, plate III/24–2.
Exhibited:
Idee und Vollendung, Städtische Kunsthalle, Recklinghausen, 1962, no. 20-J.
Rouen, 1963, no. 36 (illustrated).
Los Angeles, Detroit, Philadelphia, 1971–72, no. 78 (illustrated).

17. THE SIGHTING OF THE DISTANT ARGUS
(Plate 15)
Pen and sepia wash on paper; 205 × 285 mm.
Collections: Coutan-Hauguet (stamp, Lugt 464); Musée des Beaux-Arts, Rouen, cat. 1385. Mounted with no. 12 of this catalogue.
The drawing contributes three important innovations: it reverses the direction of the composition, it organizes the figures into distinct groups, and it determines the illumination of the scene. While in the early, rough sketch for the *Sighting,* Géricault had intuitively let the compositional movement run from the left foreground

toward a distant focus at the upper right (Plate 13), he gave to the later, more fully realized version of the *Sighting* (Plate 14) the same strong leftward thrust which he had previously tried in the composition of the *Survivors Hailing the Approaching Rowing-boat* (Plates 9–10). But now, having firmly established the figure composition, he orients it once again toward the right, accelerating its sweep. At the same time, he tightens the grouping of the figures and gives each group a distinct dramatic character. The light falls at a slant from behind the sail. It grazes the contours of the figures and leaves large areas in deep shadow. Toward the bottom, at the left, the prone or crouching figures of "Father and Son", of the man lying on his face, the crouching man, and the man holding his head in anguish have drawn closely together, their heavy stillness contrasts with the pantomime of the four figures next to them, who are struggling to rise and who motion to the distant *Argus*. A third group of men stands huddled together at the mast, alert, observant, but motionless except for one who points to the horizon. Two barrels stand, unused, at the Raft's forepart. The space which will later be occupied by the signalling Negro and his assistants is still void.
Bibliography:
Catalogue, Musée des Beaux-Arts, Rouen, 1890, no. 773.
Catalogue, Musée des Beaux-Arts, Rouen, 1911, no. 1385.
P. Gonse, *Chefs d'œuvre des musées de France,* II, Paris, 1904, p. 318.
P. Lafond, *Le musée de Rouen,* n.d., p. 78.
M. Delacre and P. Lavallée, *Dessins des maîtres anciens,* Paris, 1927, p. 194, plate 47.
Knowlton, p. 133, fig. 17.
K. Berger, *Géricault, Drawings, Watercolours,* New York, 1946, plate 27.
W. Friedlaender, *David to Delacroix,* New York, 1952, plate 59.
Eitner, p. 133, plate III 24–4.
Exhibited:
Exposition Centennale, Paris, 1900.
Fransk Malerkunst, Copenhagen, 1914, no. 286.
Centenary, 1924, no. 121.
Bernheim-Jeune, 1937, no. 125.
David à Millet, Kunsthaus, Zürich, 1937, no. 141-B.
Meisterzeichnungen aus Frankreichs Museen, Vienna, 1950, no. 147.
Winterthur, 1953, no. 174, plate XXXI.
Gros, Géricault, Delacroix, Bernheim-Jeune, Paris, 1954, no. 53-bis.
French Drawings, Chicago, Minneapolis, Detroit, San Francisco, 1955, no. 111 (2), plate 23.

Französische Zeichnungen, Hamburg, Cologne, Stuttgart, 1958, no. 133 (2).
Idee und Vollendung, Städtische Kunsthalle, Reckling-hausen, 1962, no. 200.
Rouen, 1963, no. 33.
Los Angeles, Detroit, Philadelphia, 1971–72, no. 79 (illustrated).

18. THE SIGHTING OF THE DISTANT ARGUS (Plate 16)

Oil on canvas; 375 × 460 mm.
Collections: Baron Schickler, Paris; Musée du Louvre, Paris, RF 2229 (acquired in 1919).
The earliest of the painted studies for the definitive composition (Clément, p. 121). The arrangement of the figures follows that of the preceding drawing (catalogue no. 17), except that the sailor waving a piece of cloth has now been joined by another. With this addition, the number of figures on the Raft has risen to fourteen (not counting the half-visible cadaver behind the barrels at the extreme right). The paint is laid over a dark, brownish preparation, which remains visible in the shaded parts of some of the figures. The tonality of this picture is noticeably more sombre, particularly in the grey of the clouds and the brown of the timbers, than that of the more advanced painted study at the Louvre (Plate 21). It is evident that in the course of painting this early oil study, Géricault lowered the line of the horizon, causing the extended arms of the figures at the forepart to be silhouetted against a stripe of light-blue sky.
Bibliography:
Clément, p. 121 and *Peintures,* no. 98.
Berger, p. 70, plate 42.
Ch. Sterling and H. Adhémar, *La peinture au musée du Louvre, École Française,* I, Paris, 1959, no. 945, plate 338.
N. V. Prokofief, *Théodore Géricault,* Moscow, 1963, plate 136.
Eitner, p. 133.
Exhibited:
Centenary, 1924, no. 135.
Fransk Malerkunst, David-Courbet, Copenhagen, Stock-holm, Oslo, 1928, no. 77.
Gros, ses amis et ses élèves, Paris, 1936, no. 843.
Franske Kunst, Copenhagen, 1938, no. 83.
Art français, Belgrade, 1939, no. 56.
De David a nuestros dias, Buenos Aires, 1939, no. 64.
Delacroix et les compagnons de sa jeunesse, Paris, 1947, no. 40.
Winterthur, 1953, no. 77, plate xv.
Idee und Vollendung, Städtische Kunsthalle, Reckling-hausen, 1962, no. 20-K.

Rouen, 1963, no. 3 (illustrated).
Delacroix, Bordeaux, 1963, no. 284.
Le romantisme dans la peinture française, Moscow, Leningrad, 1968–1969, no. 58.
The Past Re-Discovered, Minneapolis, 1969, no. 40.
Los Angeles, Detroit, Philadelphia, 1971–72, no. 80 (illustrated).

19. THE RAFT OF THE MEDUSA: EARLY VERSION OF THE DEFINITIVE COMPOSITION (Plate 17)

Pen on paper; 200 × 270 mm.
Collections: Walferdin (sale, 1880, no. 292); Claude Aubry, Paris.
Only the four figures at the Raft's stern are distinctly defined, yet the drawing gives interesting indications of compositional changes and additions. The figure of the "Father" retains its early form, but that of the "Son" has begun to assume the position of head and shoulders which it will retain from this point on. The "Son's" left arm, which in the previous version was stiffly thrust out, is here omitted; the unresolved passage which takes its place testifies to Géricault's indecision about this detail. Further to the right, the faintly sketched group of kneeling and rising figures has acquired its fourth member. Beyond this point, the composition fades into near-invisibility, but its general spacing seems to suggest that Géricault already had the terminal group of the signalling Negro and his two assistants in mind when he made this drawing. On the verso, a study in pen, washes, and white gouache, for the figure of the man dragging himself forward on his knees, showing it in a fairly advanced form (Plate 55; see numbers 55–60 of this Catalogue).
Bibliography:
Clément, *Dessins,* no. 116.

20. THE RAFT OF THE MEDUSA: DEFINITIVE COMPOSITION (Plate 18)

Pen and wash; 200 × 270 mm.
Collections: Walferdin (sale, 1880, no. 293); Claude Aubry, Paris.
Despite its summary execution, this drawing contri-butes several important advances to the evolution of the composition. It is the first to introduce the motif of the Negro, who, mounted on a barrel, signals with a piece of cloth. Of the two figures which the earlier sketches showed in this place, the one on the left has been converted into a supporter for the Negro, while the other, at the extreme right, remains as yet un-changed. At the opposite end of the Raft, the head of the "Father" has been turned from a profile into a nearly full-face position. The body of the "Son" still

lacks its left arm. The group of rising figures, in the centre, has undergone yet another revision. Géricault has added to it the figure of a reclining man who, supporting himself on his sharply bent right arm, reaches forward with his left. This figure, which makes its first appearance here, was later shifted forward to replace the man who attempts to pull himself up by holding onto the rim of a barrel.

On the verso, a study in ink, washes, and white gouache for the figure of a man reaching forward with his left arm (Plate 60).

Bibliography:

Clément, *Dessins,* no. 115.

Exhibited:

Aubry, 1964, no. 77 (illustrated).

Los Angeles, Detroit, Philadelphia, 1971–72, no. 81 (illustrated).

21. STUDY OF THE ENTIRE FIGURE COMPOSITION, WITHOUT THE RAFT

Black crayon, rubbed, on paper; 300 × 430 mm.

Collections: Camille Marcille (sale, 1876, no. 81); Veterhan; present location not known.

This drawing of large format disappeared from sight a long time ago. According to Clément's description, it defined the figures in the centre of the composition by means of rubbed crayon shadings, while giving only the contours of the figures on the left and on the right.

Bibliography:

Clément, *Dessins,* no. 118.

L'art, IV, Paris, 1876, p. 294 (account of the sale of the Marcille collection).

22. THE RAFT OF THE MEDUSA: DEFINITIVE COMPOSITION (Plate 19)

Pencil, pen, some sepia wash on brown (discoloured?) paper; 410 × 575 mm.

Collections: A. Hulot (sale, 1892, no. 201); Cheramy (sale, 1908, no. 103); Duc de Trévise (sale, 1938, no. 10); Musée du Louvre, Paris, RF 29109.

This is the most detailed of the extant compositional drawings. It is squared—the numbers and letters marking the divisions are still faintly visible along the edges of the sheet—and was evidently destined to be transferred to canvas. The group of rising figures in the centre still lacks the figures of the man raising both arms and of the Negro slumped over the legs of the man trying to pull himself up by grasping the rim of a barrel. This last figure is still in an early, unresolved state; it shows many erasures, as does also the figure of the "Father", whose head Géricault changed from a

profile to a full-face position. Clearly, Géricault found it necessary to make many changes in the course of completing the drawing; it is a transitional work, marking the beginning of the final stage in the compositional development, but retaining some early features. While working on this drawing, Géricault markedly lowered the line of the horizon. Vestiges of the original, higher horizon are still visible near the left margin of the sheet.

It is apparent that the drawing has suffered severe physical deterioration since 1908 when, as photographs taken at that time indicate, it was still in fair condition. At present, the ink in parts of the drawing has seriously faded, while the paper appears to have darkened to a purplish brown, and, in addition, has become badly spotted.

On the verso of the sheet are six crayon studies of a Polish lancer, showing him on foot and on horseback. They are related to a group of paintings and drawings which are known by the—possibly erroneous—title of *The Death of Poniatowski* (see Clément, *Peintures,* no. 57, and L. Eitner, *Géricault, an Album of Drawings in the Art Institute of Chicago,* Chicago, 1960, p. 37) and can be dated about 1814. There is little doubt that this must also be the date of these sketches. The mended crease which runs through the centre of the sheet and separates the sketches of the verso into two distinct groups suggests that this may have been the centre fold of a sketchbook, in use as early as 1814, which Géricault in 1818 adapted for his large compositional study by combining the two blank inner faces.

Bibliography:

Clément, *Dessins,* no. 117.

J. Meier-Graefe and E. Klossowski, *La collection Cheramy,* Munich, 1908, p. 77, no. 103.

Catalogue, Duc de Trévise Sale, Galerie Charpentier, Paris, 19 May 1938, no. 10.

Exhibited:

Centenary, 1924, no. 134.

Bernheim-Jeune, 1937, no. 123.

23. THE RAFT OF THE MEDUSA: DEFINITIVE COMPOSITION (Plate 20)

Pen on oil-impregnated paper; 330 × 540 mm.

Collections: Courtin; H. Buehler, Schloss Berg near Winterthur, Switzerland.

This drawing, a careful pen tracing, shows several advances over the foregoing. It includes both the straining figures with arms upraised and the slumped body of the Negro at the right. These additions, which raise the number of figures to eighteen, make it the immediate precursor of the painted study at the Louvre,

catalogue no. 24, which differs from it only in minor details of position and gesture.
Bibliography:
Clément, *Dessins,* no. 114.
Géricault, Sammlung Hans E. Buehler, Winterthur, 1956, no. 56.

24. THE RAFT OF THE MEDUSA: DEFINITIVE COMPOSITION (Plate 21)
Oil on canvas; 650 × 830 mm.
Collections: Géricault (sale, 1824, no. 4); Jamar; Duchesse de Montebello (sale, 1857); Moreau-Nelaton; Musée du Louvre, Paris, RF 1667 (acquired in 1906).
According to Clément, who cites Géricault's disciples Montfort and Jamar as his authorities, this was the second oil study which Géricault painted of this composition, the first being the smaller oil study also in the Louvre, catalogue no. 18. Géricault at first intended to make a finished picture of it, but left it uncompleted. Most of the figures remain as pen drawings on the bare canvas, several are shaded with bitumen, a few figures, notably the group of "Father and Son" and the signalling Negro, are more highly finished in oil. The setting of sea and sky is fairly completely rendered. It differs noticeably, in its much ampler spaciousness and in its distribution of areas of illuminated sky and dark cloud, from the final canvas. The motif of the threatening wave rising behind the Raft at the left appears fully developed for the first time (foreshadowed only by the very early drawing in Rouen, catalogue no. 15). Compositionally, the study represents the final stage of the preparatory work. All eighteen figures which Géricault meant to include in the picture at this stage are present and have assumed their final attitudes, except for such fairly minor points of difference as are evident in the position of the "Son's" legs, the greater distance between the group at the mast and the signalling Negro, and the position of the Negro's arm.
Bibliography:
Clément, *Peintures,* no. 99.
Catalogue, Collection Moreau-Nelaton, Paris, 1923, p. 19.
P. Courthion, *David, Ingres, Gros, Géricault,* Paris, 1940, unnumbered colour reproduction.
Berger, p. 70, plate 43.
A. del Guercino, *Géricault,* Milan, 1963, plate xv.
Ch. Sterling and H. Adhémar, *La peinture au musée du Louvre, École Française,* I, Paris, 1959, no. 946, plate 338.
V. N. Prokofief, *Théodore Géricault,* Moscow, 1936, p. 137.
Exhibited:
Musée des Arts Décoratifs, Paris, 1907.

25. THE RAFT OF THE MEDUSA: DEFINITIVE COMPOSITION
Oil on canvas; 1,300 × 1,950 mm.
Collections: Location unknown.
This study is known only through Clément's description: *"La composition telle qu'elle a été exécutée, moins la figure enveloppée d'un drap, au premier plan, à droite, a été tracée sur la toile, à la plume, avec une grande précision. Quelques têtes sont peintes et très-achevées. C'est cet ouvrage que Géricault abandonna pour ne pas refroidir sa verve, comme il le dit à M. Montfort, avant de commencer son grand tableau. Je n'ai pu retrouver la trace de cet ouvrage."*
Bibliography:
Clément, *Peintures,* no. 100.

26. THE RAFT OF THE MEDUSA (Plate 22)
Oil on canvas; 4,910 × 7,160 mm.
Collections: Géricault (sale, 1824, no. 1); Dedreux-Dorcy; Musée du Louvre, Paris, Inv. 4884 (acquired in 1825).
Bibliography:
Clément, *Peintures,* no. 97.
Ch. Sterling and H. Adhémar, *La peinture au musée du Louvre, École Française,* I, Paris, 1959, no. 947, plate 339.
Exhibited:
Salon of 1819.
Egyptian Hall, Piccadilly, London, 12 June–30 December 1820.
The New Rotunda, Dublin, February–March 1821.

27. "SHIPWRECK OF THE MEDUSA" (Plate 23)
Lithographic print; 100 × 160 mm.
This lithograph was drawn by Géricault and finished by N.-T. Charlet in London, about June 1820. It was used as a form of admission ticket for the exhibition of the *Raft of the Medusa* at Bullock's Egyptian Hall in Piccadilly, London. While the print conforms in nearly every respect to the composition of the painting, it introduced one important change, which can only be regarded as a correction: it quite markedly raises the line of the horizon, thus increasing the expanse of water around the Raft. This change either represents an afterthought on Géricault's part, or a concession to critics who had blamed his picture for showing too little of the ocean. It justifies considering this otherwise mediocre print as a genuine compositional variant.
Bibliography:
M. de La Combe, *Charlet, sa vie, ses lettres,* Paris, 1856, p. 274.
Clément, *Lithographies,* no. 24.
L. Delteil, *Théodore Géricault, Le peintre-graveur illustré,* vol. 18, Paris, 1924, no. 79.

28. THE RAFT OF THE MEDUSA
(Plate 24)
Watercolour on paper; 105 × 170 mm.
Collections: A. Corréard; Leclere; present location not known.
The second in a series of four watercolours painted by Géricault to illustrate the third edition of the account of the shipwreck of the *Medusa*, published in 1821. The watercolour, known only through its (reversed) litho-graphic reproduction in this book and a wood-engraving, by Pauquet, which was published in the *Magasin Pittoresque*, faithfully copies the painting, except for the fact that it raises the horizon line and thereby considerably enlarges the visible expanse of water. (See also nos. 110–112 of this catalogue.)
Bibliography:
Clément, *Dessins,* no. 139–B.
Le Magasin Pittoresque, XXVII, December 1859.

2. FIGURE STUDIES

(a) Various Studies Related to the Mutiny Composition

29. SKETCH OF A MAN WIELDING A HATCHET
Pencil on paper; 190 × 180 mm.
Collections: Camille Marcille (sale, 1876, no. 86); Heyman; Chaumont; present location not known.
The figure occurs in the scene of the *Mutiny.*
Bibliography:
Clément, *Dessins,* no. 133.

30. FOUR SKETCHES OF A MAN WIELDING A HATCHET
Pen on paper; 160 × 140 mm.
Collections: Camille Marcille (sale, 1876, no. 87); Heyman; Chaumont; P. Dubaut; M. Dubaut, Paris.
This drawing, like the foregoing, refers to a figure in the scene of the *Mutiny.*
Bibliography:
Clément, *Dessins,* no. 134.
Exhibited:
Bignou, 1950, no. 53.
Marlborough, 1952, no. 57.
Winterthur, 1953, no. 179.
Gros, Géricault, Delacroix, Galerie Bernheim-Jeune, Paris, 1954, no. 57.
Aubry, 1964, no. 78.

31. SKETCHES FOR THE HEADS OF SOLDIERS IN THE SCENE OF THE 'MUTINY'
Pen on paper; 210 × 257 mm.
Collection: César de Hauke, Paris.
Exhibited:
Winterthur, 1953, no. 145.

32. HEAD OF A BEARDED MAN, AFTER A PAINTING BY DOYEN (Plate 25)
Black chalk and watercolours on paper; 450 × 340 mm.
Collections: Duc de Trévise (sale, 1938, no. 15); Mme. Alphonse Bellier, Paris.
The head resembles, in position, type and expression, the head of a sailor in the centre of the *Mutiny* composition, catalogue nos. 5–6, who raises his hand in a gesture of supplication. An inscription at the bottom of the sheet, *Église de Saint-Roch,* gives a clue to the derivation of this motif: Géricault found it in an altarpiece by Gabriel-François Doyen (1725–1806), in the right transept of the church of Saint-Roch in Paris, which represents *St. Genevieve Interceding for the Plague-Stricken* (1767; see fig. W). This same painting, it is worth noting, contains other figures which may have left an impression on Géricault at the time when he was gathering ideas for his project. The huge, nude plague victims in the foreground of Doyen's painting, precursors of similar figures in David's *Peste de Saint-Roch* (1779) and Gros's *Pestiférés de Jaffa* (1804), may have directly influenced Géricault's invention of recumbent and agonizing shipwrecked men for the different versions of the *Raft.* The cadaver of a man lying forward on his face, both arms hanging across a stone slab, at the right side of Doyen's altarpiece, strikingly resembles a figure in a quite similar posture which has a prominent place in most of the preliminary compositions, as well as the final version of the *Medusa* (cf. catalogue nos. 15v, 51–52, 79v). It is not without significance that Doyen's painting was in process of restoration during 1819 (cf. *Le Moniteur Universel,* no. 277, 1 October 1819, p. 1278) and may therefore have been especially accessible for close viewing in that year and possibly already in 1818, when the *Mutiny* drawings were most likely made.
Bibliography:
Collection du duc de Trévise; Catalogue des tableaux et

dessins, Galerie Charpentier, Paris, 1938, p. 16, plate 15.
Berger, p. 71, plate 49.
Exhibited:
Centenary, 1924, no. 117.
Gobin, 1935, no. 38.
Bernheim-Jeune, 1937, no. 134.
Gros, Géricault, Delacroix, San Francisco Museum of Art, 1939.
Un siècle d'aquarelles, Galerie Charpentier, Paris, 1942, no. 91.
French Masters, Marlborough Gallery, London, 1950, no. 48, Bignou, 1950, no. 84.
Winterthur, 1953, no. 170.
Gros, Géricault, Delacroix, Galerie Bernheim-Jeune, Paris, 1954, no. 58.
Aubry, 1964, no. 70.

33. COPY AFTER A PORTION OF AN ENGRAVING OF RUBENS' "LITTLE LAST JUDGEMENT" (Plate 27)
Pencil on paper; 204 × 231 mm.
Collections: E. Devéria (?); Stanford Museum, Stanford University, California, inv. 67.50.
The drawing copies the central portion of Jonas Suyderhoef's engraving (1642) after Rubens' so-called *Little Last Judgement* in Munich (fig. U). Géricault's intensive preoccupation with this composition is attested also by his other copies of figures and groups from Suyderhoef's engraving (one of these drawings is in the collection of the late Pierre Dubaut). The reason for his interest evidently was that he found in the tumbling bodies of Rubens' rebellious angels suggestions which he was able to apply to his projected composition of the *Mutiny on the Raft.* Several of the falling figures of mutinous sailors in that composition echo motifs from Rubens' painting, which Géricault appears to have known only through Suyderhoef's reversed and abbreviated reproduction.
Bibliography:
Fac-similes extraits des livres de croquis de Géricault et lithographiés par plusieurs artistes, Paris, 1825, plate 15 (the lithographic reproduction of the original drawing appears to be by Eugène Devéria, cf. Clément, *op. cit.,* p. 420).
L. Eitner, "Dessins de Géricault d'après Rubens, et la genèse du *Radeau de la Méduse",* Revue de l'Art, no. 14, 1971, p. 52, fig. 4.
Exhibited:
Master Drawings in Californian Collections, University Gallery, University of California, Berkeley, 1968, no. 84 (illustrated).
Los Angeles, Detroit, Philadelphia, 1971–72, no. 76 (illustrated).

(b) The Family Group in the Mutiny Scene

This group occurs in only one of the versions of the *Mutiny* composition (catalogue nos. 6–7). It is based on the story of a sutler and her husband (the child was Géricault's own addition) to which Corréard and Savigny gave considerable space in the second edition (1818) of their account: "... *another voice was heard; it was that of the unfortunate woman who was on the raft with us, and whom madmen had thrown into the sea, as well as her husband, who defended her with courage. Mr. Corréard ... threw himself, a second time, into the sea, whence he was so happy as to rescue the woman ... while her husband was likewise saved ... We seated these two poor people upon dead bodies, with their backs leaning against a barrel ... a more affecting scene, which it is impossible for us to describe, was the joy which this unfortunate couple displayed when they had sufficiently recovered their senses to see that they were saved."* (A. Corréard and H. Savigny, *Narrative of a Voyage to Senegal in 1816,* London, 1818, pp. 90 ff.). Of distinctly Michelangelesque inspiration, the Family Group seems to be particularly influenced by the ancestor spandrels of the Sistine ceiling.

34. STUDY FOR THE GROUP OF A FATHER HOLDING HIS WIFE AND CHILD (Plate 26)
Pen on blue paper; 185 × 273 mm.
Collections: His de La Salle (stamp, Lugt 1332); J. P. Heseltine (sale, 1935, no. 237); M. Gobin, H. Marillier, Paris.
A study for the corresponding group in the *Mutiny* composition in Rouen, catalogue no. 6. Clément, who, for some reason, failed to include this drawing in his catalogue, illustrated it in the third edition (1879) of his monograph, but erroneously gave its owner as the Louvre. It is possible that an oil sketch, *"Famille de*

naufragés sur un radeau" (400 × 320 mm; collection Paul Adry, Paris) which figured as no. 59 in the Géricault exhibition at the Galerie Bernheim-Jeune in Paris, in 1937, has some reference to this composition—I have not been able to locate this painting.

Bibliography:
C. Clément, *Géricault, étude biographique et critique,* Paris, 1879, illustrated opposite p. 124.
Catalogue, J. P. Heseltine Sale, Sotheby, London, 27–29 May 1935, no. 237.
Art Prices Current, XIV, London, 1936, p. 171, no. 5380.
M. Gauthier, *Géricault,* Paris, n.d., plate 42.
Exhibited:
Gobin, 1935, no. 40.
Bernheim-Jeune, 1937, no. 131.

35. STUDY FOR THE GROUP OF A FATHER HOLDING HIS WIFE AND CHILD (Plate 28)
Pencil and pen on paper; 203 × 299 mm.

Collections: C. Roger-Marx; P. Dubaut; G. L. Winthrop; Fogg Art Museum, Cambridge, acc. no. 1943.833.
A variant of the foregoing—differing from it in the position of the heads and of the child's body—this study represents the Family Group in the form in which it appears in the *Mutiny* composition in Amsterdam, catalogue no. 7. The sheet bears the authentic signature of Géricault in the lower right corner. A tracing of this drawing is in the Musée des Beaux-Arts, Besançon, inv. D–2166.

Bibliography:
C. Martine, *Theodore Géricault, cinquante-sept aquarelles, dessins, croquis,* Paris, 1928, plate 54.
K. Berger, *Géricault Drawings and Watercolors,* New York, 1946, plate 26 (mistakenly described as the other version of this composition, catalogue no. 34).
A. del Guercino, *Géricault,* Milan, 1963, plate 58.

(c) The Man Lifting Another from the Water in the Mutiny Scene

This group, which could be based on any number of incidents of rescue described by Corréard and Savigny in their account of the mutiny on the Raft, replaces the "Family Group" in the most developed of the *Mutiny* compositions, that in the Fogg Museum (catalogue no. 8). It resembles motifs found in other compositional drawings of 1817–1818, not connected with the *Medusa*; all of these share a general dependence on Michelangelesque types, and particularly on figures from the *Pisan Battle* cartoon and the *Last Judgement.* Among these drawings are the *Battle Scene* in the Musée Bonnat, Bayonne (inv. 705, formerly 2.026), the *Drowned Man,* formerly in the Sensier collection (see Clément, *Dessins,* no. 167, and the illustration in *L'art,* XII, 1878, p. 69), and *Hercules and Lichas* in the Fogg Museum (inv. 1943.828).

36. STUDY OF A MAN LIFTING THE BODY OF ANOTHER FROM THE WATER (Plate 29)
Pencil on paper; 274 × 220 mm.
Collection: Léon Bonnat; Musée Bonnat, Bayonne, inv. 699 (formerly 722).
This appears to be a study for the group of a sailor lifting the body of another from the water which occurs on the far left of the Fogg Museum's *Mutiny* composition (catalogue no. 8), in the place of the "Family Group". The motif, in turn, prefigures the group of "Father and Son" in the final version of the *Raft of the Medusa* (catalogue nos. 38–50).
Bibliography:
Revue de l'art ancien et moderne, LVIII, 1930, p. 225, illustrated.

Exhibited:
Bayonne, 1964, no. 24 (wrongly labelled "Le Fossoyeur").

37. STUDY OF A MAN LIFTING THE BODY OF ANOTHER FROM THE WATER (Plate 30)
Pencil on paper; 230 × 178 mm.
Collections: Thomas S. Cooper; Christopher Powney, London (1968); present location not known.
This is yet another study for the group which replaces the "Family Group" in the *Mutiny* composition in the Fogg Museum (catalogue no. 8). Behind the two principal figures, there appears a third, faintly drawn, which resembles in its gesture the officer who, extending his right arm and raising his sabre to his

chest, occupies this place in the *Mutiny* drawing of the
Fogg Museum. A tracing of this study is in the
collection of Peter Nathan in Zürich.

Exhibition of Early Drawings, Christopher Powney,
London, 1968, no. 55 (illustrated).

(d) The Group of the "Father holding his Dead Son"

The first, rather sketchy appearance of this group occurs in the *Cannibalism* composition (catalogue no. 6). Later, the group became one of the most prominent elements of the version of the *Sighting,* the earliest figure group to be fully developed (see Catalogue nos. 14 ff.). It has no basis in the narrative of Corréard and Savigny, but may have been suggested to Géricault by the following passages: *"On this occasion we had also reason to be alarmed for the safety of Mr. Coudin. Wounded and fatigued by the attacks which we had sustained . . . he was reposing on a barrel, holding in his arms a sailor boy, of twelve years of age, to whom he had attached himself . . ." "This same day* [the fifth] *terminated the existence of a child, twelve years of age, named Léon; he died away like a lamp which ceases to burn for want of aliment. . . . His angelic countenance, his melodious voice . . . filled us with the tenderest interest . . . He expired in the arms of Mr. Coudin, who had not ceased to show him the kindest attention."* The designation of "Father and Son" was, nevertheless, given to this group from the very beginning, and even Corréard himself, in the fourth edition of his account (1821), in describing this detail of Géricault's painting, refers to it as *"un vieillard, tenant couché sur ses genoux le cadavre de son fils expiré".* Géricault almost certainly meant the group to be understood in this way. Early critics noted its resemblance to familiar representations of *Ugolino and his Sons in the Pisan Tower.* It does, in fact, remind one of Fuseli's *Ugolino,* which was perhaps known to Géricault through Moses Houghton's etching of 1811 (fig. AA). Géricault may deliberately have used this suggestion to serve as a reminder of the cannibalism which had occurred on the Raft (see page 44). The type of the "Father", as Clément already noted, is borrowed from a cliché of wide currency in the French school at the time. Its ultimate model is the plague-stricken man in the foreground of David's *La Peste de Saint-Roch* (1779, Marseilles), its more immediate inspiration the brooding figure seated among the dead and dying in the foreground of Gros's *Pestiférés de Jaffa* (1804, Louvre; fig. X), and it may also owe something of its form and expression to Guérin's *Marcus Sextus* (1799, Louvre; fig. BB). Géricault's friend, Lebrun, posed for the "Father's" head. The figure of the "Son" is indebted to Girodet's *Endymion* (1793, Louvre) and to the figure of Cephalus in Guérin's *Aurora and Cephalus* (1810, Louvre; fig. CC).

It is a curious fact that the bark of *Don Juan,* in Byron's poem, also contains a father who mourns over the death of his son:

> "The boy expired—the father held the clay
> And looked upon it long, and when at last
> Death left no doubt, and the dead burden lay
> Stiff on his heart, and pulse and hope were past
> He watched it wistfully . . ."

(*Don Juan,* Canto 2, stanzas LXXXVIII–XC). Byron's motif is supposed to have been derived from an account of the shipwreck of the *Juno* in Sir J. G. Dalzell's *Shipwrecks and Disasters at Sea,* III, Edinburgh, 1812, pp. 273 ff.

38. STUDY FOR THE "FATHER"
Pen on paper; 135 × 210 mm.
Collections: Eudoxe Marcille; Chevrier Marcille; present location not known.
According to Clément's description, the "Father" is shown holding his head with his left hand and extending his right leg forward, indicating a connection with the early compositional study in Lille, catalogue no. 16. On the verso, osteological studies, in pen, of two arms and a leg. Four pencil studies of the heads of dogs.
Bibliography:
Clément, *Dessins,* no. 130.
Exhibited:
Centenary, 1924, no. 124.

39. STUDY FOR THE "FATHER HOLDING HIS DEAD SON" AND THREE ADJACENT FIGURES (Plate 31)
Pen on paper; 247 × 295 mm.
Collections: Walferdin (sale, 1880, no. 290); Hermann Burg, Cologne; Kunstmuseum der Stadt Düsseldorf, inv. 26/166 (acquired in 1926).
The group is turned to the right, as in the compositional drawing in Lille, catalogue no. 16, for which it served as a preliminary study. The three further figures at the left are still in a very tentative state of development. On the verso, formerly enclosed by an oval mount, which has left its traces on the paper, the forepart of a horse, drawn in crayon or black chalk, in a style reminiscent of Carle Vernet.
Bibliography:
Clément, *Dessins,* no. 122.

40. STUDY FOR THE "FATHER" AND PARTIAL STUDY OF THE SEATED MAN (Plate 32)
Pen on paper; 187 × 137 mm.
Collections: E. Martin, London; Frances S. Jowell, Toronto.
The "Father" is shown, as in the foregoing, facing to the right, holding his head with his left hand, and extending his right leg forward, indicating a connection with the early version of the composition in Lille, catalogue no. 16; the partial study of the seated man also refers to that version. On the verso, the pen drawing of a flayed cadaver and the pencil sketch of the hoof of a horse (Plate 95). The drawings described under nos. 55 and 56 of this catalogue originally formed part of the same sheet as this study, but have recently (1970) been separated from it.

41. SKETCH OF THE "FATHER" (Plate 33)
Pen on paper, irregularly cut; 210 × 220 mm.
Collections: Camille Marcille; Defer-Dumesnil; P.

Dubaut (stamp, Lugt, Suppl. 2103–b); Graphische Sammlung Albertina, Vienna, inv. 31.652 (acquired in 1955).
Clément believed this to be the first idea for the "Father". It does, in fact, resemble the figure seated at the left of the Raft in the very early compositional sketch in Rouen, catalogue no. 15, but reverses its orientation.
Bibliography:
Clément, *Dessins,* no. 119.
Exhibited:
Gros, Géricault, Delacroix, Knoedler Galleries, New York, 1938, no. 35.
Gros, Géricault, Delacroix, San Francisco Museum, 1939.
Bignou, Paris, 1950, no. 47.
Marlborough, London, 1952, no. 51.
Winterthur, 1953, no. 175.
Gros, Géricault, Delacroix, Galerie Bernheim-Jeune, Paris, 1954.

42. STUDY OF THE "FATHER" (Plate 35)
Pencil and pen on paper; 250 × 300 mm.
Collections: Camille Marcille (sale, 1876, no. 79); Palais des Beaux-Arts, Lille, inv. 1393.
The pen drawing of the "Father's" full figure shows his head in profile view, as do all the earlier versions of this figure, cf. catalogue nos. 38–41. The separate pencil drawing of the head, at the upper left of the sheet, corresponds to the later versions, in which the "Father's" head is turned nearly to a full-face view. At the lower right, a list of names and addresses, probably of models. On the verso, a particularly vigorous pen study of the "Son" (Plate 38), related to the fairly early versions of the composition, cf. catalogue nos. 17, 18.
Bibliography:
Clément, *Dessins,* no. 126.
Pluchart, *Catalogue (Notice des Dessins),* Musée Wicar, Lille, p. 310, no. 1393.
Exhibited:
Idee und Vollendung, Städtische Kunsthalle, Recklinghausen, 1962, no. 20–C.
Rouen, 1963, no. 41.
Los Angeles, Detroit, Philadelphia, 1971–72, no. 83 (illustrated).

43. STUDY FOR THE "FATHER HOLDING HIS DEAD SON" (Plate 36)
Pencil, pen and sepia wash on yellowish paper; 180 × 250 mm.
Collections: Camille Marcille (sale, 1876, no. 78); de L'aage; Palais des Beaux-Arts, Lille, inv. 1392.

The figure of the "Father" corresponds in posture and orientation to the early compositional studies for the final version of the *Medusa* (cf. the painted study in the Louvre, catalogue no. 18). The figure of the "Son" is an experimental variant; it does not occur, in this position, in any of the other known studies. In the upper left corner of the sheet, there is a faint pencil sketch of the entire composition which, still without the figure of the signalling Negro, belongs to roughly the same stage in the picture's development as the principal group. On the verso, the figure of the man who tries to raise himself by grasping the rim of a barrel (Plate 59), corresponding to the compositional drawings in the Aubry collection and in the Louvre, catalogue nos. 20 and 22.
Bibliography:
Clément, *Dessins,* no. 121.
Pluchart, *Catalogue (Notice des Dessins),* Musée Wicar, Lille, 1889, p. 310, no. 1392.
Exhibited:
Die Handschrift des Künstlers, Städtische Kunsthalle, Recklinghausen, 1959, no. 108.
Rouen, 1963, no. 40.

44. STUDY FOR THE "FATHER HOLDING HIS DEAD SON" (Plate 37)
Pen on buff paper; 135 × 238 mm.
Collections: Thomas S. Cooper; Christopher Powney, London; Claude Aubry, Paris.
The figure of the "Son" corresponds in posture to the early painted study of the composition at the Louvre, catalogue no. 18. The "Father" is slightly more developed; his left arm overlaps the body of the "Son", a characteristic feature of the later versions of this group. On the verso, the sketch of a reclining female nude.
Exhibited:
Exhibition of Early Drawings, Christopher Powney, London, 1968, no. 33 (illustrated).

45. STUDY FOR THE "FATHER HOLDING HIS DEAD SON" (Plate 40)
Black chalk on paper; 293 × 207 mm.
Collections: J. Gigoux (?): Léon Bonnat (stamp, Lugt 1714); Musée Bonnat, Bayonne, inv. 725 (formerly 2.046).
Clément (*Dessins,* no. 123) describes the drawing of this subject in the collection of J. Gigoux simply as "très belle étude à la mine de plomb" and gives its dimensions as 290 × 210 mm, which raises the possibility that the drawing he knew is identical with that in Bayonne. This study is a variant of the late version

of the group of "Father and Son", exceptional in the position of the "Father's" right hand, which it shows holding the hand of the dead "Son".
Bibliography:
Clément, *Dessins,* no. 123 (the drawing of the Gigoux collection).
Exhibited:
Bayonne, 1964, no. 46.

46. SKETCH FOR THE HEAD OF THE "FATHER" (?) (Plate 39)
Pen on paper; 87 × 134 mm.
Collections: E. Martin, London; Frances S. Jowell, Toronto.
The head bears a marked resemblance, in type and position, to the head of the "Father" in its earlier, profile version. It is perhaps significant that this sketch originally formed part of a larger sheet, which also contained two self-portraits of Géricault (for one of these, see Fig. N; the drawings were separated in 1970). This juxtaposition and the hint of a faint likeness between Géricault's bearded face and that of the "Father", at least as they appeared together in these sketches, raises the possibility that a tinge of self-identification may have entered into Géricault's conception of the figure of the "Father".

47. STUDY FOR THE "FATHER HOLDING HIS DEAD SON" (Plate 41)
Pencil and crayon on paper; 185 × 227 mm.
Collections: Jules Maciet; Musée des Beaux-Arts, Rouen, cat. 1387 (acquired in 1905).
This drawing represents the group in the form in which it appears in the later of the two painted compositional studies in the Louvre, catalogue no. 24. At the lower left of the sheet, the pencil notation "Géricault", not in the artist's hand. On the verso, a pencil sketch of the man who attempts to rise, at the extreme right of the composition (Plate 61; see also catalogue nos. 20v, 43v, 62–64). This, too, is related to the late painted study in the Louvre.
Exhibited:
Centenary, 1924, no. 126.
Gros, ses amis et ses élèves, Paris, 1936, no. 590.
Rouen, 1963, no. 39.

48. STUDY FOR THE FIGURE OF THE "DEAD SON" (Plate 42)
Crayon on paper; 186 × 269 mm.
Collections: Leblanc; Palais des Beaux-Arts, Lille, inv. 1390 (acquired in 1864).

A study, probably from the life, which in its general pose corresponds to the late versions of this figure, except for the position of the legs.

Bibliography:
Catalogue (*Notice des Dessins*), Musée Wicar, Lille, 1889, p. 310, no. 1390.
R. Huyghe, *Le dessin français au XIX siècle*, Lausanne, 1946, plate 18.

Exhibited:
French Drawings, Washington, Cleveland, St. Louis, Fogg Museum and Metropolitan Museum, 1952–53, no. 122, plate 36.
Rouen, 1963, no. 43.

49. Study of an Emaciated Male Nude
(Plate 43)
Black chalk on paper; 201 × 285 mm.
Collections: Léon Bonnat; Musée Bonnat, Bayonne, inv. 728 (formerly 2.082).
Related to the figure of the "Dead Son". It is possible that this study, like catalogue no. 81, in the same collection, was drawn at the hospital or in the Morgue (cf. p. 164).

Bibliography:
Dessins de la collection Bonnat au Musée de Bayonne, I, Bayonne, 1925, no. 76.

Exhibited:
Bayonne, 1964, no. 84.

50. Study for the Figure of the "Father"
(Plate 44)
Black chalk on paper; 240 × 330 mm.
Collections: Camille Marcille (sale, 1876, no. 81); de L'aage; René Longa; P. Dubaut; M. Dubaut, Paris.
A study from the life for the "Father", related to the final stage in the evolution of this figure. At the upper left, a small, rough sketch of the entire composition in its definitive form. At the right, a partially effaced address, possibly that of a model. On the verso, two studies for the seated man on the "Father's" right (cf. catalogue nos. 52, 54). One of these appears to be drawn from a posing model, the other from the imagination (Plate 50).

Bibliography:
Clément, *Dessins*, no. 120.

Exhibited:
Gobin, 1935, no. 45.
Bernheim-Jeune, 1937, no. 129.
Bignou, 1950, no. 46.
Marlborough, London, 1952, no. 50.
Winterthur, 1953, no. 176.
Aubry, 1964, no. 69.

(e) Other Groups and Individual Figures

The following sketches and studies are arranged by the figures or groups to which they refer, and these are given roughly according to the order in which they made their appearance in the course of the *Medusa*'s development and final execution.

51. Study for the Dead Youth lying on his Face (Plate 46)
Pencil on paper; 200 × 248 mm.
Collections: Louis Boulanger (sale, 1887); P. Dubaut; M. Dubaut, Paris.
A life study of the figure for which Eugène Delacroix served as model. The sheet is inscribed: "*Etude de Géricault d'après Eugène Delacroix 1818–19. Acheté à la vente de feu Louis Boulanger, le 14 mars 1887*". On the verso, the study of a reclining nude.

Bibliography:
R. Lebel, *Géricault, ses ambitions monumentales et l'inspiration italienne*, Paris, 1961, plate 18.

Exhibited:
Delacroix et les compagnons de sa jeunesse, Atelier d'Eugène Delacroix, Paris, 1948.

Bignou, 1950, no. 48.
Marlborough, 1952, no. 52.
Figures nues de l'école française, Galerie Charpentier, Paris, 1953, no. 91.
Gros, Géricault, Delacroix, Galerie Bernheim-Jeune, Paris, 1954, no. 61.
Aubry, 1964, no. 74 (illustrated).

52. Study of a Seated and a Reclining Figure (Plate 47)
Pen and ink wash on yellow paper; 205 × 275 mm.
Collections: General de Brack; P. Dubaut (stamp Lugt, Suppl. 2103-b); G. Renand, Paris.
This drawing was formerly bound into an album which once belonged to General de Brack. It represents a fairly early stage in the development of the two

figures which appear immediately to the right of the group of "Father and Son". The seated figure was posed by Géricault's assistant, Jamar, while Delacroix served as model for the other.
Exhibited:
Gobin, 1935, no. 44.
Bernheim-Jeune, 1937, no. 128.
Bignou, 1950, no. 50.
Marlborough, 1952, no. 53 (illustrated).
Winterthur, 1953, no. 177.

53. SHEET OF FIGURE SKETCHES
Pencil on paper; 195 × 255 mm.
Collections: Eugène Delacroix (stamp, Lugt 838); P. Dubaut, Paris.
The figures include that of the youth lying on his face for which Delacroix posed.
Exhibited:
Bignou, 1950, no. 49.

54. STUDY OF A SEATED, NUDE MAN AND OF THE HEAD OF A MAN (Plate 49)
Pen and pencil; 190 × 262 mm.
Collections: L. Bonnat (stamp, Lugt 1714); Musée Bonnat, Bayonne, inv. 726 (formerly 2047).
A study for the man seated immediately to the right of "Father and Son". The position corresponds most closely to that of its counterpart in the compositional drawing in the Louvre, catalogue no. 22. On the verso, a study of the hindquarters of a racehorse, executed in pen and bistre.
Exhibited:
Bayonne, 1964, no. 47.

55. SKETCH OF A KNEELING MAN (Plate 51)
Pen on paper; 137 × 75 mm.
Collections: E. Martin, London; Frances S. Jowell, Toronto.
The figure is related, in posture and orientation, to that of the kneeling man who appears in the early version of the scene of the *Sighting of the Argus* in Lille (see catalogue no. 16). The drawing was recently (1970) cut from a larger sheet which originally also contained the drawings described under nos. 40 and 56 of this catalogue.

56. SKETCH OF A KNEELING MAN (Plate 52)
Pen on paper; 137 × 85 mm.
Collections: E. Martin, London; Frances S. Jowell, Toronto.
Like the foregoing sketch of the same figure, this is related to the early compositional drawing of the

Sighting of the Argus in Lille (see catalogue no. 16). It was recently (1970) cut from a larger sheet which originally also contained the drawings described under nos. 40 and 55 of this catalogue.

57. STUDY OF A KNEELING MAN REACHING FORWARD WITH BOTH ARMS (Plate 53)
Pen on paper; 197 × 267 mm.
Collections: E. Martin, London; Frances S. Jowell, Toronto.
An exploratory study for the figure of the kneeling man who forms part of the group of straining and rising figures in the middle foreground of the *Sighting of the Argus*. The figure appears in roughly this form— right knee forward, left leg extended back—in the compositional studies in Lille (reversed), Rouen, and the early painted study in the Louvre (catalogue nos. 16–18). On the verso, sketches in pen of a male, mustachioed head; of an officer standing, hat in hand, before some horsemen; and of riders on rearing horses.
Exhibited:
Los Angeles, Detroit, Philadelphia, 1971–72, no. 84 (illustrated).

58. STUDY OF A KNEELING MAN RAISING HIS RIGHT ARM (Plate 54)
Pen and pencil on paper; 232 × 389 mm.
Collections: Walferdin (sale, 1880, no. 289); Léon Bonnat (stamp, Lugt 1714); Musée Bonnat, Bayonne, inv. 727 (formerly 2.048).
Like the foregoing, an early study for the kneeling man who occupies a prominent place in the middle foreground of the *Sighting of the Argus,* cf. catalogue nos. 16 (reversed), 17 and 18. On the verso, the study of a draped arm, for the same figure, and a drawing of the forepart of a horse, the hindquarters of which appear on the verso of catalogue no. 54.
Bibliography:
Clément, *Dessins,* no. 128.
Exhibited:
Bayonne, 1964, no. 48.

59. STUDY OF A MAN DRAGGING HIMSELF FORWARD ON HIS KNEES (Plate 56)
Black chalk on paper; 257 × 198 mm.
Collections: de Mirimond; Musée du Louvre, Paris, RF 1972 (acquired in 1911).
The figure appears in this drawing in the costume and posture, left knee forward, right leg extended backward, in which Géricault used it in his painting. (For a slightly earlier drawing of this figure, showing it in the nude, see Plate 55, catalogue no. 19 verso.) The

small, rough sketch at the lower right refers to the nude youth who is shown in the painting grasping the shoulder and arm of the kneeling man.
Exhibited:
Von David zu Millet, Kunsthaus, Zürich, 1937, no. 120.

60. STUDY OF A MAN DRAGGING HIMSELF FORWARD ON HIS KNEES (Plate 57)
Black chalk on paper; 280 × 190 mm.
Collections: P. Lehoux (?); Musée des Beaux-Arts, Rouen, cat. 1384 (acquired in 1880).
Slightly closer to the painting and hence later than the preceding drawing. Inscribed, at bottom right, *Géricault* in a later hand. On the verso, a carefully drawn portrait, in black chalk, of a young man in profile, facing left, wearing a shirt open at the neck.
Exhibited:
Centenary, 1924, no. 344.
Gros, ses amis et ses élèves, Paris, 1936, no. 593.
Rouen, 1964, no. 37.

61. TWO STUDIES OF THE UPPER PART OF A SHROUDED FIGURE RAISING THE LEFT ARM (Plate 58)
Pen on paper; 210 × 152 mm.
Collections: Herriot; Claude Aubry, Paris.
This study, for which Géricault may have used a female model, concerns the figure of a youth, in the centre of the final version of the *Raft,* who supports himself on the arm of the kneeling man and raises his left arm. It appears in this form in the large compositional drawing in the Louvre, catalogue no. 22, for which this study may well have served. In the subsequent development of the composition, another figure was combined with this one and made to assume its gesture and accessories.

62. STUDY OF A MAN ATTEMPTING TO RAISE HIMSELF; STUDIES OF HANDS AND OF AN ARM (Plate 62)
Crayon on paper; 205 × 290 mm.
Collections: Mahérault (sale, 1880, no. 74); J. Maciet; Musée des Beaux-Arts, Rouen, catalogue no. 1387 (acquired in 1905).
The figure closely resembles the nude man at the extreme right of the painted study in the Louvre formerly in the Moreau-Nélaton collection (catalogue no. 24). The drawing is slightly more advanced than that study in that it shows the hand of the figure grasping the thigh of another man directly in front of him, corresponding in this respect to the final painting.

For other studies of this figure, see catalogue no. 20v, 43v, 47v, 63–65; for a study of its hand, no. 69.
Bibliography:
Clément, *Dessins,* no. 129.
Exhibited:
Centenary, 1924, no. 127.
Rouen, 1964, no. 44.

63. STUDY OF A MAN TRYING TO RAISE HIMSELF (Plate 63)
Pencil on paper; 200 × 290 mm.
Collections: J. Gigoux (stamp, Lugt 1164); Musée Magnin, Dijon.
A life study, fairly close to the corresponding figure in the finished painting, except for the position of the left arm. For earlier drawings of this figure, see catalogue nos. 20v, 43v, 47v, 62, 64–65.

64. STUDY OF A MAN ATTEMPTING TO RAISE HIMSELF
Oil on canvas; dimensions not known.
Collections: de la Rosière; present location not known.
This life study is mentioned by Clément, in the *Supplément* to his catalogue, contained in the third edition of his monograph (1879, p. 427), but is not actually listed as a catalogue item, perhaps indicating that Clément was aware of the existence of this study, but had not actually seen it. It is not impossible that the picture which he had in mind is the large (1,300 × 980 mm) painting of the man trying to raise himself (Plate 64), which was sold as item no. 30 in the sale of the Gérard collection (Hôtel Drouot, Paris, 25 February 1896) and has recently passed through the art markets of Paris, London and Zürich (1968). The execution of this picture is somewhat smooth and hard; it corresponds very closely to the finished painting, and includes the surrounding areas, unlike such life studies as the torso of the Negro in Montauban (catalogue no. 72), which set the figure on the bare canvas, as seems to have been Géricault's practice. The impression it gives, therefore, is that of a copy after the finished painting, rather than of a preliminary study.
Bibliography:
Quelques précurseurs de l'art contemporain, Galerie Jacques Dubourg, Paris, May–June 1951, no. 32.

65. STUDY OF AN ARM (Plate 65)
Crayon and rubbed black chalk on paper; 285 × 194 mm.
Collections: J. Gigoux; Musée des Beaux-Arts, Besançon, inv. D 2140.

The arm belongs to the figure of the man, at the extreme right of the final composition, who is trying to raise himself. It closely resembles, as well, the right arm of the Negro atop the barrel who, with his right hand set on his hip, somewhat oddly waves his cloth with his left hand. Géricault may have used this study for the Negro, as well as for the man raising himself, but the study agrees more precisely with the latter.

66. STUDY FOR THE SIGNALLING NEGRO AND THE SURROUNDING FIGURES

Reed pen on oil-impregnated paper; 300 × 195 mm.
Collection: Ch. Cournault (Malzéville, near Nancy); present location not known.
Clément describes this drawing as representing the signalling Negro, the man who supports him, and "five or six surrounding figures". He mentions that M. Cournault owned in addition "numerous drawings and sketches related to the *Raft of the Medusa*".
Bibliography:
Clément, *Dessins,* no. 127.

67. SKETCH OF THE NEGRO MOUNTING A BARREL, ASSISTED BY ANOTHER MAN (Plate 66)

Pen and ink wash on paper; 203 × 125 mm.
Collection: Musée du Louvre, Paris, RF 27940 (acquired in 1936).
The position of the figures agrees approximately with that of the corresponding figures in the oil study, formerly in the Moreau-Nelaton collection, and now at the Louvre, see catalogue no. 24.
Exhibited:
Bernheim-Jeune, 1937, no. 130.

68. SKETCH OF THE NEGRO MOUNTING A BARREL, ASSISTED BY ANOTHER MAN (Plate 67)

Pen on blue paper; dimensions not known.
Collections: His de La Salle; present location not known.
The posture of the Negro's raised arm corresponds to the painted study in the Louvre, catalogue no. 24. The drawing is known only through a reproduction, which Clément included in his original publication of his monograph on Géricault in the *Gazette des Beaux-Arts,* while, for some reason, he omitted the drawing itself from his catalogue. An old tracing of the drawing is at the Besançon Museum (266 × 176 mm, the recto in pencil, on the verso reinforcement in pen; inv. D 2117).
Bibliography:
Gazette des Beaux-Arts, I, 1867, p. 333.
Clément, p. 355, note 1.

69. SKETCH FOR THE LEG OF THE SIGNALLING NEGRO, A HAND, A CARICATURE (Plate 68)

Pen on paper; 120 × 195 mm.
Collection: P. Dubaut, Paris.
While the sketch of the leg is clearly related to the right leg of the Negro who mounts a barrel and signals to the distant *Argus,* the grasping hand probably belongs to the figure, at the extreme right of the composition, who attempts to raise himself (see catalogue no. 62–65). The caricature of the smiling man with sideburns has nothing to do with the *Medusa.* At the bottom of the sheet the inscription: *"Dessin de Géricault fait à la magdelaine* (sic) *près fontainebleau".* A tracing of the hand and leg is in the collection of Peter Nathan in Zürich.
Exhibited:
Bignou, 1950, no. 54.
Winterthur, 1953, no. 181.
Aubry, 1964, no. 54 (illustrated).

70. STUDIES OF A NEGRO (Plate 69)

Pen on paper; 220 × 275 mm.
Collections: His de La Salle (stamp, Lugt 1333); Musée des Beaux-Arts, Lyon, inv. X-1029/25.
The three life studies in the centre and upper right are related to the figure of the signalling Negro in the painting. The study at the lower left may be connected with the figure of the youth whose shoulders and head, with face upturned, appears between other figures in the centre of the Raft, though it is not directly a study for it. In the upper left of the sheet appears the very faint sketch of a rider on a rearing horse. The sheet is inscribed, at the lower right and by a later hand, *Géricault.*
Exhibited:
Winterthur, 1953, no. 172.
Idee und Vollendung, Städtische Kunsthalle, Reckling-hausen, 1962, no. 20g.
Rouen, 1963, no. 49.

71. STUDY OF A MAN IN BACK VIEW RAISING HIS LEFT ARM (Plate 70)

Black chalk on paper; 270 × 210 mm.
Collections: De Metz; J. Ulrich; Kunsthaus, Zürich (acquired in 1877).
This is a life study for the figure of the signalling Negro, evidently intended to explore the position and musculature of his raised left arm. The inscription *Naufrage de la Méduse,* in the lower left corner of the sheet, is not in Géricault's hand. The drawing is on folio 53 recto of a book of sketches in which Géricault drew from about 1814 to 1819 and which contains

three studies for the *Medusa,* all of them from a very late stage in the work. The sketchbook was bought at the sale of Géricault's studio in 1824 by M. De Metz who later gave it to the Swiss painter, J. Ulrich, who, in turn, bequeathed it to the Kunsthaus in Zürich, where it was recently discovered by Dr. Hans A. Lüthy (see also catalogue nos. 76–77).

Bibliography:
H. A. Lüthy, "Géricaults 'Zürcher Skizzenbuch'," *Neue Zürcher Zeitung,* 18 September 1966, Sonntagsausgabe, p. 4.
H. A. Lüthy, "Zur Ikonographie der Skizzenbücher von Géricault", *Beiträge zur Motivkunde des 19. Jahrhunderts,* Munich, 1970, pp. 245 ff.

72. Study for the Figure of the Signalling Negro (Plate 71)

Black chalk and oil on canvas; 550 × 450 mm.
Collections: P. Lehoux; Musée du Louvre, Paris, RF 580 (acquired in 1890); on extended loan, since 1955, to the Musée Ingres, Montauban, inv. D 55.4.1.
The torso of the signalling Negro is drawn in black chalk on the raw canvas and partly finished in oil. The study illustrates the manner in which Géricault, in the final stage of the work on the *Medusa,* synthesized compositional design and life study. Having transferred the contours of the figure from previously prepared compositional drawings to the canvas, he painted the figure in oil, directly from the posing model, inserting the painting, so to speak, into the predetermined contours. The Montauban study is an important document of this process and gives an idea of the appearance of the *Medusa's* canvas when in process of completion.

Exhibited:
Rouen, 1963, no. 13 (illustrated).
Ingres et son temps, Musée Ingres, Montauban, 1965, no. 133 (illustrated).

73. Study of a Man leaning with Both Arms on a Stand (Plate 72)

Black chalk, rubbed, on paper; 271 × 204 mm.
Collections: Sir Thomas Lawrence (sale, 1830, no. 222 or 223); J. Gigoux (stamp, Lugt 1164; sale, 1882, no. 594); Musée des Beaux-Arts, Besançon, inv. D 2154.
A life study for the figure, originally on the right of the barrel onto which the signalling Negro is about to step (cf. catalogue nos. 17–18), which Géricault later moved forward, in front of the barrels. This drawing was once part of one of the two sketchbooks by Géricault which Sir Thomas Lawrence owned and which were sold at Christie's auction rooms in London

in 1830. The catalogue mentions that one of these, no. 222 of the sale, was filled with "masterly sketches and studies in black chalk".

74. Study of a Nude Man (Plate 73)

Pen with some pencil markings, on the reverse of a printed page; 200 × 122 mm.
Collection: Musée des Beaux-Arts, Rouen.
This very free sketch is loosely related to the *Raft of the Medusa.* The figure corresponds, in its stance and the position of its limbs, to that of the man who leans against a barrel to the right of the signalling Negro, with the difference that, while the painting shows him in back view, the drawing turns him into front view. The sketch, perhaps nothing more than a playful doodle, must date from some time after 21 April 1819, since it occupies the blank back page of a pamphlet bearing that date, Alexandre Corréard's *Mémoire présenté aux chambres des pairs,* a protest against the light punishment meted out to the Medusa's captain, de Chaumareys.

75. Study of a Man seated in an Attitude of Despair (Plate 74)

Black chalk on paper; 170 × 210 mm.
Collections: De Metz; J. Ulrich; Kunsthaus, Zürich (acquired in 1877).
This life study, on folio 51 recto of the sketchbook in Zürich (see catalogue no. 71), is related to the figure of the man seated behind the "Father", in the shadow of the mast and sail, holding his head in both hands in an attitude suggesting despair or madness. A painting resembling this figure is, or was, in the A. S. Henraux collection, and was exhibited at the Musée de l'Orangerie, Paris, in 1956 ("Le cabinet d'un amateur", no. 54, described as *l'homme qui s'arrache les cheveux,* 560 × 680 mm; I am unable to judge the authenticity of this painting, known to me only through a photograph). The inscription *Naufrage de la Méduse* in the lower right corner of the sheet is not in Géricault's handwriting.

Bibliography:
H. A. Lüthy, "Géricaults 'Zürcher Skizzenbuch'," *Neue Zürcher Zeitung,* 18 September 1966, Sonntagsausgabe, p. 4.
H. A. Lüthy, "Zur Ikonographie der Skizzenbücher von Géricault", *Beiträge zur Motivkunde des 19. Jahrhunderts,* Munich, 1970, p. 251, fig. 7.

76. Study of a Man pointing with his Left Hand (Plate 75)

Black chalk on paper; 270 × 210 mm.
Collections: De Metz; J. Ulrich; Kunsthaus, Zürich (acquired in 1877).

Occupying folio 52 recto of the sketchbook in Zürich (see catalogue no. 71), this drawing is a study from the life for the figure of Alexandre Corréard, whom Géricault represented standing near the Raft's mast and turning to Savigny, while pointing with his left arm toward the distant *Argus*. The study seems to have been posed by a professional model, rather than by Corréard himself, whose features and beard, known from the finished painting, it does not resemble. The inscription *Naufrage de la Méduse* in the lower right corner of the sheet is not in Géricault's handwriting.

Bibliography:
H. A. Lüthy, "Géricaults 'Zürcher Skizzenbuch'," *Neue Zürcher Zeitung,* 18 September 1966, Sonntagsausgabe, p. 4 (illustrated).
H. A. Lüthy, "Zur Ikonographie der Skizzenbücher von Géricault", *Beiträge zur Motivkunde des 19. Jahrhunderts,* Munich, 1970, pp. 245 ff.

77. FIVE SKETCHES OF A NUDE MAN LYING ON HIS BACK (Plate 76).
Pencil on paper; 210 × 280 mm.
Collections: René Longa; Gaston Delestre, Paris.
These are fairly tentative sketches for the shrouded cadaver which trails from the Raft at the lower right, one of the two figures which Géricault inserted into his already finished painting just before its exhibition (see page 38). In improvising this figure at the last moment, Géricault reverted to the early, discarded compositional projects of the episodes of *Mutiny* and *Cannibalism* in which he had shown men falling or trailing from the Raft (see catalogue nos. 6–10). For those figures, he had used motifs borrowed from Rubens' *Little Last Judgement,* of which he had drawn careful copies (see catalogue no. 33). The same influence is still evident in the present sheet, particularly in the position of the figure at the top of the sheet, which closely follows one in Rubens' composition. On the verso, the drawing of a postilion stopping at an inn.

Bibliography:
Lorenz Eitner, "Dessins de Géricault d'après Rubens, et la genèse du *Radeau de la Méduse*", *Revue de l'Art,* no. 14, 1971, p. 55, fig. 14.
Exhibited:
Gobin, 1935, no. 46.
Bernheim-Jeune, 1937, no. 132.
Cent-cinquante ans de dessin, Galerie Bernheim-Jeune, Paris, 1952, no. 74.
Précurseurs de l'art moderne: de Gros à Courbet, Musée Courbet, Ornans, 1964.
Aubry, 1964, no. 69-bis.

78. STUDY OF A NUDE MAN LYING ON HIS BACK (Plate 77)
Black chalk on paper; 289 × 205 mm.
Collections: J. Gigoux (stamp, Lugt 1164); Musée des Beaux-Arts, Besançon, inv. D–2153 (acquired by bequest, 1894).
Like the foregoing, a study for the cadaver at the extreme right of the composition.
On the verso, the very faint, rubbed drawing (or possibly the off-print from another drawing) of the group of "Father and Son", facing to the right, with the "Father's" leg extended forward, as in the very early versions of this group (Plate 34; see Catalogue nos. 15–16, 39–40).

Bibliography:
Clément, *Dessins,* no. 125.
W. Hausenstein, *Der Körper des Menschen in der Geschichte der Kunst,* Munich, 1916, p. 585, fig. 535 (the recto of the drawing).
Exhibited:
Von David zu Millet, Kunsthaus, Zürich, 1937, no. 136, plate 5 (the recto only).
De Watteau à Cézanne, Musée d'Art et d'Histoire, Geneva, 1951, no. 130.
Winterthur, 1953, no. 178.
Rouen, 1963, no. 42.
Französische Zeichnungen, Freiburg im Breisgau, May-June, 1963.
Précurseurs de l'art moderne, Ornans, August-September, 1964.
Los Angeles, Detroit, Philadelphia, 1971–72, no. 86 (illustrated).

79. STUDY OF A NUDE MAN LYING ON HIS BACK (Plate 78)
Black chalk on paper; 197 × 256 mm.
Collections: J. Gigoux (stamp, Lugt 1164); Musée des Beaux-Arts, Besançon, inv. D–2125 (acquired by bequest, 1894).
Another study for the cadaver trailing from the Raft at the extreme right of the composition, somewhat closer than the two foregoing drawings to the form which Géricault finally adopted. On the verso, studies for the head of the young man who lies on his face immediately to the right of the group of "Father and Son" (Plate 48; see catalogue nos. 15 verso, 50–51).

Bibliography:
Clément, *Dessins,* no. 124.
Exhibited:
Los Angeles, Detroit, Philadelphia, 1971–72, no. 87 (illustrated).

3. RELATED STUDIES

(a) Studies of the Dead or Dying

Géricault's earliest biographer, Louis Batissier, reports that in order to give his painting *"un plus grand cachet de vérité, [Géricault] alla à l'Hôpital Beaujon peindre des cadavres, voulant avoir la mort en face pour reproduire les ravages de la mort"*. (L. Batissier, "Vie de Géricault", *La Revue du dix-neuvième siècle*, 1842, republished by P. Courthion, *Géricault raconté par lui-même et par ses amis*, Vésenaz-Geneva, 1947, p. 42.) The hospital was located in the immediate vicinity of Géricault's studio in the Faubourg du Roule. *"C'est là"*, writes Clément (p. 130), *"qu'il alla suivre avec une ardente curiosité toutes les phases de la souffrance, depuis les premières atteintes jusqu'à l'agonie et les traces qu'elle imprime sur le corps humain. Il y trouvait des modèles qui n'avaient pas besoin de se grimer pour lui montrer toutes les nuances de la douleur physique, de l'angoisse morale: les ravages de la maladie et les terreurs de la mort"*. It is curious, considering the importance given to these studies by his biographers, that so few of them seem to be preserved. In addition to the studies listed below, there exists a large study in oil of the heads of a male and a female corpse, swathed in shrouds and resting on the slab of a morgue. For many years in England, this study is now in a Parisian private collection. Despite its very considerable quality, I have not been able to accept it wholeheartedly as a work by Géricault.

80. STUDY OF THE BODY OF A DEAD YOUTH (Plate 79)
Oil on canvas; 648 × 811 mm.
Collection: Musée de Peinture, Alençon, inv. 87 (purchased in 1860).
The figure is a reversal of one of the late versions of the dead "Son" (cf. nos. 22 *et seq.* and 47 *et seq.* of this catalogue). Though a suggestion of rocky shore, sea and sky give it the appearance of a complete picture, this is essentially a life study. It may have served for the cadaver at the extreme left of the composition, one of the final additions which Géricault made at the *vernissage* (cf. Clément, pp. 126 and 144, who mentions Géricault's last-minute improvisation of the cadaver at the lower right only; but it is clear, from the evidence of the preliminary compositional studies, that the cadaver at the left, too, was added at that time). In his hurry, Géricault fell back on the expedient of reversing a figure which he had already fully developed for another purpose, in order to obtain this new motif. The very broadly executed study in Alençon may have served as an aid in this process of adaptation.
Bibliography:
Catalogue des tableaux, dessins, et sculptures du Musée d'Alençon, Alençon, 1862, p. 16, no. 50.
Catalogue du Musée d'Alençon, Alençon, 1909, p. 11, no. 44.
Peintures du Musée d'Alençon, Alençon, 1938, p. 33, no. 87.
Exhibited:
Los Angeles, Detroit, Philadelphia, 1971–72, no. 85 (illustrated).

81. STUDY OF AN EMACIATED, ELDERLY MAN (Plate 80)
Pencil on paper; 116 × 239 mm.
Collections: L. Bonnat (stamp, Lugt 1714); Musée Bonnat, Bayonne, inv. 762 (formerly 2.083).
Not directly related to any one of the figures of the *Raft of the Medusa*, this study is one of the records of Géricault's observations of the effects of sickness and suffering on the patients of the Beaujon Hospital.
Exhibited:
Bayonne, 1964, no. 85.

82. STUDY OF A SICK OR DYING MAN (Plate 81)
Pencil on paper; 225 × 315 mm.
Collections: Jacques Lipchitz; M. Gobin, Paris.
M. Gobin, who first published this drawing, believed that it was a self-portrait, drawn during Géricault's last illness. This seems improbable for various reasons, including the fact that the man in this drawing bears little resemblance to Géricault, who in his last years wore a prominent beard. It is more likely that Géricault drew this tormented figure at the Beaujon Hospital at the time of his work on the *Raft of the Medusa*.
Bibliography:
M. Gobin, *Géricault dans la collection d'un amateur*, Paris, n.d., [1958], plate 43.
M. Gobin, *L'art expressif au XIXe siècle français*, Paris, 1960, no page or plate number (illustrated).
Exhibited:
Winterthur, 1953, no. 180.

83. STUDY OF THE HEAD OF A CORPSE (Plate 82)
Oil on canvas; 452 × 560 mm.
Collections: Champmartin (sale, 1884); Foinard (sale, 1914); R. Goetz (sale, 1922, no. 138); A. A. Munger; The Art Institute of Chicago.
This study, not mentioned by Clément, once belonged to the painter Charles Émile Champmartin (1797–1883), who occasionally accompanied Géricault to the dissecting rooms of hospitals (Clément, p. 305) and there painted side-by-side with him. Champmartin's studies have not been identified. If they are still preserved, they may well become—if they have not already become—confused with Géricault's own studies of cadavers. In the instance of the particularly powerful painting in Chicago, there is no compelling reason to consider the possibility of Champmartin's authorship. There is nothing in Champmartin's known work which compares, in energy of conception and vigour of execution, to this painting, strongly marked by the mind and hand of Géricault. Like the other studies of cadavers or dissected limbs, this study did not serve any immediate, practical purpose in the execution of the *Raft of the Medusa*. It slightly resembles in position, though not in physiognomy, the head of the cadaver at the extreme left of the picture.
Bibliography:
M. Gauthier, *Géricault*, Paris, n.d. [1935], plate 59.
Berger, p. 72, plate 52.
A. del Guercino, *Géricault*, Milan, 1963, p. 66.
Exhibited:
Gros, ses amis et ses élèves, Paris, 1936, no. 279.
Bernheim-Jeune, 1937, no. 44 (illustrated).
Night Scenes, Wadsworth Atheneum, Hartford, 1940, no. 43.
De David à Toulouse-Lautrec, Chefs-d'œuvres des collections Americaines, Musée de l'Orangerie, Paris, 1955, no. 31, plate 9.
1965 Fogg Museum Course Exhibition, Fogg Art Museum, Cambridge, 1965.
Berlioz and the Romantic Imagination, The Arts Council of Great Britain, Victoria and Albert Museum, London, 1969, no. 43, p. 18.

Los Angeles, Detroit, Philadelphia, 1971–72, no. 92 (illustrated).

84. STUDY FOR THE HEAD OF THE DEAD "SON" (Plate 83)
Oil on canvas; 311 × 330 mm.
Collections: Mathey; Musée des Beaux-Arts, Rouen, cat. 1365 (acquired in 1904).
Painted by the light of a lamp, like some of the studies of severed heads and limbs (see catalogue nos. 91–93), this study seems to have been modelled by Géricault's pupil, Jamar, whose features it resembles (see catalogue no. 101). Jamar lived with Géricault during the later stages of the work on the *Raft of the Medusa* and posed for several figures in the picture, among them the "Dead Son" and one of the men standing at the mast (cf. Clément, pp. 143 and 300). The earlier compositional designs of the scene show the head of the "Son" in profile, as it appears in this study. In the later versions, the head appears turned to one side and faces the viewer.
Exhibited:
Centenary, 1924, no. 129.
Festival Européen, Saarbrücken, 1954, no. 93.
Rouen, 1963, no. 8.
Los Angeles, Detroit, Philadelphia, 1971–72, no. 93 (illustrated).

85. SKETCH FOR THE HEAD OF THE DEAD "SON" (Plate 84)
Oil on paper, mounted on canvas; 457 × 381 mm.
Collections: H. Fantin-Latour; Duc de Trévise; W. Miller; Prince Alexander zu Hohenlohe von Jagdsberg, Malaga.
Very broadly executed, and probably not based on any particular model, this sketch corresponds in the position and the illumination of the head to the more finished and portrait-like study in Rouen (catalogue no. 84).
Exhibited:
Centenary, 1924, no. 119.
Géricault to Courbet, Roland, Browse, and Delbanco, London, 1965, no. 26 (illustrated).
Los Angeles, Detroit, Philadelphia, 1971–72, no. 94 (illustrated).

(b) Studies of Severed Heads and Dissected Limbs

Géricault's studies of dissected cadavers and the purpose which they served in connection with the *Raft of the Medusa* have been discussed above, page 36. These works, understandably, gained great notoriety among his contemporaries and gave rise to lurid and, for the most part, fictional accounts. A popular journal of the period (*Le Magasin Pittoresque*, 1841, p. 110) exaggerated when it reported: "*On ne saurait se faire une idée de la quantité de cadavres qui entrèrent à cette époque dans son atelier*

du faubourg du Roule. L'hospice de Beaujon était à peu de distance, et lui envoyait tous ses morts." But even the sober Clément, drawing on the reminiscences of Géricault's friends and models, wrote that *"Pendant quelques mois son atelier fut une manière de morgue; il y garda, assure-t-on, des cadavres jusqu'à ce qu'ils fussent à moitié décomposés; il s'obstinait à travailler dans ce charnier, dont ses amis les plus dévoués et les plus intrépides modèles ne bravaient qu'à grand'peine et pour un moment l'infection."* The surviving studies seem to indicate that, however many of these macabre fragments Géricault may have collected, he actually drew or painted only a very small number of them—one male head, two severed legs, and one arm. It is possible that studies of further heads or limbs have been lost or destroyed. The catalogue of the posthumous sale of his studio refers to a lot of ten, presumably painted, studies of *"diverses parties du corps humain"*. It is probable that these were the studies of dissected cadavers—the extremely low price realized by them confirms this assumption. Today, only six painted studies are known. By way of compensation for these losses, paintings not by Géricault have been added to this group (most prominent among them the mediocre *Guillotined Head* in the Geneva Museum) evidently on the assumption that only Géricault could ever have posed portraits or still-lifes of human remains. In fact, however, there were other artists who occasionally attempted such subjects, and sometimes did so in a spirit of sensationalism or ghoulish jocularity, of which Géricault's studies are entirely free. An instance of this, from the work of Auguste Raffet (1804–1860), is cited in an unsigned article (possibly by P. Burty) in the *Gazette des Beaux-Arts*, 6, 1860, p. 314, and very aptly contrasted with Géricault's studies of cadavers: *"Un jour Raffet obtint, à l'Hôpital Militaire, la tête d'un jeune soldat qui venait de mourir. Il la garda trois jours entiers dans son atelier, la peignant sous toutes ses faces: fichée sur une baïonnette, posée sur un plat, reposant sur un linge; tantôt nue, avec ses cheveux bruns crêpés, tantôt coiffée d'un bonnet rouge, les yeux éteints, les traits flétris, la bouche pâle, ou encore avec les expressions tragiques de la douleur ou de l'horreur. Il voulait, je crois, s'en servir pour une scène de massacre, et il eut le courage de garder son horrible modèle jusqu'à ce que la décomposition l'eut envahi de ses tons sinistres. Ces études, trop froidement étudiées peut-être par un peintre plus intelligent que passionné, ont difficilement trouvé un acquéreur. C'est qu'elles n'étaient point échauffées par cette exécution grandiose qui fait pardonner aux Espagnols les détails les plus repoussants. Nous connaissons, dans le cabinet de M. Claye, notre habile imprimeur, un monceau de membres désarticulés* [see catalogue no. 92] *qui jette l'âme dans l'émotion la plus profonde; mais on oublie vite l'horreur du sujet devant le sublime de l'exécution. C'est une étude de nature morte (le mot est bien juste cette fois), peinte de verve, par Théodore Géricault, dans une salle de dissection. C'est un chef-d'œuvre, parce que l'on sent, à ne point s'y méprendre, que Géricault était ému lui-même en présence de ce 'je ne sais quoi qui n'a plus de nom dans aucune langue'."* This remarkable tribute seems to echo the opinion of Eugène Delacroix, who was moved by the sight of one of Géricault's studies of dissected limbs to record in his Diary, on 5 March 1857, the highest praise which he ever paid Géricault: *"Aujourd'hui, pendant mon déjeuner, on m'apporte deux tableaux attribués à Géricault, pour en dire mon avis. Le petit est une copie très médiocre . . . L'autre, toile de 12 environ, sujet d'amphithéâtre, bras, pieds, etc., de cadavres, d'une force, d'un relief admirable, avec des négligences qui sont du style de l'auteur et ajoutent encore un nouveau prix.*

"Mise à côté du portrait de David [the portrait of Delacroix's sister, Henriette de Verninac, by Louis David], *cette peinture ressort encore davantage. On y voit tout ce qui a toujours manqué à David, cette force pittoresque, ce nerf, cet osé qui est à la peinture ce que la* vis comica *est à l'art du théâtre . . . Ce fragment de Géricault est vraiment sublime: il prouve plus que jamais qu'il n'est pas de serpent ni de monstre odieux, etc. C'est le meilleur argument en faveur du Beau, comme il faut l'entendre. Les incorrections ne déparent point ce*

morceau: à côté du pied qui est très précis et plus ressemblant au naturel, sauf l'idéal propre au peintre, il y a une main dont les plans sont mous et faits presque d'idée, dans le genre de figures qu'il faisait à l'atelier, et cette main ne dépare pas le reste: la force du style la met à la hauteur des autres parties. Ce genre de mérite a le plus grand rapport avec celui de Michel-Ange, chez lequel les incorrections ne nuisent à rien."

86. FOUR STUDIES OF THE SEVERED HEAD OF A MAN (Plate 85)
Pencil on paper; 209 × 276 mm.
Collections: J. Gigoux (stamp, Lugt 1164); Musée des Beaux-Arts, Besançon, inv. D 2157 (acquired in 1894). Géricault had obtained the head, that of a thief, from Bicêtre, an institution which was at once a home for the aged, a prison, and a lunatic asylum. According to Clément (p. 131), he kept the head for fifteen days on the roof of his studio in the rue des Martyrs, drawing and painting many studies of it. These may ultimately have helped him in the execution of the cadaver at the extreme left of the *Raft of the Medusa,* one of the two figures which he added to the picture after completing the rest, though this was apparently not Géricault's original purpose in making these studies.
Bibliography:
Clément, *Dessins,* no. 132.
Exhibited:
Winterthur, 1953, no. 185.
Rouen, 1963, no. 47.
Los Angeles, Detroit, Philadelphia, 1971–72, no. 88 (illustrated).

87. FOUR STUDIES OF THE SEVERED HEAD OF A MAN (Plate 86)
Pencil on paper; 209 × 279 mm.
Collections: Mahérault (sale, 1880); General Mellinet (sale, 1906); P. Dubaut; M. Dubaut, Paris.
The same head as in catalogue nos. 86, 88, 89.
Bibliography:
Clément, *Dessins,* no. 135.
Exhibited:
Centenary, 1924, no. 133.
Bernheim-Jeune, 1937, no. 133.
Bignou, 1950, no. 51.
Marlborough, 1952, no. 54.
Winterthur, 1953, no. 184.
Aubry, 1964, no. 71.
Los Angeles, Detroit, Philadelphia, 1971–72, no. 89 (illustrated).

88. STUDY OF THE SEVERED HEADS OF A MAN AND A WOMAN (Plate 87)
Oil on canvas; 500 × 610 mm.

Collections: A. Colin (sale, 1845, no. 52); E. Giraud; P. A. Cheramy (sale, 1908, no. 104); National Museum, Stockholm, inv. 2113 (acquired in 1918).
The male head represents the same model as catalogue nos. 86, 87, 89; its position is similar to that of the head at the lower left of the drawing in the M. Dubaut collection. The female head, according to Clément (p. 131 and 304, no. 105), was that of "a little hunchback who posed in the studios", which would seem to mean that it was painted from the living model, but given every appearance of death in expression, complexion, and the bloody cut at the throat, a very curious circumstance.
A copy of this study is in the Musée des Beaux-Arts of Rouen (cat. 1358). Several copies exist of the male head only, the best known is that in the Musée de l'Art Moderne in Brussels and was formerly in the Binder and Picard collections (Clément, *Peintures,* no. 105).
Bibliography:
Clément, *Peintures,* no. 105.
J. Meier-Graefe and E. Klossowski, *La collection Cheramy,* Munich, 1908, p. 78, no. 104.
Berger, plate III, pp. 51 ff.

89. STUDY OF THE SEVERED HEAD OF A MAN (Plate 88)
Oil on paper, applied to a wooden panel; 410 × 380 mm.
Collections: Auguste Boulard; Duc de Trévise; P. Dubaut; M. Dubaut, Paris.
The same head as in catalogue nos. 86–88; its position resembles that of the head at the upper left of the drawing in Besançon. The process of decomposition seems more advanced than in the painting in Stockholm. The truly Medusan beauty of these studies, to which Delacroix responded so strongly, and the sublimity of their terror reach the highest point in this painting.
Bibliography:
A. del Guercino, *Géricault,* Milan, 1963, p. 65.
Exhibited:
Centenary, 1924, no. 132.
Gros, ses amis et ses élèves, Paris, 1936, not listed in the catalogue.
Bernheim-Jeune, 1937, no. 43.

Marlborough, 1952, no. 24.
Winterthur, 1953, no. 81.
Aubry, 1964, no. 25.
Los Angeles, Detroit, Philadelphia, 1971–72, no. 90 (illustrated).

90. STUDY OF A SEVERED ARM WITH HAND
(Plate 89)
Oil on canvas, mounted on a wooden panel; 180 × 335 mm.
Collections: Lehoux; Musée du Louvre, Paris, RF 581 (acquired in 1890).
Bibliography:
Clément, *Peintures,* no. 106, p. 131.
Ch. Sterling and H. Adhémar, *La peinture au musée du Louvre, École Française,* Paris, I, 1959, no. 943, plate 337.
Exhibited:
Rouen, 1963, no. 11.

91. STUDY OF TWO SEVERED LEGS AND AN ARM
(Plate 90)
Oil on canvas; 540 × 640 mm.
Collections: J. Claye (?); Duc de Trévise; R. Lebel, Paris.
Géricault painted several still-life studies of an arrangement consisting of two legs, severed above the knee, placed crosswise one upon the other and covered by an arm cut off at the collar bone (see catalogue nos. 92–93). Clément included two of these studies in his catalogue (cf. *Peintures,* nos. 107 and 108). One of these (no. 108), then in the collection of Lehoux, is almost certainly identical with the study now in the Louvre (catalogue no. 93). Two other extant studies claim to be the second study catalogued by Clément (no. 107), namely that which he saw in the collection of J. Claye. One of them, now in the museum of Montpellier (cf. catalogue no. 92), corresponds fully to Clément's description and can be traced with certainty to the Claye collection. The other, now owned by R. Lebel, also fits the description given by Clément and is believed to have come from the Claye collection. It is therefore difficult to ascertain which of these two studies is identical with Clément's no. 107. Unless Claye owned both studies, something of which Clément makes no mention, the one in Montpellier must be considered the more likely contender, since it can be traced with certainty to the Claye collection. It is also the better of the two studies. But the study in the Lebel collection seems worthy of Géricault, and its style and technique support this attribution. It must be assumed

to be a variant, not described by Clément, but mistakenly identified, by its recent owners, with Clément's no. 107. In this connection, it may be well to recall that Clément mentions that the painter C. E. Champmartin, working with Géricault, also painted a study of this arrangement of severed limbs which, in Clément's time, was in the collection of Lehoux (cf. Clément, *Peintures,* no. 107).
Bibliography:
L. Eitner, "Géricault in Winterthur", *The Burlington Magazine,* August 1954, pp. 254 ff, fig. 25.
Exhibited:
Centenary, 1924, no. 118 (also listed as 130 in the catalogue).
Bernheim-Jeune, 1937, no. 42.
Marlborough, 1952, no. 25.
Winterthur, 1953, no. 83.
Quatre siècles de natures mortes françaises, Boymans Museum, Rotterdam, 1954, no. 68 (illustrated plate 37).
Natures mortes de Géricault à nos jours, Musée de St.-Étienne, 1955.
Los Angeles, Detroit, Philadelphia, 1971–72, no. 91 (illustrated).

92. STUDY OF TWO SEVERED LEGS AND AN ARM
(Plate 92)
Oil on canvas; 520 × 640 mm.
Collections: J. Claye (1874); Alfred Bruyas; Musée Fabre, Montpellier, catalogue no. 562 (acquired in 1876).
The same limbs in the same arrangement as in catalogue nos. 91, 93, but painted from a different point of view. This study is most probably the one which Clément included in his catalogue (*Peintures,* no. 107) and which Delacroix some years earlier had praised in his diary entry of 5 March 1857; it is, at any rate, the only one among the extant studies which exactly fits the description which Delacroix gives in that passage: *"à côté du pied qui est très précis et plus ressemblant au naturel, sauf l'idéal propre au peintre, il y a une main dont les plans sont mous et faits presque d'idée"* (cf. the entire passage, quoted above, p. 167). The powerfully sculptural execution of these limbs by means of densely placed hatchings of the brush corresponds to that of the cadavers in the foreground of the *Raft of the Medusa.* Clément, rightly, considered this study as one of Géricault's most beautiful in point of execution. For another tribute paid to this study, possibly by Burty, see p. 166.
Bibliography:
Journal d'Eugène Delacroix (A. Joubin, ed.), III, Paris, 1932, p. 70–71, entry of 5 March 1857.

P. Burty (?), "Vente Raffet", *Gazette des Beaux-Arts*, 6, 1860, p. 314.

Clément, *Peintures*, no. 107.

P. Borel, *Le roman de Gustave Courbet*, Paris, 1922, p. 26.

A. Joubin, *Catalogue, Musée Fabre*, Montpellier, 1926, p. 172, no. 562.

G. Oprescu, *Géricault*, Paris, 1927, p. 102–104.

L. Gillet, *Les trésors des musées de province*, Paris, 1934, p. 222.

Magazine of Art, XXXIII, 1940, p. 461.

A. Lhote, *Parlons peinture*, Paris, 1936, p. 104.

A. Lhote, *De la palette à l'écritoire*, Paris, 1946, p. 148.

Berger, p. 72, plate 53.

G. Dumur, "La Galerie Bruyas", *l'Oeil*, 60, December 1954, p. 41.

A. del Guercino, *Géricault*, Milan, 1963, plate 45.

Exhibited:

Les chefs-d'œuvre du Musée de Montpellier, Musée de l'Orangerie, Paris, 1939, no. 54 (the exhibition was repeated, later in 1939, at the museum of Berne, where the painting was numbered 43).

Rouen, 1963, no. 9.

93. STUDY OF TWO SEVERED LEGS AND AN ARM (Plate 91)

Oil on canvas; 375 × 460 mm.

Collections: Lehoux; Princesse de Croy; Musée du Louvre, Paris, RF 579-A (acquired in 1890).

The same limbs, in the same arrangement as in catalogue nos. 91, 92, but seen in a different view and painted by the light of a lamp.

Bibliography:

Clément, *Peintures*, no. 108.

Ch. Sterling and H. Adhémar, *La peinture au musée du Louvre, École Française,* I, Paris, 1959, no. 942, plate 337.

Exhibited:

Bernheim-Jeune, 1937, no. 41.

Rouen, 1963, no. 10.

94. STUDY OF TWO FLAYED CADAVERS (Plate 93)

Pen on paper; 242 × 343 mm.

Collections: E. Martin, London; Mrs. Frances S. Jowell, Toronto.

The casualness of the arrangement suggests that these studies were made in the dissecting room and were not copied from anatomical plates. The study occupies the verso of a sheet of figure studies (Plate 94) loosely related to the preparatory work for the *Medusa,* though the poses do not precisely correspond to those of any of the figures of the composition. Eugène Delacroix,

who evidently had this drawing in his possession in the 1820's, drew a copy of one of the life studies (Mrs. B. Diamonstein collection, New York).

Bibliography:

L. Eitner, "Dessins de Géricault d'après Rubens, et la genèse du *Radeau de la Méduse*", *Revue de l'Art,* no. 14, 1971, p. 54, fig. 11 (the recto).

Exhibited:

Los Angeles, Detroit, Philadelphia, 1971–72, no. 82 (the recto illustrated).

95. STUDY OF TWO FLAYED CADAVERS (Plate 96)

Pencil on paper; 228 × 340 mm.

Collections: Thomas S. Cooper; Christopher Powney, London (1968); present location unknown.

Whether sketched in the dissecting room or derived from an anatomical illustration, this study appears to have served Géricault in the composition of the *Mutiny* scene. The body at the left, lying face down with arms spread sideways, is strikingly similar to a figure in the centre of the *Mutiny* drawing at the Fogg Museum (catalogue no. 8). In a somewhat altered form, it was to become one of the recurrent motifs in the subsequent compositional development of the *Raft of the Medusa* and a prominent feature of the final composition (see catalogue nos. 16–26). The other body, turned to the side and with arms hanging limply down, played a more ephemeral role. It appears, protruding from between two barrels, at the right side of the Raft in the *Mutiny* drawings in the Fogg and the Amsterdam museums (catalogue nos. 7–8).

Exhibited:

Exhibition of Early Drawings, Christopher Powney, London, 1968, no. 51.

96. STUDY OF A FLAYED LEG (Plate 97)

Black chalk on paper; 282 × 200 mm.

Collections: J. Gigoux (stamp, Lugt 1164); Musée des Beaux-Arts, Besançon, inv. D 2113 (acquired in 1896).

According to Clément, Géricault drew this leg in the dissecting room, using the body of a guillotined criminal as his model.

Bibliography:

Clément, *Dessins*, no. 137.

Exhibited:

Winterthur, 1953, no. 182.

Rouen, 1963, no. 46.

97. STUDY OF A FLAYED LEG AND FEET (Plate 98)

Black chalk on paper; 295 × 210 mm.

Collections: J. Gigoux (stamp, Lugt 1164); Musée des

Beaux-Arts, Besançon, inv. D. 2112 (acquired in 1896). This may be the second drawing, "of slightly larger dimensions", which Clément describes as having been made after the dissected body of a guillotined criminal (see also catalogue no. 96).

Bibliography:
Clément, *Dessins,* no. 137.
Exhibited:
Winterthur, 1953, no. 183.
Rouen, 1963, no. 45.

(c) Portrait Studies

98. SIX STUDIES OF HEADS (Plate 99)
Pencil on paper; 260 × 400 mm.
Collections: J. Gigoux (stamp, Lugt 1164; sale, 1882, no. 593); Baer; Wildenstein, New York; Walter Baker, New York.
The six studies, based on two different models, were evidently drawn during the final phase in the development of the composition. They are related (upper row) to the kneeling figure with upraised arms, the figure of Savigny, that of Corréard, that of Savigny again, and (lower row) to the seated man in the foreground of the composition and, once more, to the suppliant figure. The inscription *Géricault* at the lower right is by a later hand.
Bibliography:
Clément, *Dessins,* no. 131.
Exhibited:
French XIX Century Drawings, Wildenstein & Co., New York, 1947–48, no. 26.
Drawings through Four Centuries, Wildenstein & Co., New York, 1949, no. 63.

99. PORTRAIT STUDY OF THE HEAD OF A YOUTH WITH EYES CLOSED (Plate 100)
Oil on canvas; 460 × 370 mm.
Collection: P. Dubaut; M. Dubaut, Paris.
This study may be related to the figure of the dead "Son", see catalogue nos. 34–45, 84–85.
Bibliography:
L'Art vivant (Supplement), 15 June 1927 (illustrated).
A. del Guercino, *Géricault,* Milan, 1963, plate 55.
Exhibited:
Prague, 1923.
Centenary, 1924, no. 131.

100. STUDY OF THE HEAD OF A WOMAN
Rubbed black chalk on paper; 260 × 200 mm.
Collection: Jamar, present location not known.
Clément describes this lost drawing as *"Etude d'après une domestique du père de Géricault qui avait l'intention de s'en servir dans le* Radeau de la Méduse". Since, of all the preliminary versions, only the *Mutiny* included a woman, it is likely that the drawing was made with that episode in view, and hence at an early stage of the project.
Bibliography:
Clément, *Dessins,* no. 136.

101. PORTRAIT OF THE PAINTER JAMAR (Plate 101)
Oil on canvas; 730 × 600 mm (the catalogue of the Cheramy collection gives the dimensions as 710 × 680 mm, an evident misprint).
Collections: Jamar; Pernet (sale, 1878); Dupré (sale, 1890, no. 144); P. A. Cheramy (sale, 1908, no. 106); F. de Hatvany, Budapest; presumed to have been destroyed during the siege of Budapest in 1944.
According to Clément, Géricault painted this portrait of his assistant and pupil, Jamar, in a few hours, at the time of his work on the *Raft of the Medusa.* Jamar lived with Géricault in the large studio in the faubourg du Roule, where the picture was being executed. He posed for two of the figures of the *Raft,* for the young man who stands between Savigny and the Negro at the mast and for the dead "Son" (see in particular catalogue no. 83). His features can also be recognized in various caricatures and portrait drawings of that time in the sketchbook of the Zürich Kunsthaus and the sketchbook fragments of the Chicago Art Institute. The well-known *Portrait of a Painter in his Studio* at the Louvre, often mistaken for a self-portrait, also bears a marked facial resemblance to Jamar, except for the colour of the sitter's hair, which seems darker than Jamar's.
Since the portrait of Jamar formerly in the Cheramy and Hatvany collections apparently exists no more, the following description of it, taken from the catalogue of the Cheramy collection, has some interest as a record of its colour and manner of execution: *"On retrouve dans ce portrait le caractère de ce tableau* [i.e. the Raft of the Medusa], *avec son large modelé, si plastique. L'energie, la plénitude, le rendu vivant des chairs, sont obtenu plutôt par un sobre et robuste modelé des volumes que par la caractérisation des détails ou le rapport des colorations.*

L'impression d'ensemble est sombre: les cheveux sont d'un blond vigoureux, le visage d'une chaude tonalité jaune brunâtre. Le jeune homme, à l'expression ouverte et de bonne humeur, aux traits pleins d'une robuste santé, à la bouche charnue et sensuelle, regarde au loin. Il est vêtu d'un habit noir aux reflets gris verdâtre bombé sur la large poitrine, avec une cravate noire: le col de la chemise est indiqué seulement, en peu de traits, par quelques touches grasses lumineuses."

Bibliography:

Clément, *Peintures,* no. 120.

J. Meier-Graefe and E. Klossowski, *La collection Cheramy,* Munich, 1908, p. 78, no. 106.

E. Gerlötei, "L'ancienne collection François de Hatvany", *Gazette des Beaux-Arts,* May, 1966, pp. 357 ff.

102. PORTRAIT OF A MAN, SOMETIMES CALLED "THE CARPENTER OF THE MEDUSA" (Plate 102)

Oil on canvas; 460 × 380 mm.

Collections: Marquiset (?); Musée des Beaux-Arts, Rouen, catalogue 1357 (acquired in 1892).

The reason for the identification of this portrait as the *Medusa*'s carpenter (first suggested in the catalogue of the *Centenary* exhibition in 1924) may be its resemblance to the head of the kneeling man in the centre (cf. catalogue nos. 55-59), which may well be the one to which Clément (p. 143) refers as having been painted after the carpenter of the *Medusa*. The earliest published description of the painting, the pamphlet issued in London in 1820 (*A Concise Description of Monsieur Jerricault's Great Picture,* p. 13) does mention "Lavalette, a sergeant of artillery, (who) was carpenter of the frigate", but identifies him with the figure supporting the signalling Negro. The *Medusa*'s carpenter is, in fact, an elusive figure and his connection with Géricault's painting is shrouded in some confusion. Clément (p. 130) explicitly mentions him as having been among the survivors and as having furnished Géricault an exact scale model of the Raft. Corréard and Savigny, on the other hand, mention "*Lavilette, chef d'atelier*" as one of the survivors of the Raft who died shortly after their rescue (*Naufrage de la frégate la Méduse,* Paris, 1817, p. 99).

Bibliography:

Clément, *Peintures,* no. 123 (?).

Exhibited:

Centenary, 1924, no. 247.

Bernheim-Jeune, 1937, no. 51.

Rouen, 1963, no. 12.

103. PORTRAIT STUDY OF THE HEAD OF AN ELDERLY, EMACIATED MAN (Plate 103)

Oil on canvas; 460 × 370 mm.

Collections: Lherbette; J. Gigoux; Musée des Beaux-Arts, Besançon, inv. 79-Chu (acquired in 1896).

Clément identified the subject of this study as Cadamour, *roi des modèles,* who served Géricault for the figure of the "Father", but this hardly accords with what is known of Cadamour's age and appearance in 1819. Nor is it likely that this study represents Géricault's friend Lebrun, who also posed for the "Father". It is probable, rather, that Géricault found this elderly man of frighteningly haggard appearance among the patients of the Beaujon Hospital, where he made drawings and some oil studies at this time (see catalogue nos. 81-83).

Bibliography:

Clément, *Peintures,* no. 103.

Exhibited:

Winterthur, 1953, no. 78.

Besançon, le plus ancien musée de France, Musée des Arts Decoratifs, Paris, 1957, no. 53.

104. PORTRAIT STUDY OF M. LEBRUN

Oil on canvas; 460 × 380 mm.

Collection: Present location not known.

M. Lebrun, a friend of Géricault and for many years director of the *école normale* of Versailles, described in a letter (quoted by Clément, p. 132) the peculiar circumstances under which this portrait was painted, in 1818 or 1819, at Sèvres, where he had gone to recover from a severe attack of jaundice. "*J'eus bien de la peine à trouver un gîte: ma figure cadavreuse effrayait tous les aubergistes, aucun ne voulait me voir mourir chez lui. Je fus obligé de m'adresser à un logeur de roulage qui eut pitié de moi . . . J'étais chez lui depuis huit jours, lorsqu'une après-midi, m'amusant sur la porte à examiner les passants, je vois venir Géricault avec un de ses amis. Il me regarde, ne me reconnaît pas d'abord, entre dans l'auberge sous prétexte de prendre un petit verre, me considère avec attention, puis tout à coup me reconnaissant, court à moi et me saisit le bras: 'Ah! mon ami! que vous êtes beau!' s'écrie-t-il. Je faisais peur, les enfants fuyaient, me prenant pour un mort: mais j'étais beau pour le peintre qui cherchait partout de la couleur de mourant.*" A short time after, Géricault returned to Sèvres to spend several days with Lebrun during which he painted several portrait studies of him, according to Clément (p. 134), including one which was to serve for the head of the "Father". The particular portrait study of Lebrun which Clément listed in his catalogue (*Peintures,* no. 109) has not been satisfactorily identified. The study of an elderly, emaciated man in Besançon which appears to be related to the head of the "Father" (catalogue no. 103) can hardly represent Lebrun, a much younger man at

the time. Nor is it possible to accept the *Study of a Male Head in Profile View,* in the collection of the late Pierre Dubaut, which has repeatedly been exhibited as the portrait of Lebrun (*Cent Portraits d'Homme,* Galerie Charpentier, Paris, 1952, no. 34; Marlborough, 1952, no. 27; Winterthur, 1953, no. 79), for reasons which are not compelling on the grounds of style, though its dimensions fit those named by Clément and its yellow and ochre complexion recalls Lebrun's malady.
Bibliography:
Clément, pp. 132 ff. and *Peintures,* no. 109.

105. PORTRAIT STUDY OF A MAN (Plate 104)
Oil on canvas; 410 × 330 mm.
Collections: Leon Cogniet; P. A. Cheramy; Otto Ackerman; Col. H. E. Buehler, Schloss Berg-am-Irchel, Winterthur, Switzerland.
The head resembles in its inclination and expression that of the desperate man who, holding his head in both hands, cowers in the shadow of the Raft's sail. Its identification as a portrait of Alexandre Corréard, which the catalogues of the Winterthur exhibition and of the H. E. Buehler collection propose, seems untenable in the absence of any facial resemblance to the known portrait of Corréard, which occurs in the *Raft of the Medusa,* see catalogue no. 75. The abbreviated signature and date at the lower left of the canvas, "Glt 1818", has no parallel among Géricault's known authentic signatures, and may be by another hand.
Bibliography:
Atlantis, 1950, no. 4.
Géricault, Sammlung Hans E. Bühler, Winterthur, 1956, no. 21.
Exhibited:
Winterthur, 1953, no. 80.

106. PORTRAIT STUDY OF THE NEGRO MODEL JOSEPH (Plate 105)
Oil on canvas; 465 × 380 mm.
Collections: G. Duplessis; Col. H. E. Buehler, Schloss Berg-am-Irchel, Winterthur, Switzerland.
Clément identified the sitter as Joseph, a professional model who posed for Géricault at the time of the execution of the *Raft of the Medusa* and who, in particular, served him for the figure of the signalling Negro. Joseph, still young at the time of his work for Géricault, lived to become a fixture and a legend of the Parisian studios of the mid-century. "*Je ne veux pas oublier un personnage que l'on rencontrait très fréquemment chez Gleyre . . . C'est le nègre Joseph. Il avait été admirablement beau. C'est lui qui avait servi de modèle à Géricault . . . et qui, bravant l'infection des cadavres que l'artiste avait*

rassemblés dans son atelier, était resté seul avec lui pendant la plus grande partie du temps que le peintre avait mis à exécuter cet ouvrage. Il savait sur Géricault et sur les autres peintres de cette époque une foule d'anecdotes qu'il racontait avec une verve intarissable . . ." (C. Clément, *Gleyre, étude biographique et critique,* Geneva-Neuchâtel, n.d., p. 207). According to an early account (E. de la Bédollière, in "Le modèle", *Les Français peints par eux-mêmes,* II, Paris, 1840, p. 7), "*. . . Géricault recruta parmi les acteurs de madame Saqui le nègre Joseph, qui, venu de Saint-Domingue à Marseille, et de Marseille à Paris, avait été engagé dans la troupe acrobate pour jouer les Africains. Le Naufrage de la Méduse amena une nombreuse clientèle à Joseph, et ses épaules larges et son torse effilé la lui ont conservée, malgré ses innombrables distractions. Car pensez-vous que l'Haïtien, brûlé par le soleil des tropiques, va demeurer tranquille dans sa pose comme Napoléon sur sa Colonne? Non: vous voyez tout à coup sa figure s'épanouir, ses grosses lèvres s'ouvrir, ses dents blanches étinceler: il se parle à lui-même, il se conte des histoires, il rit à gorge deployée: il songe à son pays natal: rechauffé par la chaleur du poêle, il rêve le climat des Antilles: au milieu des émanations de la tôle rougie et de la couleur à l'huile, il respire le parfum des orangers. O illusions!*"
Bibliography:
Clément, *Peintures,* no. 104-bis (Supplement).
Géricault, Sammlung Hans E. Bühler, Winterthur, 1956, no. 22.
Exhibited:
Winterthur, 1953, no. 86 (illustrated).

107. STUDY OF THE HEAD OF A NEGRO (Plate 106)
Rubbed black chalk on paper; 245 × 175 mm.
Collection: P. Dubaut; M. Dubaut, Paris.
A study for the head of the Negro who stands with Savigny and Corréard near the mast of the Raft, this drawing has the look of a tracing, worked up with rubbed chalk, and left in a partially finished state.
Bibliography:
Berger, p. 72, plate 50.
Exhibited:
Bignou, 1950, no. 52.
Marlborough, 1952, no. 55.
Winterthur, 1953, no. 171.

108. HEAD OF A NEGRO IN LOST PROFILE VIEW (Plate 107)
Pastel on bistre paper; 370 × 285 mm.
Collections: Sauzay; Musée des Beaux-Arts, Rouen, catalogue 1399 (acquired in 1909).
Not directly related to any of the figures in the *Raft*

of the Medusa, the position and type of the head in this study bears a very general resemblance to that of the Negro who stands with Corréard and Savigny at the mast of the Raft. The technique and medium (pastel) are extremely unusual for Géricault. The one artist of his circle who frequently drew with pastel colours was the enigmatic Jules-Robert Auguste (1789–1850), his neighbour in the rue des Martyrs. It is possible that this unique essay in pastel in Géricault's work was inspired by him. The purity of line and smoothness of surface which give to this head something of the look of bronze sculpture have their parallel in the oil

Portrait of a Negro in the Albright-Knox Art Gallery in Buffalo.
Bibliography:
R. Regamey, *Géricault,* Paris, 1926, plate 30.
W. Friedlaender, *David to Delacroix,* New York, 1952, plate 55.
L. H. Lem, "Le thème du nègre dans l'œuvre de Géricault", *L'Arte,* January–June 1962, p. 19.
Exhibited:
Centenary, 1924, not listed in catalogue.
Französische Zeichnungen, Hamburg, Cologne, Stuttgart, 1958, no. 135.

(d) Illustrations for Corréard's and Savigny's Naufrage de la frégate la Méduse

109. A SHIP SINKING IN A STORMY SEA
(Plate 108)
Pencil on paper; 340 × 370 mm.
Collections: Le Breton; Musée des Beaux-Arts, Rouen, catalogue 1412 (acquired in 1909).
This very rough sketch may be connected with the first of the four watercolour illustrations which Géricault drew for Corréard's and Savigny's *Naufrage de la frégate la Meduse,* fourth edition, 1821 (cf. no. 110 of this catalogue). A faint pencil sketch of a similar subject occurs on folio 17 recto of the sketchbook fragment of 1818–19 in the Chicago Album (cf. L. Eitner, *Géricault, an Album of Drawings in the Art Institute of Chicago,* Chicago, 1960, no. 17).

110. THE ABANDONED MEDUSA, AFTER THE DEPARTURE OF THE BOATS AND THE RAFT
(Plates 109, 112)
Watercolour on paper; 105 × 170 mm.
Collections: A. Corréard; Leclère fils; present location unknown.
Géricault painted this and three further watercolours as illustrations for the fourth edition of Corréard's and Savigny's account of the shipwreck of the *Medusa,* published in 1821. The lithographer Champion reproduced Géricault's watercolours in the form of small, lithographic plates, reversing the compositions in the process. The original watercolours remained in the possession of Alexandre Corréard, after whose death they were published, in the form of crude wood engravings by Pauquet, in the popular illustrated journal, *Le Magasin Pittoresque* (XXVII, December 1859). Their subsequent fate is not known. It is possible that the watercolour drawing of a shipwreck by Géricault which appeared in the sale of the Walter Goetz

collection in 1922 was the *Abandoned Medusa* from this set of illustrations. The catalogue of the sale gives its dimensions as 130 × 230 mm. (*Séquestre Goetz,* Durand-Ruel, Paris, 23–24 February 1922, no. 189–C, *Le naufrage*). See also nos. 27, 111 and 112 of this catalogue.
Bibliography:
Clément, *Dessins,* no. 139–A.

111. THE MINISTER OF THE KING ZAÏDE, TRACING THE MAP OF EUROPE (Plates 110, 113)
Watercolours on paper; 105 × 170 mm.
Collections: A. Corréard; Leclère fils; present location not known.
The illustration of an incident of the voyage of survivors of the shipwreck of the *Medusa* in the Senegal, this is the third in the series of four watercolours drawn by Géricault for the fourth edition of Corréard's and Savigny's account of the shipwreck (see nos. 27, 110 and 112 of this catalogue).
Bibliography:
Le magazin Pittoresque, XXVII, December 1859.
Clément, *Dessins,* no. 139–C.

112. ENGLISH OFFICERS VISITING CORRÉARD AFTER HIS RESCUE (Plates 111, 114)
Watercolours on paper; 105 × 170 mm.
Collections: A. Corréard; Leclère fils; present location not known.
The fourth in the series of four watercolours which Géricault produced for the fourth edition of Corréard's and Savigny's account of the shipwreck of the *Medusa* (see nos. 27, 110 and 111 of this catalogue).
Bibliography:
Le Magazin Pittoresque, XXVII, December 1859.
Clément, *Dessins,* no. 139–D.

LIST OF COLLECTIONS
Numbers outside brackets refer to the Plates

Alençon, Musée de Peinture: 79 (Cat. no. 80)

Amsterdam, Stedelijk Museum: 6 (Cat. no. 7)

Bayonne, Musée Bonnat: 29 (Cat. no. 36), 40 (Cat. no. 45), 43 (Cat. no. 49), 49 (Cat. no. 54), 54 (Cat. no. 58), 80 (Cat. no. 81)

Besançon, Musée des Beaux-Arts: 12 (Cat. no. 14), 34 (Cat. no. 78v), 48 (Cat. no. 79v), 65 (Cat. no. 65), 72 (Cat. no. 73), 77 (Cat. no. 78), 78 (Cat. no. 79), 85 (Cat. no. 86), 97 (Cat. no. 96), 98 (Cat. no. 97), 103 (Cat. no. 103)

Budapest, Hatvany Collection (formerly): 101 (Cat. no. 101)

Cambridge, Mass., Fogg Art Museum: 7 (Cat. no. 8), 28 (Cat. no. 35)

Chicago, Art Institute: 82 (Cat. no. 83)

Dijon, Musée des Beaux-Arts: 1 (Cat. no. 1)

Dijon, Musée Magnin: 63 (Cat. no. 63)

Düsseldorf, Kunstmuseum: 31 (Cat. no. 39)

Lille, Palais des Beaux-Arts: 14 (Cat. no. 16), 35 (Cat. no. 42), 36 (Cat. no. 43), 38 (Cat. no. 42v), 42 (Cat. no. 48), 59 (Cat. no. 43v)

London, Powney Collection (formerly): 30 (Cat. no. 37), 96 (Cat. no. 95)

Lyon, Musée des Beaux-Arts: 69 (Cat. no. 70)

Malaga, Prince Hohenlohe Collection: 84 (Cat. no. 85)

Malzéville, Cournault Collection (formerly): (Cat. no. 66)

Montauban, Musée Ingres: 71 (Cat. no. 72)

Montpellier, Musée Fabre, 92 (Cat. no. 92)

Mortain, Queslier Collection (formerly): (Cat. no. 13)

New York, Baker Collection: 99 (Cat. no. 98)

Paris, Louvre: 16 (Cat. no. 18), 19 (Cat. no. 22), 21 (Cat. no. 24), 22 (Cat. no. 26), 56 (Cat. no. 59), 66 (Cat. no. 67), 71 (Cat. no. 72), 89 (Cat. no. 90), 91 (Cat. no. 93)

Paris, Aubry Collection: 17 (Cat. no. 19), 18 (Cat. no. 20), 37 (Cat. no. 44), 55 (Cat. no. 19v), 58 (Cat. no. 61), 60 (Cat. no. 20v)

Paris, Bellier Collection: 25 (Cat. no. 32)

Paris, Chaumont Collection (formerly): (Cat. no. 29)

Paris, Chenavard Collection (formerly): 4 (Cat. no. 5)

Paris, Delestre Collection: 76 (Cat. no. 77)

Paris, Dubaut Collection: 2 (Cat. no. 2), (Cat. no. 30), 44 (Cat. no. 50), 46 (Cat. no. 51), 50 (Cat. no. 50v), 68 (Cat. no. 69), 86 (Cat. no. 87), 88 (Cat. no. 89), 100 (Cat. no. 99), 106 (Cat. no. 107)

Paris, Gobin Collection: 8 (Cat. no. 10), 81 (Cat. no. 82)

Paris, de Hauke Collection: (Cat. no. 31)

Paris, His de La Salle Collection (formerly): 67 (Cat. no. 68)

Paris, Jamar Collection (formerly): (Cat. no. 100)

Paris, Lebel Collection: 90 (Cat. no. 91)

Paris, Leclère Collection (formerly): 24 (Cat. no. 28), 109-111 (Cat. nos. 110-112)

Paris, Lesourd Collection (formerly): 9 (Cat. no. 11)

Paris, Marcille Collection (formerly): 9 (Cat. no. 11)

Paris, Chevrier Marcille Collection (formerly): (Cat. no. 38)

Paris, Marillier Collection: 26 (Cat. no. 34)

Paris, Renand Collection: 47 (Cat. no. 52)

Paris, de la Rosière Collection (formerly): (Cat. no. 64)

Paris, Veterhan Collection (formerly): (Cat. no. 21)

Poitiers, Musée des Beaux-Arts: 3 (Cat. no. 3), 11 (Cat. no. 3v)

Rouen, Musée des Beaux-Arts: 5 (Cat. no. 6), 10 (Cat. no. 12), 13 (Cat. no. 15), 15 (Cat. no. 17), 41 (Cat. no. 47), 45 (Cat. no. 15v), 57 (Cat. no. 60), 61 (Cat. no. 47v), 62 (Cat. no. 62), 73 (Cat. no. 74), 83 (Cat. no. 84), 102 (Cat. no. 102), 107 (Cat. no. 108), 108 (Cat. no. 109)

Stanford, Cal., University Museum: 27 (Cat. no. 33)

Stockholm, National Museum: 87 (Cat. no. 88)

Toronto, Jowell Collection: 32 (Cat. no. 40), 39 (Cat. no. 46), 51 (Cat. no. 55), 52 (Cat. no. 56), 53 (Cat. no. 57), 93 (Cat. no. 94v), 94 (Cat. no. 94), 95 (Cat. no. 40v)

Vienna, Albertina: 33 (Cat. no. 41)

Winterthur, Bühler Collection: 20 (Cat. no. 23), 104 (Cat. no. 105), 105 (Cat. no. 106)

Zürich, Kunsthaus: 70 (Cat. no. 71), 74 (Cat. no. 75), 75 (Cat. no. 76)

Zürich, private collection: 64 (Cat. no. 64)

INDEX

Ansiaux, 4
Arnoux, Albert de, *see* Bertall
Auguste, Jules-Robert, 173 (Cat. no.
 108)

Baring, Sir T., 63
Batissier, Louis, 32n, 40n, 48n, 60n, 164
Bertall, 56
Blanc, Charles, 49n
Bro de Comères, Louis, 14n
Brunet, Auguste, 11, 57
Bullock, William, 62, 63, 64, 151
 (Cat. no. 27)
Burty, Philippe, 166, 168 (Cat. no. 92)
Byron, Lord, 14, 45, 55, 155

Cadamour, 31, 32, 171 (Cat. no. 103)
Caravaggio, 63
Carey, David, 45n, 58n
Caruel de Saint-Martin,
 Alexandrine-Modeste, 12–13
Champion, A., 173 (Cat. no. 110)
Champmartin, Charles Émile, 165
 (Cat. no. 83), 168 (Cat. no. 91)
Charlet, N.-T., 20, 62, 65, 151
 (Cat. no. 27)
Chaumareys, Hugues Duroys de, 7, 10,
 162 (Cat. no. 74)
Chenavard, Henri, 141 (Cat. no. 5)
Chenavard, Paul, 65n
Chennevières, 66n
Chesneau, Ernest, 24n, 56
Claye, 166
Clément, Charles, 12n, 20, 22, 38, 40,
 41n, 49, 56, 57, 58, 60n, 65, 139
 (Cat. no. 1), 141 (Cat. no. 5),
 142n, 144 (Cat. no. 11), 145 (Cat.
 no. 13), 151 (Cat. nos. 24–5), 156
 (Cat. no. 41), 160 (Cat. no. 64),
 161 (Cat. nos. 66, 68), 164, 164
 (Cat. no. 80), 166, 168 (Cat. nos.
 91–2), 169 (Cat. no. 96), 170 (Cat.
 nos. 97, 100–1), 171 (Cat. nos.
 102–4), 172 (Cat. no. 106)
Coeuré, Sebastien, 20n
Cogniet, Léon, 61
Copley, John Singleton, 47
Corréard, Alexandre, 7n, 10n, 11, 22,
 23, 24, 25, 29, 31, 44, 45n, 52, 53n,
 60n, 62, 139, 140–1, 143, 144,
 145–6, 153, 154, 155, 162 (Cat. no.
 74), 163 (Cat. no. 76), 170 (Cat. no.
 98), 171 (Cat. no. 102), 172 (Cat.
 no. 105), 173 (Cat. nos. 109–12)

Couder, Louis-Charles-Auguste, 4
Coudin, 146, 155

Dalzell, Sir J. G., 45n, 155
Dante, 45, 60
Dard, Mme., 7n
Dastier, 32
David, Jacques-Louis, 4, 17, 32, 48,
 49–50, 51, 58, 63, 64
 Battle of the Romans and Sabines, 34,
 49n, 50, 62, 141 (Cat. no. 5)
 Coronation of Napoleon, 50
 Henriette de Verninac, 166
 Leonidas at Thermopylae, 34, 49n, 50
 Oath of the Horatii, 1
 La Peste de Saint-Roch, 48, 152 (Cat.
 no. 32), 155
Debouchage, 10
Decazes, Élie, 10
Dedreux-Dorcy, Pierre Joseph, 31, 40,
 64, 67
Delacroix, Eugène, 14n, 31, 32, 34, 36,
 40, 56, 61n, 65, 66, 158 (Cat. no.
 51), 159 (Cat. no. 52), 166, 167
 (Cat. no. 89), 168 (Cat. no. 92),
 169 (Cat. no. 94)
 Bark of Dante, 56
 *Greece Expiring on the Ruins of
 Missolunghi,* 66
 Liberty on the Barricade, 56
 Massacre of Chios, 66
 Notre-Dame des sept Douleurs, 61n
Delécluze, Étienne, 48–9, 50, 51, 57, 58
De Metz, 162 (Cat. no. 71)
De Musigny, 59n, 61n
Devéria, Achille, 67n
Didot, Firmin, 10n
Doyen, Gabriel-François,
 *St Genevieve Interceding for the
 Plague-Stricken (Miracle des
 Ardents),* 48, 152 (Cat. no. 32)
Ducis, Louis, 4
Dupont, Captain, 8, 9
Duval, Emeric, 58n

Etex, A., 31n, 67n

Fodor, J. C., 142 (Cat. no. 7n)
Forbin, Comte de, 1, 60–1, 66–7
 Inez de Castro, 66n
Fualdès, 20–1, 22
Fuseli, Henry, 45
 Ugolino, 155

Galbacio, B., 52n
Gault de Saint-Germain, 42n, 58n
Gérard, Baron, 5, 61
Gerfand, 32
Géricault, Théodore,
 death, 38, 65
 disposal of his belongings, 67
 finances, 5, 12, 65
 illness, 57, 61, 65
 love affair, 12–13
 Rome Prize competition, 12
 studies, 12
 suicide attempt, 65
 takes up lithography, 19–20
 travels to England, 61–5
 travels to Italy, 12, 13, 17–18, 49n
 works,
 Artillery Caisson, 19
 Battle Scene, 18, 147 (Cat. no. 14),
 154
 Boxers, 19
 Cart Loaded with Soldiers, 19
 Cattle Market, 18, 54n
 Charging Chasseur, 12, 15, 50, 54n,
 60n, 61n
 Death of Paris, 50
 The Death of Poniatowski, 150
 (Cat. no. 22)
 Drowned Man, 154
 Hercules and Lichas, 154
 Horses Battling in a Stable, 19
 *Liberation of the Prisoners of the
 Inquisition,* 66n
 *Mameluke Defending a Wounded
 Trumpeter,* 19
 Murder of Fualdès, 20–1, 22, 52
 Negro Slave Trade, 66n
 Portrait of a Painter in his Studio,
 170 (Cat. no. 101)
 Race of the Barberi Horses, 17–18,
 50, 54n
 Return from Russia, 19
 Self Portrait, 65
 Signboard of a Blacksmith, 54n
 Surrender of Parga, 66n
 La Tempête, 55n
 Ugolino in Prison, 45
 Wounded Cuirassier, 12, 15–16, 54n,
 61n
Gigoux, Jean, 6n
Girodet de Roucy Trioson, Anne-
 Louis, 46, 58
 Endymion, 46n, 155
 Pygmalion, 5

Goncourt, Edmond and Jules de, 56
Gouvion de St. Cyr, 10n
Granet, François-Marius,
 *Interior of the Church of the Capuchins
 in Rome,* 5
Gros, Antoine-Jean, 6n, 14, 15, 17, 18,
 23, 24, 37, 43, 49, 50, 51, 57
 Battle of Aboukir, 47n
 Battle of Eylau, 50
 Battle of the Pyramids, 47n
 *Embarkation of the Duchess of
 Angoulême,* 5, 139 (Cat. no. 1)
 *Napoleon Visiting the Plague-Stricken
 in the Hospital of Jaffa,* 46, 48, 50,
 152 (Cat. no. 32), 155
Guérin, Pierre, 5, 12, 16, 32, 38, 49
 Aurora and Cephalus, 46n, 155
 Marcus Sextus, 46, 155
Guillemardet, Felix, 40
Guillemot, Nicolas,
 Christ Raising the Widow's Son, 4, 60n

Henner, J. J., 41n
Hersent, Louis,
 Gustave Wasa, 4–5
Houghton, Moses, 45, 155

Ingres, Jean Auguste Dominique, 58
 Odalisque, 5
Isabey, Eugène, 65

Jal, Auguste, 58n, 60n
Jamar, Louis Alexis, 31, 32n, 38, 41n,
 151 (Cat. no. 24), 159 (Cat. no. 52),
 165 (Cat. no. 84), 170 (Cat. no. 101)
Joseph, 32, 172 (Cat. no. 106)
Jouvenet, Jean, 49n
 Miraculous Draught of Fishes, 49n
 Triumph of Justice, 49n, 142 (Cat. no.
 7)
Jouy, Etienne de, 4, 58n, 60n

Kératry, Auguste Hilarion, 45n, 58n

Lami, Eugène, 137
Lamme, A. J., 142 (Cat. no. 7n)
Landon, C. P., 2n, 3n, 42n, 52n, 58n
Lauriston, M. de, 66

Lavalette, 171 (Cat. no. 102)
Laviron, G., 52n
Lawrence, Sir Thomas, 162 (Cat. no.
 73)
Lebreton, G., 49n
Le Brun, Charles, 49n
Lebrun, Théodore, 31, 33, 36, 155,
 171–2 (Cat. no. 104)
LeComte, Hipolyte, 23n
Lehoux, Pierre-François, 31
Lemaigre, 139
Lethière, Auguste, 62
Lethière, Guillaume, 62
Louis XVIII, King, 1–3, 6, 60
Loutherbourg, Jacques-Philippe de, 47

Martigny, 32
Meynier, Charles, 1, 4
 France, Protectress of the Arts, 1, 4
Michelangelo, 13, 16, 17, 18, 23, 63,
 64, 67, 167
 Last Judgement, 47, 142 (Cat. no. 7),
 154
 Pisan Battle, 139 (Cat. no. 2), 154
 Sistine Chapel frescoes, 25, 47, 153
Michelet, Jules, 56
Molière, 14
Montfort, Antoine Alphonse, 15, 31,
 32n, 33, 34, 48n, 151 (Cat. nos. 24,
 25)
Morland, George, 47

Napoleon, 1, 3, 16n, 17

O'Mahony, Count, 58n, 59, 60

Pauquet, H. L. E., 152 (Cat. no. 28),
 173 (Cat. no. 110)
Picot, François-Edouard,
 Amor and Psyche, 5
Pillet, Fabien, 54, 58n
Planche, Gustave, 45n, 56
Pothey, 56n
Prud'hon, Pierre, 46, 58
 Assumption of the Virgin, 5
 *Justice and Divine Vengeance Pursuing
 Crime,* 46n

Pujol, Abel de, 4
 Rebirth of the Arts, 1

Raffet, Auguste, 166
Reynolds, Sir Joshua,
 Ugolino, 45, 64
Ricourt, 67n
Robert-Fleury, Joseph Nicolas, 31
Rochefoucault, Vicomte de la, 67
Rubens, Sir Peter Paul, 12, 15, 23, 25,
 50
 *Little Last Judgement (Fall of the
 Damned),* 47, 49n, 53n, 142
 (Cat. no. 7), 153 (Cat. no. 33),
 163 (Cat. no. 77)

Savigny, Henri, 7–11, 22–5, 29, 31, 44,
 45n, 52, 53n, 62, 139, 140–1, 143,
 144, 145–6, 153, 154, 155, 170
 (Cat. no. 98), 171 (Cat. no. 102),
 173 (Cat. nos. 109–12)
Schaal, Louis, 141 (Cat. no. 5)
Senonnes, Vicomte de, 1
Silvestre, Théophile, 14n
Soulary, 45n
Southey, Robert, 62n
Steuben, Charles, 31
Suyderhoef, Jonas, 47n, 142 (Cat. no.
 7), 153 (Cat. no. 33)

Thoré, Théophile, 66n
Titian, 12

Ulrich, J., 162 (Cat. no. 71)

Vernet, Carle, 12, 14, 15, 156 (Cat. no.
 39)
Vernet, Horace, 2n, 11, 14–15, 17, 18,
 19, 20, 22, 31, 33, 52, 66n
 Massacre of the Mamelukes, 5
Vernet, Joseph, 47
Verninac, Henriette de, 166
Véron, L., 34n

Westall, Richard, 47